3/61

TRIBAL ARTS

BÉRÉNICE GEOFFROY-SCHNEITER

PREFACE BY DOUGLAS NEWTON

THE VENDOME PRESS
NEW YORK

To the memory of my father, Henri Geoffroy,
who was a doctor in Africa

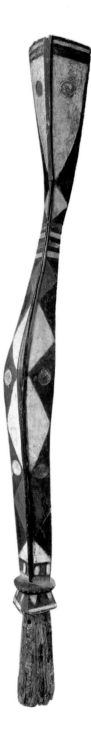

CONTENTS

PREFACE

When, in the history of Western art appreciation, did the visual arts of Oceania and Africa, at least sculpture and painting, begin to enter our consciousness? There is no doubt that they have done so; almost every museum in the Western world is now felt to be incomplete unless it possesses at least a few examples of them, and displays them side by side with the classical arts.

Almost invariably, when the question arises, the same stories are repeated. We hear again and again about Vlaminck's, Derain's and Picasso's "discovery" of African sculpture. Whether that event was as important as it is made out to be is debatable. What was to be learned in aesthetic terms from these arts (and from a great deal else) was absorbed with remarkable speed, and the artists passed on to other things.

To obtain a more realistic picture of how we have reached our present position, we must take into account the contributions of art historians and anthropologists—even though it is not possible to do them justice in a few words, and a selection of incidents must suffice.

In the first place, are the things we see in this book "art" at all? Some writers have noticed that, in languages of the societies from which they derive, there is no word that corresponds to "art" in Western languages. Is there any pressing reason why there should be, and does it matter that there is not? Many words in these societies define the activities of art-making and expressions of qualitative judgment. "Art," in any case an imprecise word, is in its present usage of very recent coinage, and a semantic hiatus means very little. We cannot conclude

that a phenomenon does not exist for people because they have no word for it. To do so drops us into the pitfall of ignoring aesthetic intentions and aesthetic responses. While we can, and do, respond aesthetically to a vast range of human and nonhuman phenomena, it does seem mistaken to think that aesthetic responses to manmade works do not imply that the makers of the works had aesthetic intentions. If they did, then they were knowingly creating what we can call works of art.

Art historians began to study "primitive" art, as a problem in itself, about the middle of the 19th century. Their ambitions were limited. Owen Jones and Gottfried Semper discussed and illustrated this art; but what they concentrated on was "decorative art," meaning essentially patterns. Sculpture, of which a good deal was already available to them in museum collections, was virtually ignored—indeed, for a long time to come it was generally grouped under the rubrics of "idols," "fetishes," or by the more enlightened "ancestor figures." Semper considered the effect of the material used on pattern-making; and this led to the discussion of what might become the history of pattern.

The great scientific revolution of the age was Darwin's theory of evolution. As scientists, the anthropologists were deeply aware of its possible implications and tended to use evolutionary theory as a foundation for large-scale historical speculation about the growth, that is to say, "progress," of society; and a presumed stasis in the societies they studied.

Around the turn of the 20th century, the budding science of anthropology accepted without too much question the equation of "art" with "decoration." Descriptions of cultures were often compartmentalized, and art was seen as one of the compartments. (The many editions of Notes and Queries on Anthropology, the famous handbook for researchers, duly had a brief section on "Art" that, in 1954, held that tribal art should be considered on a level with that of the great civilizations: the rest was still about patterns.)

Otherwise, the visual arts were a problem. Anthropologists were constantly puzzled by the problem of the naturalism in art current since the Renaissance versus conventionalism, and invoked evolution of one from the other—in either direction—to solve it. For instance, A. C. Haddon, a firm believer in the merits of naturalistic representation, saw departure from it as "degeneration"—a historical process. W. H. R. Rivers saw coexistence of the two styles as evidence of the mingling of populations – again invoking history.

This period of calm academic speculation came to an end with the advent of new theories and methods of research; the key personality is Malinowski, who introduced the radical notion that anthropologists should actually live among the people they were investigating. Now Malinowski was short-sighted, as the photographs he published of himself at fieldwork amply attest. In the Trobriand Islands of New Guinea he saw much, but to at least one aspect of the culture, he was as blind as a proverbial bat. Situated at the heart of a culture with a brilliant art tradition, he was impervious to it. His mistake was, of course, that though he recognized societies as "functional"—composed of interlocking institutions—he could not envisage art as such an institution. For him art remained marginalized. Malinowski's indifference, coupled with his vast prestige, slighted the subject; and his influence—and not only his—ensured that his followers did the same. In America, the pupils of Franz Boas, who had been so involved with material culture, did not follow in his footsteps, however.

When The Museum of Primitive Art opened in New York in 1957, the news was not altogether welcome to anthropologists. H. L. Shapiro wrote that such an institution was unnecessary; such works of art were already in ethnographic museums, where they belonged, and could be seen in appropriate perspectives. But it was too late to protest. From the strictly ethnographic point of view, the "rot" had set in long before. As far as museums were concerned, it developed that art museums were

increasingly using anthropological information in their displays, and ethnographic museums increasingly displayed works of art. It was no longer so important that some modern art had been influenced by "primitive" art: in time, the situation was turned on its head. As late as 1959, a lady was heard to say at an exhibition of Lake Sentani paintings, "You can tell they are good—they look like Klees." The field of "primitive art" had been taught as an academic subject for years in New York; and a whole generation of students was prepared to enter the field—not only as anthropologists but as art historians.

The result, from about the 1950s onward, was an immense expansion of information about the "ethnographic" societies, this time from the inside, as it were. It transpired that, as might have been expected, the arts of such societies had rich systems of symbolism and purpose.

It may be said that the appreciation of these arts is difficult. Indeed it is; but it is well to remember that the arts of all times and all places are equally difficult. We cannot slip easily into the aesthetic worlds of the people who created them, even in the traditions we think of as ours, and we should remember that to think we can do so with traditions of others more familiar to us can also be self-deception. I will take two examples, one familiar to all Westerners, one not.

In Handel's Messiah, the soprano sings out, "I know that my Redeemer liveth." She does not say that this is her opinion, or that, to her best information, she has good reason to believe it is so: she knows. A Maori who was Handel's contemporary knew, without the slightest doubt, that the hero Maui hauled New Zealand out of the ocean in the form of a stupendous fish. This event is shown in certain carvings. Without questioning either belief, we are aware that both the Maori and Handel lived in physical, political and conceptual worlds totally different from each other's—at that time, neither was aware the other existed—and both differed emphatically so from ours 200 years later. If we think of either of them as 20th- early 21st-century men with slightly dif-

ferent ideas from ours, we are wrong; and if we imagine we can think as they did, we are foolish. And yet Handel's solo moves us to tears; and a great achievement of Maori carving, the famous Te Kaha house front, for example, moves us to awe. Both responses are complex but, at heart, aesthetic. The lesson is that the aesthetic response, and aesthetic creativity, are universal in humanity.

Aesthetic response is a faculty that must be exercised, like a muscle. Works of art are not soothing or comfortable. They are never as accessible as we may wish, or even as they may seem. To appreciate them, we can often dispense with knowledge, or even information, but we cannot bring to them less than inquiry, sympathy and, above all, our senses. If we wish them to give up their secrets, we must work; and if we make the effort, we will be richly rewarded.

Douglas Newton

Former Director of the Department of Primitive Art at The Metropolitan Museum of Art, New York

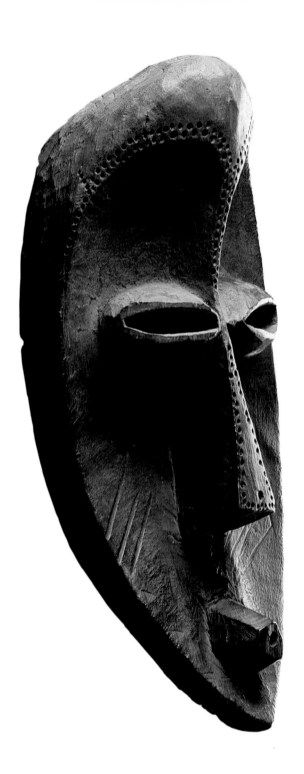

INTRODUCTION

"Negro art? Never heard of it!" Picasso's famous quip, tossed out in 1920 in response to the exasperating and interminable barrage of questions from critics regarding the influence of primitive art on his works, now takes on an ironic edge. For who would have believed, less than a century earlier, that the works of African and Pacific island natives—savage "barbarians" considered to be without history, writing or culture—would one day achieve the status of works of art? That after years of destruction or plunder, or of quite simply having their very existence denied, these "fetishes" and "idols" would, in the space of a few decades, excite the desire of dealers, whet the interest of collectors, stimulate research in the field of ethnography, and stir the passions, arouse the imagination and feed the inspiration of poets and painters?

The tale of the encounter between "civilized" and "primitive" peoples is a long one, peppered with misunderstandings and punctuated by tragedies. Blood was spilled on an appalling scale, and virtually always by the same side: men and women were sacrificed, exterminated or driven into slavery or other forms of servitude; their religions were destroyed, their gods and altars overturned or torched, when they were not ripped from their natural environment in order to become curios or museum pieces.

A singular destiny thus lay in wait for these cultures, derided one moment and feted the next. Perhaps the dawn of the new millennium offers an opportunity to

Mask. People's Republic of the Congo, Etoumbi region, Mahongwe (?). Hardwood; h. 35.5 cm. Formerly Aristide Courtois and Charles Ratton collections and Museum of Modern Art, New York. Collected before 1930. Musée Barbier-Mueller, Geneva.

salve our collective conscience, or simply to divest ourselves of the final vestiges of latent colonialism; to seek rehabilitation and debate. "Negro" art, "primitive" art, "tribal" art, and now most recently "primal" art: fluctuations in terminology that reflect more clearly than any learned thesis the changing status accorded to these objects and to the cultures from which they come. It is this story of our attitudes toward the "Other" and his or her world that will be retraced here, in the conviction that "barbarism" and "savagery"—quite as much as beauty—are in the eye of the beholder.

CHRONICLE OF AN ENCOUNTER FORETOLD

"Let it suffice to say that Africa ever bringeth something new," observed the Renaissance poet François Rabelais. As a true man of his times, Rabelais was already in thrall to the fascination of this mysterious and distant continent. Innumerable cabinets of curiosities, and most notably that of his benefactor André Tiraqueau, were indeed by that time overflowing these "exotic" objects, including native costumes, animal skins, ivory finials and idols. The lure of such objects—as eclectic as they were incongruous—soon gave rise to a full-blown trade within Africa itself in these hybrid pieces, which now inundated the courts of Europe. Commissioned direct from African ivory-carvers, salt boxes, carved horns, spoons, forks and bowls thus came to constitute (above and beyond their status as "commissions") the earliest material evidence of this encounter between two worlds—prompting references also to the novel concept of "Afro-Portuguese" art.

While the story of this relationship between Europe and Africa is punctuated with intriguing anecdotes (such as the baptism at Versailles of the son of an Agni chief, with Louis XIV as his godfather), new interests were about to come into play. It was against a background of economic crisis (from the late 15th century gold, abruptly became an increasingly scarce commodity) that Europe now turned its gaze towards Africa and its riches. True, Arab merchants and travelers peddled the image of a sumptuous earthly paradise, an Eldorado ruled by sovereigns who literally tottered under the immense weight of their jewels. At the same time, the myth of the "noble savage" gave way to that of the "wild heathen," whom it was

Hunting fetish Squatting figure with a magic horn on its head.
Zaire, central southern region, Luluwa. Patinated hardwood; h. 24 cm.
Musée Barbier-Mueller, Geneva.

only prudent to convert to Christianity in their native lands. But now the precious metal was no longer enough: soon the nations of Europe, each in its turn, would seek a human cargo on the coasts of Africa. The reason was as simple as it was shocking: "Negroes" appeared indisputably more vigorous than the Indian populations of America, decimated by massacre and disease. And did not the color of their skin, the outward sign of their diabolical nature, naturally condemn them to slavery? Thus, as Jean Laude has rightly observed, "When in the 19th century the European powers rediscovered Africa in order to carve it up between themselves, explorers, soldiers and missionaries sent back reports of states that were materially and morally ruined, and of peoples who were the survivors of this ruin: the result of four centuries of the slave trade was callously laid at the door of savagery, and of the unfitness of Africans for civilization." (1966)

The case of Oceania appears at once more complex and more ambiguous. When expeditions led by John Byron and Samuel Wallis, and afterwards by Bougainville and Cook, revealed virtually simultaneously the existence of native

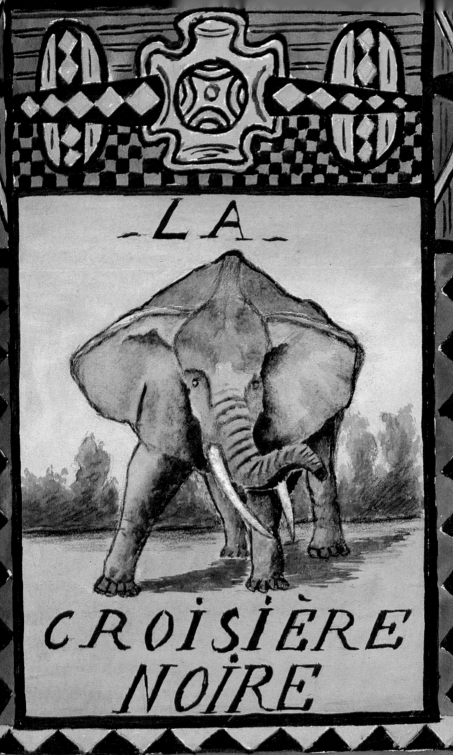

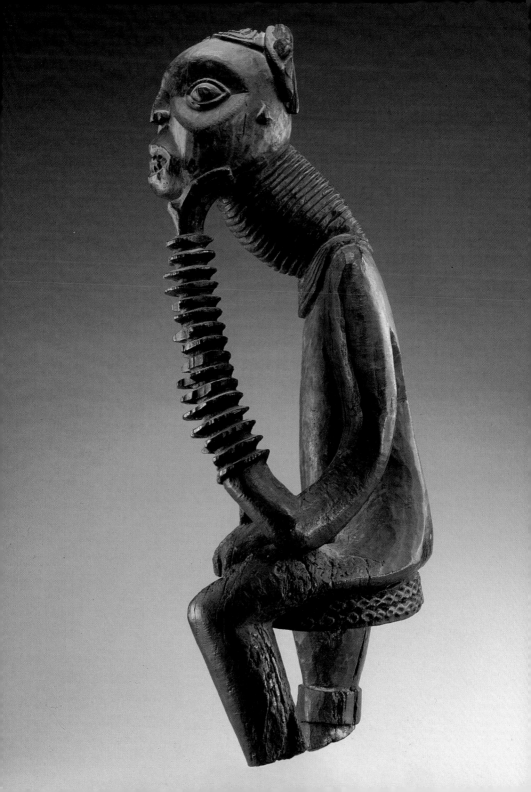

populations in the South Seas, Europe and the Enlightenment seized eagerly on the discovery as fuel for the philosophical debate then raging on the natural condition of man. In fact, however, contemporary readings of the explorers' accounts of their voyages rapidly proved to be limited to the point of prejudice. Attention was focused exclusively on Polynesia, depicted as an earthly paradise inhabited by untouched peoples who were paragons of innocence and virtue. Elevated to the status of "New Cythera," Tahiti rapidly inflamed European imaginations, for did not this "Utopia," inhabited by people of nobility and grace whose lives were devoted to the worship of the god of love, recall the pure and simple customs of the peoples of antiquity? Sadly this idyllic image was soon to be tarnished by two notable misadventures: the death of Cook in a skirmish in Hawaii in 1779, and that of the French explorer Marion-Dufresne in New Zealand.

The early 19th century nevertheless saw a series of great expeditions by French navigators such as Freycinet and Duperry, whose purpose—above and beyond their political and economic missions—was to enrich the various branches of human understanding. Thus, on December 27, 1827, Charles X ordered the creation of a maritime museum, which he installed in the galleries of the Louvre itself. From the day of its public opening, on July 22, 1830, the new museum proved hugely popular, with crowds of visitors contemplating a large and eclectic array of objects, drawn largely from the collections of Baron Denon. This celebrated admirer of antiquities prided himself, indeed, on his interest in ethnography and "savage handicrafts," even if, like the majority of his contemporaries, he failed to distinguish between "fetishes" of American and Oceanian origin. But the greatest contribution to the Louvre collections was to be made by the fruitful expeditions led by Dumont d'Urville in the Pacific from 1826 to 1829 and from 1837 to 1840. In what the artist Sainson described as a "scientific frenzy," the entire crew set out on an orgy of collecting. As Dumont d'Urville himself observed on his return from New Zealand, New Guinea and the Fijian islands: "I procured almost an entire natural history cabinet (shells, corals and madrepores [a type of coral?]) in return for 20 beads; a complete

Previous pages: **Poster for the *Croisire noire*,** a long-distance automobile race in Africa, of 1928. Exoticism was now in vogue. Musée des Arts d'Afrique et d'Océanie, Paris.
Seated figures Cameroon, Bamileke. Wood; h. 81 cm. Private collection, Brussels.

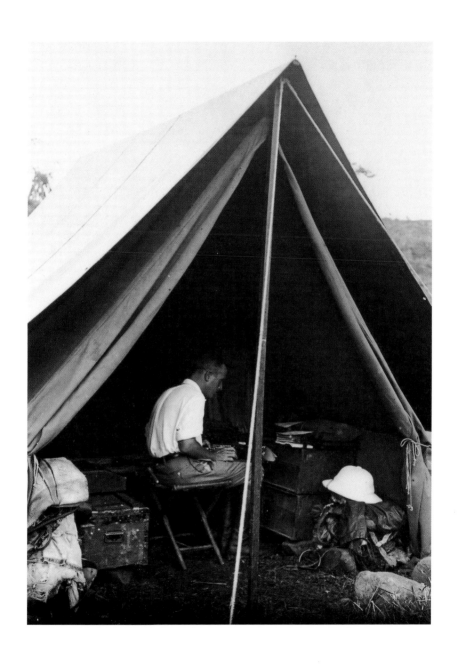

Michel Leiris in his tent. Photograph by Michel Leiris, 1931-1933.
Musée de l'Homme, Paris.

museum of native weapons (daggers, clubs, pikes and shields) cost me only 50."

But this period of passion for discovery was soon to be superseded by the age of colonialism, with all its appalling excesses, as deplored by Gauguin. The image of the "noble savage," strongly tinged with memories of J.J. Rousseau, was now to give way forever to another image, which lingers on so persistently to the present day: that of the "primitive."

FROM "PRIMITIVE" TO "PRIMITIVISM"

A museographical event in Paris, however, was now set to overturn contemporary thinking: the creation, in the aftermath of the 1878 Exposition Universelle, of the Trocadéro museum of ethnography, which opened its first galleries to the public in April 1882. Belgium and England soon followed suit with their own prestigious collections. In 1896, the Royal Museum of the Belgian Congo opened in Tervuren, a suburb of Brussels, while the British capture of Benin, Nigeria, was followed by the arrival in London of a magnificent collection of pieces in bronze and ivory.

Admittedly, the late 19th century was not yet ready for the establishment of museums celebrating, both didactically and aesthetically, the beauty and genius of these distant peoples. Visitors to the Trocadéro museum were thus greeted by a chaotic display of bizarre nail-studded fetishes, ghostlike masks and idols with scarified cheeks and flanks, which left them feeling browbeaten rather than moved. On his first visit to Paris in 1899, the Italian Futurist painter Carlo Dalmazzo Carrà criticized the museum as mediocre and insignificant, while three years later Jacob Epstein dismissed its collections as nothing more than a mass of primitive sculptures, badly displayed. Picasso himself reported to André Malraux his initial impressions of this "awful museum": "It was disgusting; a flea market. The smell … I wanted to leave. I didn't go. I stayed." (*La Tête d'obsidienne*) Yet the artist also admitted that "something happened to him, … something very important," as he suddenly realized "why he was a painter." We are familiar now with the close and passionate relationship that the Catalan master pursued with these "medium masks," these "fetishes" of whose "magical" character he was profoundly aware. The question – hotly debated in rarefied art historical circles – remains: did he or did he not visit the

20

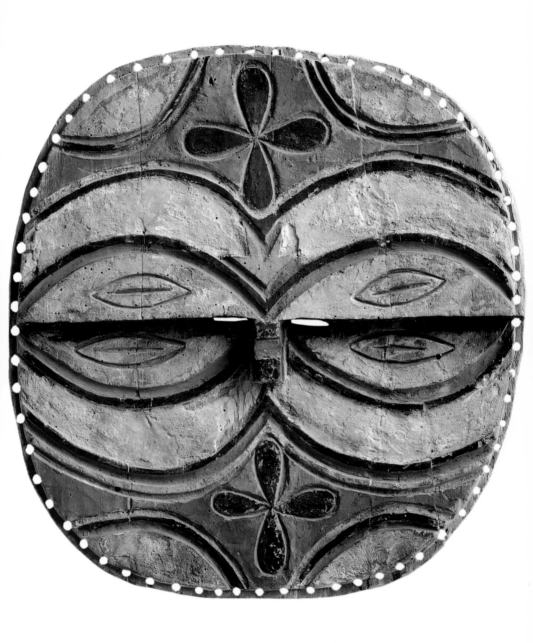

Face mask. Congo, Teke. Polychrome wood.
Formerly André Derain collection.
Musée Barbier-Mueller, Geneva.

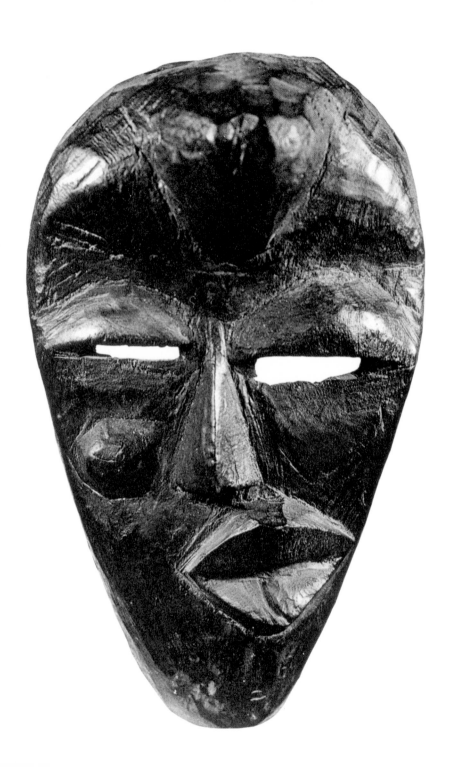

collections of the museum of ethnography before the completion, in 1907, of his disturbing "Demoiselles d'Avignon," the masterpiece that he himself described as his 'first painting of exorcism' ?

Certainly in Paris, then the capital of avant-garde movements, the terms "Negro art" and "primitive art" were still used interchangeably and more or less indiscriminately to denote objects of both African and Oceanian origin. A few decades earlier, Gauguin himself had described the arts of Persia, Egypt, India, Java, Cambodia and Peru as "primitive" and "savage": epithets that were by no means pejorative, but were intended rather to stress the non-academic character of styles that owed nothing to canons of classicism inherited from the worlds of ancient Greece and Rome. Prompted by the same desire to "sharpen their eyes" with new forms, avant-garde artists turned eagerly toward the bracing inspiration of the "barbarian lands." Following the example of Matisse, Derain and Vlaminck, perhaps the pioneer in this regard, Picasso started to collect "Negro" art, finding bargains at Sunday morning flea markets with Fernande. The intrinsic quality of these works was of little importance to him, for as William Rubin recalls: "Picasso was less a collector as an accumulator of objects, and he devoted more passion than care to their acquisitions. ... The collector tries to know a work in every respect (the etymology of the word connoisseur) and savor it for itself. Of the major artists, Matisse was closest to this spirit of delectation. For Picasso, who usually did not even distinguish between African and Oceanian art, tribal sculpture represented primarily an elective affinity and secondarily a substance to be cannibalized. ... Unlike the serious collector, he might buy a mask simply because of the shape of the ears, or the profile of the nose, because of an aspect of its overall stylization—or to amuse his friends." (*"Primitivism" in 20th Century Art*).

"You don't need a masterpiece to have an idea," retorted Picasso, whose studio

*Opposite-***Dance mask,** showing symptoms of facial paralysis. Liberia. Hardwood.
Photograph by Eliot Elisofon.
Following pages:
Mask. Liberia Grebo, Wood, pigment; h. 69.9 cm. M.C. Rockefeller collection.
N.A. Rockefeller Bequest. Metropolitan Museum of Art, New York.
Mask. Ivory Coast, Grebo, Wood, white paint, plant fibers. Formerly Pablo Picasso collection.
Musée des Arts d'Afrique et d'Océanie, Paris.

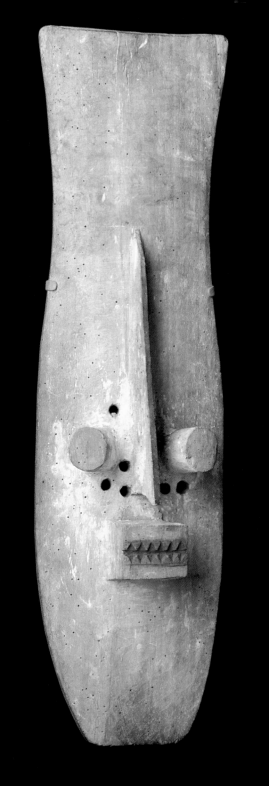

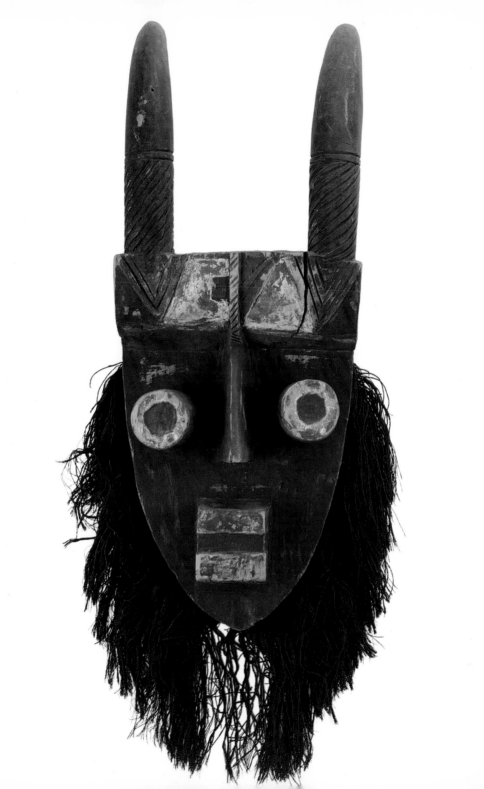

was like a picturesque Aladdin's cave. On April 16, 1911, Apollinaire noted: "Picasso takes delight in cultivating chaos in his studio, where you may see a confusion of Oceanian and African idols, anatomical specimens, musical instruments, fruit, bottles and a great deal of dust." (*La Vie anecdotique: quelques artistes au travail*). And for good measure the poet André Salmon added: "Grimacing atop all the furniture were singular wooden figures, the best examples of African and Polynesian sculpture. Long before he shows you his own work, Picasso will make you admire these marvelous primitive works."

But aside from this slightly bohemian "folk" appeal, coming face to face with these strange and unusual works seems to have charmed and reassured the painter rather than inspiring him. In a distant part of the world, an artist was wrestling with the same problems of transcribing reality and, after experimenting, had set forth artistic solutions capable of transcending the simple world of appearances. And Picasso, in some bizarre fashion, discovered elective affinities between himself and this artist completely unknown to him. From that moment, however, art historians gleefully joined the quest for some influence or form in Picasso's work that might be attributed to one or another of his masks or fetishes. Sometimes the critics were justified: there are evident similarities, for instance, between the tubular eyes of a Grebo mask from the Ivory Coast in the artist's personal collection, and the central hole of the guitar he created from sheet metal in 1912, which was to be regarded as one of the most striking examples of Cubist sculpture (now in the Metropolitan Museum of Art, New York). Others pointed out the stylistic links between the great Baga mask of the fertility goddess Nimba from Guinea, which he bought in about 1927, and his series of portraits of a woman in plaster, actually disguised portraits of Marie-Thérèse Walter. They reveal the same separation of the head from the neck, the same prominent hooked nose, and above all the same impression of grandeur and monumentality, almost sacred in essence. But sometimes the critics were wrong: any attempts to sum up Picasso's primitivism in terms merely of formal borrowings were shown to be excessively reductive, if not downright fallacious. Not until the memorable exhibition *Primitivism in the 20th Century*, staged in New York in 1984, was Jean-Louis Paudrat able to demonstrate, for instance, that masks

Pablo Picasso in his Bateau-Lavoir studio, 1908.
Musée Picasso, Paris.

from the Congo—generally accepted as the clear models for some of the faces of Picasso's "Demoiselles"—were unknown in Europe before 1930, almost 23 years after the execution of the famous painting. And yet, by one of those coincidences so dear to art history, the similarities between the two works are indisputably striking. Though in normal circumstances they would never have been compared, the two faces display the same long nose, the same mouth in the form of a question mark and the same expression in the eyes, at once vacant and focused. Was the encounter between avant-garde and "primitive" artists both much simpler and much more complex than was once thought, shaped by passion and chance, but also by clashes and concerted borrowings?

The case of Alberto Giacometti is also fascinating in many respects. Like many

Following pages: **Mask.** Congo (former Zaire). Kwilu region, western Pende. Wood, pigments, fiber; h. 27 cm., w. 22 cm. Musée royal de l'Afrique centrale, Tervuren.
Face mask. Congo (former Zaire), Kasai region. Wood, pigments, fiber; h. 33 cm., w. 18 cm. Musée royal de l'Afrique centrale, Tervuren.

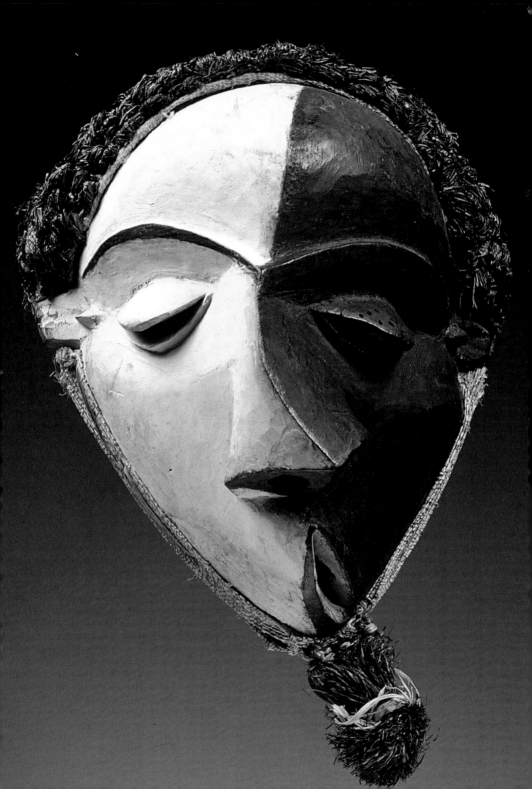

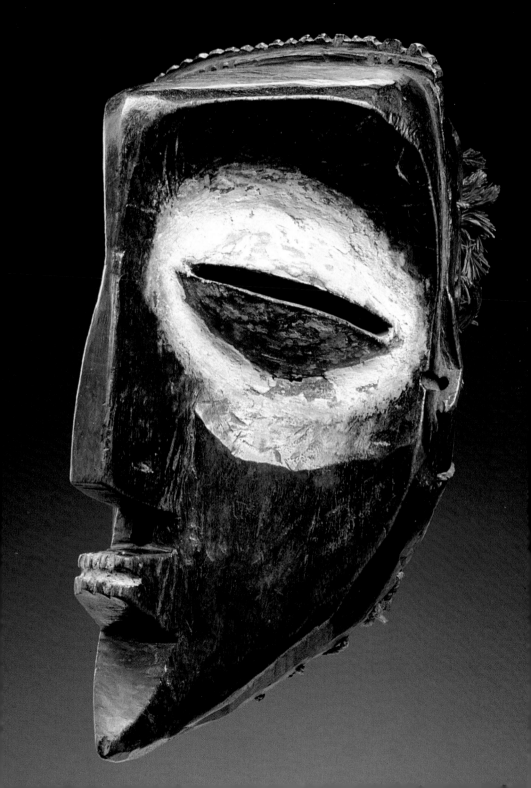

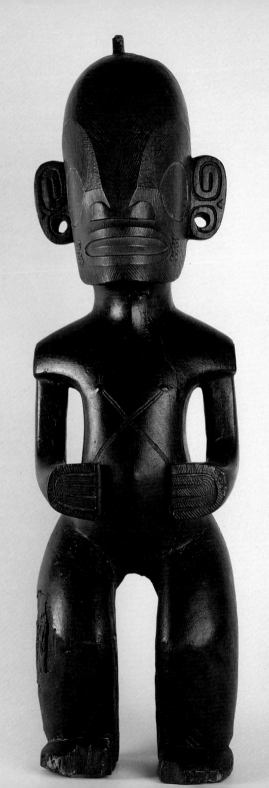

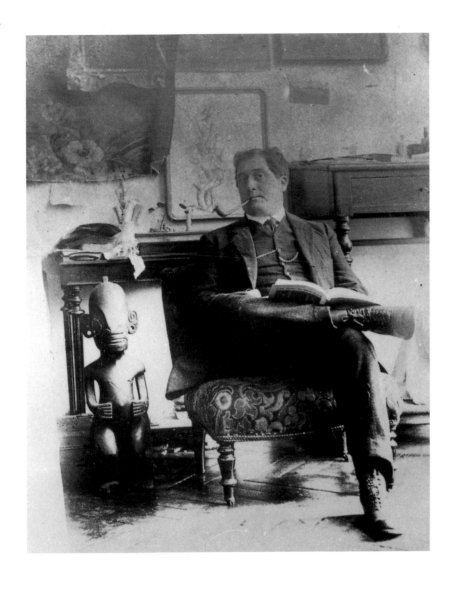

Above: **Guillaume Apollinaire.** Seen here in his studio at 11 boulevard Clichy, autumn 1910. Photograph by Pablo Picasso. Musée Picasso, Paris.

Opposite: **Tiki.** Marquesas Islands. Wood; 72 x 23 x 16 cm. This sculpture is seen standing beside Apollinaire in Picasso's photograph. Formerly Pablo Picasso collection. Private collection.

of his Surrealist friends (including Max Ernst, André Breton and Joan Miró), the Swiss sculptor was attracted to the more ethereal and dreamlike art of Oceania rather than to the more concrete and earthy art of Africa. According to André Breton, the group's theoretician, Oceanian art expressed "the greatest age-old attempt to render the interpenetration of the physical world and the world of the mind, to triumph over the dualism of perception and representation, to go beyond appearances and to reach the heart of things?" African art, by contrast, presented only "never-ending variations on the external appearances of men and animals … heavy, material themes; structures attributable to the physical being—face, body, fertility, domestic tasks, horned beasts." We know that Giacometti liked to visit ethnographic museums, especially the one in Basel with its rich collection of objects from Oceania. There, moreover, he discovered a remarkable group of African ritual spoons, made by the Dan people of the Ivory Coast, that were to inspire one of his most ambiguous works, the "Femme-cuillère" of 1927. The most startling sight he would have come across, however, was undoubtedly a Baining helmet mask from New Britain, an airy, uncanny creation of painted bamboo, tapa and feathers. Certainly there are unmistakable echoes of this astonishing object in his famous "Nose" of 1947, a sort of grimacing and funereal Pinocchio with bloodied skin.

Max Ernst's fascination with the art of Oceania, altogether calmer and more cerebral, was to find expression in his veritable passion for the mythological "bird man" of Easter Island, whose silhouette appears repeatedly in his work.

Unlike German Expressionist painters such as Emil Nolde and Max Pechstein, artists of the Parisian avant-garde were never to accompany scientific expeditions to the Pacific, and their knowledge of these distant shores remained wholly formal and derived from the printed word. A few journals and galleries nevertheless played an important part in the discovery and circulation of arts from the antipodes. As early as 1926, Roland Tual organized an exhibition in which the works of Man Ray

Opposite: **Marquesas Islanders worshipping a tiki.** 19th-century (?) engraving.
Archives Barbier-Mueller, Geneva.
Following pages: **Vungvung blowpipe mask.** New Britain, Baining. Bark cloth, wood, fiber,
pigments; h. 80 cm., l. (tube) 110 cm. Museum der Kulturen, Basel.
Kavat (night dance) mask. New Britain, Baining. Painted bark cloth; h. 76 cm. Collected by R. Parkinson,
1890-1913. Museum der Kulturen, Basel.

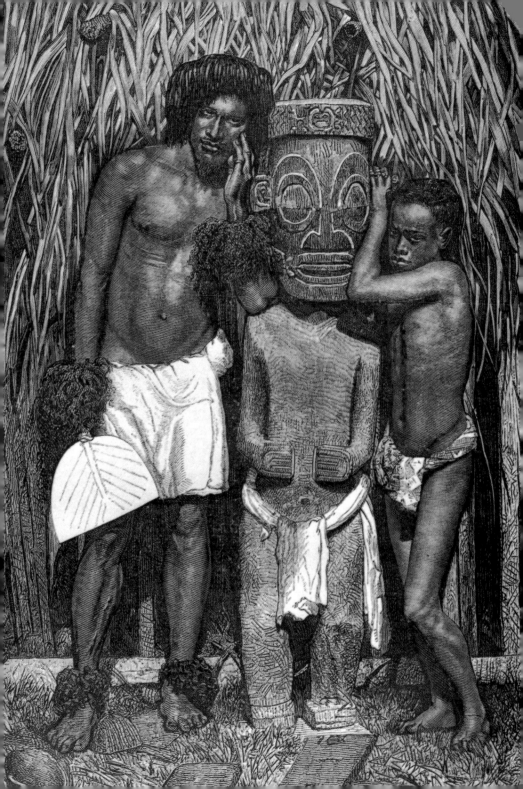

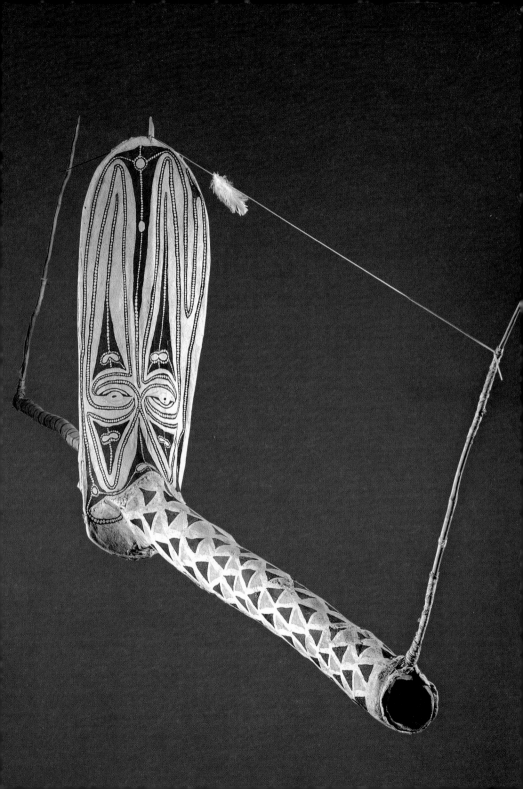

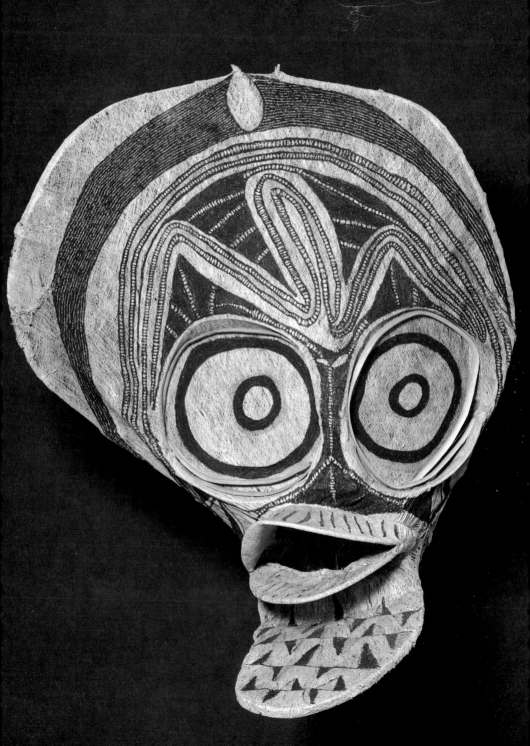

The collector Joseph Mueller
. 1970 Photograph. Archives Barbier-Mueller, Geneva.

were brought face to face with works from the Southeast Asian islands, drawn from the collections of Eluard, Aragon and Breton, among others. Christian Zervos was prompted to observe: "What happened 20 years ago with Negro sculpture is happening now with Melanesian and pre-Columbian art, from which we ask not direct inspiration but rather a relationship of sensibility." The editor of the celebrated journal *Cahiers d'art* devoted an entire issue to Oceanian art, focused largely on Polynesia. The gallery owner Pierre Loeb, dealer and friend of the Surrealist painters, had no hesitation, meanwhile, in sending Jacques Viot to New Caledonia to bring back objects.

The art of Oceania thus came into vogue in its turn, invading all the fashionable Paris salons. In 1917, Tristan Tzara had published translations of Maori chants, which he declaimed at soirees in Zurich; André Breton was soon to dance the *pilou-pilou* and, in 1928, the Comte de Beaumont gave a "marine ball" at which the masks, designed by Louis Marcoussis, looked as much to Oceania as to Africa. At the Colonial Exhibition held in Paris in 1931, entire halls were given over to the "art

of the Pacific," while the Trocadéro museum, reorganized under the joint leader-ship of Paul Rivet and Georges-Henri Rivière, was renamed the Musée de l'Homme in 1938. Henceforth, the world of art was to give way to the world of ethnology. At this time of economic crisis, the dealers Charles Ratton and Louis Carré turned to America and its rich clientele, while on March 18, 1935, a memorable exhibition entitled *African Negro Art* opened at the Museum of Modern Art in New York. For the first time in history, some 600 "ethnographic documents" were thus displayed in a modern art gallery.

THE AGE OF CONSECRATION: BIRTH OF THE "PRIMAL ARTS"

Traditionally, there have been two faces to the display of this art: On the one hand are dusty display cases piled high with objects behind yellowing labels, all main-tained by disillusioned, disheartened ethnologists, chronically short of funds. This is the unhappy scene that has prevailed for many years at the Musée de l'Homme. On the other hand we find, behind its majestic Art Deco façade on the edge of the Bois de Vincennes, the former Musée des Colonies, renamed the Musée des Arts d'Afrique et d'Océanie (MAAO) under André Malraux in the 1960s. Promoted to the rank of the twelfth department of the Musées nationaux in 1991, it views itself resolutely as a museum of art and not of ethnography, even if it does preserve from its "exotic" past somewhat antiquated galleries and a bizarre tropical aquarium still inhabited by crocodiles. Yet it has greatly enriched its collections in recent years with the purchase in 1996 of an exceptional collection of 280 masterpieces of Nigerian art from the prestigious Barbier-Mueller collection in Switzerland.

A recent presidential decision could spell an end to the long-standing rivalry between these two institutions. This decision will bring their collections of "primi-tive" art in a building on the banks of the Seine, under the new name of *arts pre-miers* (primal arts), and at the same time combine the ethnological approach with the aesthetic: this is the prize now being held out to these cultures that for so long have been despised or ignored. It is to be hoped that the architects of this ambitious project will not omit full and amply deserved credit to the people responsible for cre-ating these masterpieces.

THE ARTS OF AFRICA
A Distant Past

"Negro art" was not born with the arrival of the first Europeans on African soil. On the contrary, the "Black Continent" was for centuries the cradle of prestigious civilizations whose masterpieces have been unearthed on a virtually continuous basis by archaeologists in recent years. Modeled in clay more than a thousand years ago, the figures created by the Nok in Nigeria and the Djenne in Mali bear witness to the grandeur and sophistication of these vanished kingdoms, while still retaining many of their mysteries. The sacred art of the Tellem and Dogon peoples, meanwhile, discovered during ethnological expeditions led by Marcel Griaule in the 1930s, has entranced art collectors ever since with the restrained, stylized qualities of its finest works.

Fragment of a funerary statue. Northern Nigeria, Nok. Terracotta; h. 15 cm. Late 1st century BC. Formerly Barbier-Mueller collection. Musée des Arts d'Afrique et d'Océanie, Paris.

ENIGMAS OF THE NOK FIGURES

As is so often the case in the world of archaeology, it was by a pure fluke that one of the most dazzling of African civilizations suddenly emerged once more from the mists of oblivion. This one small word—Nok—conjures up images of the most arresting terracotta figures found in Africa in recent decades.

It was in 1943 that a miner from one of the tin mines in this rich region of Nigeria came to Bernard Fagg, a young British administrator and archaeologist, to show him a terracotta head some 8 inches high. With its stylized features, smooth cheeks and full lips, this mysterious face produced an impression of daunting power. As he examined its highly sophisticated workmanship, Fagg was not surprised to observe stylistic similarities to another piece—a moving face with childlike features—that had been discovered some 40 miles away in 1928. Realizing the importance of this discovery, Fagg lost no time in requesting the miners to inform him if they should happen to unearth any other similar pieces while working in the mines. Little by little, the small village of Nok, on the edge of the Jos plateau, yielded a stream of terracotta figures, the unique and unmistakable style of which would lend its name to an entire civilization.

It is their highly stylized character that renders these works—ranging in height from about 5 to 50 inches—so striking and compelling. Frank Willett, the great specialist in this field, has put forward the hypothesis that the artfully distilled geometric forms of some of these pieces (a mouth and beard compressed to form a single block, for instance, or lines engraved on the "skin" to emphasize the contours of teeth or lips) belong to a now-vanished tradition of figures. Whether or not this is the case, the people who modeled these figures in clay in the years from 900 BC to AD 600 were artists of towering stature, working within the stylistic canons found with variations over a large part of northern Nigeria. The heads of these figures are thus conceived primarily as geometric forms—spherical, conical or cylindrical—of apparently real and intrinsic power. It also became clear that, although these faces have survived on the whole, the limbs and torsos once attached to them have almost invariably been reduced to shattered fragments that defy all recognition. The

Head of a funerary statue. Northeastern Nigeria, Nok. Terracotta; h. 30 cm.
Musée Barbier-Mueller, Geneva.

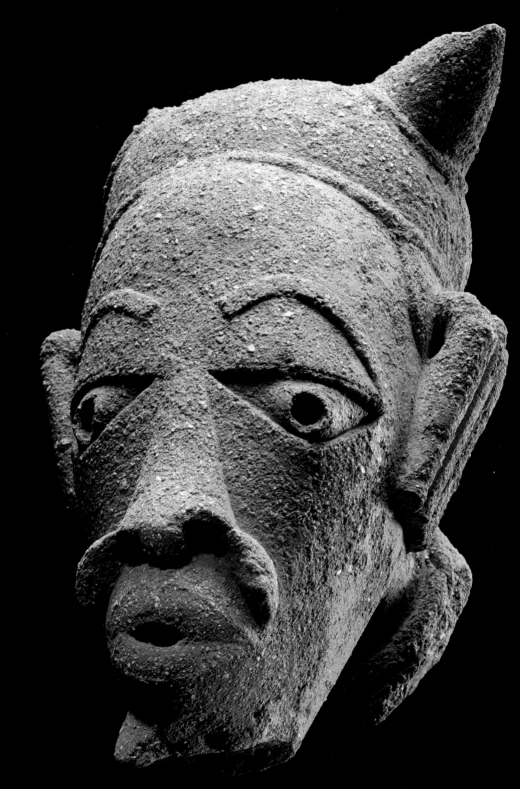

distinctiveness and sophistication of the "Nok style" lie in the tremendous variety of treatment of the eyes and eyebrows, a feature sufficient in itself to silence those who criticize African art as "monotonous"! The treatment of the eye—forming sometimes an arc, sometimes a sort of triangle in which the eyebrow balances the curve of the lower lid, and sometimes a perfect circle—represents a symbolic vocabulary of exceptional richness. And what are we to make of the perforations that pierce mouths, nostrils and ears, as well as eyes? Curiously, these small holes appear in parts of the face where they might be least expected. One figure, for example, is pierced through the forehead, another through the back of the head, and another beneath the nose. Is this merely a matter of coincidence? A technical necessity connected with phenomena caused by the firing process? An atavistic memory of working in wood? Or are they, as some scholars suggest, intended to symbolize the senses of sight, hearing, touch and smell? And this problem is just one of the unanswered questions raised by these figures: why, for example, are the ears positioned so curiously at the angle of the jaw, or even at the back of the head?

A further refinement of these pieces lies in the meticulous care devoted to the rendering of the hair, a feature later seen in many other regions of Africa. A number of the Nok faces are thus framed by hair dressed in a fashion that would be immortalized by sculptures produced in the neighboring kingdom of Ife. Sometimes the hair was gathered up into small knobs on the crown of the head, each pierced with a hole doubtless intended to hold a feather. In a striking example of continuity, the Kachichiri and Numan who today live some 30 miles from the small village of Nok still wear their hair in this same fashion.

Finally, one of the most compelling features of Nok art lies in the sophistication of the ornaments that embellish the finest heads and the few busts, sadly often fragmentary, that have survived to the present day. Necks, loins, wrists and ankles— four critical parts of the body—are emphasized by a profusion of necklaces, bracelets and beads. Are they indications of wealth, or symbols of status or power? Do these figures represent kings, ancestors or gods? Without being absolutely certain, it is reasonable to suppose that a society sophisticated enough to produce figures such as these would also have practiced the courtly arts and ancestor worship. How else are we to interpret fragments of figures in which the lower part of the body, wrapped in a long skirt, displays the same power and vigor as statues of the

Khmer kings? Or the magnificent head preserved in the national museum in Jos, proudly sporting a handsome moustache, short beard, headband and braided hair brushing cheeks and neck? Even more remarkable are a small figure in the national museum in Lagos, representing a woman, her head protected by a hood and carrying a young child on her stomach, and another of a man literally buckling under the weight of his jewels! And among the most enigmatic of all is a small head with its cheeks strangely puffed out, like a musician learning to play a reed instrument.

Clearly many mysteries still surround the Nok culture, the influence of which has been traced so far to some 20 other sites in Nigeria. Though no written or linguistic data survive, many similarities may be observed with neighboring cultures and their artistic creations, as for instance in the little village of Igbo-Ukwu in the southeast of the country, or the Ife kingdom on the opposite bank of the River Niger.

By the same token, is it reasonable to suppose that a single Nok culture covered such a vast area for nearly 2000 years, without in turn becoming impregnated by other cultures, more recent and as yet unidentified? Bernard Fagg himself originally took the precaution of indicating the provenance of his discoveries (identified as specimens from "Jemaa," or "Nok" series), while at the same time emphasizing the originality of their appearance and workmanship, as may be seen in these notes from 1945: "The material is a mixture of clay with small fragments of local quartz and silicates. … The entire surface, which is over-fired, has the appearance of light biscuit, but originally the head must have been finished in the manner of traces to be seen on the neck and the cheek around the ear. The internal folds and the fingermarks suggest that the maker worked from above as well as from below and that at the end he filled in the holes made by his fingers with clay plugs that he afterward smoothed flat."

More recently, questions have focused on the gender of the artists responsible for these works. But currently one of the most intriguing debates surrounds the coexistence within this tradition of terracotta sculptures conceived in two distinct

Following pages: **Reliquary figurine.**
Inland Niger delta. Terracotta; h. 39 cm. Musée Barbier-Mueller, Geneva.
Figurine for snake cult (?).
Mali, Djenne region. Terracotta; h. 37 cm. Musée Barbier-Mueller, Geneva.

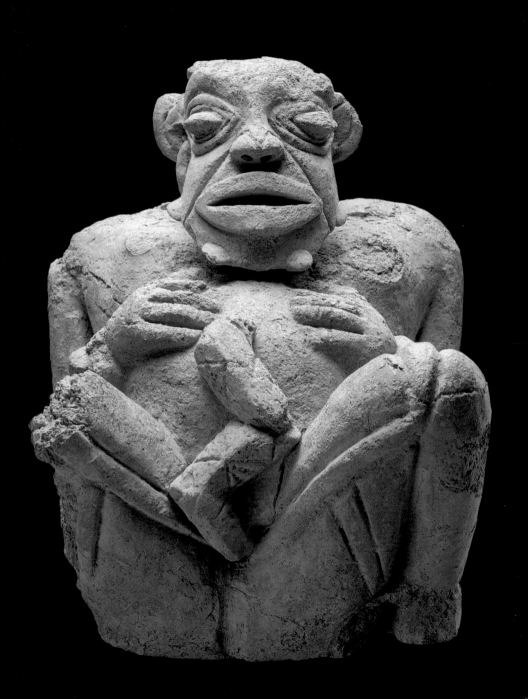

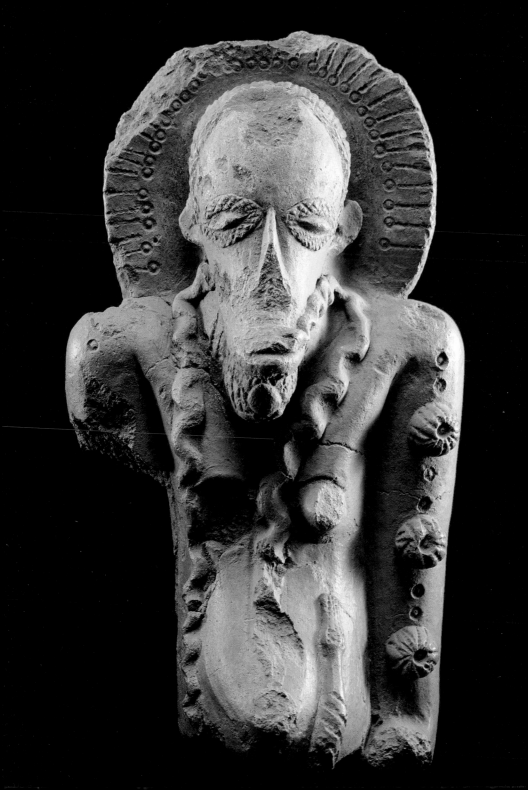

aesthetic languages. For while human figures are stylized in the extreme, by contrast the sculptures of animals (elephants, monkeys and the like) display a degree of realism that is sometimes striking. Was this prohibition that apparently hung over the naturalistic representation of men and women prompted by the overriding fear of being accused of witchcraft? Frank Willett notes that even some contemporary African artists admit that they avoid making portraits resembling living people, for fear of coming under suspicion of practicing sorcery.

Whatever the questions that remain unanswered, many Nok figures seem to carry within them the seeds of the aesthetic canons of the great tradition of African statuary (featuring notably large heads and short legs), and many of their fine arc-shaped eyes anticipate those to be found in modern Yoruba woodcarvings. Is this not dazzling proof of the extraordinary vitality of a culture that flourished two and a half millennia ago?

KINGS, PRIESTS AND MEDIUMS

Unlike the terracotta statues discovered in ancient Chinese tombs or the earthenware figures found in Egyptian burial chambers, Nok statuary has never been found in a funerary context. The pillarlike form of some figures suggests rather that they were placed on altars and in other places of worship. The profusion of beads used in their decoration and the sophistication of the hairstyles leave little doubt as to the rank of certain figures, both male and female, who must have been people of note. Their identity remains a mystery, however. Were they kings and queens, priests and mediums, civilizing heroes, or ancestors raised to the rank of gods?

Smaller figures, only a few inches high, were worn as amulets around the neck. According to a recent hypothesis advanced by Bernard de Grunne, these miniature masterpieces served a similar purpose to the *modelli* of Renaissance artists, carrying the aesthetic canons of Nok statuary far beyond the region's borders—an attractive theory which places these small and expressive figures (up to 17 different positions have been recorded) among the most ancient archetypes of artistic activity in Africa.

THE "CONVULSIVE BEAUTY" OF DJENNE TERRACOTTA FIGURES

By a quirk of fate, it was in the same year—1943—that the naturalist Theodore Monod discovered, in the ancient city of Djenne in Mali, the first terracotta figure destined to give its name to a whole series of similar pieces discovered in this region of the inland Niger delta. Yet a tremendous gulf separates the ineffable serenity of Nok figures from the fascinating "convulsive beauty" of their counterparts from Mali. Only recently have these pieces appeared on the international market, in the wake not only of archaeological discoveries but also of clandestine looting which has regrettably removed them from their context (and without the benefit of scientific excavations, archaeological finds are destined to remain locked in silence). Some of them are striking in their brutal and obscurely disturbing power. Mutilated or even fragmented (were they systematically destroyed for ritual purposes?), these male and female torsos with their handsome apricot-flushed patina nevertheless possess a wild, dreamlike quality that is irresistibly striking. With its plastic power and the crudeness of its pose (a woman spreads her thighs to give birth to a long zigzag ribbon that proves to be none other than a snake), the figure of a mother in the Barbier-Mueller collection evokes the archetypes of *dea mater* and the most ancient chthonic divinities. Probably linked to fertility rites, this "African allegory of the spasms of childbirth" also fired a powerful shot at the Muslim religion that had become established in the region in the 14th century, and at its hostility to representations of the human form: proof, if proof be needed, that despite the imposition of an official religion, in country areas away from the seat of centralized power, traditional beliefs and rituals will always live on. There is a seemingly obsessive emphasis, too, on the theme of the snake, an animal which, according to research carried out by the ethnologist Germaine Dieterlen, embodies the concept of immortality with particular reference to early ancestors. Coiled on the ground or stretched out in a sinuous or zigzag line, the snake is used as a simple decorative element, as in the reliquary or altar figure also preserved in the Barbier-Mueller collection, which it surrounds with its hypnotic presence. Hieratic and imposing, this enigmatic figure with half-closed eyes has the curious appearance – by one of those strange coincidences so dear to art historians—of an "African Buddha."

Another recurring theme, featuring male figures, seated, kneeling, sleeping or lying down with their wrists bound, has sometimes been interpreted as represent-

Female figure. Mali, Djenne region.
Terracotta; h. 36.5 cm. 7th-9th century.
Musée des Arts d'Afrique et d'Océanie, Paris.

ing prisoners. Their coherent mass is quite unlike the contorted anatomical attitudes of other figures from the Djenne region. But if there is one subject that dominates the entire production of terracotta figures in the triangular region described by Mopti, Ke Macina and Djenne, it is that of the horse and its master. As became clear from the outstanding *Hunters and Warriors* exhibition at the Musée Dapper in Paris in 1998, this equestrian theme appears in numerous myths and legends relating to the distant origins of Mali. Many of the country's patronymics still reflect this fascination with horses, such as Cissé (horseman), Kalé (spotless horse) and Souwaré (dappled horse). Horses were eulogized, put on a pedestal, sacrificed and even immortalized in statues made not only from clay but also from gold and silver. But just who were they, these proud horsemen whose effigies display their haughty pro-

Figurine in Bankoni style.
Mali, Segu region. Terracotta; h. 44.3 cm.
Musée Barbier-Mueller, Geneva.

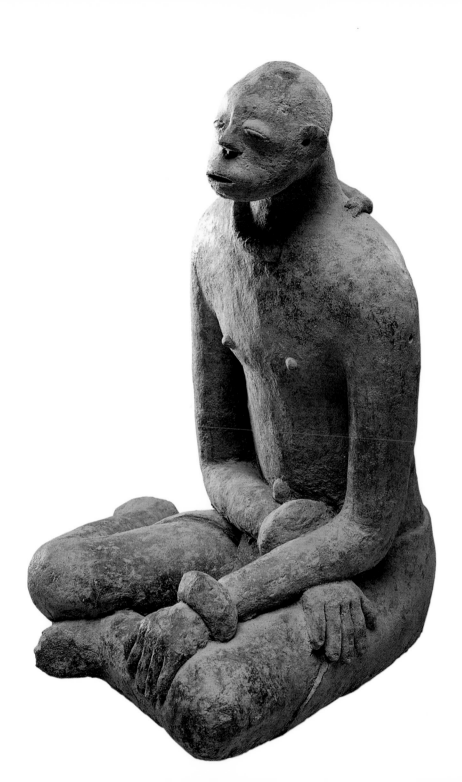

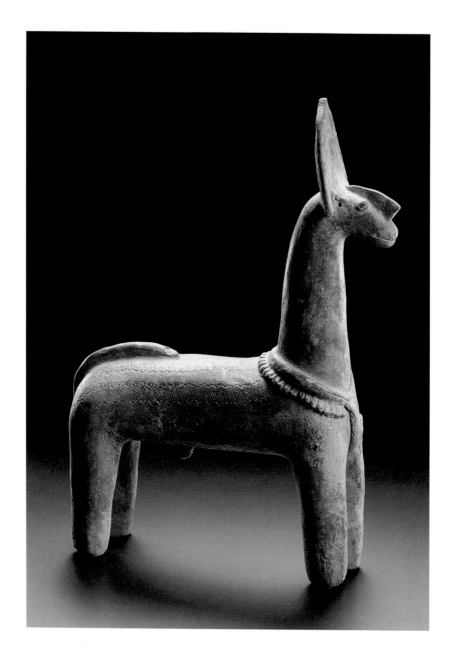

Mythical animal. Mali, Djenne region. Terracotta; 74 cm. 12th-15th century.
Musée Barbier-Mueller, Geneva.

files, their splendid weapons and ornaments, and their noble and magnificently harnessed mounts? Were they mythical ancestors or long-dead invaders? Aristocratic horse-owners or autocratic warlords? Or perhaps all of these, given Mali's long and complex history and the waves of immigrants who arrived—in the face of drought and bloody conflicts—to enrich this land that stretched to either side of the River Niger and its principal tributary, the Bani. Among them were the famous Sotigi (horse-owner) horsemen, in whom we may recognize today the aristocrats of the Wagadou and their allies. And they almost certainly also included peoples such as the Soninke, the Bozo and the Tellem, to be followed many years later by the celebrated Dogon.

Perhaps it is a consequence of this incessant warfare that so many of these terracotta masterpieces have come down to us in such a pitiful condition. Tales are told to this day of victorious armies systematically smashing them as they passed through, "in order to destroy for ever the presence and power of their enemies."

Figures of deified ancestors, dignitaries or army chiefs, soldiers in the flower of their youth or veteran generals sporting long beards, these equestrian statues, modeled more than five centuries ago, cut an impressive figure. One wears a jerkin, another short breeches, belt and crested cap, while a third, clad in a leather waistcoat, sports a wristband holding a cutlass. Some of the faces, meanwhile, display virtually every conceivable variation on the theme of facial decoration. Scarification on the temples, outlining of the eyes and braided tresses tumbling over cheeks are all unmistakable evidence of the sophistication of the art of body adornment in ancient Africa. With its haughty bearing, its carefully combed beard and its feet touching the ground as though to signify its exceptional height (or possibly rank), a remarkable figure now in the Musée Dapper seems to embody all the most impressive features of these "giants of battle." What more telling evidence could there be of the fascination exercised by these proud horsemen than this masterpiece, in which the richness of the polychromy is rivaled only by the wealth of decorative detail? Too often, the pieces that have come down to us are deceptively bland in appearance, having lost their original colors; only rarely do these terracottas still boast their colorful ochre and kaolin decorations. Yet now another civilization would express its admiration for the horse in clay and wood: the austere Dogon.

GRIAULE AND LEIRIS: ON THE TRAIL OF *L'AFRIQUE FANTÔME*

Smooth and polished as works by Brancusi, virile and powerful as those of Lipchitz, coated with sacrificial daubs, encrusted, discolored and gleaming with oil: who were these figures carved in a dry wood made brittle by time? Hewn with an adze by unknown sculptor-smiths, these remarkable effigies can be understood only in the context in which they were conceived. The stony and austere dry cliffs of Bandiagara, in present-day Mali, were unforgettably described by a young writer named Leiris as a "landscape of the ends of the earth ... of nothing but chasms, open sky and subterranean chambers," in a book that would become a bible for all apprentice ethnologists: *L'Afrique fantôme.*

In the early 1930s, when his book first appeared, the European fascination for "Negro art" was at it height: through one colonial exhibition after another, France was now discovering the civilizations that created these disconcerting pieces, whose plastic power had already seduced artists such as Vlaminck, Matisse, Braque and Picasso. The vogue for exoticism reached its peak with the arrival of a troupe of masked Dogon dancers, brought specially from Mali to perform before crowds of bemused Parisians on the Trocadero esplanade.

A lieutenant in the French colonial infantry named Desplagnes had in fact ventured into this arid region contained in the bend of the Niger as early as 1904-5, at the head of an archaeological and ethnological expedition. The objects and sculptures that he collected during these two years would form the nucleus of the Dogon collections in the future Musée de l'Homme. But although he clearly traveled the length and breadth of the plateau with supreme confidence, not hesitating to march into people's dwellings and demand to see their "divinities," the sad truth of the matter is that the Dogon clearly showed him precisely what they wanted to show him, and nothing more. "Let us go and see the village grigris hidden in a crevice ... in a little dry-stone hut. ... These are the gods handed down by the ancestors." But the unfortunate Desplagnes was not allowed to detach the statues from the

Equestrian figure.
Inland Niger delta, Djenne (Mali). Terracotta, pigments; h. 59 cm. Musée Dapper, Paris.
Following pages:
Dogon village viewed from the top of the Cliffs of Bandiagara. Photograph by Marcel Griaule, 1935.
Musée de l'Homme, Paris.

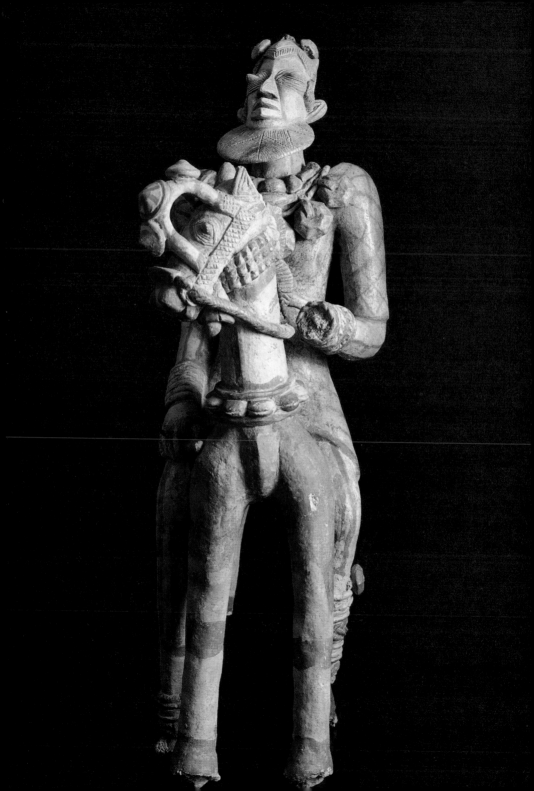

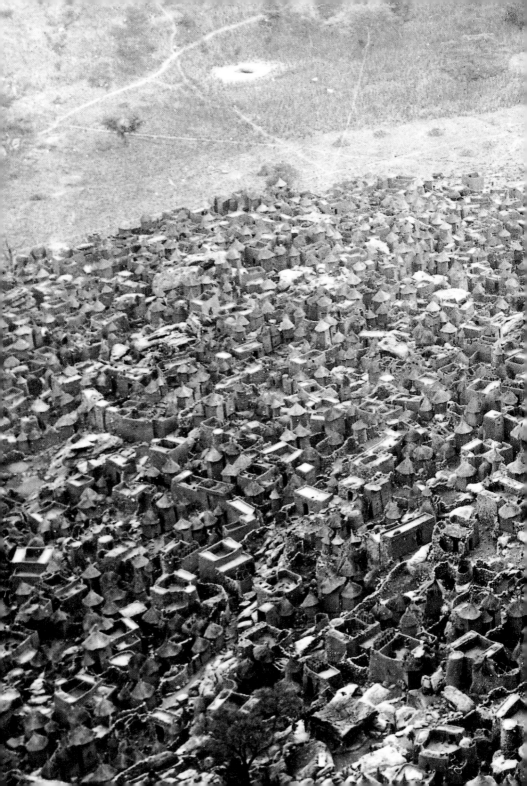

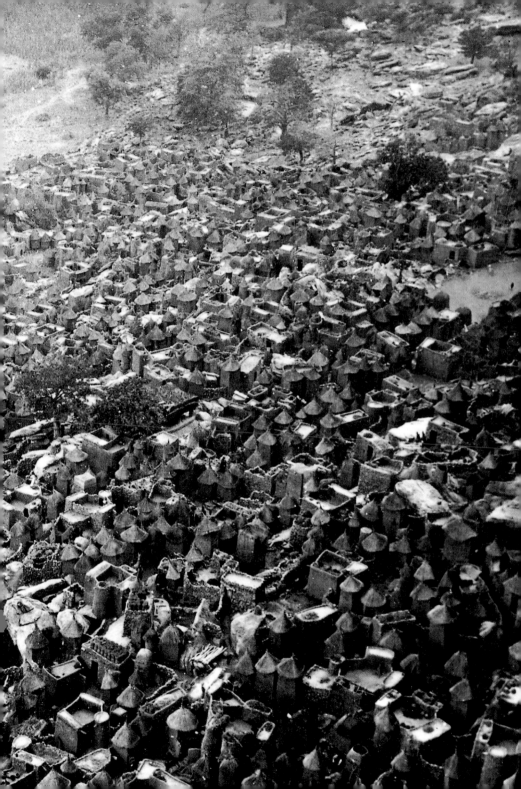

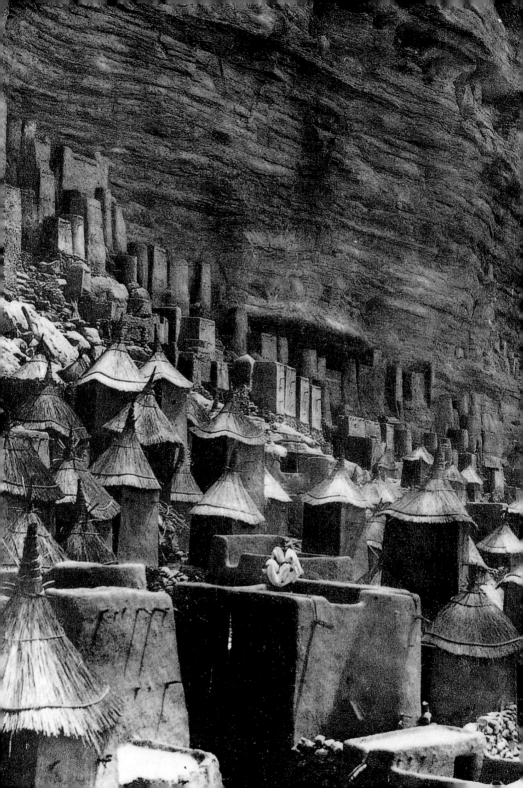

lianas that shrouded them, nor to remove them from the strips of cloth in which they were wrapped. The German explorer Leo Frobinius fared little better on his travels in the French Sudan from 1907 to 1909, as he attempted in vain to eke information out of the fiercely independent Dogon people.

In 1928, the Citroën car company sponsored the famous *Croisière noire*, or Black Cruise, the first car rally from Paris to Timbuktu, which sparked another wave of interest in these far-flung lands. The writer Paul Morand, a passionate devotee of travel and adventure, thus crossed the Dogon region, where he was fascinated to discover traditional dances "which reveal their sacred character by the fact that women are forbidden to participate in them," going so far as to draw comparisons with the choreography of Diaghilev!

But it was the young ethnologist and Abyssinian scholar Marcel Griaule who, with his celebrated expedition from Dakar to Djibouti, launched the age of the great geographical surveys and lent academic credentials to the rapidly developing science of ethnology. This friend of the Surrealists also had the inspired notion of inviting on the expedition the poet Michel Leiris, whose inquiring and sensitive approach would produce one of the finest of all eye-witness accounts of experiences on the African continent. From May 1931 to February 1933, the small team (whose members included among others Jean Mouchet and Eric Lutten, who were soon to be joined by Deborah Lifchitz) crossed some 15 countries, collecting photographs, information and more than 3500 objects. Prompted more or less by Desplagne's book, *Le Plateau central nigérien* (in which Griaule had been engrossed on the boat to Dakar), they decided to make a detour into the Dogon region. The rest of the story is now familiar: the expedition set up camp at Sanga, a small village clinging to the edge of the cliff which became home to a French research outpost for over half a century. "Tremendous religious feeling. Sacred objects everywhere," noted Michel Leiris enthusiastically.

Numerous difficulties were encountered on the ground, nevertheless. To the ethnologists' exasperation, the Dogon for the most part refused to parted from their "fetishes." "Attempt to buy some locks, complete the purchase, then the people

Village of Sanga, viewed from the west-southwest.
Photograph by Marcel Griaule, 1931. Musée de l'Homme, Paris.

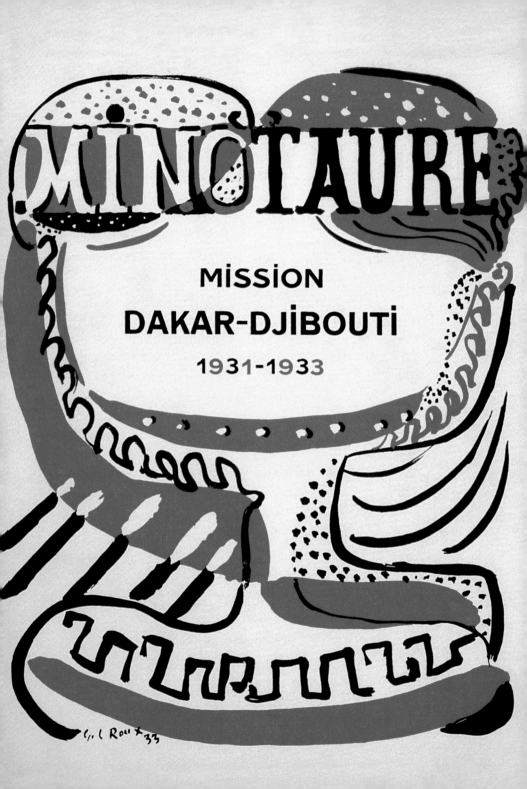

MINOTAURE

MISSION
DAKAR-DJIBOUTI
1931-1933

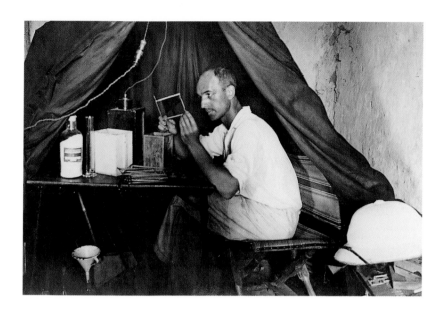

Marcel Griaule in his tent. Mali, 1931. Photograph.
Musée de l'Homme, Paris.

protest and go back on the deal: with a furious gesture, Griaule smashes a *wasamba* that he has paid for and tells them that he has put a curse on the village. A little further on, all goes well," noted Leiris with scrupulous honesty. What Griaule's critics sometimes forget is that these reactions should be viewed in the paternalistic and colonialist context of his times. So enamored was he of Dogon culture, indeed, that he dedicated two further expeditions to intensive research work in the region: the Sahara-Sudan expedition of 1935, and the Sahara-Cameroon venture of 1936-7.

Opposite: **Cover of *Minotaure* magazine.** Paris, 1933. Private collection.
Following pages:
Figure with raised arms on a base in the form of a flattened cone. Mali village of Nini, Dogon.
Wood, thick granular patina; h. 42 cm.
Figure with broken legs.
Dogon (Mali). Wood, thick granular patina; h. 27 cm. 10th-12th century (?).
Figure hiding its face.
Mali, village of Yaya, Dogon. Wood, sacrificial patina; h. 40 cm.
All three figures: Musée de l'Homme, Paris.

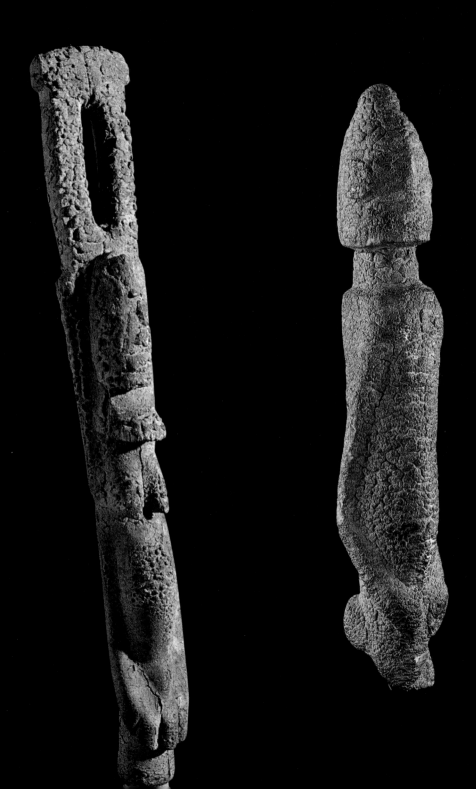

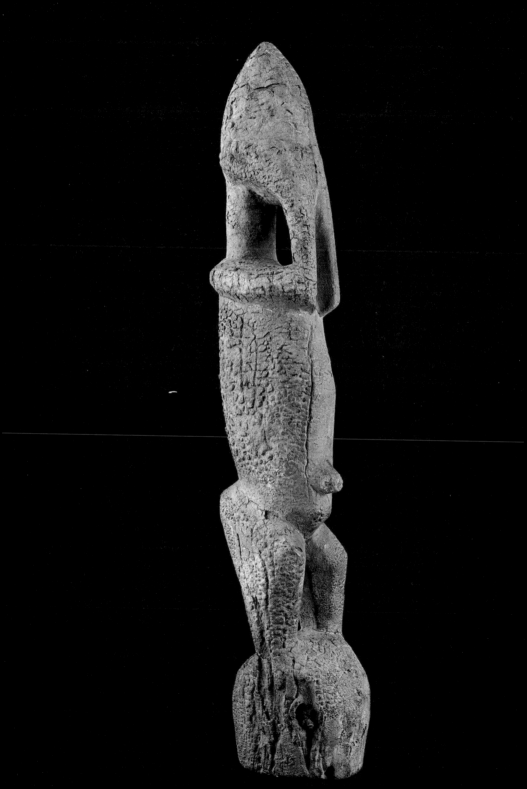

Dogon granary or sanctuary. Forming part of a "large family house" (*ginna*), this example
has a carved wooden door. Photograph by Marcel Griaule, 1935.
Musée de l'Homme, Paris.

As a result, a treasure trove of remarkable doors, heddle pulleys, locks, masks and
figures joined the collections of the Musée de l'Homme, accompanied by pho-
tographs documenting their original context. Together these reflected a research
project as moving as it was precious. But if there is one book that remains indelibly
linked with the name of Marcel Griaule, it is his myth-centered *Dieu d'eau*, or Water
God, a series of conversations with the now-famous Ogotommeli, an old and blind
hunter. As Griaule's daughter, Geneviève Calame-Griaule, wrote on the book's pub-

Miniature ladder. Village of Yaya. Light wood, dark brown patina,
lumpy in places; h. 33 cm. Collected by Paulme-Lifchitz expedition.(?) 1935.
Musée de l'Homme, Paris.

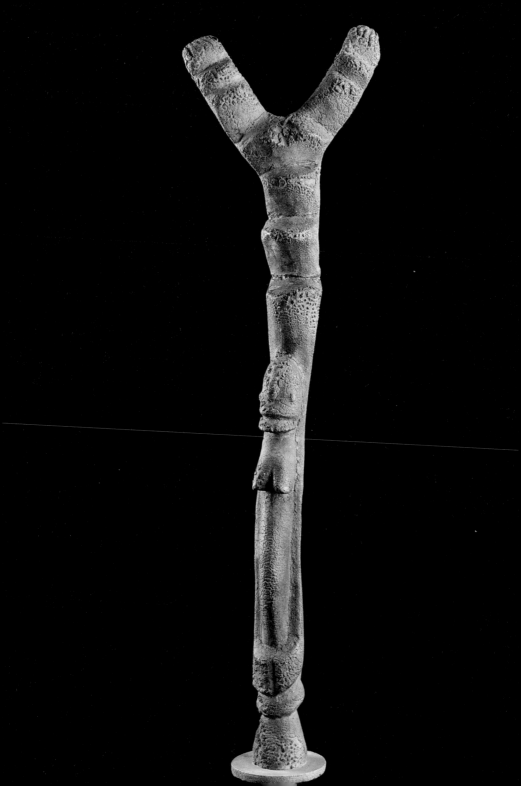

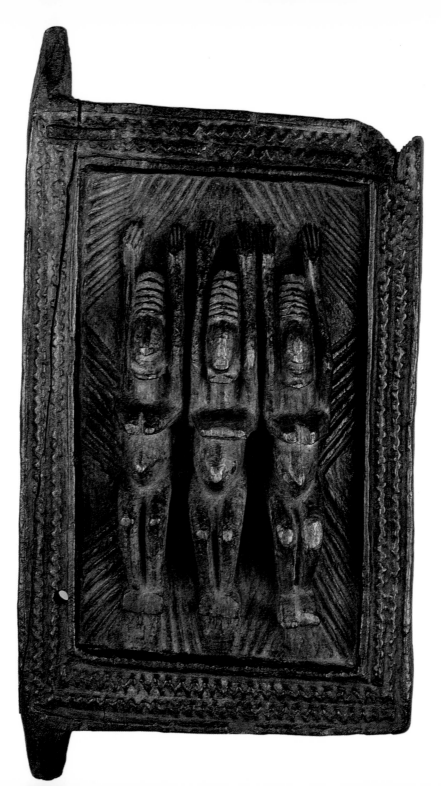

lication in 1948: "Now we have discovered that the Dogon possessed a cosmogony and a mythology of a richness comparable with those of antiquity."

TELLEM AND DOGON: "PRIMITIVES OF PRIMITIVES"

"The world was created by the god Amma, a paternal figure who existed before everything. After a first failed attempt, from which he retained only the four elements (earth, air, fire and water), Amma created through his "word" a placenta or "egg of the world," in which he placed the seeds of a pair of androgynous twins in the form of fish. ... Their gestation inside the egg was cut short by the rebellion of one of the twins, who left the placenta prematurely, alone and without his female partner—thus prefiguring single births—although Amma had planned twin births. He descended into the primordial darkness, taking with him a piece of the placenta, which became the Earth. Becoming aware of his loneliness, he began to wander through space in search of his twin sister; he returned to the sky and even searched the entrails of the Earth for her, an incestuous act which compounded the confusion that he had brought into the world. As a result, the placenta began to putrefy and death appeared on the Earth. Amma put an end to this disorderly behavior by turning the guilty one into a fox, an animal that occupies an important place in Dogon ideology." No one has offered a more convincing analysis than Geneviève Calame-Griaule in 1987 of Dogon mythology, the intense and poetic richness of which seems to inform every statue, mask and object, however modest or insignificant they may appear. In this region covering barely 1550 square miles of western Africa, a society thus elaborated over the centuries a system of thought in which religious and social life were so closely interwoven that they underlay every act of creation undertaken by its members. Yet there was no element of violence or strangeness to be found in these impassive and restrained figures of couples, these Adams and Eves of an unknown *Genesis*. Nor was there any tenderness or familiarity in these imposing maternal figures, these hieratic, majestic and potent idols

Opposite: **Granary shutter.** Exact origin unknown. Very dense wood, patina resulting from use; h. 48 cm. Collected by Louis Desplagnes expedition.(?) 1903-5. Musée de l'Homme, Paris.
Following pages: **Horse rider.** Wood. Musée Barbier-Mueller, Geneva.
Horserider. Cliffs of Bandiagara, village of Nini, Dogan. Wood, thick ash-colored patina; h. 36.5 cm. Collected by Paulme-Lifchitz expedition, 1935.
Musée de l'Homme, Paris.

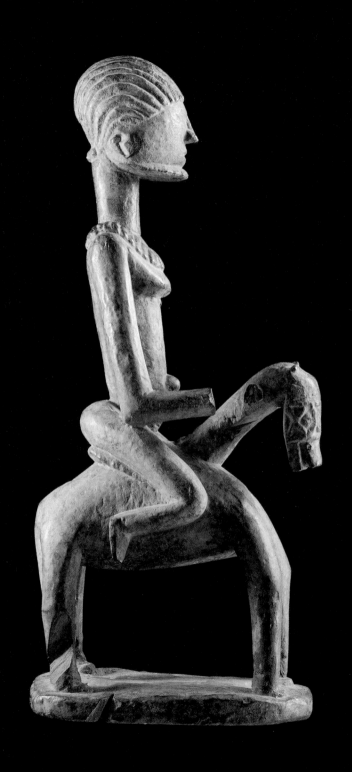

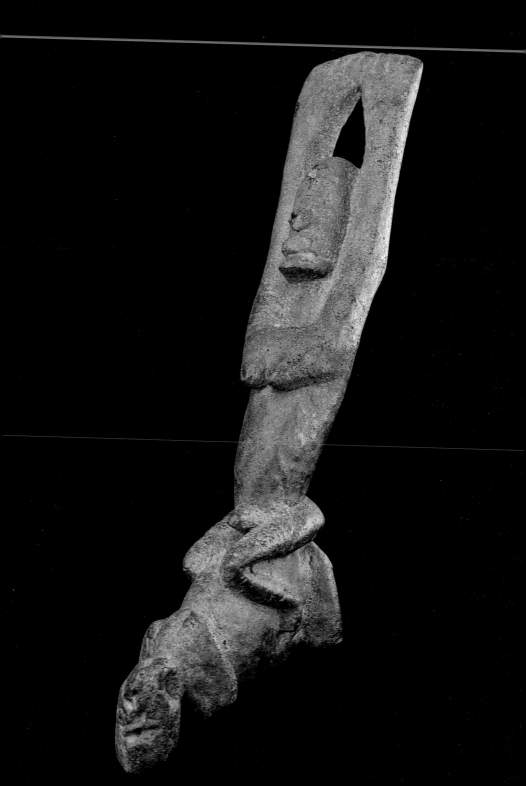

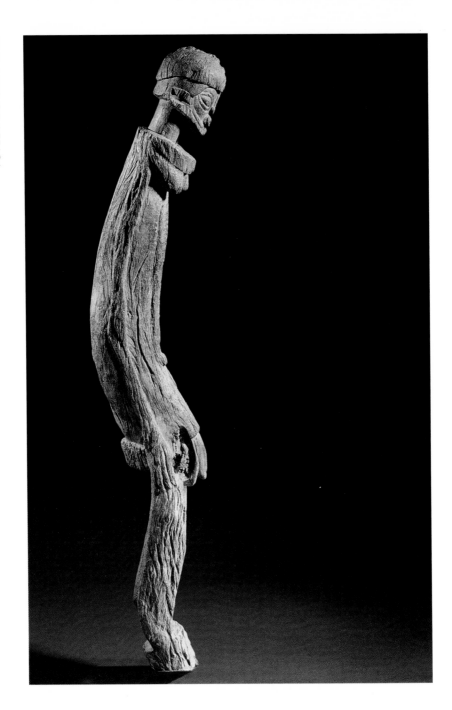

which are among the most austere to be found anywhere in Africa. And what should we make of these figures who thrust their arms skyward like improbable question marks? Giacometti might not have disowned these attenuated silhouettes whose leprous outer form seems to echo the painful thinness of his own bronze matchstick figures. But above and beyond the emotional response that the solemn grandeur of Dogon sculpture arouses, it also poses numerous questions with regard to the eclectic nature of the aesthetic vocabularies it employs, which in turn reflect the diverse and distant influences that shaped the Dogon philosophy. Does not the supremely understated gesture of a figurine discovered in the southern Bandiagara plateau, a male figure hiding his face in his hands, thus immortalize the ancestral shame of the Dogon people, forced to abandon their native land in order to save their women and children from famine?

Having turned their backs on the region of Mande ("homeland of the king"), probably in the early 14th century, the Dogon colonized the cliffs of Bandiagara, expelling the mysterious Tellem, "the people of the past," whose name means literally "we have found them." But who exactly were these first inhabitants of the cliffs, who abandoned hidden in rock crevices a wealth of funerary objects (including sculptures, jewels and textiles) that bear witness to their advanced state of civilization? Though current research has not yet revealed their true origins, the contemporary inhabitants of these lands consider them even today as their ancestral masters, making offerings to them to obtain their indulgence. It is not difficult to understand, therefore, why at the time of Griaule's first expeditions, very few people dared to venture into the isolated and dimly terrifying lands that formed the Tellem graveyards. Embedded in this harsh and awe-inspiring landscape, did not these necropolises conceal at their heart these famous figurines, still covered with the detritus of sacrificial rites, whose disturbing beauty is now so prized by collectors? Gnarled figures with arms raised to heaven, perhaps in a desperate gesture of supplication for rain; hermaphrodite creatures sporting tufts of beard and pubescent breasts; hybrid pieces evoking simultaneously both Dogon ritual carvings and rainmaking statues.

Androgynous figure. Mali, village of Yaya, Dogan. *Minu* wood, unpatinated; h. 135 cm. 17th century. Collected by Paulme-Lifchitz expedition, 1935. Musée de l'Homme, Paris.

Similarly, how can we continue even today to lump together under the reductive term of "Dogon" a body of work containing pieces conceived in aesthetic languages that are so diametrically opposed? Are these pilasters of the "Great Shelter," carved with naked female figures with overdeveloped breasts, Dogon work? Are these Soninke figurines with bodies conceived according to strictly codified rhythms and proportional ratios also Dogon? And what of these strangely minimalist silhouettes, hewn with rough adze blows, found in the Yatenga region: are these Dogon also? And finally, consider these bearded figures placed on top of each other, these horsemen with scathingly haughty profiles, or these pairs of musicians gravely playing the xylophone: are they all Dogon? Each is imbued with its own history of experimentation, of diverse origins and religious beliefs, and of a corresponding variety of uses—and perhaps of meanings.

It is always said that on the cliffs of Bandiagara "the ancient statues speak," and that by the very process of being carved, a piece of wood "enters into a relationship with minds and spirits." How is it therefore possible to reduce to the status of simple "works of art" objects which, in the eyes of the Dogon people, still embody the material and tangible representation of the tenuous, magical link between the visible and invisible worlds? There are no superfluous elements in the workmanship of these sculptures; no profane sentiment of pure delight; but rather the overriding impulse to repeat over and over the immemorial ancientness of the myth, to imprison within the wood the most important part of the individual, his *nyama*, which will thus continue to play a part in family life until death. For if there is one concept that refutes totally and absolutely our quintessentially Western notion of "art for art's sake," it is the status of "invisibility" conferred on Dogon sculptures. Their original and intended destiny, it should be remembered, was to lie forever in the womblike darkness of a cave—and certainly not to end up in the hands of dealers, curators or the simply curious.

Opposite: **"Great Shelter" post.** decorated with a female figure. Dogon (Mali). Wood; h. 132 cm. 16th-17th century. Formerly Lester Wundermann collection. Musée Dapper, Paris.
Following pages: **Walu face mask.** Dogon (Mali). Hardwood, traces of white paint; h. 63 cm. Formerly Joseph Mueller collection. Musée Barbier-Mueller, Geneva.
Female figure with raised arms. Dogon (Mali). Wood, flaky red patina; h. 76 cm. 15th century. Formerly Emil Storrer and Joseph Mueller collection. Musée Barbier-Mueller, Geneva.

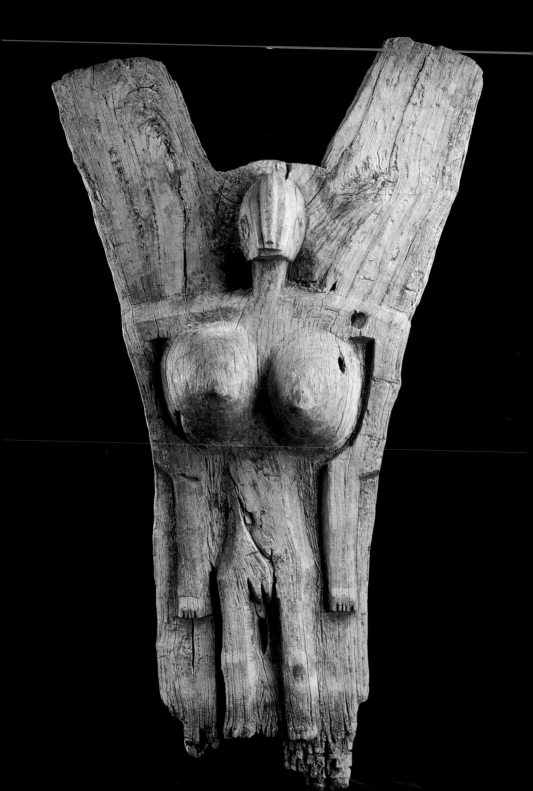

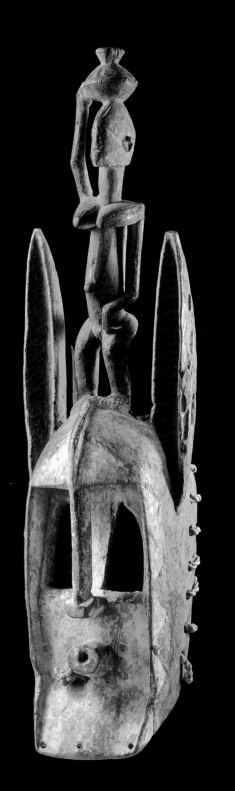

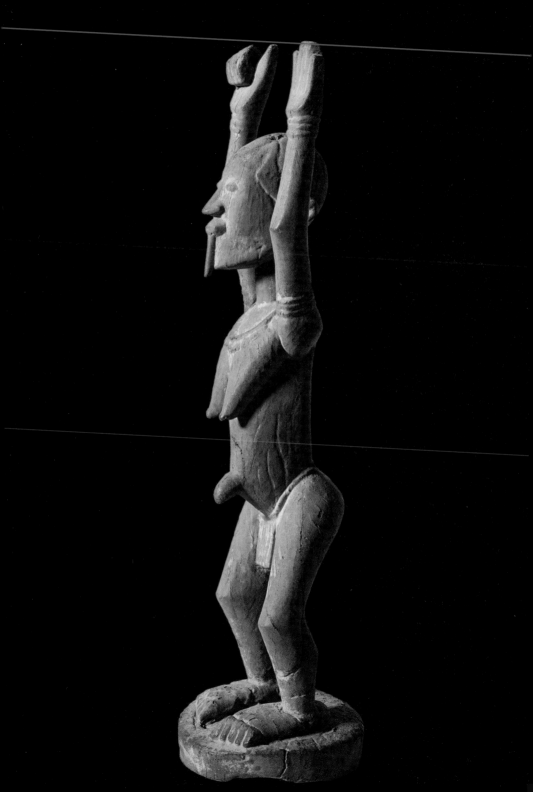

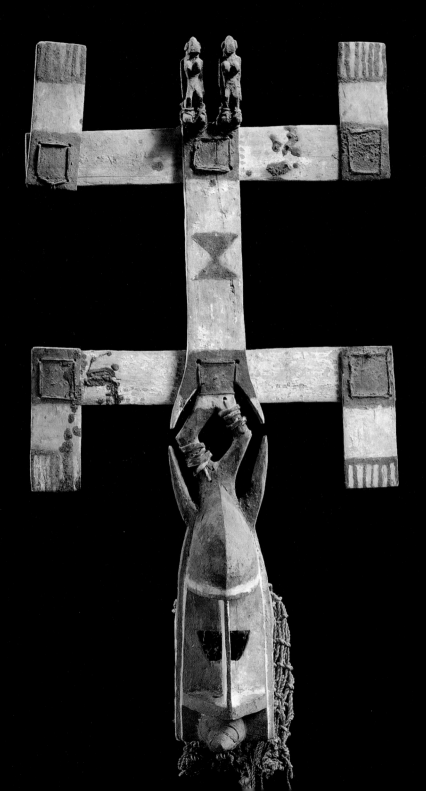

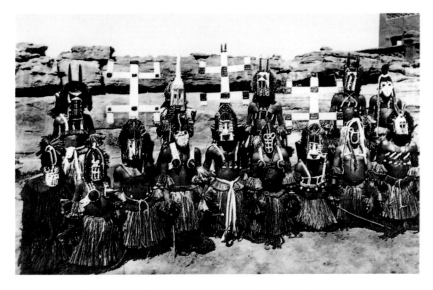

Above: **Group of *kanaga*-type masks.** Dogon (Mali). Period photograph.
Archives Barbier-Mueller, Geneva.

The role allotted to masks, meanwhile, could hardly be more different, While statues appear to be turned irrevocably toward the past (and were made by specialist craftsmen who formed the elite caste of the smiths), masks derived both their meaning and their aesthetic dimension from their public display, notably on the occasion of celebrations to mark the lifting of mourning (or *dama*). Birds, mammals, people, reptiles, lizards and even objects: Marcel Griaule had counted no fewer than 78 different types by the end of his lengthy expeditions. Carved in light wood by the dancers themselves, away from the sacrilegious gaze of women and children, the masks were brought out for ceremonies in which the element of the spectacular rivaled that of the sacred. Nevertheless, looking at these fantastic creations with their sudden and perfectly judged contrasts between decorated and undecorated sections, we should not forget that their original purpose was to celebrate in dance and song the creation of the world.

Opposite: Kanaga-type face masks. Dogon (Mali). Polychrome wood, leather,
hide laces; h. 115 cm. Formerly Joseph Mueller collection.
Musée Barbier-Mueller, Geneva.

75

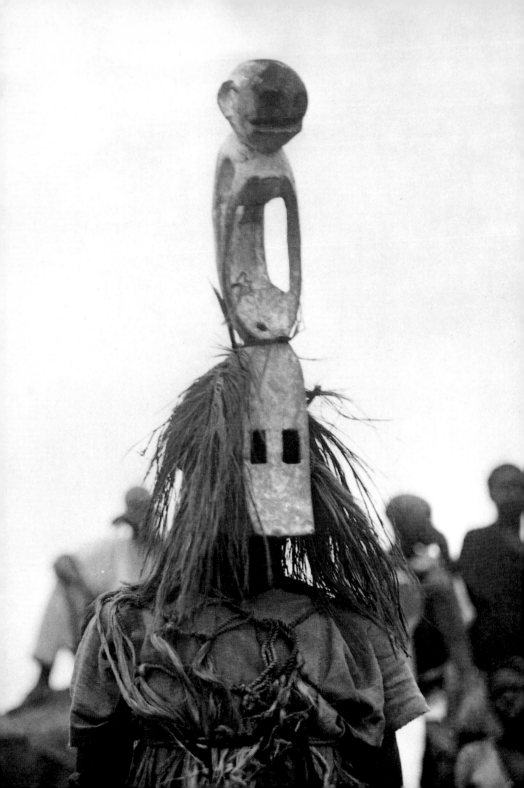

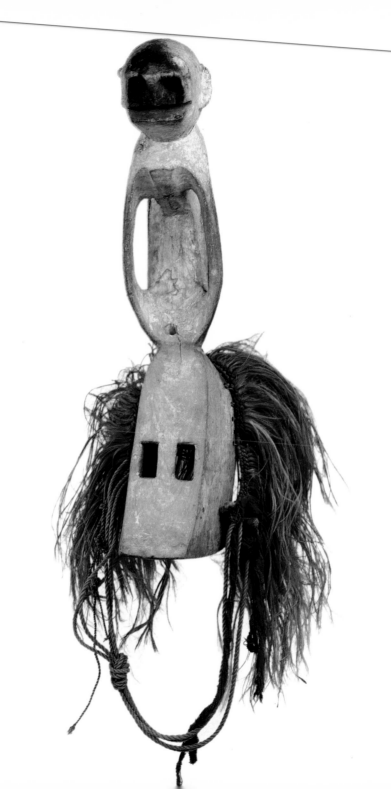

THE SACRED ROLE OF THE SMITHS

The sculptor-smiths—mediators whose role was nothing less than to weave a web of relations between the world of the living and that of the dead—occupied an extremely important position in the religious and social life of the Dogon. According to a myth recorded by Marcel Griaule, they were descended from one of the eight Nommo ancestors who came down from the sky in order to instruct men. "The smith weighs heavy on our heads" is still a Dogon saying, evoking the fear inspired in them even now by this magician who manipulates fire, the sorcerer, healer and circumciser all rolled into one. But the smith was also, and above all, the keeper of tools and the maker of "fetishes," whether of wood or metal. He was an artist in the sense that his gifts and qualities received recognition when his works, hidden from view for the vast majority of the time, were briefly brought into the open for sacred ceremonies. *"Wolo dagui"* ("our work is good") and *"Ezu dagui"* ("it is beautiful"): everyone was entitled to an opinion on the aesthetic qualities of these pieces. While the majority of artists remained anonymous, reporting on his 1931 expedition, Michel Leiris mentioned the name of one Ansege, a sculptor who had died ten years earlier and whose memory was still celebrated.

Previous pages:
Dama festival. White monkey mask.
Photograph by Marcel Griaule, 1931.
Musée de l'Homme, Paris.
White monkey mask. Mali, Sanga region, village of Ireli.
Wood, fibers, white pigment;
h. 40 cm. Collected by Dakar-Djibouti expedition, 1931-3.
Musée de l'Homme, Paris.

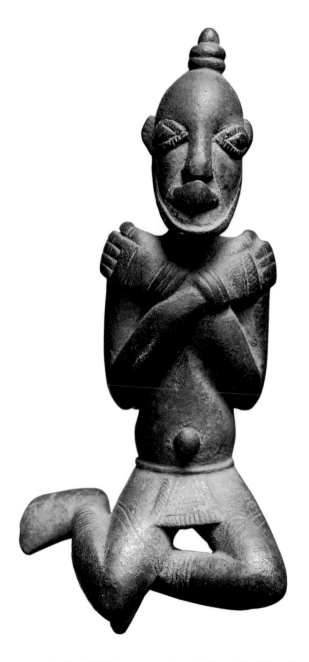

Pendant. Mali, Djenne region. Bronze; h.9.6 cm. 12th-17th century.
Musée Barbier-Mueller, Geneva.

The Omnipresence of the Sacred

"It's staggering, terrifying in its expressiveness!" the painter Derain is supposed to have exclaimed upon visiting the "Negro art" collections in the British Museum. Did his reaction indicate an admiring artist's unreserved enthusiasm for the genius of another people, or a more complex expression of the intuitive and slightly anguished response of a Westerner in the face of the indelibly sacred quality that emanates from all such works created on African soil? Probably it was both, given the disturbing and compelling power of these masks still fringed with fiber manes and beards, these reliquaries gleaming beneath their handsome dark patina or these magical figures bristling with nails. How is it possible to contemplate an African object, however modest or precious, without taking account of the spiritual context in which it was created? And conversely, how is it possible to view a "fetish," figure or mask simply as an instrument of religion, thereby denying its aesthetic dimension and the talent of the artist who made it? Vast in scope, this is a debate that continues to range ethnologists against art historians.

Opposite: **Bobo dance mask.** Wood. Photograph by Eliot Elisofon.
Following pages:
Anthropomorphic mask with large horns. Gabon, Kwele.
Painted wood; h. 42 cm, w. 62.5 cm. Collected by Aristide Courtois before 1930.
Musée Barbier-Mueller, Geneva.

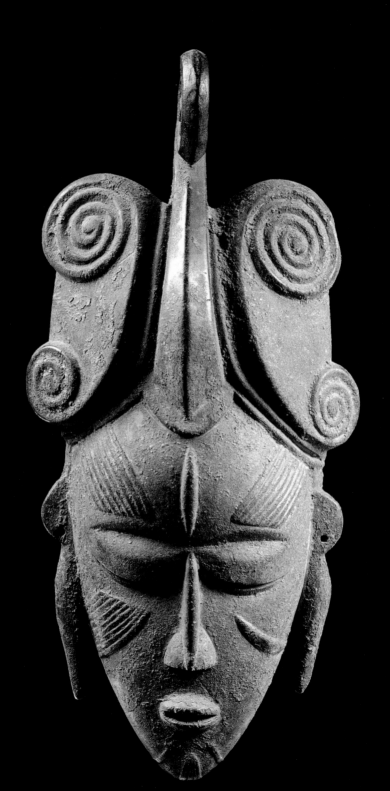

THE MASKED DANCE

The fate of African masks has been a strange one. Made exclusively by men according to precise rituals, and believed to be the embodiments of spirits of ancestors, of mythical heroes or of natural elements, they are now relegated to the ranks of works of art, museum pieces and collectors' items, preserved from destruction in sterilized display cases: objects of wonder, certainly, but also ghostly objects, disembodied and toppled from their sacred pedestal.

Few of the world's regions, it seems, have celebrated masks to the degree that they are celebrated on the African continent. Anthropomorphic and zoomorphic; celebrations of the union, at once poetic and savage, of the human and animal kingdoms; terrifying or seductive, realistic or abstract, minuscule or gigantic, red, black or white; carved in wood, cast in metal or sculpted in ivory; ostentatious or concealed; ephemeral or eternal: an indispensable element of religious ritual, masks in Africa are ubiquitous and omnipresent. "The African mask," observed André Malraux, "is not the fixed representation of any human expression, but rather an apparition. … In the mask, the sculptor is not lending form to a spirit that he does not know, but rather creates the spirit through its form; the mask is not effective to the degree that it resembles human shape, but rather to the degree that it does not; animal masks are not animals: an antelope mask is not an antelope but rather the spirit of Antelope, and is turned into a spirit by its style." And who could be better qualified then the author of *L'Intemporel* to describe the double function of the mask, as simultaneously both a sacred instrument and a work of art, the beauty of which rivals its religious power? Carl Estein, meanwhile, defined the mask as "an unmoving ecstasy." "Ecstasy" is certainly an appropriate term, in that the wearer of the mask ceases for a while to be himself, and instead becomes the incarnation of a tutelary ancestor, a spirit of the bush or a mythical hero linked to his clan. But "unmoving"? Hardly, given the intrinsic purpose of the mask: is it not intended precisely to mimic Creation, to sing the origins of the world, to make spirits whirl?

Opposite: Do society face mask. Ivory Coast, Banduku country. Hardwood, crust-like patina; h. 33.8 cm. Formerly Charles Ratton collection.Musée Barbier-Mueller, Geneva.
Following pages: **Face mask.** Ivory Coast, Dan. Fiber wood; h. 36 cm.
Musée Barbier-Mueller, Geneva.
Mask wearer. Congo, Boshongo region. Mask: polychrome wood, twigs, cloth, shells, feathers.
Photograph by Eliot Elisofon.

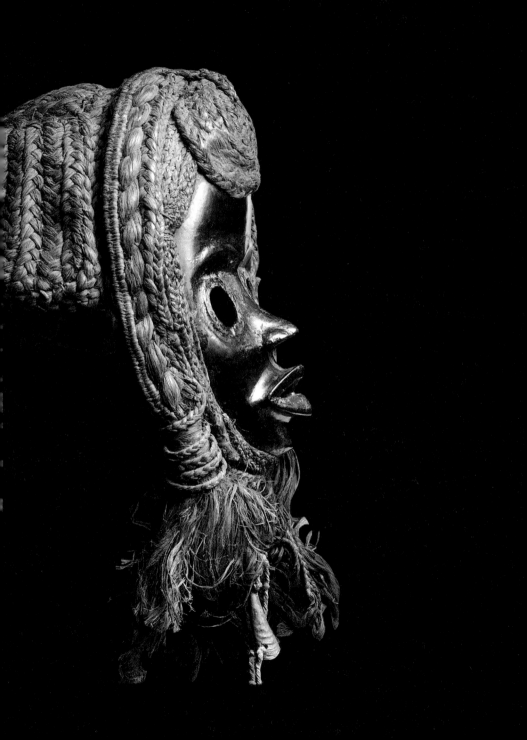

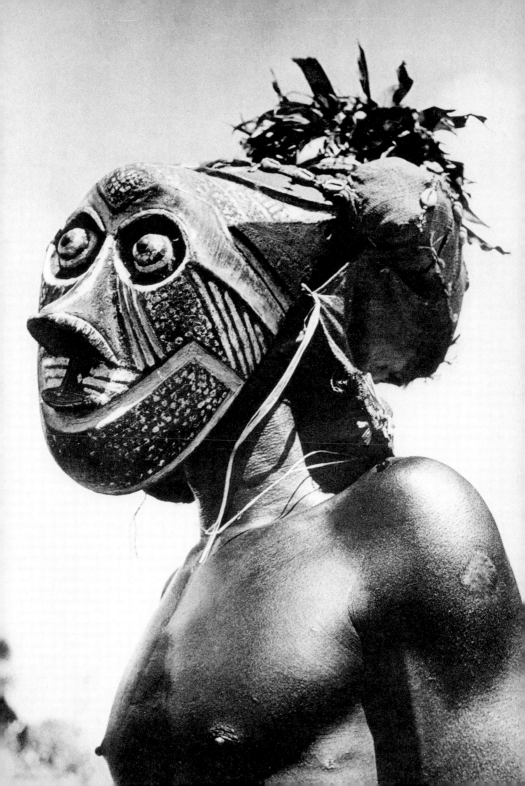

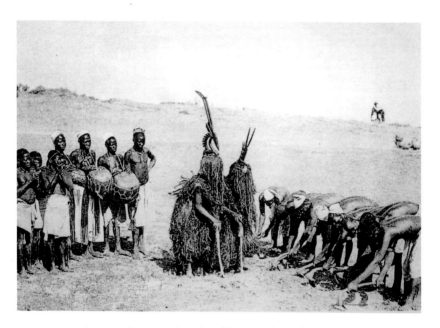

Above: **Pair of *tiwara* masks** Male and female antelope in hoeing contest.
Mali, Kutalia region. Archives Barbier-Mueller, Geneva.

Nothing could be less static, in fact, than African masks. And nothing could be more mistaken than our perception of them, as we contemplate these serried ranks of heads with braided hair, like so many butterflies in their museum display cases. For under African skies, masks signify a simultaneous whirl of dancing, music, prayer and color. The masked dance is a total spectacle, a masquerade in the full meaning of the word, that is a masked ballet imbued with wonder and sacred meaning, and sometimes even with comedy and burlesque, which provokes laughter or tears, joy or terror. Thus, the carved wooden face that we admire in a museum, frozen like a statue, stripped bare, cleaned up and smoothed down like some exotic trinket, is

Opposite: ***Tiwara* dance crest.** Mali, Segu and Kadanka regions, Bamana (Bambara).
Semihard wood; h. 78 cm. Formerly A. Moris and J. Mueller collection.
Musée Barbier-Mueller, Geneva.
Following pages:
Dama festival. Masked *kanaga* dance by Gona people
(reconstruction staged November 2, 1931).
Photograph by Marcel Griaule, 1931. Musée Barbier-Mueller, Geneva.

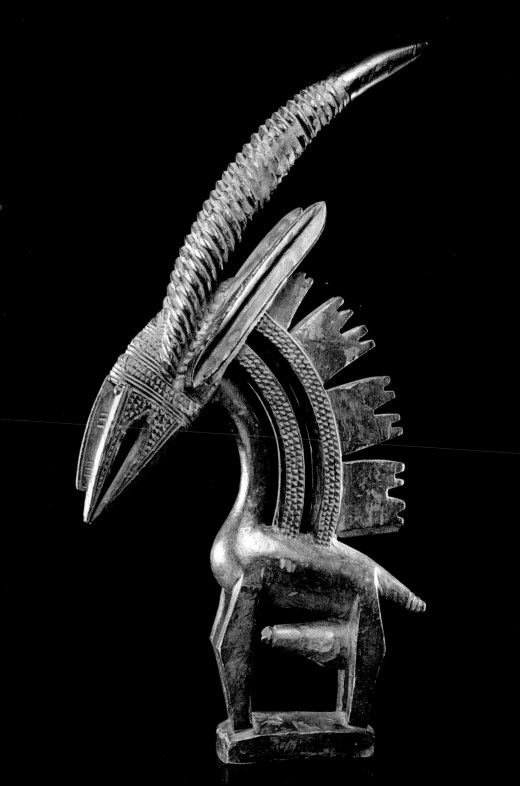

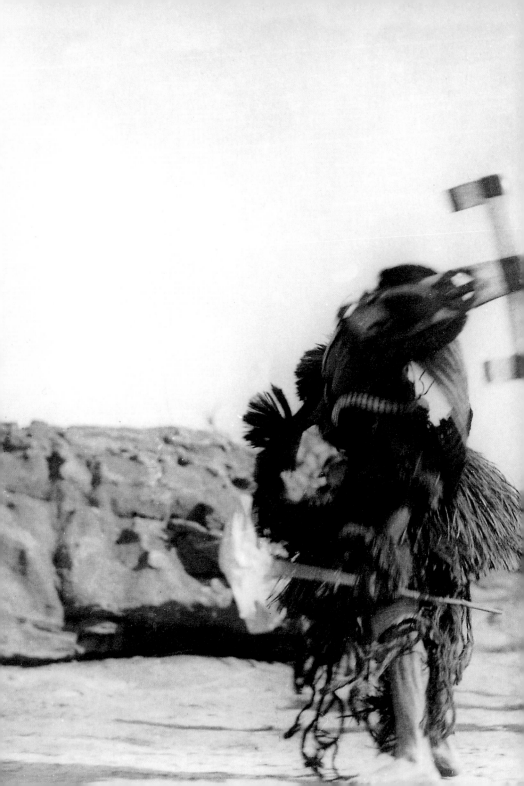

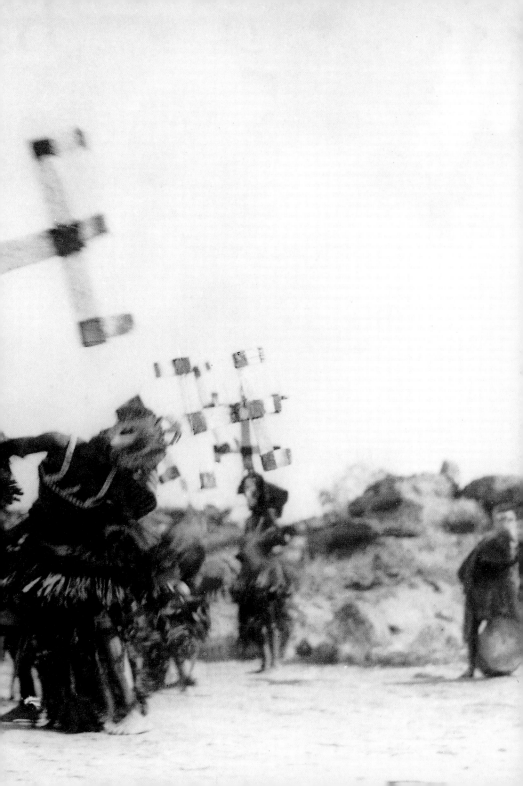

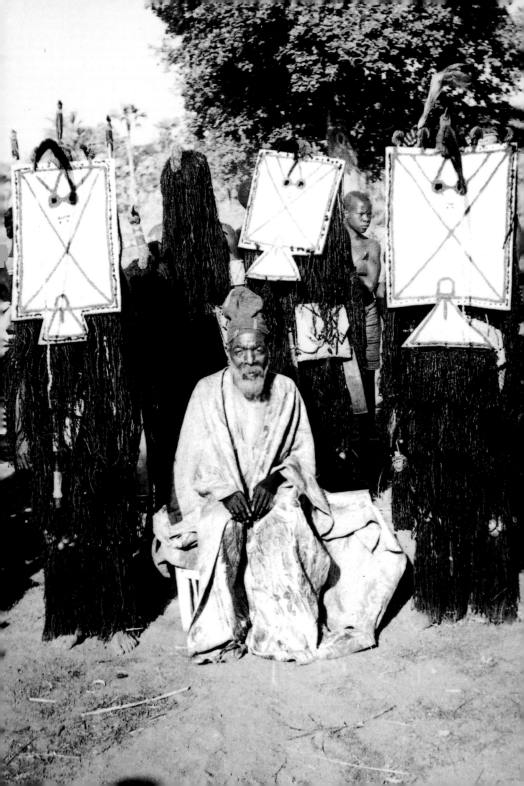

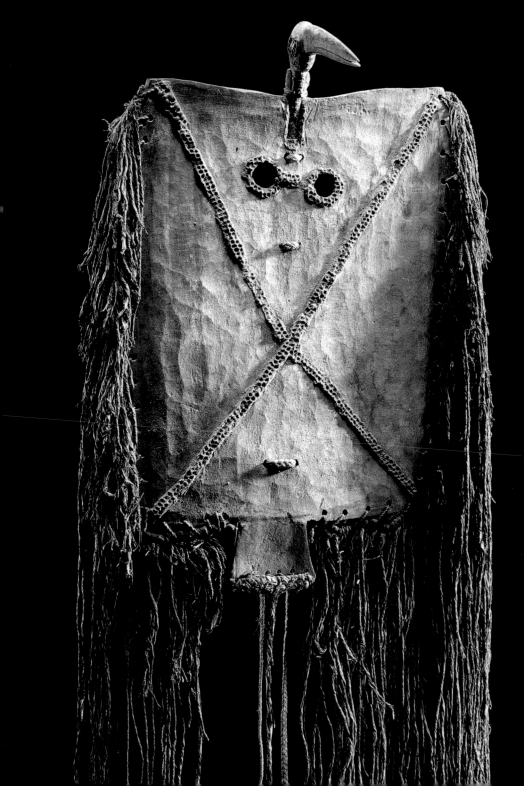

only a mutilated part of what is known as a mask in its native land. To understand it properly, we have to imagine it still crowned with its halo of plant fibers, rushes or cloth, whirling in pace with a twirling dancer to the cries of spellbound onlookers, lost in wonder but also a little in dread.

Michel Leiris penned a faithful description of the fervor whipped up by a Dogon masked dance alive with noise and color, a sacred spectacle in which music and dance play an integral part: "The masks were worn by young men. In addition to the one that is so tall that they call it the 'two-story house,' there is another with long black false hair, parted in the middle and falling down to either side of a face concealed by a mask of cowrie shells representing a marabou. Others sporting false breasts, covered with clay colored black, represent young girls; these are worn by the youngest boys. Others again, worn by the oldest of the men, consist of a type of helmet topped by a cross of Lorraine and look like iguanas. ... And others, finally, worn by young men and those recently initiated, are made entirely of plaited black cord..." He goes on to describe what could never be suggested solely by the contemplation of masks reduced to the status of museum pieces: "The dance of the girl masks consists of lascivious, sinuous movements of the breasts and belly. That of the masks with the great cross consists principally of a brusque movement of the head, describing with the tip of the cross that surmounts the helmet an almost vertical circle, skimming the soil at its lowest point, so that the end of the cross scrapes the mud violently, making a sound like a horse pawing the ground. ... But the most wonderful of all is the dance of the two-tier mask. First the dancer walks along, undulating his hair like a long tame snake. The old men call out to the dancer in a

Opposite: Wanyugo masked dance. Northern Ivory Coast,
Korhogo region, Senufo country. Mask wood covered with kaolin,
spotted with ocher and topped with calao feathers.
Photograph by Jean-Paul Barbier, 1988.
Archives Barbier-Mueller, Geneva.
Previous pages:
Ioniake masks topped with birds. Archives Barbier-Mueller, Geneva.
Ioniake plank mask. Tussian, Burkina Faso. Rectangular piece of hardwood,
abrus seeds, cowrie shells, kaolin, black plant fiber; h. 67 cm (without fringes).
Musée Barbier-Mueller, Geneva.
Following pages:
Wanyugo-type helmet mask. Ivory Coast, Senufo.
Hardwood; w. 74 cm. Collected by Emil Storrer 1950.
Musée Barbier-Mueller, Geneva.

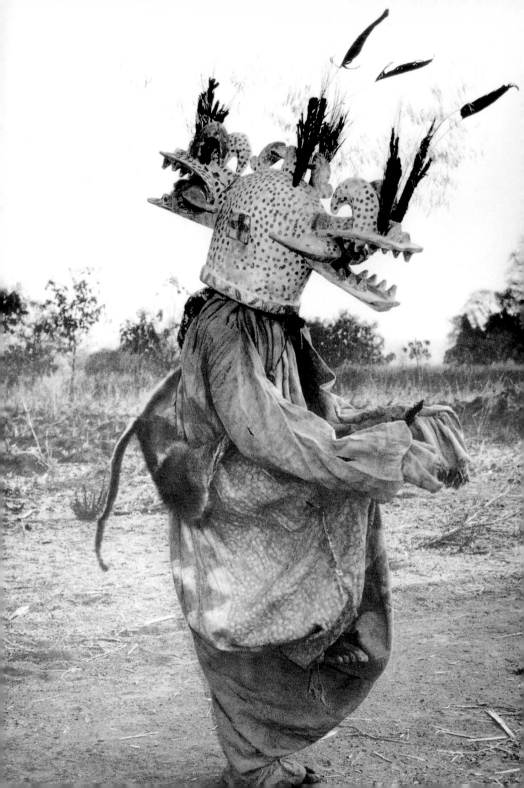

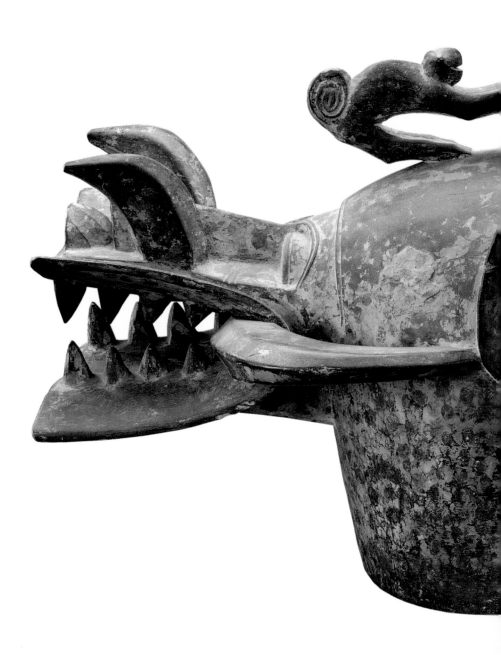

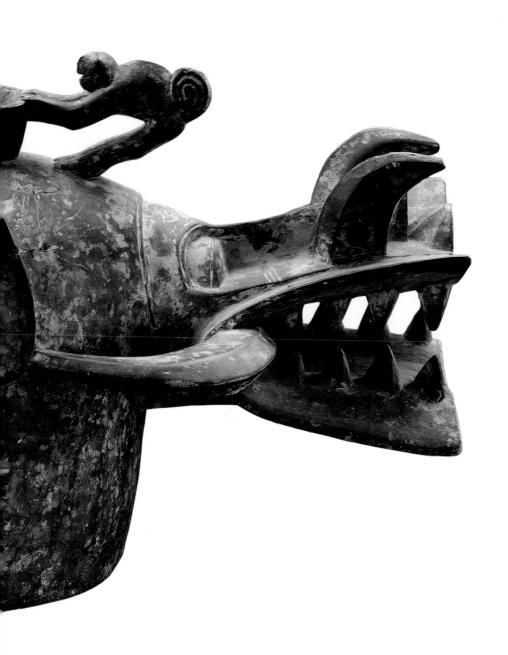

secret language. For a few moments, an old man carried away by his enthusiasm dances with him. In a slow gesture, the great mask is inclined so that its tip touches the ground, then it draws back, quietly lifting its tall pole. Once again it is like a snake ..." (L'Afrique fantôme, notes for October 2, 1931).

How many different varieties of shape, form and type are contained in the simple word "mask"! Ephemeral masks made from leaves or basketry, too fragile to be represented in museums or private collections, but easy to imagine whirling in a haze of brilliant color in forested regions such as the extreme southeast of Cameroon; flexible masks made of plaited fabric or fibers, following the shape of the head and shrouding like a cowl not only the dancer's head but also sometimes his entire body; "tightrope-walking" masks stretched over threadlike structures in basketry or rattan. Very often, however, the mask consists above all of a carved wooden face, wholly or partly covering the features of the wearer, which in style may be realistic or abstract, idealized or caricatured, animal, human or composite. Among some tribes in Mali and Burkina Faso, masks are increased in height by means of a paddle-shaped addition, solid or pierced, frequently polychrome and sometimes as much as 13 to 16 feet tall. Sometimes masks are replaced by simple face painting: in the Ivory Coast, young Ubi women decorate their faces with painted designs related to those commonly found on the masks of the region. Helmet masks or bell masks, are carved out of a hollow block of wood so as to cover the dancer's entire head and sometimes even his shoulders. Crest masks, worn—as the name suggests—on the forehead or the top of the head, offer the carver much greater scope and may include entire carved scenes, with either human or animal protagonists. Frontal masks, perched horizontally on the head, are found in the Cameroon Grassland; shoulder masks, in the form of extremely heavy busts, cover the dancer's head and shoulders, with a small aperture at eye level allowing him to see out. Plank masks are extended in height or width; while stele masks and sword masks are further variations employed by these extraordinarily versatile carvers in their quest to combine the practical with the sacred.

Helmet mask for conjuration ceremonies. *Bonu amwin.*
Ivory Coast, Baule. Wood; l. 49 cm.
Formerly Joseph Mueller collection.
Musée Barbier-Mueller, Geneva.

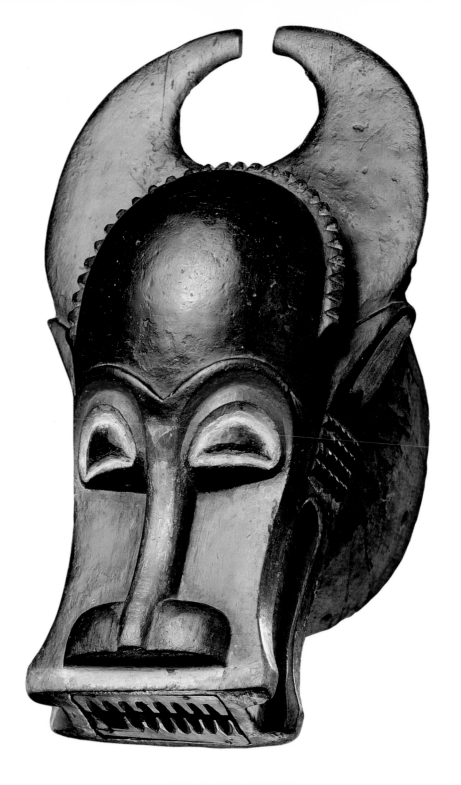

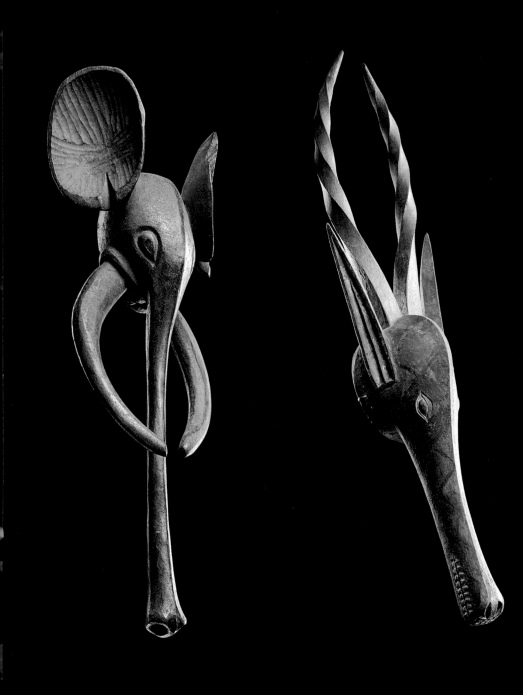

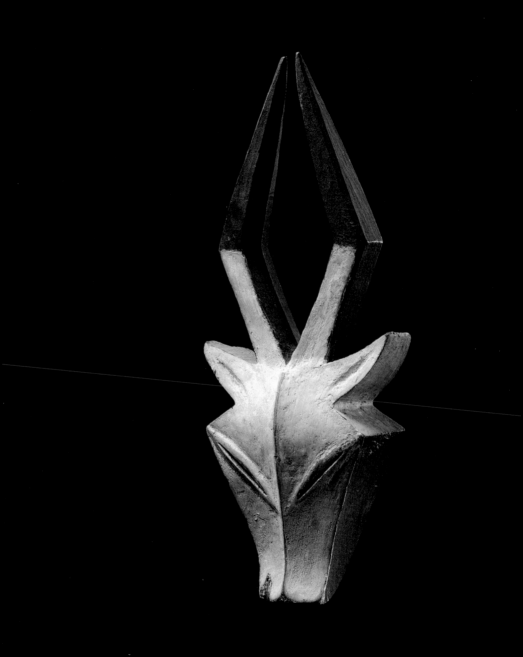

IN THE BEGINNING WAS THE ANIMAL

Anyone who has trodden African soil has almost certainly experienced that confused and disturbing impression of the insignificance of human beings amid the vastness of nature. For Africa still remains a virgin continent, potent and vivid, supremely beautiful but also supremely violent. On the fringes of towns and of civilization, wild animals roam. Their silhouettes, too, are magnified in masks and figures, and many of their attributes (such as horns, claws and feathers) are included in subtle compositions.

Primordial beasts or totems, protective or tribal, they also inspire fear. But we should be wary of appearances: in the sharing culture of the Baule of the Ivory Coast, gold figures of crocodiles biting their tails symbolize family solidarity. The Baga snake figure found in Guinea, with a sinuous tail that may be several yards long, is a hunter of criminals and sorcerers. This "medicine master" is also invoked against sterility and drought. Buffalo, monkeys, sheep, bats, birds and more rarely leopards and elephants—the entire animal kingdom seems to be summoned to appear in the form of masks at commemorative feasts. On occasion, animal and human traits are combined to create some of the most striking and unusual pieces ever to come out of Africa. The magnificent and almost abstract face masks with curved horns produced by the Kwele people of Gabon, for example, are a potent reminder that in Africa the animal kingdom is never very far away.

Opposite: Kplekple face mask.
Ivory Coast, Baule. Wood, pigments; h. 42 cm.
Formerly Charles Ratton collection. Musée Barbier-Mueller, Geneva.
Previous pages (left to right):
Mask in the shape of an elephant's head.
Cameroon-western Grassland. Hardwood; h. 112.3 cm.
Helmet mask in the shape of a gazelle's head.
Nigeria, Ijo (?). Wood pigment, L. c.107 cm.
Mask in the shape of antelope's head.
Gabon, Kwele. Two-color soft wood; h. 38 cm.
Formerly André Fourquet.
All three pieces: Musée Barbier-Mueller, Geneva.

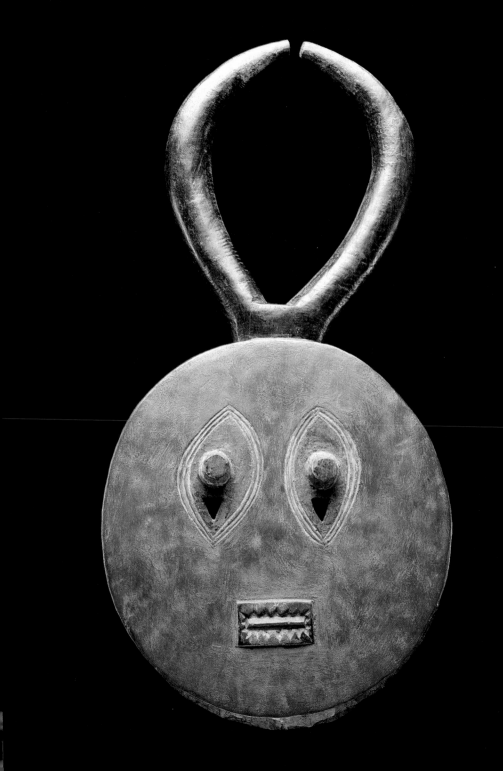

This eclecticism of forms and materials is matched, moreover, by the wealth of symbolism associated with masks and the multiplicity of their functions. As Jean Laude observed so rightly in his book, *Les Arts de l'Afrique noire* (1966): "In placing the mask over his face, the dancer is not setting out to disguise himself, nor to enhance himself, nor to assert himself, but rather to retreat behind an image that is sufficiently simple and true to the requirements of the myth that it may both ensnare and mirror the god." This outlook also helps to explain the plethora of precautions surrounding the creation and use of these slightly disturbing "holy traps." For the carver, who was invariably male, viewed himself as a mere tool at the service of the supernatural powers—although pride in having created a thing of beauty, sometimes verging on arrogance, was not unknown among the greatest of mask sculptors. Yet despite this recognition of their own talents, they nevertheless considered themselves as anonymous craftsmen working for the needs of the community as a whole. Indeed, there was little room for artistic freedom in a creative process that was so rigidly controlled. On the contrary, innumerable ritual precautions and jealously guarded secrets had to be observed before the carver was permitted to administer the first adze blow in making one of the sacred faces. And during the creative process, he was subject to numerous constraints and prohibitions: most notably he was required to work in isolation, to practice fasting and sexual abstinence, and to avoid all contact with women and with anything connected, whether intimately or remotely, with death. Many taboos also surrounded the wearer of the mask, who in addition was believed to be specially protected—for was not he, like the carver, invested with a higher mission? In many African societies, it was the spirit or god himself who was believed to indicate the dancer destined to impersonate him by means of a dream, a vision, a trance or sometimes an illness. Here, too, women appear to have been excluded from this profoundly misogynistic world: forbidden to take part in the masked dances or even, with rare exceptions, to watch them, women were believed to defile them by simply being

Opposite: Do society face mask. Ivory Coast, Ligbi. Polychrome patinated hardwood,
traces of plant fiber, cloth; h. 28.8 cm. Musée Barbier-Mueller, Geneva.
Following pages: Female *kifwebe* face mask. Congo, Songye. Wood; h. 34 cm.
Musée Barbier-Mueller, Geneva.
Appearance of a male *kifwebe* mask. Photograph. Archives Barbier-Mueller, Geneva.

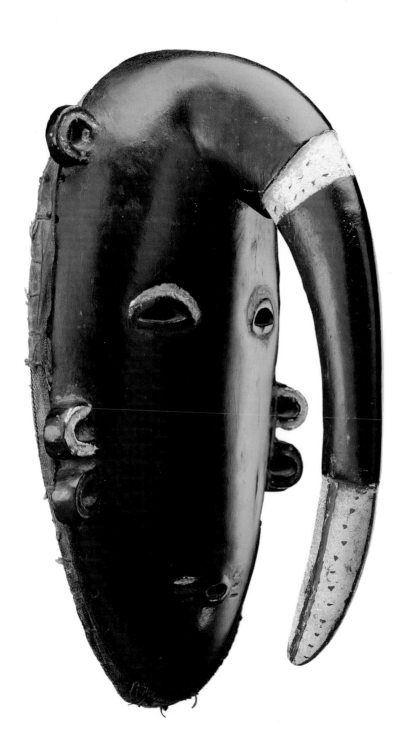

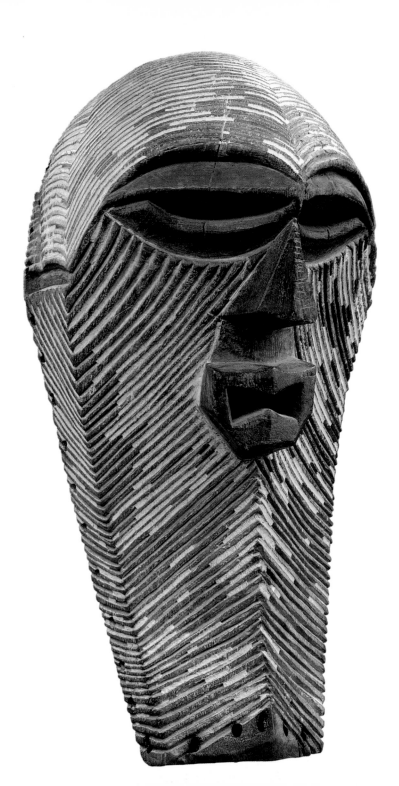

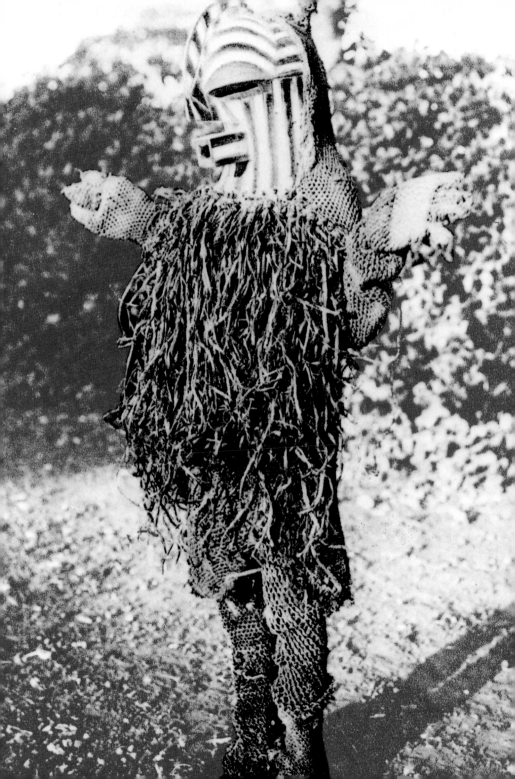

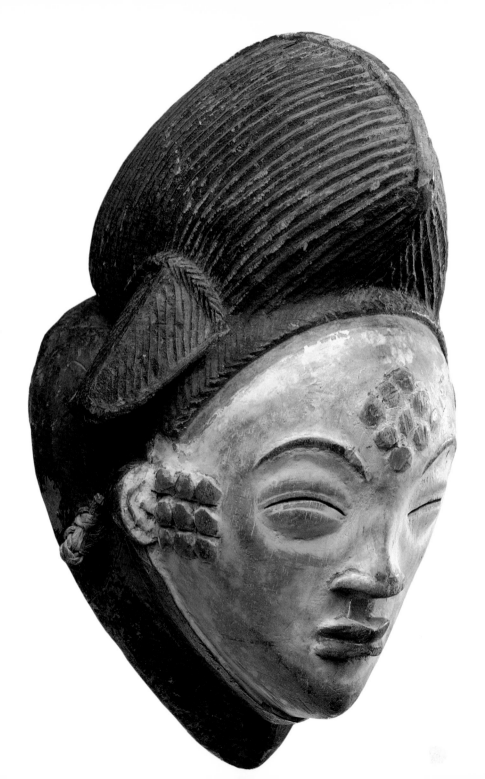

present and were obliged to flee with their children, under pain of reprimand or physical punishment.

If enthnologists are to be believed, the uses to which masks are put in Africa are almost as various as the different types created. Thus, when not required for dancing, initiation masks were entrusted to dignitaries for safekeeping and hidden from view: subject to strict prohibitions, they were exhibited only at the ceremonies accompanying certain rites of passage, such as circumcision. Even more disturbing are the masks created for the secret societies of West and Central Africa. Endowed with magical powers or even inhabited by supernatural creatures, they were the privileged upholders of the groups' spiritual powers, and as such received offerings and blood sacrifices. Brought out solely for the purpose of rites practiced by members of these societies, they were protected from the gaze of the uninitiated and sometimes even destroyed after use. According to some accounts, in certain regions of Africa these masked rituals served in reality as a means of maintaining a reign of terror over local villages, or as a pretext for the worst excesses of pillage and plunder. Thus the Scottish explorer Mungo Park, who traveled through the region of the Niger in the late 18th century, gave a detailed description of the way in which the forest spirit "Mumbo Jumbo" would pose as a defender of virtue, chasing—with masked face and whip in hand—women suspected of infidelity.

More peaceful altogether were masks associated with agricultural activities and the rituals associated with them. In Mali, the elegant figures of Bambara antelope, surmounted by tapering horns, might be seen dancing publicly in the fields, with their multicolored counterparts providing a similar spectacle in Burkina Faso. And finally come the masks devoted to what might almost be described as pure entertainment, if such a notion does not appear too sacrilegious in the African context. Performed by day or by night, to audiences of both men and women, these masked dances were occasions of general rejoicing, celebrating in festive fashion the grain harvest, the return of the newly initiated or communal hunting or fishing expedi-

Opposite: Okuyi **mask.** Gabon, Punu, Lumbo. Wood; h. 28 cm.
Formerly Joseph Mueller collection (before 1939). Musée Barbier-Mueller, Geneva.
Following pages: **Face masks.** Gabon, Fang and Punu. Polychrome wood; h. 44 and 34 cm.
Both pieces: Musée Barbier-Mueller, Geneva.
Page 112: **Helmet mask.** Belonging to the female *sande* society. Bassa, Liberia.
Hardwood; h. 36 cm.
Page 113 **Helmet masks.** Photograph, Archives Barbier-Mueller, Geneva.

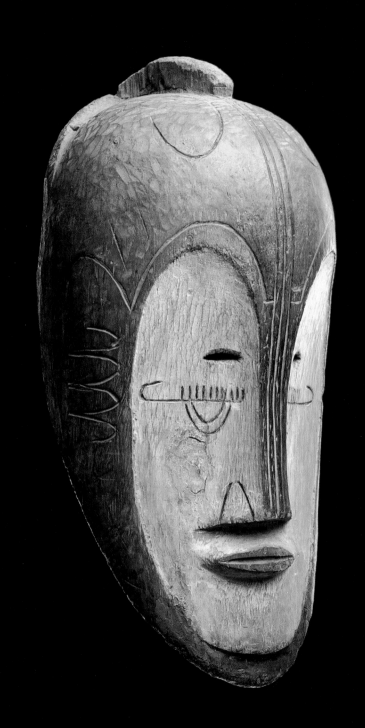

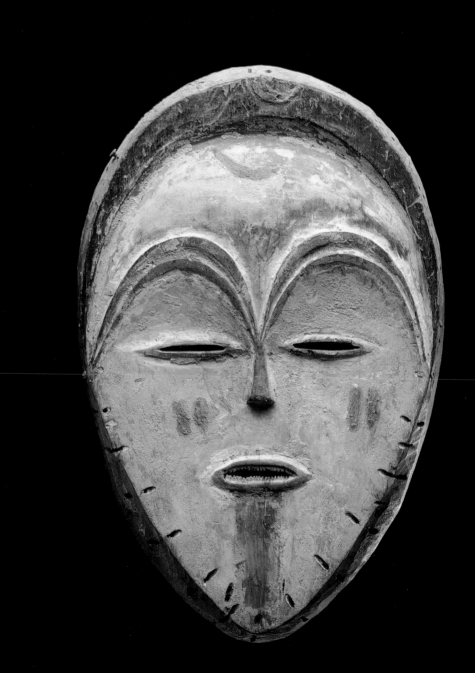

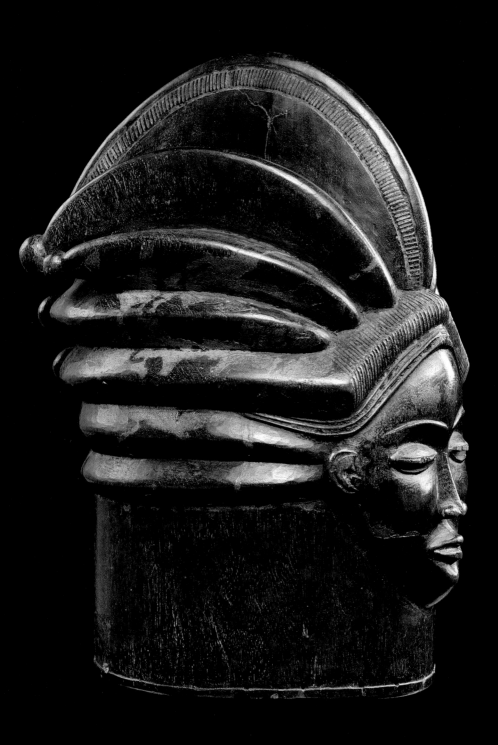

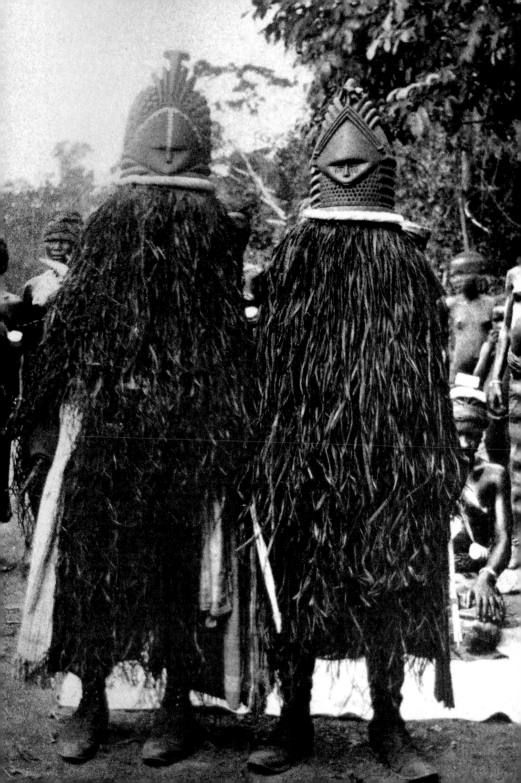

Mask. Congo. Lega, Pangi, Kivu. Wood, fibers (?).
Musée royal de l'Afrique centrale, Tervuren.

tions. Yet here too we should tread cautiously. What appears to Western eyes as a delightful secular spectacle might well conceal a reality that is considerably more complex. Among the Senufo people of the Ivory Coast, for example, the masked figure known as Yarajo appears at first sight to be an amiable clown who heckles his audience, which includes women and children, with facetious eloquence. But his apparently absurd remarks are in fact a series of subtle passwords, comprehensible only to members of the powerful *poro* society.

Large *Nwantantay* plank mask. Burkina Faso, Bwa. Wood; h. 203 cm.
Formerly Emil Storrer and Joseph Mueller collection. Musée Barbier-Mueller, Geneva.

114

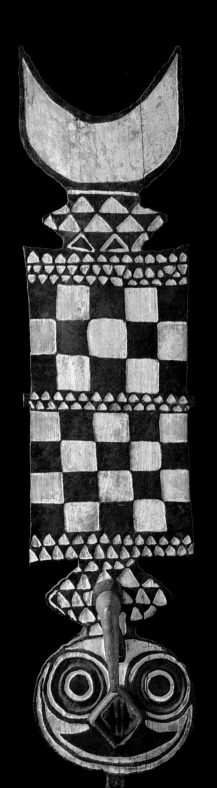

Sadly, the conversion of large numbers of African peoples to Islam and Christianity, not to mention the political and social upheavals of recent decades, has all too often transformed what were originally spectacles of the highest religious importance into meaningless masquerades aimed at the tourist market. The last survivors of these ancient ceremonies are thus these masks, whose undeniable creative power has sometimes earned them the status of works of art. The greatest painters of the 20th century, from Matisse to Picasso, were convinced of their importance, seeking in their skillful combinations of signs the confirmation of the artists' own researches rather than using the masks as a source of inspiration. Writing in 1966, Jean Laude was caustic in his criticism of the tendency of some art historians to borrow the vocabulary of modern Western art to describe these works: "To describe a Bamum mask as Expressionist (or Baroque), a Bambara or Dogon or Senufo mask as Cubist, or an Ibo or Ibibio mask as Surrealist is meaningless: it is to reduce to the same level works of totally different appearance and purpose, by means of false analogies founded on superficial appearances."

True as this undoubtedly is, there are nevertheless some elective affinities to which only art holds the secret. For what could be more magical than the inexplicable affinities between the expressive decoration (a sumptuous black-and-white checkerboard pattern) of a large Bedu mask carved by an unknown sculptor and the elegant graphics of a canvas by Paul Klee? What could be more thrilling than the realization that the celebrated "white masks" of the Shira, Punu, Nzabi and Lombu peoples of western Gabon were also part of the imaginative worlds of painters as diverse as Vlaminck, Magnelli, Picasso and Lhote? It comes as no surprise that these idealized masks representing the features of dead young girls should sometimes have been confused with the masks used in Japanese Noh theater. And there is a fine irony in the fact that an extraordinary heart-shaped Kwele mask from Gabon should have found its way into the collection of the poet Tristan Tzara, for it now seems inevitable that he should have succumbed to its astonishing crescent-moon-shaped eyes. Nor can it be by chance that the magnificent Teke mask from the Congo, now in the Barbier-Mueller collection, once belonged to André Derain:

Pibibuze **mask.** Gabon, Kwele. Wood; h. 25.4 cm. Formerly Tristan Tzara collection.
Musée Barbier-Mueller, Geneva.

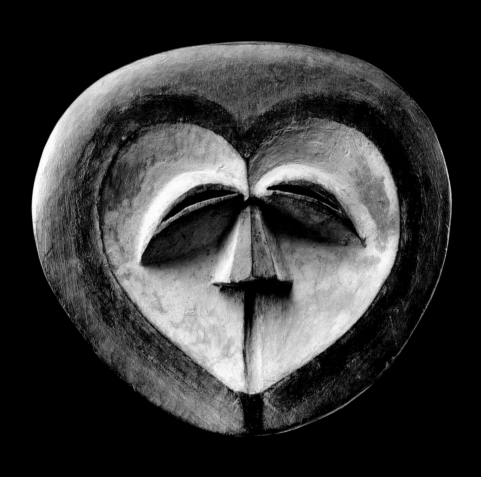

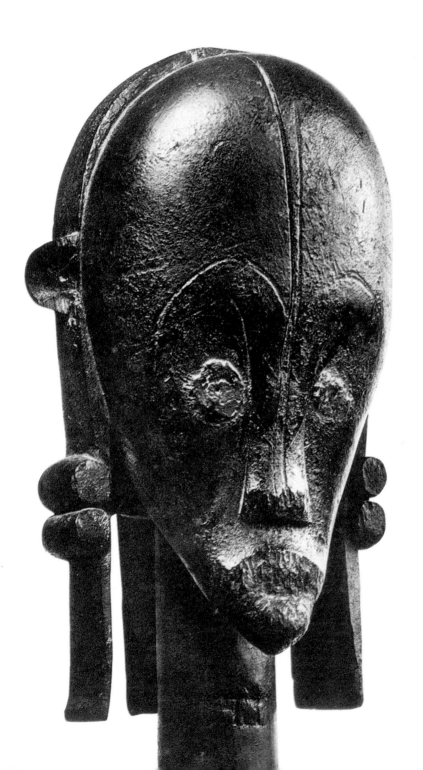

two-dimensional and polychrome, its "playing card" decoration in all probability seduced the painter with its dreamlike, timeless quality. Other collectors, such as Dr Pierre Harter, meanwhile preferred the brutal plastic qualities of the Bamileke (or Batcham) masks of Cameroon. With all due respect to Jean Laude, these monumental pieces are among the most Expressionistic works ever created by any artist, whether in the West, in Asia or in Africa.

FANG AND KOTA RELIQUARIES: THE DEAD RULE THE LIVING

"You, father, who do not die,
Who will never know death,
And whose breath is always living,
Without ever suffering the chill of sleep,
Your children have all come here.
They are gathered around you.
Wrap them in your strength, O father,
Let your shadow reach into them,
You, father, who do not die,
You, father of our lineage."

"Prayer to a Byeri", after R.P. Trilles, 1912

Few African peoples have given such cogent form to their obsession with death as the Fang, nor demonstrated so clearly the links binding the living and the dead. Spreading through southern Cameroon and northern Gabon from the 18th century, the Fang were tainted with a disconcerting reputation for cannibalism. Nevertheless, the wooden sculptures they carved represent some of the most

Opposite: **Head of reliquary.** Gabon, Fang. Wood. Private collection. Photograph by Eliot Elisofon.
Following pages:
Male *byeri.* Equatorial Guinea, Rio Muni coast, Mabea/Benga. Light wood, necklaces, inlays; h. 60 cm. Collected in Bata. Hamburgisches Museum für Völkerkunde, Hamburg.
Female *byeri.* Southern Cameroon, Mabea. Wood with a light patina; h. 60 cm. Göteborg Etnografiska Museum, Göteborg. Women and the uninitiated were forbidden to look at the statues known as *byeri,* which were associated with ancestor worship.

sophisticated funerary art created by any people anywhere. Here, too, Western artists were not mistaken in their judgment, placing Fang figures among the ranks of African masterpieces. Hieratic and frozen for eternity, their exaggerated proportions balanced between the delicate and the monumental, these heads and funerary statues belonging to the *byeri* cult are instantly compelling in their "classicism" and in the harmony of their proportions. Gleaming beneath a rich black patina, these austere figures carved with the aid of a simple adze are indisputably the work of great sculptors. Yet like the masks, many of these figures have come down to us in an incomplete state: detached from the tall cylindrical bark boxes on which they perched (and in which the bones of tribal ancestors were piously preserved), they have on the whole lost their original function as "guardians of the relics" to become purely "objects of enjoyment." Enlarged into giant statues or miniaturized to the point where they could be threaded into the knob of a staff or the top of a harp, they possess a quality that is impossible to ignore. Is it the hypnotic power of their gaze, originally highlighted with shining brass nailheads? Is it the nobility of the heads, with their high, swelling foreheads describing perfect arcs against the sky? Or is it the rigid severity of their posture, planted solidly on a stool, their hands sometimes clutching a dish of offerings? Poised halfway between the world of the living and that of the dead, these mediators seem to blur all the usual categories of human types: neither old nor young, neither present nor absent. *"Noirs messages de bois"* ("black messages in wood") was the neat description coined by the French ethnologist Louis Perrois, who has devoted a considerable time to their painstaking and almost loving study. But Perrois never overlooks an opportunity to stress their intrinsic purpose: hidden from the eyes of women and the uninitiated, these pieces that our aesthetic judgement places in the category of works of art were and remain far more than that in the eyes of the Fang people.

The word *byeri* continues to be used to indicate not only the cult of ancestor worship but also all the rites and ritual objects necessary for its smooth functioning. Thus a small box containing the skulls or other bones of the most distinguished members of the lineage, surmounted by an anthropomorphic figurine or a head with a long neck, would be jealously stored away in a dark corner, probably in a hut beside the owner's bed, where it would be safely hidden from uninitiated eyes. There was a high price to be paid for transgression of this prohibition: only a "pro-

tection" ceremony could remove the stain caused by any impudent, unauthorized contact with the world of the dead. The skulls—potent symbols and constant, concrete reminders of the power of the dead—require regular outings from their sepulchral darkness. Brought out for every important occasion concerning the future of the community as a whole, they then receive offerings and sacrifices: the blood of a chicken or kid, meat from a hunted animal, bananas or simply drinking water. And this is no mere folklore: in an environment as precarious and hostile as the equatorial jungle, it is a matter of common sense to harness the protective power of the dead. Nothing must be left to chance: before leaving on a hunting or fishing expedition, as a prelude to going off to war, or before a journey or the selection of a wife, the *byeri* is always consulted.

What once appeared as a form of family religion practiced within the strict intimacy of individual lineages has become a widespread belief observed to this day. Louis Perrois has described how, in 1967-8, he was able to take part in collective "protection" ceremonies in the Ntumu villages of Gabon. Gunther Tesmann, meanwhile, has gone so far as to describe and photograph in detail an entire *byeri* ceremony as it unfolded: under the influence of a hallucinogenic drug called *alan*, the young initiates communicate directly with the ancestors while reverently holding their skulls, extricated from their reliquaries for the occasion. While this is going on, the figurines are set in motion behind a fiber curtain: manipulated like marionettes by initiates, they "dance" to the music of drums (*mbe*) and xylophones (*medzang*), expressing over and over again the power of the dead in the afterlife. When the ritual is complete, the skulls and figurines are returned to their silent darkness; all return home, the living and the dead alike.

"Who in the West can claim to have understood and felt what they are, this world of the ancestors, this kingdom of the dead, this intimate relationship and irreconcilable opposition between the living and the dead, this necessary shock of the rite of initiation?" asks Louis Perrois. "For me, these works are "objects" and "signs"; they have appeared in cities and villages, in secret societies made up of living men and women, complete with a history and a lived experience which, in context, it seems unthinkable and wholly unjustified to overlook," he emphasizes again in his preface to the catalogue of the magnificent *Fang* exhibition held in Marseille in 1992. Yet how do we explain the way in which the novice initiate is immediate-

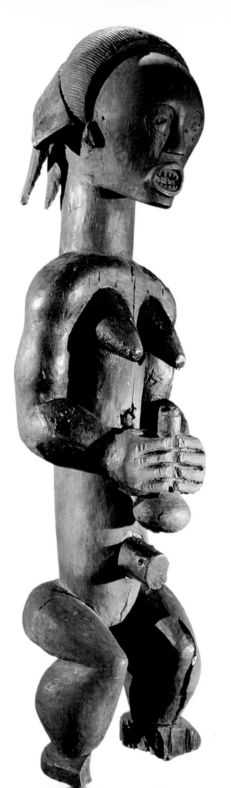

ly drawn to the byeri reliquary, an object which is completely outside his cultural experience and surroundings? Perhaps the explanation lies quite simply in the powerfully compelling quality of these perfectly proportioned carved heads and bodies: for are not Fang sculptors not only believed to be creators of "beautiful things" but also of "good things"? In this respect, the widespread cliche of the anonymous African artist collapses instantly. In truth, the artists who have remained anonymous are those whom "we" have not wanted to name: the profound lack of interest among collectors with regard to the identity of the artists whose work was to become the pride of the finest private collections at the turn of the last century is another subject, and one on which much remains to be said.

Far from being considered as simple craftsmen, Fang artists—sculptors or smiths, or sometimes both—were well known and sought out from one village to another for their skills. Indeed, the carving of ritual objects intended to establish direct contact between the living and the dead could hardly be considered a mundane activity. For this exceptional task of supreme sacred significance, no element of amateurism could be tolerated in either the commissioning or the execution. Further, it was a virtuoso exercise in style to which the Fang artist was required to submit, and one all the more complex for being governed by extraordinarily narrow and restrictive parameters. "Variations on a theme" would make an apt title for these rigid heads and unbending bodies, still gleaming beneath their oiled patina. Nowadays, specialists in the field vie to their hearts' content in finding distinguishing characteristics between the "Northern style", elegant and long and thin, and the "Southern style, readily conceded to be heavier and squatter. Aesthetes and art lovers, meanwhile, take delight in hunting down particular examples of stiff "hair bows," of hairstyles with flowing braids, of acutely angled shoulders, of engraved decoration beneath an earlobe, of pouting lips, and of tense, grimacelike smiles. Miraculously preserved from the wholesale destruction of the missionaries, and from the almost equally aggressive attacks of termites, these disconcerting figures reveal—even when deprived of their context—the staggering virtuosity of Fang artists, and their fascination, not unmixed with dread, for death and its veiled mysteries.

Female *byeri*.
Southern Cameroon, Ngumba. Wood. Reitberg Museum, Zurich.

ELDER AND INFANT COMBINED

One of the distinguishing characteristics of Fang sculpture is the exaggerated size of the head in relation to the rest of the body. Clearly, in an art form of such consummate balance and sophistication, it would be absurd to attribute this difference in scale to any lack of skill on the part of the sculptor. The specialist James Fernandez prefers a more symbolic explanation for this singular feature, observing that "the large torso, the big head and the improbably short bent legs are all childlike in character. The figurines thus present a twofold appearance, infantile and ancestral. According to the Fang, they symbolize old age and the ancestors, whose mighty powers enable them to intervene in the affairs of their descendants, but at the same time they also recognize their childish traits. ... An alternative explanation lies in the cult of ancestor worship and its principal preoccupation with fertility and growth. A representation of a child is a sufficient representation of the desire to have children. ... For the Fang, these opposing characteristics of the figures of their ancestors confer on them a vitality that they could not possess if they represented simply an old man or an infant." (*Principles of Opposition and Vitality in Fang Aesthetics*).

Female byeri. Southern Cameroon, Ngumba. Wood with brass inlay; h. 60 cm. Gift of G. Zenker to the Völkerkunde Museum of Leipzig, 1900. Private collection.

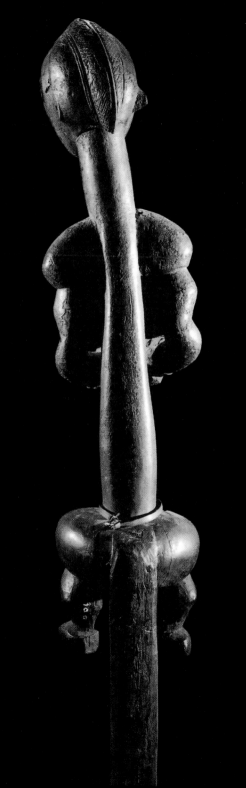

On his travels up the Ogoouwe river in 1877, Pierre Savorgnan de Brazza became the first European to come into contact with the Kota peoples and was able to observe their burial practices, certain aspects of which bore a marked resemblance to the Fang *byeri*. "The memory of the ancestors is cherished religiously in every household; fetishes, ornaments and weapons are handed down. If the memory of dead parents is not honored, they will wreak vengeance in the form of an ineluctable punishment," he noted in his scrupulously detailed book, *Au coeur de l'Afrique*. But where the Fang artists displayed a preference for powerful sculpture in the round and skillful juxtapositions of volumes, angles, curves and counter-curves, the Kota showed a marked tendency toward abstraction and stylization. Sheathed with fine plates of copper or brass, their reliquary figures are surprising in their two-dimensional character. A charming engraving published in 1888 in the famous journal, *Le Tour du Monde*, shows some of these figures in their original context: crowning the bark boxes in which the skulls and other bones of important members of the tribe were kept, and gathered together in a little hut, away from impure or profane eyes. The feature of these eminently decorative sculptures that struck collectors and artists of the early 20th century above all was their strangely flat, ovoid faces, punctuated by the large round eyes of the "keepers of other-worldly powers". Sadly, explorers and missionaries alike remained resolutely unimpressed by these "fetishes", which they deemed impure and demonic. Numerous examples of these fascinating sculptures were destroyed by burning, and with them was lost the ancient cult of Kota ancestor worship. In the 1920s, the painter Juan Gris, unable to procure an authentic example of these reliquary figures, was obliged to cut one out of cardboard.

BETWEEN MEDICINE AND MAGIC: NAIL-STUDDED FETISHES

Gris-gris, amulets and fetishes; healing figures and malevolent figures; lucky charms and unlucky charms; bizarre effigies crowned with feathers, studded with nails and sometimes even smeared with blood, saliva or scabs; jewels hidden under clothes and pendants displayed around the neck: in short, African cultures nurtured as

Reliquary figure. Gabon, Kota (Obamba-Mindumu). Wood overlaid with copper and brass;
h. 41 cm. Formerly Olivier Le Corneur collection.
Musée Barbier-Mueller, Geneva.

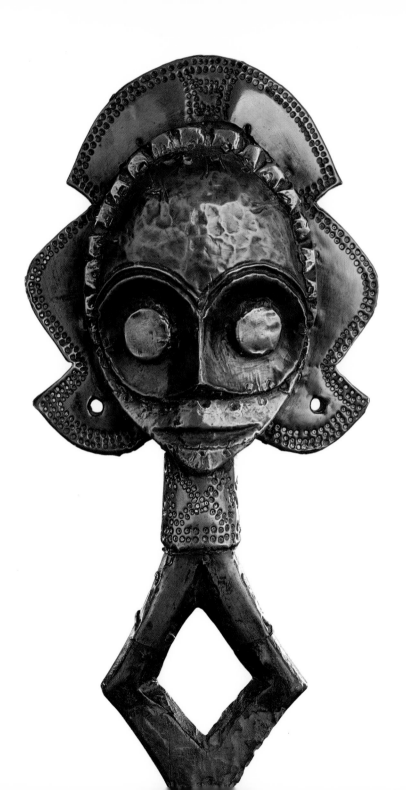

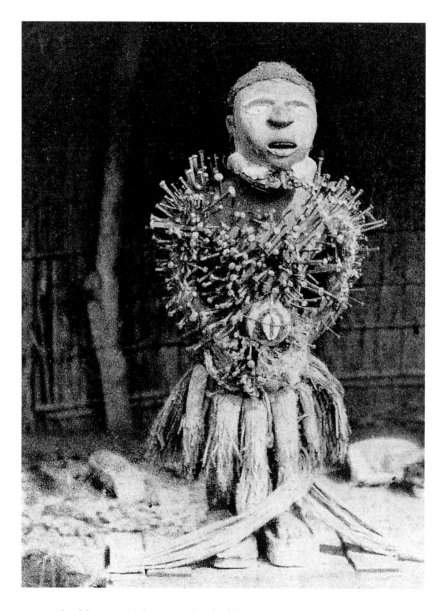

Nkondi figure. Period photograph. The role of these purely beneficent figures is to act as mediators. Each blade or nail hammered into their bodies signifies an agreement reached between two parties. Archives Barbier-Mueller, Geneva.

Opposite: Nkondi figure. Congo, Zaire region. Wood, nails.
Musée royal de l'Afrique centrale, Tervuren.

Following pages: Figure of a dog. Wood, iron nails; l. 88 cm. Musée de l'Homme, Paris.

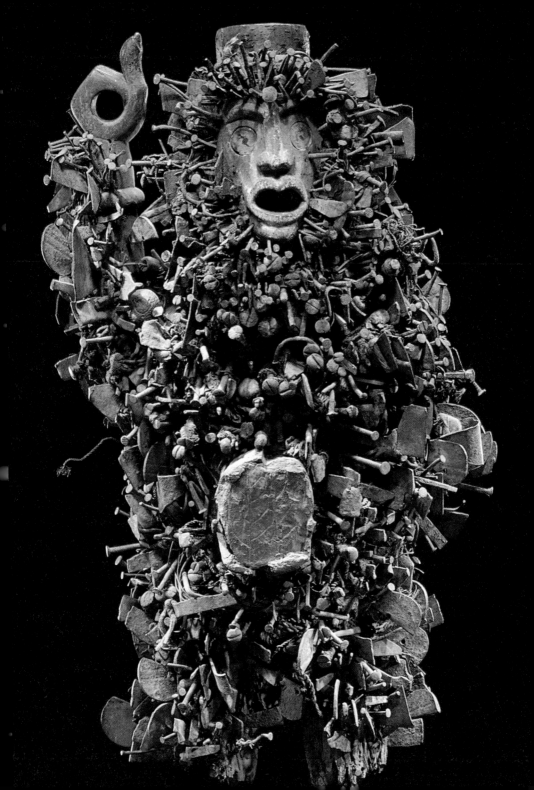

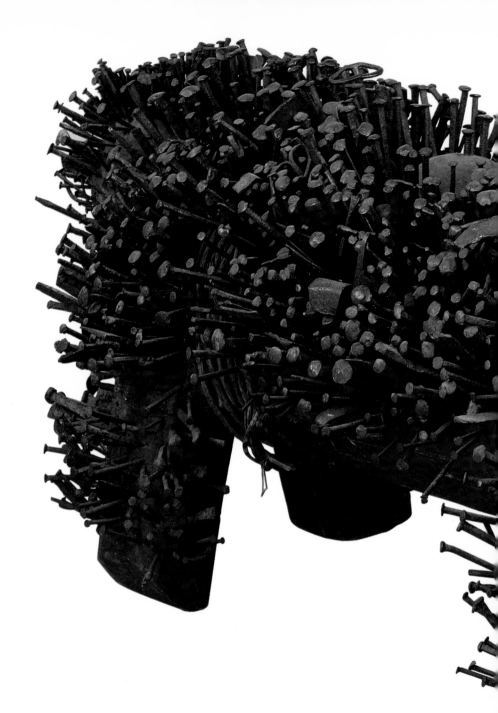

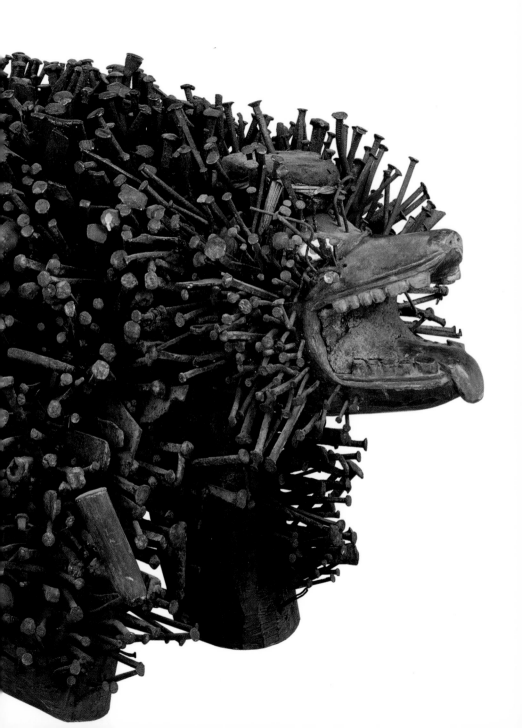

many occult practices as there were fears to cast out or wishes to grant. Praying for rain to ward off famine, predicting the sex of an unborn child, seeking to appease natural forces as well as supernatural ones: was this magic or sorcery? Medicine or charlatanism? Clairvoyance or divination? To Western observers with their implacably rationalistic approach to life, "Black Africa" has always been and remains still the natural home of healers and "witch doctors": figures of more or less disturbing powers who are able enter into direct contact with occult powers. And indeed there are few other continents where the real world flirts so closely with the supernatural, where the world of the living has such prolific contacts with the spirit world, and where horror and evil are tamed and diverted into charms and fetishes to ward them off.

Rings and necklaces, belts and bracelets, pendants and animal or anthropomorphic figures formed a tremendous variety of receptacles for protective forces, whose talismanic power was equaled only by the eclecticism of its forms and materials. Almost anything might serve to endow an object with power: beads, leather, metal and ivory, as well as human teeth, bones, hair, fingernails, canine teeth of cats, antelope horns, snail shells, and even china buttons and padlocks borrowed from the "civilized world." In this realm characterized by hectic accumulation and overdecoration, the torso of a figurine might well vanish completely beneath a rancid amalgam of (for example) gruel, saliva and dried blood. Frequently, the body as a whole plays second fiddle to the highly expressive face, with pupils in enameled iron embodying a presence of an obscurely daunting nature. For the creators of these works—intended to function as vehicles for beliefs and for messages or petitions to the other world—aesthetic considerations were subservient to efficacy. As Jean Laude rightly observed in 1966: "Every African statue has a religious or, in a broader sense, social purpose: it is an instrument, a tool, and from the outset its aim is never to arouse emotion or aesthetic contemplation."

In this earnest context, what could be more unexpected, and by the same token more appealing, than the *nkisi* (defined by Denise Paulme as "any receptacle consecrated by a magician") of the lower Zaire and Congo Rivers, their bodies riddled

Consecrated male figure. Teke (right bank of Congo).
Wood, cotton cloth, plant fiber, porcelain buttons, composite material; h. 38 cm.
Musée des Arts d'Afrique et d'Océanie, Paris.

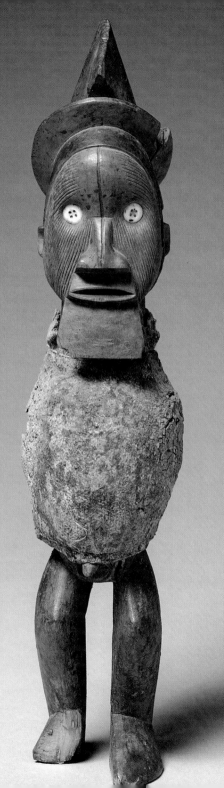

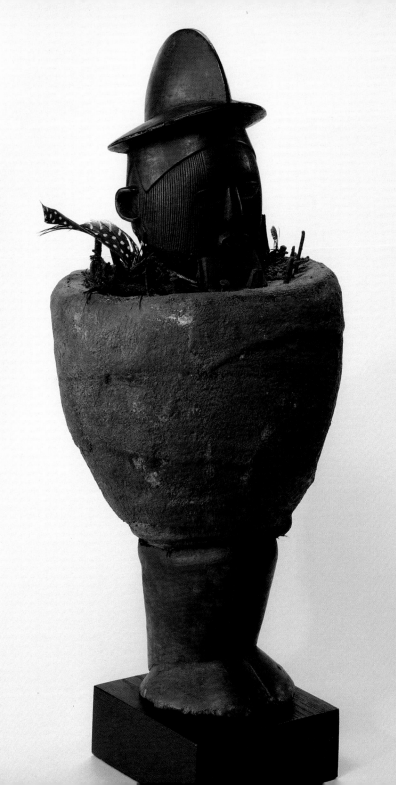

with metal blades and nails, each representing a petition to the spirit world by the fetish maker? Sometimes the torsos of these fascinating figures are set with mirrors, whose reflective properties will guide the medium and help him pass through the screen of appearances (we might almost be in the fairytale world of Lewis Carroll or the films of Jean Cocteau). Dogs also feature in this theory of figures-as-mediums, by virtue of their exceptionally keen sense of smell, which enables them to sniff out the presence of malevolent forces. Endowed with a single head, or more rarely two Januslike faces, these figures, too, bristle with a forest of nails which transforms them into formidable hunters of *ndoki* (witches).

Yet there is nothing occult or malevolent about these objects, which were displayed to all eyes in the center of the village. Manipulated by a *nganga* (a term which may be translated variously as "specialist in rituals," "medicine man" or "fetish maker"), these figures are intended above all to heal the sick and re-establish universal harmony. Figures which Western sensibilities interpret initially as disturbing and "tortured" (the nails perhaps reminding us subconsciously of the tragic and haunting image of the Crucifixion), to African eyes, by contrast, are reassuring and positive. Each metal blade or nail, for instance, is conscientiously licked by the nganga before being driven perpendicularly into the figure's neck or torso, thus signifying—according to scrupulously observed ritual—that an agreement has been reached between two parties.

Among the Teke, a people straddling three Central African countries, the practice of medicine was an omnipresent feature, oscillating once again between therapy, witchcraft and magic. The power of the *nganga* (medium, priest, hunter, doctor, surgeon and even psychotherapist, all rolled into one!) here appears to have been unlimited. There were few significant events in life that did not require his services: he comforted mothers in childbirth, he sharpened the wits and senses of hunters before they set off on expeditions, and above all he warded off famine and cured illness. In the face of the terrible suffering that these twin scourges continue to inflict on Africa, it is not difficult to understand the aura and veneration with which these people surrounded the person of the *nganga*. For it was he who gave

Consecrated male figure. Teke (right bank of Congo).
Wood, earth, iron nails, feathers, pigments; 41 x 18.5 cm.
Musée des Arts d'Afrique et d'Oceanie, Paris.

a fetish all its sacred potency, by placing within a cavity hollowed out of the base of the figure a round parcel of ingredients chosen for their magic powers. Sadly, many of the Teke works now in private collections in the West have lost these composite bundles in which their intrinsic value lay: quite simply, they have be "deactivated" by dealers, or by the families who were forced to hand over their fetishes to Swedish missionaries in the early years of the 20th century. Almost invariably masculine, with their hair drawn up into a small crest bearing an uncanny resemblance to the sun-screening topis affected by colonials, sporting goatee beards and with scarification lines running the length of their cheeks, they continue to exert a hypnotic power with their shirt-button eyes. Do they represent ancestors? Protective spirits? Mediating spirits between the visible and invisible worlds? So minuscule is the number of objects whose use is well documented that it is impossible to come to any definite conclusion. As for the *nganga's* bag, compiling a detailed inventory would be a herculean task, but the contents might include eagles' claws and feathers, fishbones, antelope horns, leopards' teeth, snakes' heads and tails, different-colored chalks, curiously shaped roots and plants of all sorts.

Similarly, what should we make of these fly whisks for protection against the rain, these glass bottles supposed to imprison evil spirits, these bracelets and diadems decorated with eyes with which to probe the invisible world? The ethnologist Marie-Claude Dupré, a great expert on Teke art, has offered the most convincing definition of these pieces, which were to grip the Surrealists with their poetic power: "The invisible spirits are benevolent to those able to see them; when the "found object" is charged with meaning and purpose, the beauty that springs from these assemblages of apparently unrelated elements has seduced humankind since earliest times, during every period of awakening and coincidence. In them we may see the ancient actuality of the most contemporary art." (Batéké. *Peintres et sculpteurs d'Afrique centrale*).

THE AMBIVALENT POWER OF FETISHES

"Fetish": the word is believed to be derived from the Portuguese *fetiçao*, as we are reminded by Jean Laude. Subsequently used in a work entitled *Du culte des dieux fétiches* by Charles de Brosses in a book published in France in 1760, it rapidly became a pejorative term, used indiscriminately to designate any object linked more or less directly with magic practices. Fetishism, magic, witchcraft: still today we are swayed by such associations of ideas – more or less negative – in the face of a continent which continues to inspire not only fascination but also a degree of fear. And it remains true that Africans themselves admit to feeling the greatest respect, or even fear, for the "medicine man." It is the *nganga* who tends and heals the sick, but he may also use fetishes to cast spells and to cause illness or death in a far-off victim. It is in this that the ambivalence of the *nganga* lies: only the nature of his incantations will reveal whether he is using his powers for good or ill.

Following page: **Statuette of the medium "Asie Usu."**
Ivory Coast, Baule. Wood; h. 44 cm. Formerly Joseph Mueller collection.
Musée Barbier-Mueller, Geneva.

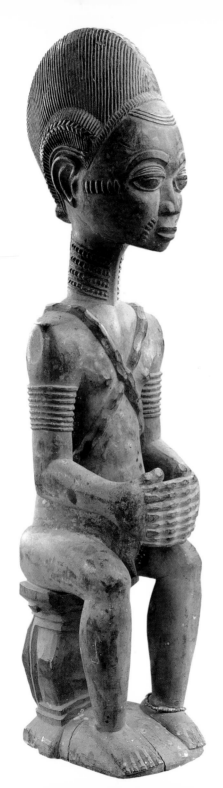

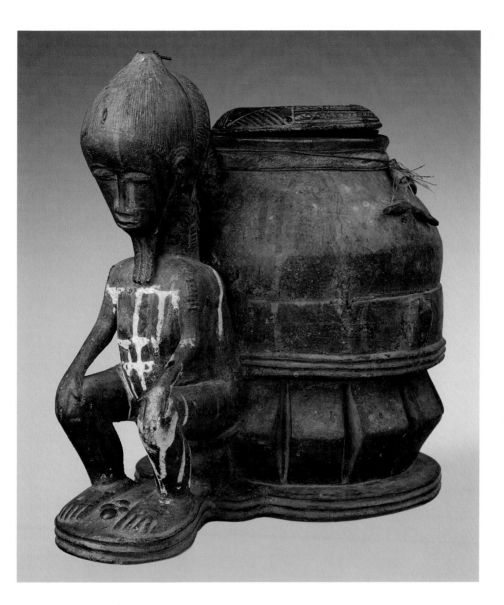

Divining box. Ivory Coast, Baule. Wood, hide, plant fiber; h. 25 cm, base diameter 18 cm.
19th century. Wood, terracotta. Musée de l'Homme, Paris. The post of this mouse oracle
is divided into two chambers. A pair of fasting mice shut in the bottom chamber climb up to
the top one. There they move six sticks attached to a tortoise shell: the signs composed by
each new arrangement of these sticks will be interpreted by the medium.
Musée de l'Homme, Paris.

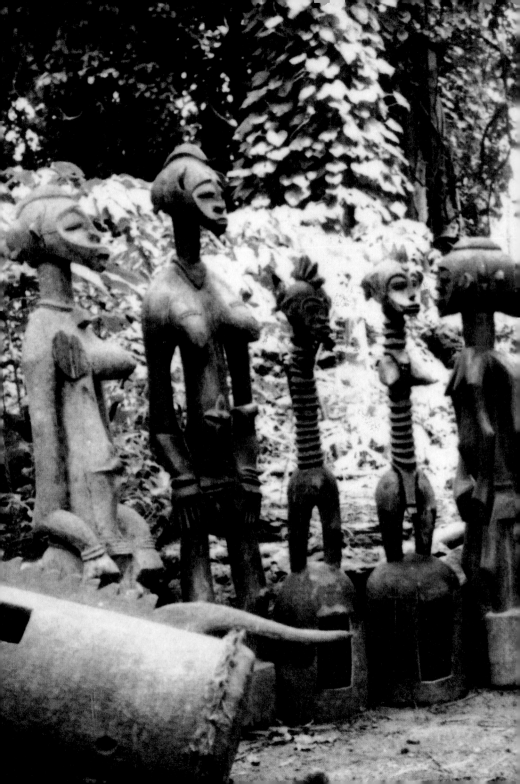

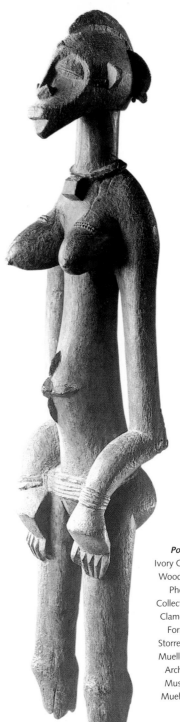

***Poro* figure.**
Ivory Coast, Senufo.
Wood; h. 118 cm.
Photograph.
Collected by Father
Clamens in 1951.
Formerly Emil
Storrer and Joseph
Mueller collection.
Archives of the
Musée Barbier-
Mueller, Geneva.

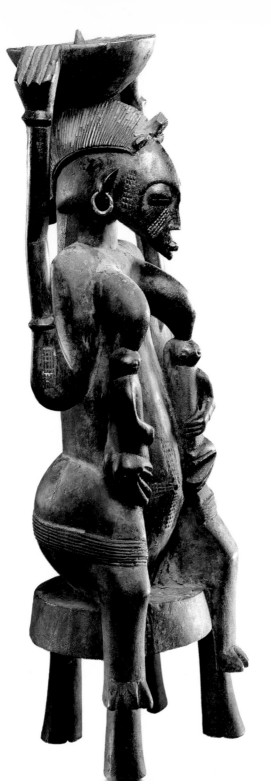

Female *poro* figure,
Ivory Coast, Senufo.
Wood; h. 65 cm.
Formerly Emil Storrer and
Joseph Mueller collection.
Musée Barbier-Mueller,
Geneva.

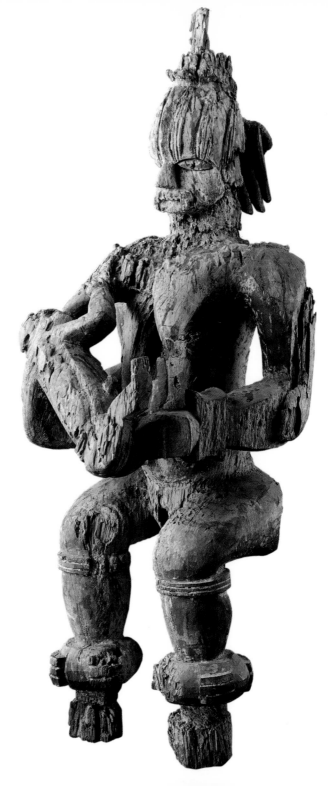

Female figure suckling a child

The figure represents a natural spirit named *Edjo re akare.* Nigeria, southwestern region, village of Eherhe, Urhobo. Second half of 19th century. Hardwood; h. 142 cm. Musée Barbier-Mueller, Geneva.

THE ETERNAL FEMALE PRINCIPLE

Mother and wife, potter, priestess and occasionally even fetish maker, African women play an important role in both the myths and the reality of everyday life. Giver of life, educator of children and transmitter of power and wealth, woman is omnipresent and sacred: Eve, Virgin and *Dea Mater* all in one. Female beauty is thus celebrated by numerous African peoples, who express their concept of the eternal female principle in masks and sculptures. Among the Punu of Gabon, the ideal is characterized by a light complexion, well-defined lips, a slightly hooked nose and hair arranged with consummate artistry. The Bambara of Mali and the Senufo of the Ivory Coast, meanwhile, prize the strong, youthful figures of girls before motherhood, with proud, pointed breasts and slender, arching waist.

But if there is one image above all that is dear to African sculptors, it is that of the mother and child, a sacred theme that recurs in different forms and in almost obsessive fashion. Carved in stone, ivory or wood, naturalistic, stylized or even Expressionistic in style, and ranging in form from figurines a few inches high to posts several feet tall, these mothers proudly holding their infants display a surprising degree of inventiveness. Austere and hieratic as Romanesque Virgins; tender and profound in their humanity, like Bellini Madonnas; nursing one child or even two; carrying their child on their back or, more rarely, holding a child on their lap. But who are they, these nameless mothers elevated by the sculptor's art to the ranks of sublime goddesses?

Are they symbols of fertility and prosperity? Are they "spirit brides" whom an earthly husband might ask to grant a child to his sterile wife? Are they idealized portraits of female ancestors? Are they figures for use in rites of initiation, or are they part of the soothsaying equipment used by old women to consult the spirits of the bush? Each of these lovingly carved figures seems to be imbued with its own symbolic power. Giving birth, suckling their babies, seated or standing, these fascinating "idols" are to be found everywhere, from pipe bowls to toilet articles and jewelry, from mirrors to fly whisks and from royal scepters to stools. Feared and respected, are African women not also the humble repository of the secret of the gods?

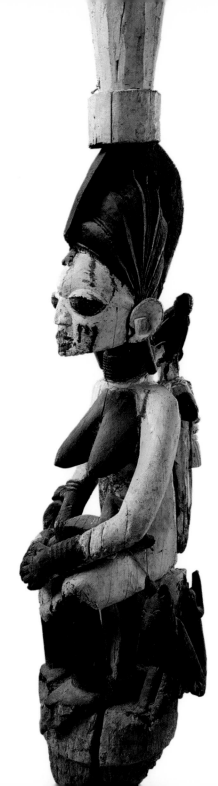

Veranda post
From the palace of a
Yoruba king. Nigeria,
southwestern region.
Wood,
frequently repainted;
148 x 28 x 28 cm.
Formerly Barbier-
Mueller collection.
Musée des Arts
d'Afrique et d'Océanie,
Paris.

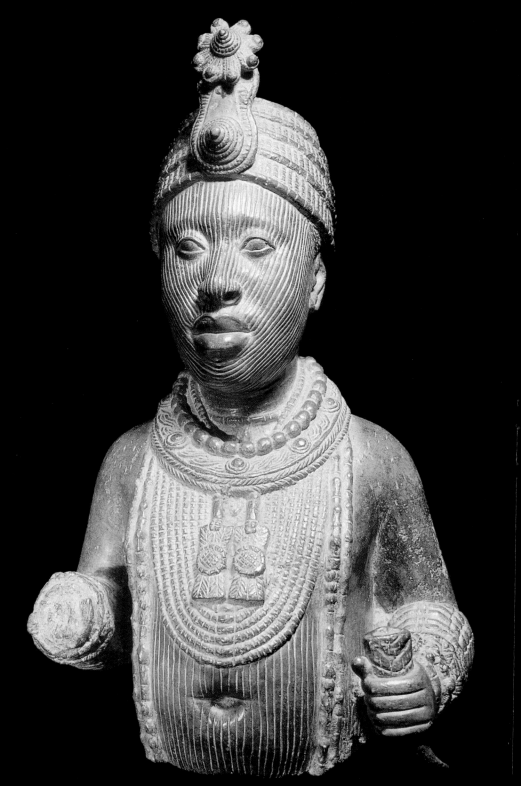

A Courtly Art

With their lurid mixture of fascination, fear and dread, the tales brought back from Africa by Arabic and European travelers have created an enduring image of the splendor of its kingdoms. Yet no traces of palaces, castles or impregnable fortresses like those in Europe exist to fire our imaginations. Were African kings less ostentatious than their European counterparts, so smitten with show and etiquette? Frequently of divine origin, these sovereigns were sacred figures who ensured the well being of the kingdom and the stability of the world as a whole. Healers, sorcerers, miracle workers, father figures, omniscient and occasionally mad, or sometimes even sculptors, these were outstanding figures, dedicated in every way—including their physical appearance—to an exceptional destiny.

Opposite: **Figure of an** *oni.* Nigeria, Ife. Copper, zinc; h. 37 cm.
Late 15th- early 16th century. National Museum of Lagos.
Following pages:
Commemorative head. Nigeria, Ife. Bronze, Photograph by Eliot Elisofon.
Wearing a beaded crown and weighed down with a multitude of necklaces, this imposing royal figure bears on his face and body the parallel striations that recall the custom of scarification, still practiced by some African peoples today.
Commemorative head. Nigeria, Ife. Bronze, h. 14cm, British Museum, London.

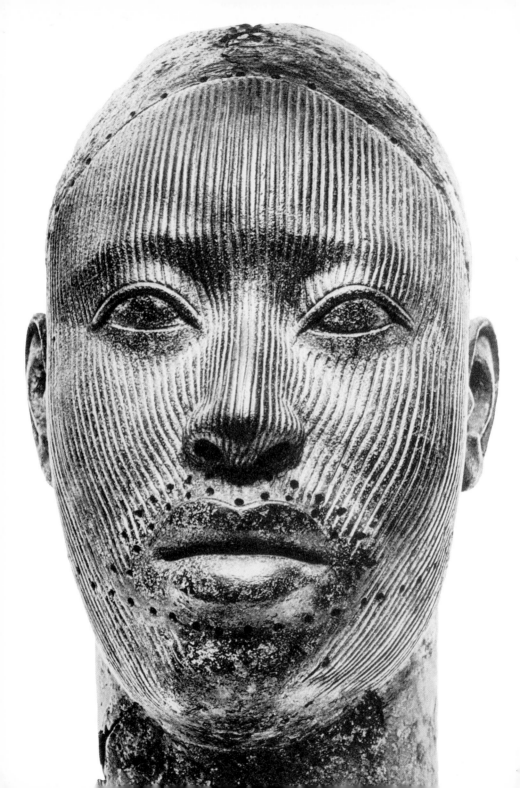

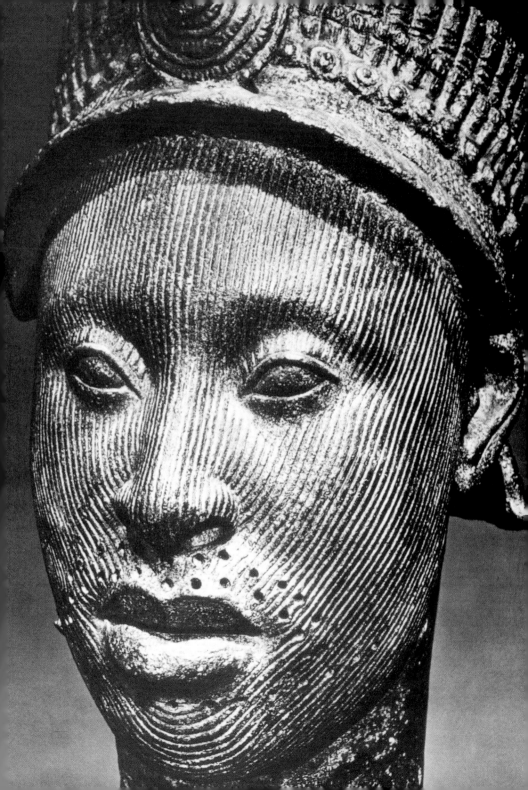

Royalty and its many functions have generated specific art forms in Africa. Thus, though little inclined as a general rule toward realism and the illusory pursuit of capturing likenesses, African sculpture has nevertheless produced a highly attractive art of official portraiture. The numerous effigies of kings and queens that have come down to us, in terracotta, metal, stone or wood, now stand as dazzling reflections of the magnificence of kingdoms such as Ife and Edo.

Divorcing itself from the consciously symbolic and timeless character of much other African art, courtly art successfully explored a vigorously narrative approach, as may be seen in the astonishing brass plaques produced in the kingdom of Benin (present-day Nigeria) and the bas-reliefs and hangings in the palace of ancient Dahomey (present-day Benin).

But if there is one domain in which the royal person itself was exalted above all, it was clearly in the insignia, or regalia, of power. Crowns, headdresses, staffs, seats, ceremonial weapons, dishes, drinking horns, finery and jewels were all so many trappings in a royal panoply of staggering luxury, which reveals among other things the fascination for gold of certain African sovereigns, then as now.

FROM IFE TO BENIN: BIRTH OF THE PORTRAIT

As Michèle Coquet points out in her masterly study of African royalty (*Arts de cour en Afrique noire*), until the recent appearance of photography, portraiture was a privilege enjoyed exclusively by royal figures and their close entourage. Far from reproducing in faithful detail the features of their august models, however, royal effigies set out instead to offer an idealized, symbolic vision. Neither too old nor too young, nor too fat nor too thin, the king who was thus immortalized embodied—in the eyes of his subjects—the serene, soothing image of a monarch who would not falter under the weight of his task, a superhuman being endowed with virtually unassailable health and beauty.

It is against the background of this codified approach to representation that we should consider the superb effigies in "bronze" (actually copper and brass alloys) and terracotta created in the ancestral kingdom of Ile-Ife, in present-day Nigeria. Heads of kings with cheeks almost imperceptibly inflated, quivering nostrils and sensual, well-defined lips, held slightly apart as though in a shy smile; effigies of queens who, with their proud bearing and sophisticated hairstyles, could rival the

most exquisite of the wives of the Egyptian pharaohs; faces of nobles of the clan, imbued with grave dignity: so remarkable was the skill of the sculptors who carved these faces that their features seem to return to life before our eyes. Certain details—the shape of an ear, the suggestion of shadows under the eyes, the positioning of the eyes within their sockets—are rendered with impressive accuracy, suggesting that the artists of this little kingdom must have observed their subjects with minute care before setting to work to reproduce their vision (however lacking in objectivity) of reality. A few fragile remains of polychromy have survived to indicate, moreover, that colored highlights must have been used to create even more striking effects. The parallel striations that serve to emphasize and articulate the gentle proportions of these faces are inspired, meanwhile, by numerous ritual practices, including scarification and face painting, still in use in Africa today.

But once again we should be wary of jumping to conclusions. Seduced by the subtlety with which some of them seem to portray a range of feelings (the full lips on one face seem to be puckered into a scornful pout, for instance, while another mouth by contrast curves in a smile), we are quick to describe these effigies as "portraits." Yet closer observation reveals that they conform to a rigidly conventional code. All invariably look young, their oval-shaped faces firm but well-fleshed, their eyelids lowered slightly in an expression of serenity and contemplation, and with folds of flesh plumping out their necks in an indication of vigor and prosperity. No detail appears to have been left to chance. Admittedly, a few rare examples seem to have escaped this rigorous conformism, such as a small head with heavy jowls and rings under the eyes verging on caricature, or another wearing a gag, the mark of prisoners condemned as sacrificial victims. As a general rule, however, the art of the kingdom of Ife, a city state ruled from the 11th to 14th century by a king, or oba, was carried out conventionally; this was a courtly art, intended to glorify the person of the king. Individualism was avoided and realism eschewed in these effigies that have so misleadingly been compared with portraits of the Roman emper-

Following pages:
Young boy. His cheek striated with deep scarifications, the boy shows markings similar to those worn by the ancient kings of Ife. Photograph.
Archives Barbier-Mueller, Geneva.
Head of a figurine. Nigeria. Ife. Terracotta; 15.5 x 11.5 x 2.3 cm. 12th-14th century. Formerly Barbier-Mueller collection. Musée des Arts d'Afrique et d'Océanie, Paris.

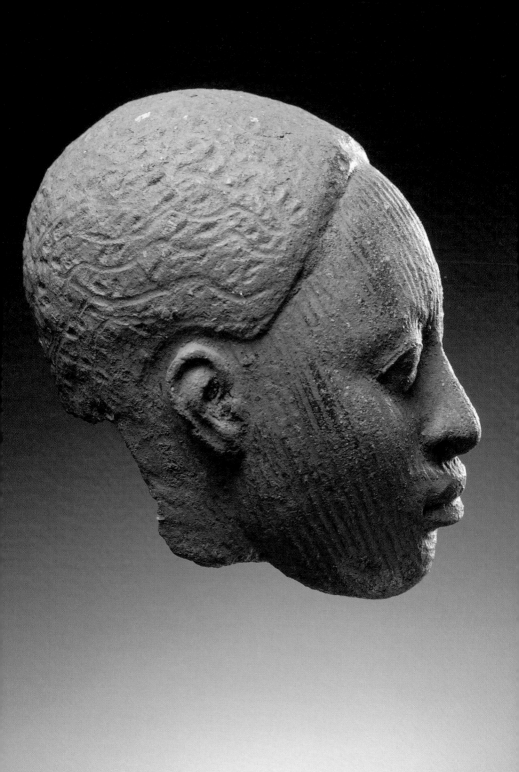

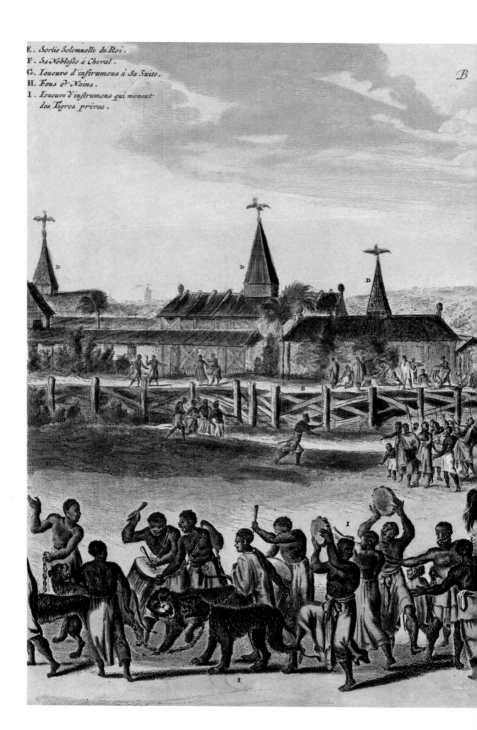

E. _Sortie Solemnelle du Roi._
F. _Sa Noblesse à Cheval._
G. _Ioueurs d'instrumens à Sa Suite._
H. _Fous & Nains._
I. _Ioueurs d'instrumens qui menent_
 des Tigres privés.

B

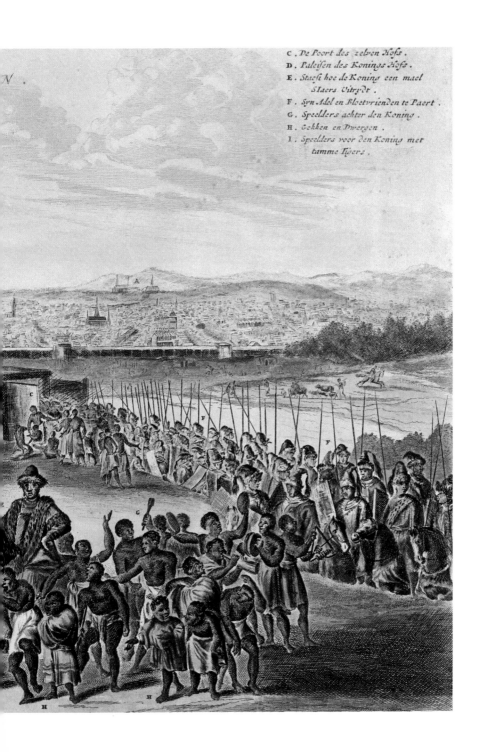

C . De Poort des zelven Hofs .
D . Paleisen des Konings Hofs .
E . Staet hoe de Koning een mael
 S'Iaers Uitrydt .
F . Syn Adel en Bloetvrienden te Paert
G . Speelders achter den Koning .
H . Gekken en Dwergen .
I . Speelders voor den Koning met
 tamme Tijgers .

ors. The overruling concern was rather to conform to the canons of royal perfection, as embodied in the virtues of serenity, imperturbability, vigor, youth, portliness and dignity. For as Michèle Coquet reminds us: "Imperfection and physical decline were forbidden to these African kings; as the metonym of the kingdom, the body of the king should not be subject to the constraints imposed by his human nature, such as the necessity to eat, drink, suffer injury, grow old and die. ... The body and face of the king, and by logical implication their images, seem consequently to be required to exalt an idealized vision of man, adult and at the height of his physical and spiritual powers."

This is undoubtedly the reason why, to Western sensibilities weaned on the concept of uniqueness, these formulaic faces appear at once so different and so strangely similar, like subtle variations on a musical theme. Though wild hypotheses regarding their original purpose have proliferated (the German ethnologist Leo Frobenius, who explored the region from 1910, claimed to recognize in them a foreign artistic tradition brought by the Greeks, or even by the inhabitants of the mythical continent of Atlantis). Frank Willett, more seriously, has postulated that they functioned as "doubles" of the royal person. The presence of holes at the top of the forehead and around the mouth and neck suggests, indeed, that false hair and mustaches might originally have been added, or even royal regalia such as the crown with beaded fringes that was believed to conceal the king from the eyes of his subjects. Attached to the body of a mannequin, these magnificent terracotta or metal effigies would thus have been displayed at the funerals of kings, thus symbolizing the continuity of the royal line during the coming interregnum: in other words, "The king is dead. Long live the king!"

But if there was one kingdom more than any other that fired European imaginations with its magnificence and cruelty, it was ancient Benin. Fear and fascination thus mingle in equal measure in *Description of Africa*, a book based on foreign eyewitness accounts and published in 1688 by the Dutchman Olfert Dapper. Though he had never actually been to Benin, Dapper was able to furnish the following

Opposite: **Pendant mask.** Nigeria, kingdom of Benin. Ivory; h. 25 cm, c.1520.
British Museum, London.
Previous pages: **The city of Benin.** Engraving from Olfert Dapper, *Description of Africa* (1688),
Musée des Arts d'Afrique et d'Océanie, Paris.

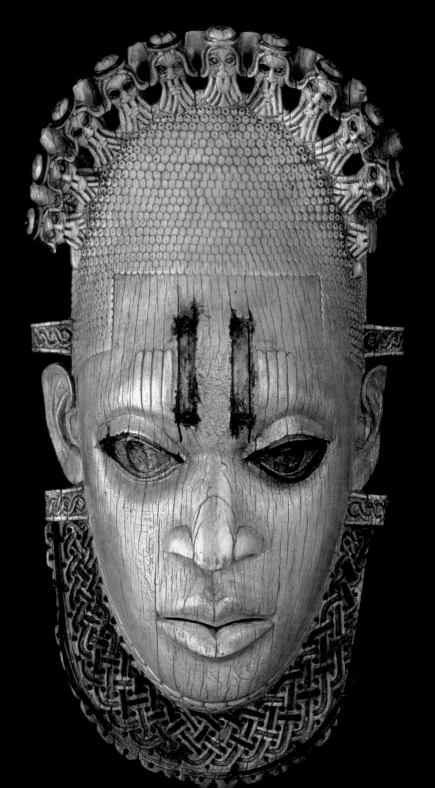

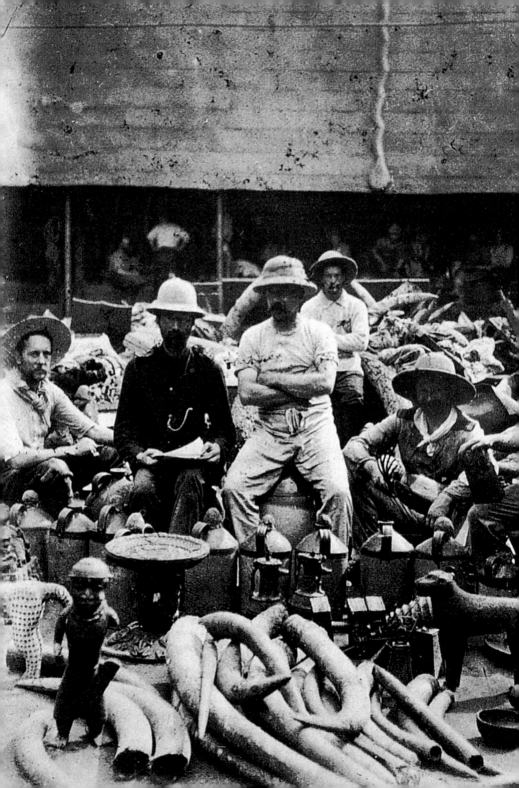

description of life in the royal palace: "This prince appeared in public every year, on horseback, decked out in his royal finery, with an entourage of 300 or 400 gentlemen made up of infantry and cavalry and a troupe of musicians before and after. The cavalcade rode around the palace without moving far away. Led on chains were some tame leopards and a good number of dwarfs and deaf people to provide entertainment for the king. To ensure solemnity, 10, 12, then 15 slaves were strangled and had their heads cut off in the belief that these unfortunate victims would depart for another world where they would live again in greater happiness, and that when the king arrived, he would find his slaves again. There is another day on which all visitors are shown the royal treasures, which consist of jaspers, coral and other rarities." In the face of such marvels, objectivity was the first casualty, as may be seen from the slightly earlier account penned in about 1600 by another Dutchman, Peter de Marees. He was particularly struck by the royal palace, a veritable "exotic Versailles": "The king's palace is square in plan. ... It is truly as large as the town of Haarlem, and completely surrounded by a special wall. It is divided into numerous magnificent apartments, with vast and beautiful galleries, about as broad as the Amsterdam Stock Exchange. ... Most of these royal apartments are roofed with palm leaves ... and each turret is adorned with a pinnacle rising to a point. On each of these perches a bird, cast in copper, its wings spread, artistically modeled from nature." We could hardly be further from the cliche of bare, unfurnished interiors that we habitually associate with the African world!

But it was in 1897, in the aftermath of a bloodthirsty and unfortunate punitive expedition led by the British, that the West would really discover and be dazzled by the precious and sophisticated courtly art of this distant kingdom. Powerful bronze heads encased in massive necklaces, magnificently worked elephant tusks, swords with pierced blades, bells belonging to dignitaries, plaques carved with narrative scenes, *aquamaniles* in the form of leopards, jewelry and headdresses made of coral beads, pendant masks in ivory and metal: nearly 3000 objects such as these were to find their way to Europe, where they were sold at auction to the great museums. France was not to discover this remarkable art until 1932, however, when the deal-

Members of the British punitive expedition of 1897,
Photograph taken in the palace of Benin (Nigeria).

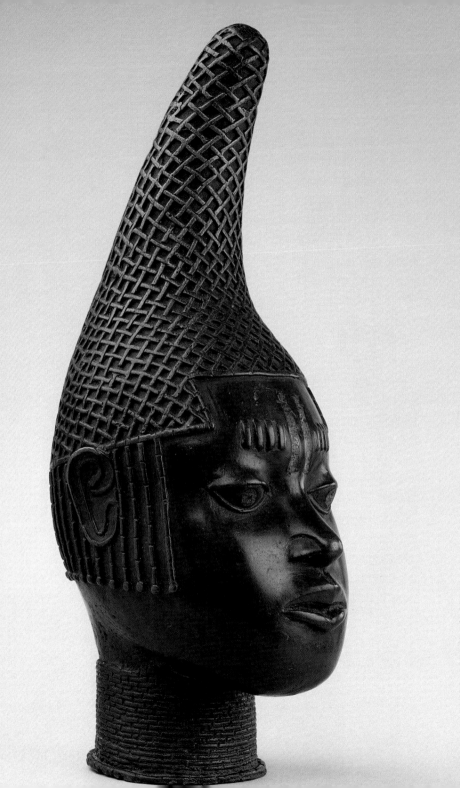

Queen Nenzima. Mangbetu, Democratic Republic of the Congo.
Wearing the fingernails long indicates high rank.

er Charles Ratton organized a memorable exhibition at the Musée d'Ethnographie. Collectors were immediately struck by these pieces, made from precious materials and reassuringly naturalistic in style.

Yet nothing could have been less bland or facile than these chilly effigies whose smooth appearance and repetitive character were dictated, once again, by a highly elaborate symbolism of power and the royal person. If, as some scholars suggest, the art of Benin is in direct line of descent from that of the town of Ife (and whatever the foundation of their myths and traditions, the two kingdoms certainly formed part of the same spiritual world, that of the Yoruba), there can nevertheless be no denying the great gulf that separates these two artistic languages from each

Head of a queen mother. Nigeria, kingdom of Benin. Brass; h. 39 cm, c.1500-50.
British Museum, London.

163

other. Gone are the serene features inspired with life, the imperturbable faces with their generous proportions and subtle contours. Instead we are in the realm of state-controlled art, impersonal and mechanical, where the individual, up to and including the king, vanishes behind his function. There is no room here for flourishes, nor for any indulgence or frivolous touches by the artist – all are banished. For the purpose of this art is not to seduce or flatter, but rather to conquer and mesmerize. Is not this the significance of these flashing metal eyes, of undeniable hypnotic power? The same oval faces, the same architectural noses with dilated nostrils, the same lip profile, the same slightly bulging eyes with disproportionately large almond-shaped pupils: in ancient Benin, all faces seem to be in the same mold, reproducing in identical fashion the features of the *oba*, or king. Only his panoply of attributes (including beaded hairstyles, hairnets, necklaces and scarification) tend to distinguish the royal person from mere dignitaries, slaves or even foreigners. Commissioned, conventional, academic and totalitarian, this was also mass-produced art, even if there was the occasional lively exception to the unbending rule—as for instance some admirable figures of clowns and dwarfs, whose function as entertainers was described so precisely by Dapper. Was it also official art? Clearly, although some portraits attained tremendous artistic heights and were staggering in their virtuosity. A case in point is a group of "queen mothers" wearing coral and beaded net headdresses that curve upward to a graceful point (inelegantly dubbed "chickens' beaks" by art historians). With their unalloyed purity and elegance, these delicate and sensual effigies possess all the dignity of a Khmer goddess, allied with the grandeur and nobility of an Egyptian queen.

What was the purpose, meanwhile, of these rows of faces which at first glance seem so inexpressive and vaguely disconcerting? According to the many theories on the subject, they are commemorative portraits; votive heads to be placed on the

Opposite: **Head of a dead or vanquished king.** Nigeria, kingdom of Benin.
Bronze; h. 21 cm. Before 1550. On loan from Musée Barbier-Mueller,
in course of acquisition by the French state.
Following pages:
Head of an *oba*. Nigeria, kingdom of Benin. 18th century. Bronze. Musée des Arts d'Afrique et
d'Océanie, Paris.
Plaque. Nigeria, kingdom of Benin. 6th-7th century. Bronze; h. 40 cm.
Musée Barbier-Mueller, Geneva.

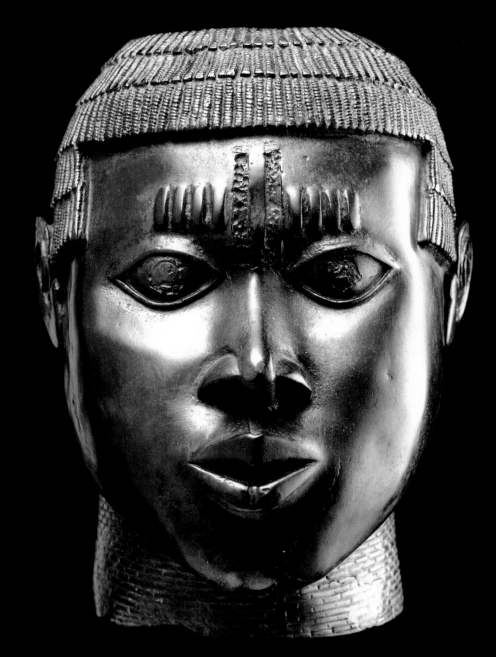

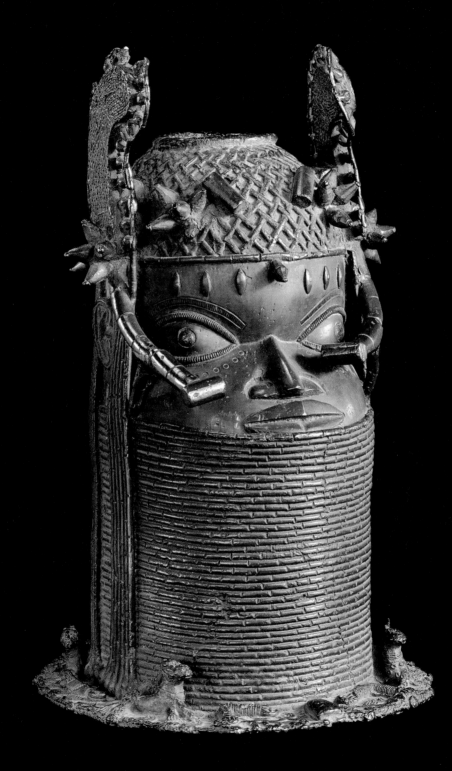

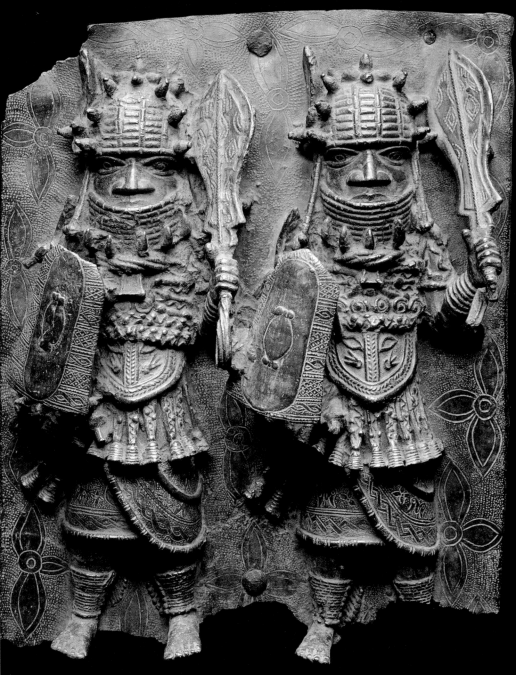

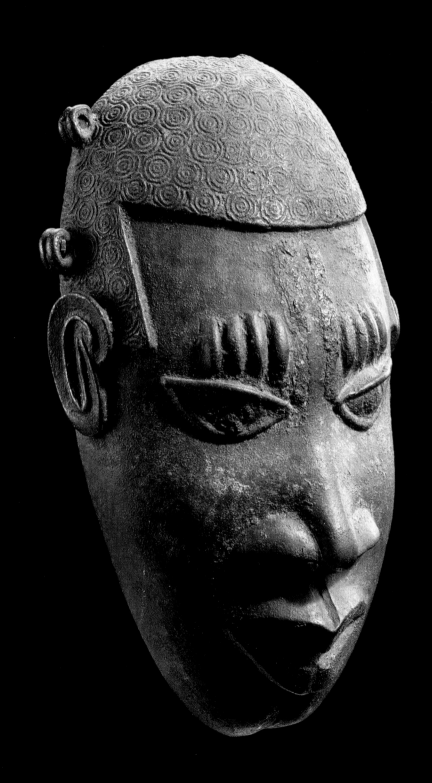

altar dedicated to ancestor worship; royal effigies embodying the permanence and continuity of the monarchy; or "trophy heads" immortalizing the features of chiefs or vanquished enemies. For one thing we do know: here again there can be no recourse to the notion of "art for art's sake" to explain these powerful effigies, originally extended by a long and painstakingly engraved elephant's tusk.

Nor is there any superfluous element in the execution of the plaques bearing narrative panels relating the history of the ancient kingdom of Benin. Does this rare incursion of African art into the narrative domain indicate some kind of external influence? Some scholars suggest the influence of European books with their illustrations, and it is certainly true that this work is diametrically opposed to the timeless, symbolic approach so characteristic of African art. Originally intended to decorate the palace walls, these panels cast in a metal that is itself of European origin depict in intriguing detail the colorful variety of life in the kingdom of Benin. No one is excluded from this snapshot of a day at court, from the king shown at the head of his army to soldiers, dignitaries, musicians, dwarfs, clowns, servants, animals (wild beasts, fish and birds) and even foreigners, such as the Portuguese soldiers recognizable by their helmets, long hair and flowing beards. Here a group of merchants prepares to exchange merchandise with some Europeans; there acrobatic dancers perform on ropes tied to the branches of trees. Another panel shows members of the leopard hunt, their arms laden with arrows, and another appears to represent the sacrifice of a cow. All the characters in these strange little dramas look us straight in the eye, hieratic, imperturbable and slightly stiff in their costumes, as though slipped in front of a screen or stage curtain. Frozen for eternity, they stand now as the unwitting chroniclers of a world destined to disappear.

Another warlike monarchy would also record its exploits for posterity: the court of the Fon kings of ancient Dahomey, in present-day Benin. But bronze, though solid and enduring, was not the medium chosen by these kings for the presentation of their heroic deeds. The official art of the court developed in two separate forms: a series of bas-reliefs modeled in the round in unbaked clay; and "patchworks" cut out from and applied to large pieces of cloth to create colorful and flamboyant nar-

Pectoral mask. Nigeria, kingdom of Benin. Bronze; h. 17.9 cm.
Formerly Comte Baudouin de Grunne collection. Musée Barbier-Mueller, Geneva.

ratives. In this way, animals, flowers, domestic utensils, royal objects, together with an assortment of items of foreign origin (including wheels, rifles, cannon, sedan chairs and boats), invaded not only the walls of the palace but also hangings, banners, cushions, hammocks, parasols and the cloth coverings of tents exhibited for special occasions. Puzzles and pictograms combined, these "Bayeux tapestries of the African world" thus plunge us into a delightful poetic universe filled with metaphors that are fascinating to unravel. In a term coined by Paul Mercier, they are "royal chronicles": shimmering, dreamlike epics of a world without writing.

THE HUNTER KINGS

Among the Chokwe of the Democratic Republic of the Congo, or DRC, (formerly Zaire), the figure of the king, founder of the dynasty, is confused with that of the hero Chibinda Ilunga, who is supposed to have introduced hunting and invented magic charms. The latter is easily distinguished by his numerous attributes, including a headdress with two lateral wings curving to the back, in the right hand a staff from which hang magic charms, and in the left hand an animal horn containing magic powders, or more rarely a gun. By virtue of the subtle ploy of appropriating another figure's iconic trappings, we find the same symbols of power in the numerous representations of the Chokwe chiefs that adorn fly whisks, scepters and other staffs. Standing upright or seated on a traditional throne, or even a folding chair inspired by Western models, the chiefs benefit from an artistic treatment intended to convey their exceptional vigor and physical strength. With oversized hands and feet, an exaggerated musculature and a beard made from human hair, they are the tangible incarnation of the solidity and stability of the kingdom. Their artfully codified poses, meanwhile, have led Michèle Coquet to describe them as "gesture portraits."

Figure of Chibunda Ilunga. Mozambique, Maxixa region. Wood, hair; h. 40 cm.
Museu de historia natural da faculdade de ciências da universade do Porto.

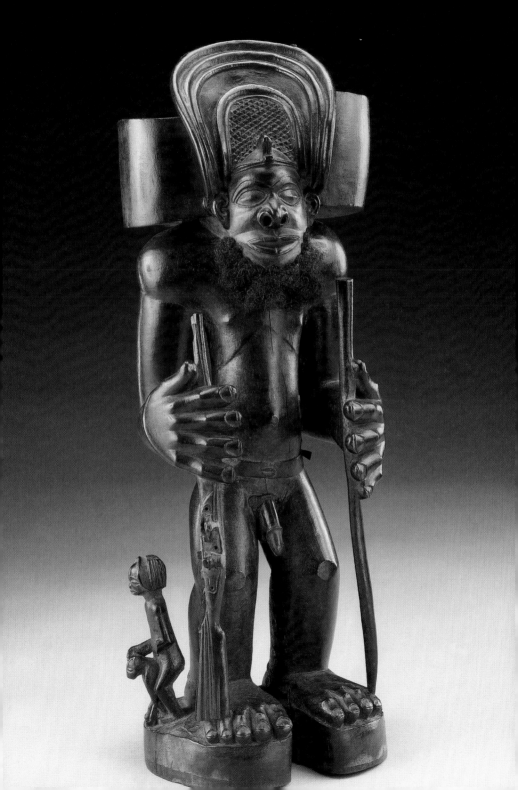

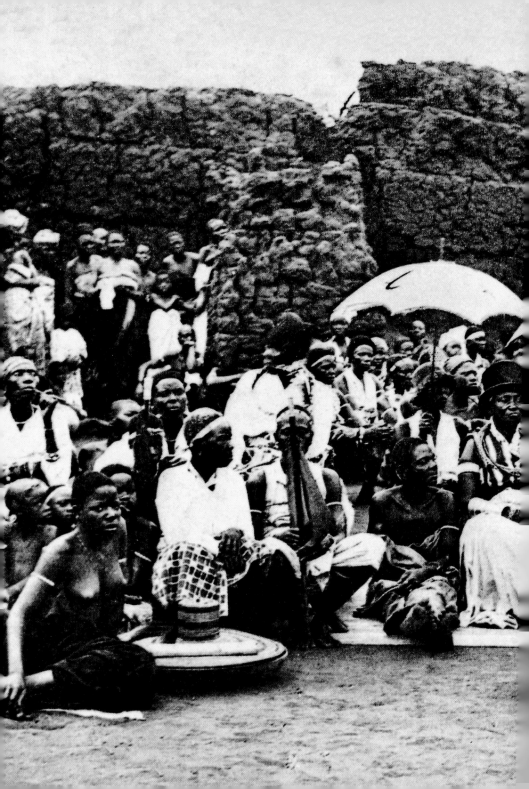

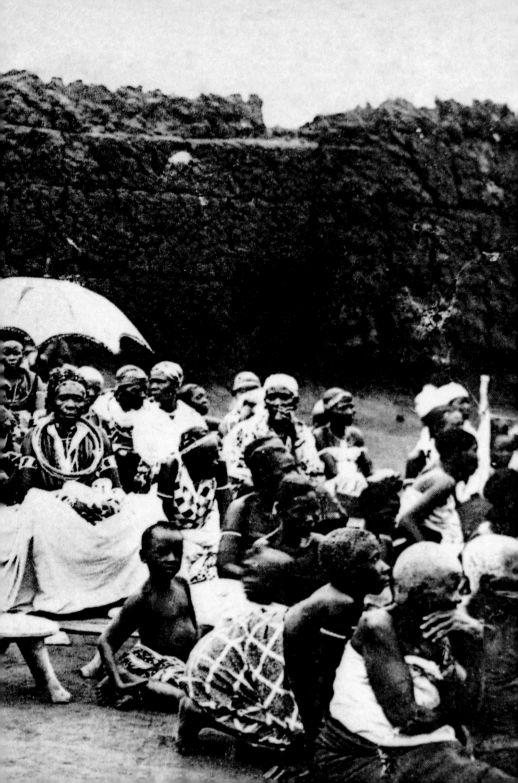

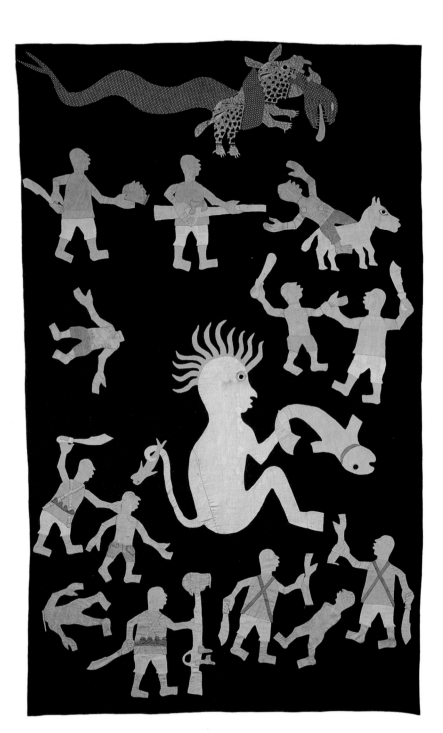

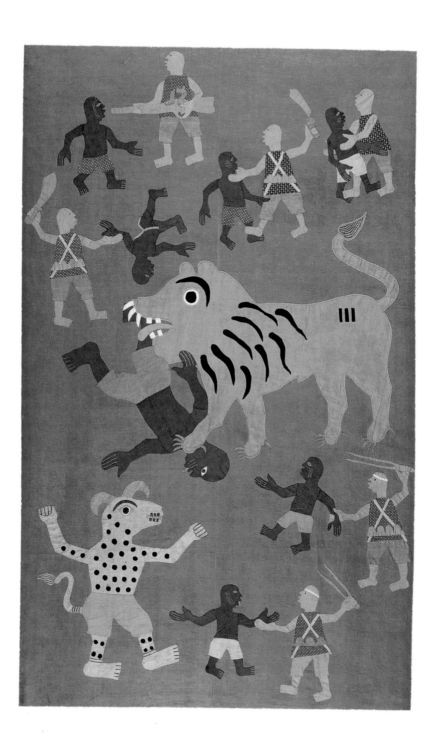

AT THE COURT OF THE MFON NJOYA IN CAMEROON

Only a few decades ago, the once-forested high volcanic plateaus of the Cameroon Highlands were still divided into numerous kingdoms, chiefdoms and independent villages. In the 1950s more than 100 were identified, ranging in size from 500 to 50,000 inhabitants. This fragmented and profoundly hierarchical social structure was reflected particularly clearly in the architecture of the region, which was studded with bamboo huts roofed with elegant conical thatched roofs, and above all in its courtly art, among the most original and sophisticated in the whole of Africa.

"To be able to approach the chief and speak to him is both a piece of good fortune and an honor. The procedure is as follows: you clap your hands and bow to attract his attention, all the while addressing him respectfully with the ritual greeting *"O zie mu"* ("You know, you who are great"), before presenting him with your grievances or desires," explains B. Maillard in *Pouvoir et religion, les structures socioreligieuses de la chefferie de Bandjoun*. The artistic output of the peoples of Cameroon, and in particular that of the Bamileke, was devoted entirely to the glorification of the exceptional and divine being of the *fo*. As the living representative of ancestral chiefs, this figure possessed immense powers, both on the economic plane and on the spiritual. According to popular belief, he was able to change himself at will into a panther, a boa constrictor, an elephant or a buffalo, before turning back into human form in an instant. This is precisely the highly symbolic bestiary to be found in the decorations of palaces and ordinary dwellings, as well as in the insignia of power belonging to the *fo*. Lord of the land, war chief and religious leader rolled into one, this sovereign waited on by a phalanx of servants was also the possessor of an immense treasure, the infallible guarantee of both his prestige and his authority. Commemorative figures, beaded thrones, carved pillars and door frames, monumental pipes, highly worked calabashes, drums decorated with caryatids: here once again, nothing appears to have been left to chance. Like veritable ideograms of royal status, through their magnificence and the virtuosity of their craftsmanship, all these objects express the greatness of the sovereign and the

Pages 172-3: **The Court of Dahomey.** A scene of royal fetishism.
Photograph, Archives Barbier-Mueller, Geneva.
Previous pages:
Historiated hangings. From the palace of Abomey, Dahomey, Benin, Fon kingdom.
Musée des Arts d'Afrique et d'Océanie, Paris.

power of the chiefs. The same is true of the strikingly expressive masks known as *batcham*, featuring giant faces with swollen cheeks of monstrous creatures, half-human half-animal, which were brought out only on very rare occasions such as the funeral or enthronement of a *fo*.

Far from being neglected in Bamileke art, the theme of the female figure, symbol of fertility, recurs frequently, in a style that is sometimes reminiscent of Cubism and sometimes of the Baroque. Notable examples are their magnificent figures of queens holding dishes, hieratic "idols" represented standing or kneeling, and on occasion transformed by a "sheath" of blood-red beads into strange and somewhat terrifying creatures. Displayed at ritual ceremonies such as the investiture or funeral of a king, they would be placed beside a portrait-throne of the king, where they would receive the same attention as members of the royal family. Supernatural powers or legendary exploits were even attributed to these singular figures, which were brought out of their hiding place by the keepers of the royal treasure only after a long and complicated protocol had been satisfied.

But if there is one person to have left his mark on the history of Cameroon above all others, it is King, or Mfon, Njoya, who reigned over the Bamum people from 1870 to 1933. The appearance of this enlightened monarch, who came to power while still an adolescent, is captured in a photograph taken in 1912: seated on a throne, he is shown granting an audience in front of the renovated facade of the palace built by his father Nsa'ngu. Sporting a splendid turban, leather shoes and robes inspired by the Hausa-Fulbe chiefs to the north, Njoya displays the dignity characteristic of an African king. His barefoot subjects bow low in his presence, putting their hands together in front of their mouths in order to protect him from impure breath or saliva. Njoya nevertheless revealed himself to be extremely modern in his approach. Having converted to Islam while still maintaining close links with Christian missionaries from Europe, he finally created his own religion, a curious amalgam of foreign rituals and traditions. He even went so far as to invent a new type of writing, using a combination of Arabic and Western alphabets,

Following pages:
Mask. Cameroon, Grassland. Wood; h. 26 cm. Reitberg Museum, Zurich.
Royal mask of the *Kah* society. Cameroon, western province, Bamileke, Bamendu.
Wood; h. 86 cm. Musée des Arts d'Afrique et d'Océanie, Paris

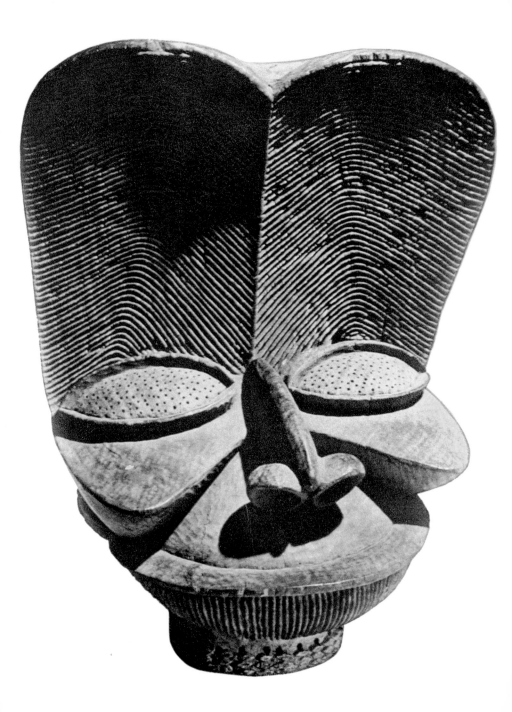

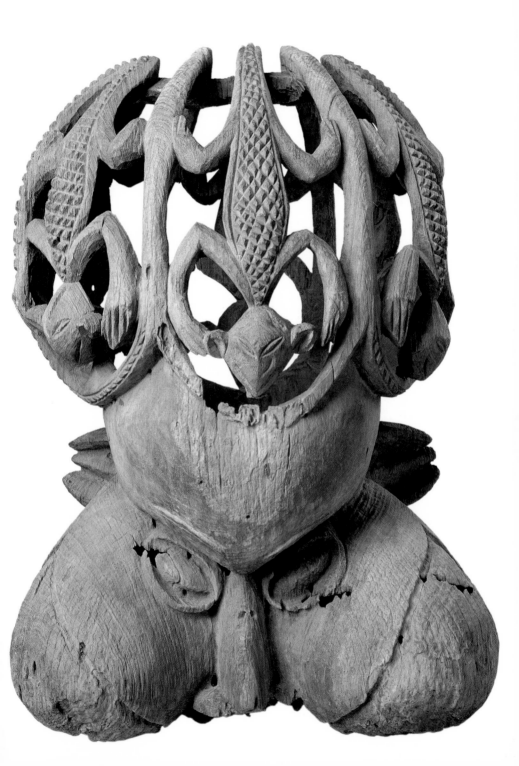

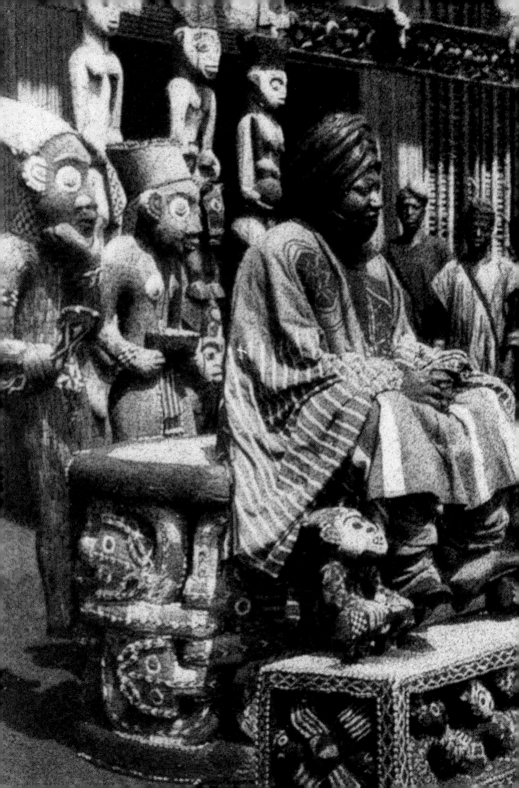

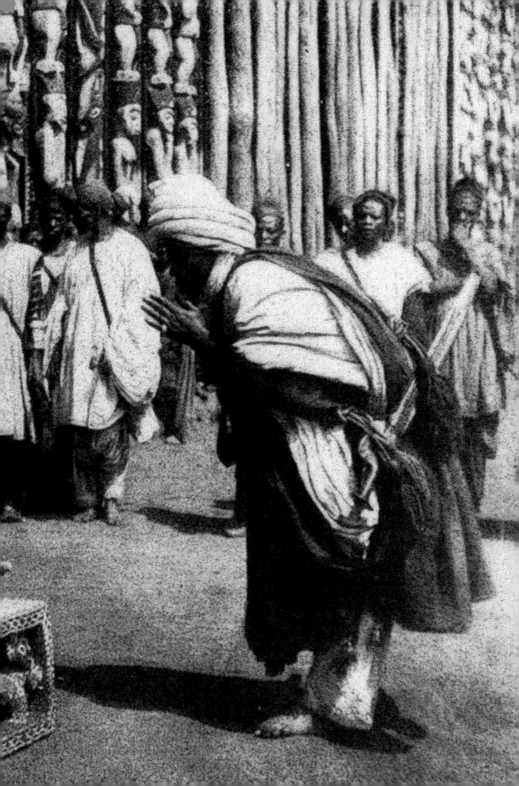

Royal pipe. Cameroon, Bamum. Terracotta bowl, bronze figures; l. 170 cm.
Gift from the Mfon Njoya to the German Captain Glauning, c.1905.
Musée Barbier-Mueller, Geneva.

setting up schools to ensure its spread throughout the kingdom. He was no less ambitious, moreover, in the field of the arts. Besides experimenting with new techniques in metallurgy and weaving (he designed a new court dress, taking his inspiration from foreign models), he also built a series of magnificent palaces, evidence of his policy of patronage, as fertile as it was enlightened. A veritable labyrinth boasting a maze of verandas, bedchambers, pavilions and courtyards, the royal residence thus became home to the king's 1200 wives and 350 children, not forgetting an army of some 2000 servants. But Njoya was to come to a tragic end when, in 1931, the French authorities exiled him to the colonial capital of Yaunde, where he died only two years later.

Opposite: **Royal seat.** Cameroon, Bamum group, Foumban. Wood covered with
cowrie shells and beads with a frieze of figures viewed in profile, hands and faces
sheathed in copper; h. 57 cm. Gift from the Mfon Njoya to the German Captain Glauning,
c.1905. Formerly Speyer and Ch. Ratton collection. Musée Barbier-Mueller, Geneva.
Previous pages:
The Mfon Njoya. Seated on his throne he is granting an audience in front of the palace
built by his father. Photograph. 1912. Cameroon, Bamum.

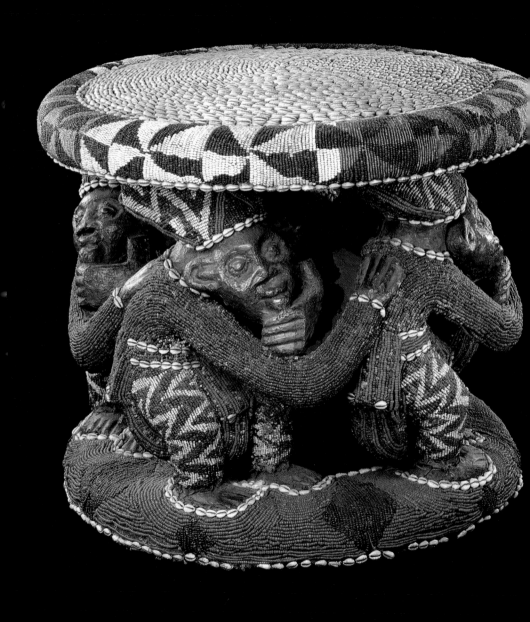

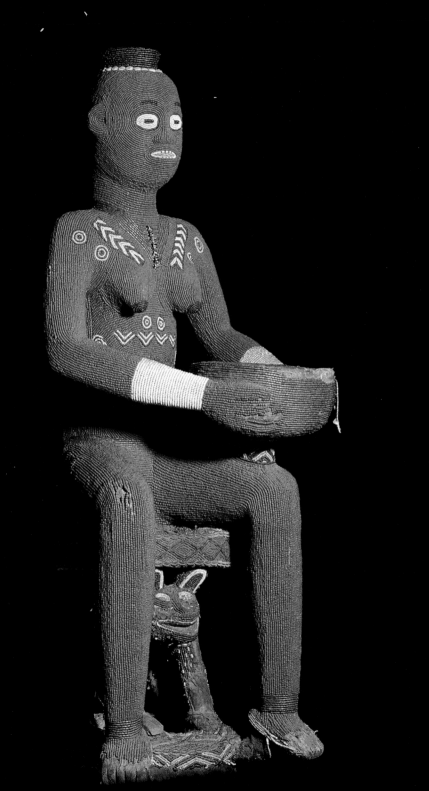

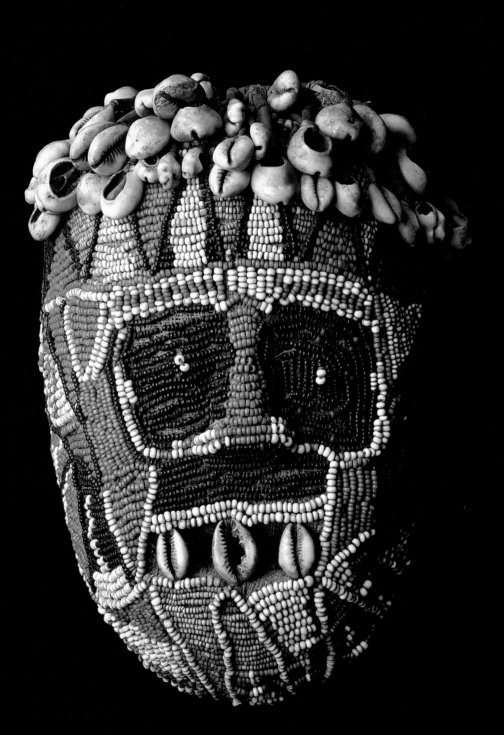

BEADED SPLENDORS

Hood masks, belts, thrones and figures of queens were only some of the objects whose prestige was heightened by a precious and glittering outer covering of beads. Whether the beads were long or cylindrical, imported from abroad (Venice or Bohemia) or of local manufacture (from recycled ground glass), their symbolism was always the same: an expression of the prosperity that the ruler was required to bestow on his people as a whole. There was nothing gratuitous about this type of decoration, as beading was a right reserved exclusively for the king and his close circle. This sophisticated technique nevertheless gave rise to an unusually expressive art form, introducing a note of shimmering color to African statuary. But here once again, the demands of symbolism took precedence over aesthetic considerations. Black, the color of night, was thus used to evoke links between the worlds of the living and the dead; white, the color of bones, indicated the world of the ancestors. Red, meanwhile, was associated with blood and symbolized life, women and royalty in general, as demonstrated by a magnificent figure of a queen holding a dish, now in the Musée National des Arts d'Afrique et d'Océanie in Paris.

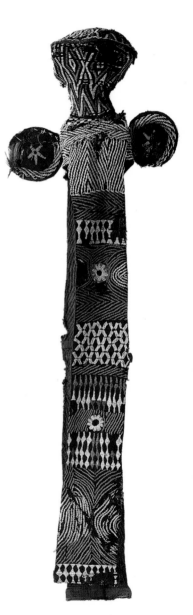

Opposite: Atwonzen representation of a human skull. Cameroon, western province, Bamileke, ex-Fonchatula. Wood, glass beads, cowrie beads; h. 24 cm.
Musée des Arts d'Afrique et d'Océanie, Paris.
Right: Hood mask. Cameroon, Bamileke. Cloth, beads.
Musée des Arts d'Afrique et d'Océanie, Paris.
Previous pages: Left and (detail) right:
Commemorative statue of a queen, Seated figure holding a dish. Cameroon, western province, Bamileke, Bansoa. Wood, multicolored granular beads; h. 111.5 cm. 19th century.
Musée des Arts d'Afrique et d'Océanie, Paris.

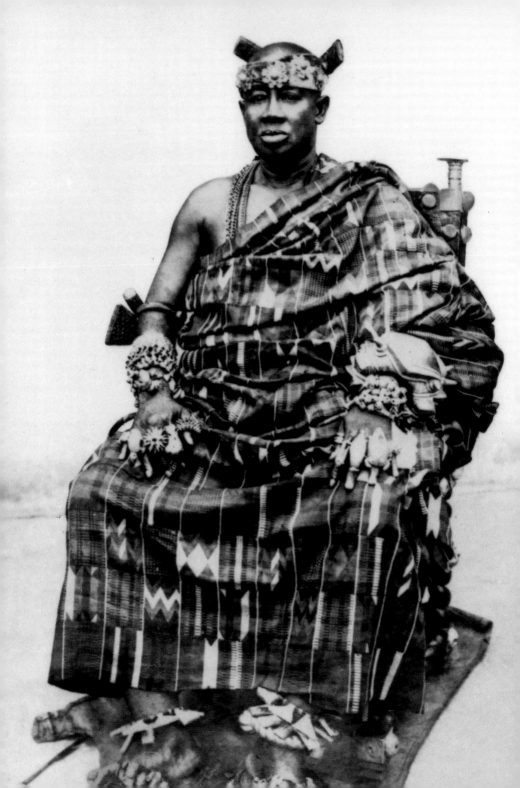

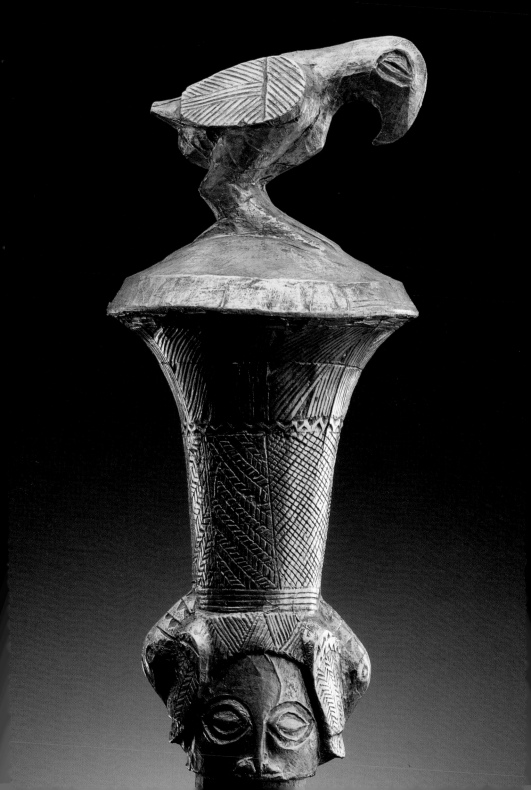

JEWELRY AND REGALIA: THE PASSION FOR GOLD

The outside world was not slow to discover the gold jewelry and ornaments of the African continent. In the Middle Ages, Arabic geographers and travelers told tales of the sumptuous riches of ancient Ghana and Mali; and in the 15th century, Dutch and Portuguese merchants marveled at the jewelry worn in such abundance by some members of coastal tribes. Yet in the distant past, most of the peoples of Africa stood in terror of this precious metal, avoiding it with a mixture of dread and superstition. Endowed with a life of its own, and capable of killing, injuring or even driving to madness anyone who discovered it, gold was believed to grow like a plant, spreading in the ground and even moving from place to place. It was undoubtedly due to this curse that so many years passed before gold was exploited.

Far from sharing the terror felt by their neighbors, the inhabitants of the countries of North Africa believed on the contrary that jewelry in gold or any other shiny metal would ward off the "evil eye." Accordingly, the women decked themselves out in innumerable jewels which, with the development of communications across the Sahara, soon became the height of fashion. It was only with the emergence of this highly lucrative trade that the peoples of West Africa learned to overcome their superstitious fears in order to prospect for gold in rivers as well as mines. While the gold fields of Bambuk in Senegal and Bure in Guinea were certainly exploited as early as the 4th century (supplying most of the gold exported to North Africa), the mines belonging to the Akan in Ghana remained unknown to the outside world until the fourteenth century. Soon caravans started to pour in from all directions, and the first trading posts, such as Begho, began to specialize in this profitable commodity. Yet every aspect of the process of gold extraction was still viewed as being of religious significance. The opening of a mine required the prayers of a Muslim scholar and the offices of a priest-cum-fetish maker. Only the sacrifice of a cow, meanwhile, would kill the spirit that lay hidden in the precious metal, which might erupt at any moment in the form of a gilded dog or snake.

Previous pages:
Akan chief. Ghana. The ornaments of gold and pearls worn by these chiefs are
known as *wasuman*. Photograph, Archives Barbier-Mueller, Geneva.
Fly whisk handle topped by a parrot. Ivory Coast, Baule.
Wood covered with gold leaf;
h. 28 cm. Musée Barbier-Mueller, Geneva.

Cap with attached amulet goatskin, amulet covered with hammered and embossed gold leaf; h. 12.6 cm. Musée Barbier-Mueller, Geneva.

Africa did not prove to be the land of Eldorado described by some and dreamed of by others, however. The vast majority of its gold was finally exported in the form of powder, with a much smaller proportion traded ornaments. But it was nevertheless the continuous flow of this gold that for more than 1000 years supplied the trade with the empires of the Sahel and, on the other side of the Sahara, with North Africa and Egypt. In the 15th century, the arrival of the first European ships would bring prosperity to Africa's coastal kingdoms and encourage the development of new schools of gold design, markedly less open to the influences of the Sahel.

Some 30 years ago, Nana Bonzou II, king of the Anyi in the Ivory Coast, gave the following description of the practices and customs governing the dress and adornment of his predecessors: "The ancient kings spent their days in idleness; work was forbidden to them. They were anointed with unguents and fed. They spent most of their time with the children and young people. ... The unguent with which they were smeared was made from an oil extracted from roasted palm seeds. ... The king's whole body was covered with it. His beads and gold bracelets were rubbed with a white powder made from a mushroom that grows in the forest. ... The king wore gold, masses of gold. His arms were laden with bracelets. ... He wore precious stones, red in color ... set in ankle and wrist bracelets. He also wore a thong, orange in color and draped with a brick-colored loincloth."

But of all the peoples of West Africa, it was the Akan people of Ghana who raised gold, its color and its brilliance to the status of a cult. Indeed, this untarnishable metal, symbol of wealth and power, was so abundant that it was to give its name to the region (only at independence in 1957 did the Gold Coast become Ghana). As non-Muslims not subject to the strictures of the Koran forbidding men from wearing jewelry, the Akan kings began to load themselves with such an array of sumptuous adornments that they were literally unable to stand under the weight, and could move around the palace only with the aid of a team of serving boys. The women of the coast were also "heavily laden with necklaces, bracelets, rings and chains in gold, copper and ivory," according to a report by the Englishman John Lock in 1554.

Opposite: **Pectoral ornament in the form of a disk.** Ghana, Akan.
Gold, cast by lost wax process; diam. 15.6 cm. Musée Barbier-Mueller, Geneva.

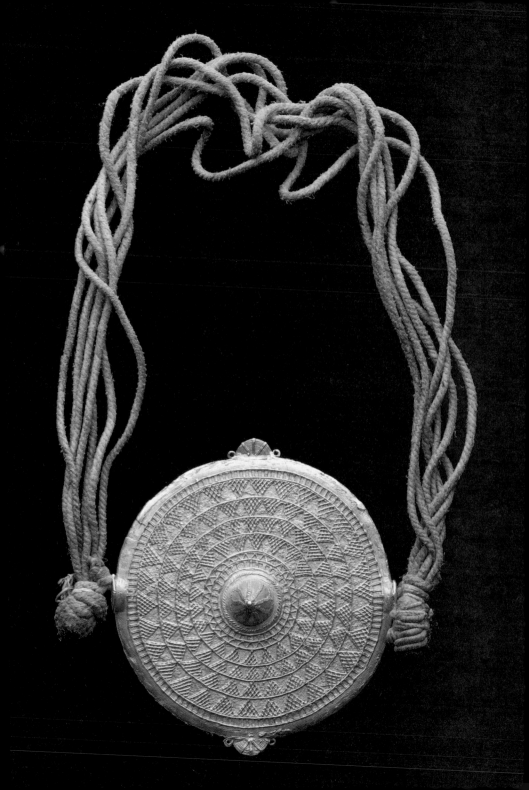

But it is to the French Huguenot slave trader Jean Barbot that we owe the most detailed surviving description of 17th-century Akan jewelry. The engraved plates that illustrate his work reveal a repertoire of forms that was quite literally unheard of in Europe, and Barbot was unstinting in his praise of the skills of the Akan gold workers whose work he described: "They are able to make numerous types of gold utensils and ornaments, especially buttons, whether of filigree or solid gold, solid or braided rings, toothpicks, curious hatbands and sword sheaths, besides many other kinds of curiosities. This has frequently furnished me with the opportunity to admire their skill in casting gold in filigree shapes, so as to represent with great precision the shapes of a large sea winkle and every other kind of snail and shell. … Most curiously, they also cast all sorts of other animals, wild and domestic; the heads and skeletons of lions, tigers, leopards, bulls, deer, monkeys, goats, etc., which serve them as idols, whether solid or pierced, are all cast in moulds; I have brought back several pieces of this kind, and in particular a winkle shell as large as an average goose egg, which have all been greatly admired at La Rochelle and in Paris, even by the finest goldsmiths."

If in places Barbot's account betrays his naivete, or simply his unfamiliarity with Akan culture (what he describes as "buttons" are almost certainly disk-shaped beads, as in the breastplates of the great pectoral ornaments worn by chiefs and their entourage), it nevertheless provides a true reflection of the Akan kings' fascination with gold. From the 18th century, their capital Koumassi, originally a modest center of the gold trade, was thus to become a bustling, cosmopolitan town with a population of more than 20,000, its streets laid out on a gridiron plan and divided into quarters occupied by blacksmiths, goldsmiths, weavers, court functionaries and Muslims. The very legitimacy of the Asante state now assumed material form in the most precious object in its regalia: the famous "Golden Throne" or "Friday Golden Throne." According to legend, Osei Tutu, founder of the kingdom, was sitting quietly under a tree one Friday in 1701 when this miraculous object sent by the god Nyame came down from the sky, amid peals of thunder and lightning, and landed in his lap. This splendid gleaming throne was to become the symbol of the Akan state, and only the sovereign was allowed to sit on it. The king's death, moreover, was announced with the laconic phrase, "A seat has fallen." Other thrones intended for kings, queen mothers and even local chiefs, meanwhile, were

merely covered with sheets of gold, the value of the gold varying according to the rank, sex and function of the person for whom the throne was intended.

Many other items in the regalia also bore witness to the divine nature of the king: sandals to enable him to avoid touching the earth, thereby polluting the soil and causing famine and sickness; headgear fashioned in imitation of the crowns of European monarchs; ceremonial sabers with pommels entirely sheathed in gold leaf; and prestigious parasols and staffs with ferrules invested with profound symbolic significance. In the manner of the massive rings worn by monarchs, their carved patterns conveyed messages in the form of metaphors that could be generally understood. Thus the image of a bird pecking at a seed was a reference to the traditional proverb, "The woodpeckers hope the mulberry tree will die," the subtext being that the only hope for the little people in this world is to wait or hope for the fall of those with power. Another winged creature turning its head to look over its shoulder was an exhortation to heed the lessons of the past. Displayed by "spokesman" servants, these precious symbols of power inspired the highest quality of workmanship and made a lavish contribution to the splendor of official ceremonies.

But of all ornaments the most important were indisputably the circular pectoral ornaments known by scholars as "soul disks" or "insignia of the purification of the soul." Worn by the king, the queen mother and certain members of the court (interpreters, military chiefs and sometimes messengers), these pendants served—like many African jewels—as talismans to ward off danger. The Akan kings even went so far as to require specialist "washers of souls" to wear these disks in their hair or clothes: known as *akrafo*, these high-ranking dignitaries (chosen in their earliest childhood for their exceptional beauty) duly conducted ritual ceremonies with the purpose of purifying the royal soul. Whatever the purpose of these ornaments, it is impossible not to be struck by the beauty of their decoration of swirling rosettes and palmettes, patterns broadly inspired by the goldsmith work of the Tuareg and other Saharan peoples.

Following pages: **Fish.** Ivory Coast, Lagoon region. Gold; h. 9 cm.
Musée Barbier-Mueller, Geneva.
Pendant with two crocodiles.
Ivory Coast, Baule. Gold; h. 9.5 cm, l. 6.6 cm. Musée des Arts d'Afrique et d'Océanie, Paris.

Royal ceremonies were not the only occasions when such finery might be exhibited: far from it indeed. In 1817, for instance, a certain Mrs. Bowditch described the nuptial procession of a future bride and her entourage: "The young girl's hair was drawn up on top of her head in the form of a cone, and adorned with quantities of butterflies in gold and other small jewels. ... Each of her fingers was covered with rings up to the knuckle; her loincloth was secured on her hips by a belt from which hung lions and other golden ornaments. ... The two slaves who followed her into the room were equally richly garbed, and each wore around her head a row of English guineas strung together with gold wire." Far from dwindling, this "passion for appearances" and love of show was to continue to the present day among the peoples of Ghana and the Ivory Coast, where highly theatrical "gold festivals" still serve as the pretext for astonishing displays of family fortunes. Gleaming for all to see in the dazzling sunshine are bracelets, necklaces, diadems, fly whisks and even imitation eyeglasses, the height of modern sophistication!

ON THE IVORY COAST: THE ELEGANCE OF THE BAULE

Whereas in Ghana all forms of art appear to have been dedicated to the glorification of the supreme being, in the Ivory Coast personal adornment was the preferred mode of expression—a fundamental difference which may confidently be attributed to the lack of chiefdoms among the Lagoon peoples. The gold rings that represent one of the finest expressions of Akan art (if only for the moral messages they transmit to all who contemplate them) are, for instance, virtually nonexistent among the Baule people. With their virtuoso skill in casting by the lost-wax process, they instead created an infinite variety of gold beads and cobweb-fine spiral disks, sometimes crowned with the silhouette of a bird, fish or crocodile. Occasionally described mistakenly as masks, these little "pendant-faces" are of exceptional elegance. Are they portraits of friends or lovers, effigies of ancestors or dead kings, or trophy heads representing slaves or enemies killed in combat? To the Baule and Lagoon peoples they are known simply as "human heads."

Turtle. Ivory Coast, Lagoon region. Gold; h. 4.5 cm.
Musée Barbier-Mueller, Geneva.

Beauty and Usefulness

Headrests, seats, spoons, jewelry, fabrics, weapons, musical instruments: all objects of small apparent significance but which to African eyes, nevertheless, were traditionally far more than mere utensils or simple adornments. Arbitrators between the realms of the living and the dead, insignia of power or wealth or symbols of welcome or prosperity, they accompanied and marked out all of life's turning points, from birth and puberty to marriage, childbirth and finally death. Nor was there anything gratuitous about their decoration: in societies without handwriting, every one of these objects told a myth or story. And above and beyond their practical uses for ritual and domestic purposes, they were also invariably beautiful in form, reflecting the skills of the nameless craftsmen who raised these objects—which provide so much valuable information about the details of daily life—to the ranks of works of art. On the evidence of these pieces, are not African craftsmen, past and present, among the most virtuoso of designers?

Above: Hinged *yatenzalaga* chair. Ivory Coast, Senufo. Wood; 94 cm.
Below: Dwa stool with antelope. Southern Ivory Coast, Anyi or Akye. Wood; h. 50 cm.
Right: Ceremonial anthropomorphic spoon. Ivory Coast, Dan. Wood with brown patina, lightly bleached incisions; h. 48.5 cm.
All three pieces: Formerly Joseph Mueller collection.
Musée Barbier-Mueller, Geneva.

Stool supported by four figures.
Southeastern Ivory Coast. Wood; h. 50.8 cm.
Musée Barbier-Mueller, Geneva.

SEATS, STOOLS AND THRONES

Seats ranging in style from a wealth of figurative detail to a minimalism verging on the abstract; baroque polychrome thrones from the Cameroon Grasslands; miniature chairs showing European influence; caryatid stools made by the Luba and Songye peoples: few societies are able to boast seat furniture of so many different types and made in such a tremendous variety of shapes and materials. And practical and functional though they are, these objects created under African skies are nonetheless also beautiful, carved by craftsmen with painstaking skill according to

Opposite: The uses of a stool may sometimes vary from its original purpose.
Photograph, Archives Barbier-Mueller, Geneva.
Previous pages: **Mak pan game.** Ivory Coast, Dan. Wood with dark patina, metal, beads;
l. 72 cm. Musée Barbier-Mueller, Geneva.

the wishes of the people who commissioned them. Whereas in Western societies nothing could be more banal than sitting down on a chair or stool, in numerous African villages chairs are viewed very differently. Possession of such an object induces feelings not only of pleasure but also of pride and status. Furthermore, seats are for strictly personal use and are never offered to anyone else, even including close relations. Among the Akan peoples, and most particularly the Asante, they are even believed to be inhabited by the soul of their owner, who turns his stool on its side when he is not using it in order to prevent any outside power from possessing it and tarnishing his spirit. We have already seen, moreover, the symbolic role of the Asante "Golden Throne," the embodiment of the monarchy and of the collective soul of the people. But while chairs and thrones occupy a fundamental place among the regalia of monarchy as insignia of power, other types of stools worked in more modest materials (such as leaves, matting or tree trunks) are put to less exalted use. Frequently, carved from a single block of wood, square or cylindrical in shape, occasionally rocking but more often stationary, these sometimes boast carved decorations such as kneeling caryatids or zoomorphic shapes. To Western eyes they are surprisingly low—rising from three inches to a maximum of a foot from the ground—their modest height adapted to the squatting position habitually assumed by Africans, rather than to sitting around a table in Western style. African seats on the whole have neither backs nor arms, but are supported on one or more legs or even form part of a solid block placed directly on the ground. Yet these objects designed for daily use were created in a tremendous variety of shapes and forms, sometimes endowed by years of use with a handsome glossy patina greatly sought after by connoisseurs. Notable among them are the stools with elegantly curving seats supported by two or four substantial legs made by the Dan people of the Ivory Coast; Dogon seats embellished with carved figures, arms raised, and horses, recalling this people's obsession with equestrian figures; stools made in Cameroon with energetically carved uprights invaded by a mythological bestiary of dazzling profusion, featuring among other creatures bird-eating spiders, buffalo, rabbits, snakes and leopards; the seats of the Luba of Congo supported by graceful caryatids dec-

Stool with female figures and lizard (?). Mali, Dogan seat. Wood; h. 33 c.m. 16th century. Formerly Lester Winderman collection. Musée Dapper, Paris.

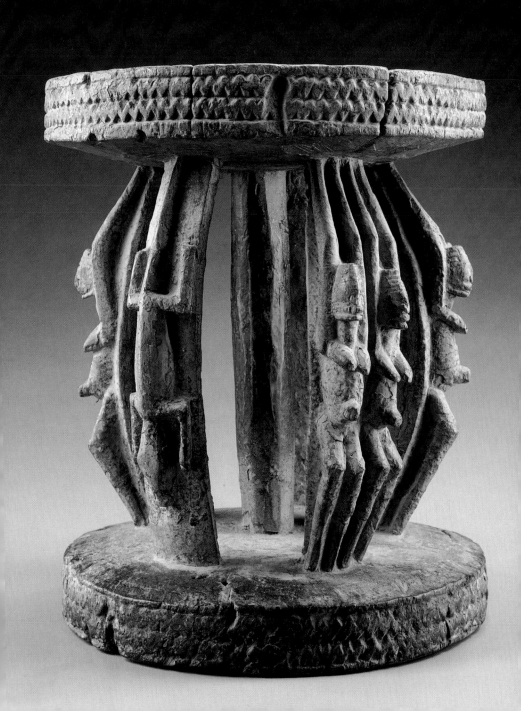

orated with scarification indicating their high rank; Chokwe thrones with backrests clearly inspired by European models but peopled by crowds of small figures that might appear in daily life as fetishes; and many, many more.

But if any regions of the continent were to be singled out for their virtuosity in this field, they would have to be East and South Africa. It is in these areas indeed—though generally considered as artistically impoverished—that the greatest range of such "everyday" objects is found: spoons, gourds, pipes, jewelry, headrests and, naturally, chairs and stools of breathtakingly modernist design. Three-, four- or eight-legged, with or without a backrest sporting an anthropomorphic figure, the stools of Ethiopia, Kenya and Tanzania are captivating in their sober restraint and their intense purity of form.

SPOONS AND HEADRESTS

What could be more insignificant, in Western eyes, than the spoon with which you eat your soup or the pillow on which you lay your head to sleep? But here, too, every African group has its own traditions. Far from being regarded as merely a kitchen implement relegated to the sole activities of eating and drinking, the spoon in Africa represents an essential element in certain rituals, a status symbol and a pretext for an astonishing degree of inventiveness. As for headrests, these devices known to the ancient Egyptians perform the valuable function of protecting the most elaborate hairstyles while their owners slumbered. Veritable sculptures in miniature, they are also magnificent invitations to dream and to enter the spirit world.

"Among the Guro, it is the custom usually to eat with the fingers," observed Louis Tauxier in his book on the Guro, published in 1924. But although rarely described by ethnologists, spoons were in use in Central and West Africa before colonization, not only for preparing and eating meals but also for decanting more or

Opposite: **Ceremonial spoon in the shape of a woman.** South Africa. Zulu.
Carved wood with light brown patina; h. 56 cm. Musée de l'Homme, Paris.
Among peoples such as the Zulu with no sculptural tradition, everyday
objects may be elevated to the ranks of works of art.
Following pages:
Headrest. Zimbabwe. Wood; h. 14 cm. Musée de l'Homme, Paris.
Headrest. Congo, Songye. Wood. Musée des Arts d'Afrique et d'Océanie, Paris.

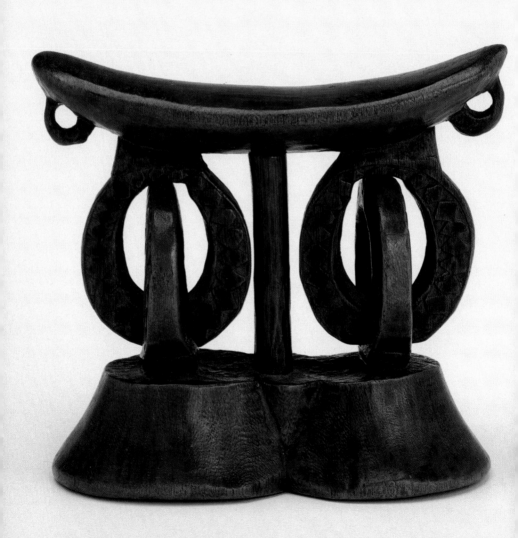

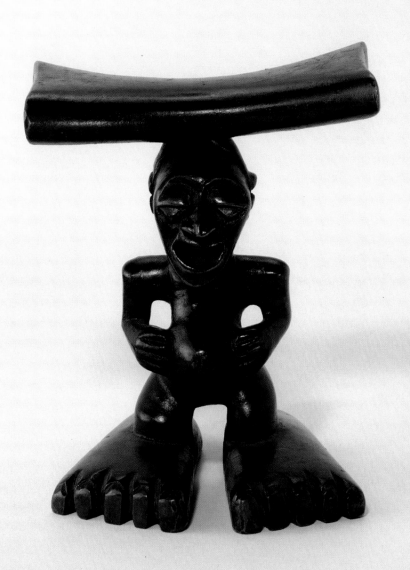

less liquid food from one recipient to another. Carved in wood or more rarely ivory, spoons were nevertheless to lose their original function in certain regions in order to become objects of religious significance, or marks of status or show. Thus among the Senufo of the Ivory Coast, it is still the custom to use spoons not only as domestic implements but also as prestige cutlery, to be brought out only for great occasions and distinguished visitors. Not eating with the fingers is also taken as a mark of courtesy and an indication of high education.

Large and virtually spherical ladles fulfilled a quite different function. Intended for serving millet or maize beer, these implements play their part in complex ritual ceremonies such as initiation to the *poro* (a secret society specific to the Ivory Coast). The young novices, aged seven, are thus initiated by senior members, who invite them to drink from these ladles, the handles of which may be embellished with delicate animal carvings. Among the Dan, who live by farming on the borders of the Ivory Coast and Guinea, the spoon reigned supreme, playing a role of central importance in cult practices and attaining a level of aesthetic distinction that has rarely been equaled. It appears in numerous different guises for different purposes. The "little spoon" (*mia nä*) was thus reserved for the elderly: virtually an extension of the hand, it was used for eating (generally rice with a sauce). Kept in pretty, finely woven cases when not in use, these spoons were frequently the principal possession of old people who had become dependent on their families, and were endowed with symbolic and affectionate nicknames signifying sentiments such as: "It's not your fault if I don't get enough to eat." Other spoons, with handles as much as 15 inches long, were the prerogative of young brides entering their new families. Smaller, slimmer spoons, meanwhile, belonged to the principal wife who did the cooking: marks of wear and tear on them bear witness to their daily use.

This was clearly not the case with the large and broad ceremonial spoons proudly displayed by representatives of women's societies at masked dances and festivities to mark occasions such as the Festival of Merit or Festival of Cows. Featuring pairs of legs terminating in a belly, these were more reminiscent of fertility symbols. The exclusive property of the woman judged to be the most hospitable in the village, these objects of pride and prestige became the pretext for highly original and artistic designs. The end of the handle might be embellished at will with a female face, a replica in miniature with the canons of Dan sculpture (high rounded fore-

head, half-closed eyes and possibly aluminum teeth), the head of a ram or cow, or more rarely a hand, an allusion to its owner's liberality in sharing rice. Far more than a mere accessory of everyday life, these large spoons were thus invested among the Dan with a deeply sacred significance. A sort of equivalent among women of the role played by masks among men, these spoons were handed down from mother-in-law to daughter-in-law, and woe betide any new bride who was not accepted by the "spirit" of her spoon!

Nowadays, although modernization and the growing uniformity it inevitably brings have brought the gradual replacement of these handsome wooden spoons with mundane metal equivalents (usually in aluminum), some peoples still persevere in the production of these miniature masterpieces. An outstanding example of this are the Zulu of South Africa, the anonymous creators of "woman spoons" or "spoon women" whose attenuated elegance rivals the finest of Giacometti sculptures.

African headrests—distant descendants of funerary pieces found in the tombs of the pharaohs of ancient Egypt—are found essentially in cultures that boast highly elaborate and time-consuming hairstyles. It was to protect these valuable adornments (those that involved particularly sophisticated plaited arrangements might represent an entire day's work) that men and women alike had recourse to this item, as hard as it was uncomfortable. While more modest examples were often made simply from a forked branch adapted naturally to the required purpose, others were carved with care by skilled craftsmen. Despite their small size (which also made them highly portable), these were impressive examples of the sculptor's art, made all the more precious by the fact that the Zulu, being seminomadic, tended to produce little in the way of large-scale sculpture. Even today, in Kenya, Somalia or Uganda, it is not unusual to encounter a member of this proud tribe of herdsmen, the noble lines of his silhouette interrupted only by his headrest slung on his belt. In societies where resources are so scarce, this essential item—like seats in other cultures—assumes the role of a symbol of status and power.

Like their remote Egyptian ancestor, headrests in Africa also play a part in funerary arrangements and the world of dreams. The Tellem, ancestors of the Dogon, placed them beside their dead, while the Luba supported them with caryatids, in many cases with closed or half-closed lids. Does this signify that in Africa, as in the

myths of ancient Greece, Sleep and Death are perceived as twin brothers (Hypnos and Thanatos)? Whatever the case, hovering as they do somewhere between naturalism and abstraction, between the everyday and the poetic, African headrests are one of the most beautiful gateways ever created to the world of the unknowable.

CARVED IN IVORY: SPOONS OF PRESTIGE

Jewelry, scepters, pendant-masks, fly whisks, spoons: the list of small objects carved in the fascinating whiteness of ivory is a long one. Held in the highest esteem because of its intimate links with the life force (frequently associated with royalty, elephants in Africa also represent power and prosperity), ivory also offers a wide range of other tones to seduce carvers, from money-blond to amber and deepest red. This sophisticated palette is to be found in the little mask-amulets created by the lega people of Congo, as well as in their spoons, which are among the finest in Africa. Once again, they were far from being considered mere domestic implements, but instead played a well-defined and central role in the complex lega initiation ceremonies. When not in use for rituals, they were wrapped in a cloth made from beaten bark and kept in darkness in a bag.

The infinitely more secular spoons of the 16th-century Bini-Portuguese were conceived for their part as unique pieces suitable for gracing the collections of European connoisseurs. Delicately chiseled in fine white ivory, these miniature masterpieces celebrate in their own specific fashion the fruitful and creative marriage of African and Western art.

Spoon. Ivory Coast, Dan. Carved wood; h. 67 cm.
Musée des Arts d'Afrique et d'Océanie, Paris.

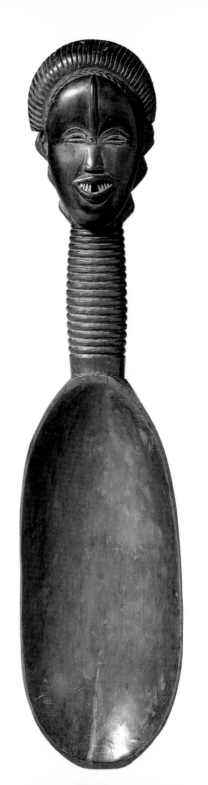

FEMALE POTTERS AND DEMIURGES

"What humans eat, they offer to the spirits," states an Ibo adage. What women carry, they offer to the gods, we might be tempted to add. For anyone who has traveled in Africa cannot fail to have been impressed by these majestic figures supporting with a gracefully curved arm the pot or basket miraculously balanced on top of their heads. It is no coincidence, moreover, that in most African societies and throughout the world, the vocabulary of the human body is borrowed to describe the different parts of a pot: neck, belly, foot, lip and so forth. And like men and women, these pots also carry engraved on their flanks the embellishments and scarifications that distinguish every other member of the community. Flesh and blood are thus echoed by the clay-rich soil that will give birth to these containers for liquids, grain, herbs and all other seeds of life.

Pot-bellied or elongated, smooth or rough-surfaced, anthropomorphic or zoomorphic, these pots, made for the most part by women, are all splendid in appearance. Nor is it mere coincidence that in Africa making pots is essentially women's work. These anonymous craftswomen themselves kept all their riches (robes, finery and jewels) in the secure depths of an earthenware jar; and on their death the dishes on which they ate their meals were smashed, while their other pots were handed down, according to tradition, to their own daughters.

As with spoons, headrests, seats and other everyday objects, beauty and functionalism are once again combined, conferring on these containers qualities that are at once practical and magical. Goblets for palm wine from the Kuba kingdom, Dogon unguent caskets and boxes of all kinds—for face paints, powder, tobacco and a variety of talismanic charms—these pottery containers assume a huge variety of forms and functions in different African societies.

Yet none of them can rival the elegance and purity of the most basic pots made of brown clay, fired and cracked by the sun, curved and sensual as a woman's belly.

Scene from daily life.
Old postcard. Archives Barbier-Mueller, Geneva.

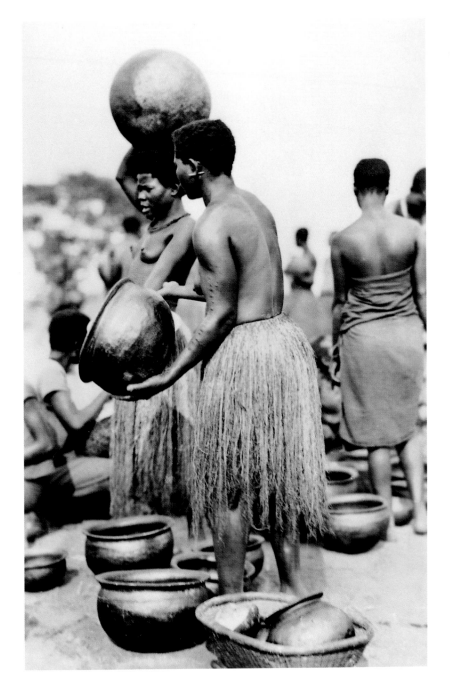

Above and (detail) opposite:
Shield. Intended as a decoration for a Kifwebe cult hut.
Songye. Wood; h. 76.5 cm. Formerly Charles Vignier and Joseph Mueller.
Musée Barbier-Mueller, Geneva.

AXES, DAGGERS AND SHIELDS

In Africa as elsewhere, the art of warfare stretches back to the beginning of time. Defending tribal territory, nurturing dreams of expansion and even simply indulging bellicose instincts have always been major preoccupations and—as recent bloody tribal warfare demonstrates—sadly remain so. Many African kingdoms, neither more peace-loving nor more aggressive than other cultures, have thus been born out of the chaos of warfare and weaponry. Knives, axes, swords, sabers, and assegais (a type of spear) form a deadly armory as remarkable in its variety as in the technical virtuosity exercised in its creation. For the dispatching of one's enemies

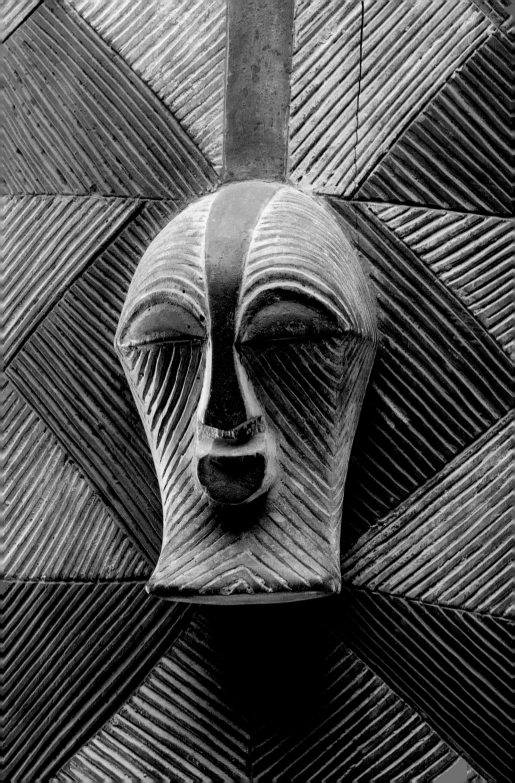

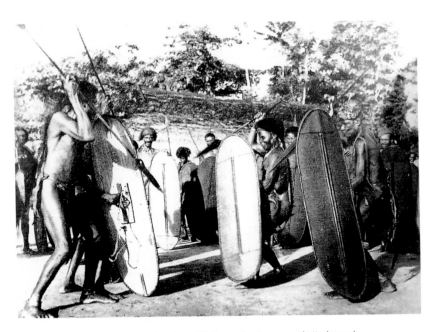

The many accessories of war. Warfare makes its own aesthetic demands
in Africa as elsewhere throughout the world. Period photograph.
Archives Barbier-Mueller, Geneva.

clearly requires the accompaniment of the flash of arms and other warlike para-
phernalia, in all their ferocious pomp and splendor. Indeed, in the face of the "sav-
age beauty" and extreme sophistication of these sumptuous accessories, it is easy
to forget their original purpose. For before becoming status symbols, trophies or
even fully-fledged works of art, these were instruments not only of death, but also
of sacrifice and torture. Thus the intended purpose of the "execution" knives of the
Ngombe people of the former Zaire, which have always entranced collectors with
their double-crescent blades, was to rain violent blows on enemy warriors before
decapitating them. And the elongated swords of the ancient Edo kingdom, in the
form of leaves with pierced centers, were originally used in ritual ceremonies cul-
minating in human sacrifices.

But if there is one object above all others that sums up the singular aesthetic of

Shield. Cameroon, southwestern province. Basketwork with parallel wooden laths;
h. 124 cm, w. 95 cm. Musée Barbier-Mueller, Geneva.

warfare it is the shield, defensive weapon and symbol of prestige as well as intimidation. Whether fashioned from the thick, pitted skin of a hippopotamus or from the hide of buffalo, rhinoceros or elephant, carved in wood or made of woven bark skillfully arranged in checked patterns worthy of Paul Klee, these distant cousins of the ancient Greek *gorgoneion* seem to experiment with every form of creative expression. Rare examples, in the African context, of a two-dimensional approach are found here. Flirting with the geometrical and the abstract, these "war paintings" are dazzling in the eclecticism of their forms (round, oblong or squat), the splendor of their materials (fiber, precious woods or animal skins) and the energy of their designs (checks, crosses or stripes). Accomplished patterns, adroit changes in rhythm and sudden changes in surface texture artfully avoid any danger of monotony. And there is nothing superfluous in the decoration, the stylized quality of which appeals to our modern sensibilities. Far from limiting themselves to their warlike role, these shields moreover convey a wealth of visual information waiting to be decoded. As Purissima Benitez-Johannot notes in her handsome volume on the shields in the Barbier-Mueller collection: "When confronted with other warriors, the Mambila and Wuli of Cameroon distinguish their allies from their enemies by the design and overall shape of their woven shields. The Zulu, meanwhile, regularly used shields made from the skins of white, black or tawny cows as a means of distinguishing between seasoned warriors, married men and novices among their own ranks. Among the Kikuyu, young warriors would proudly wear their new shields high up on their arm, like a badge. This would convey to others their age as well as their place of origin."

"Souvenir-trophies" handed down to the youngest male in the family among the Manza, symbol of bravery among the Masai and of family or political allegiances among the peoples of Cameroon, ex-voto offerings to the gods, prestige gifts offered to colonial governments as pledges of peace: these escutcheons of the African world fulfilled numerous different functions.

By a nicely ironic twist that goes far beyond any ethnological treatise, it is their stripped-down modernist vocabulary that now appeals so strongly to collectors. Museum pieces and collectors' items, these instruments of war have now invaded glossy design magazines as well as chic interiors in New York, Paris and London.

Poignard. Gabon, Fang. Musée Barbier-Mueller, Geneva.

THE HUNT: FEARED AND VENERATED

Going on a hunting expedition was not simply a pleasurable pastime, nor was it an act of no particular significance. To ensure the safety and success of this dangerous activity, African hunters were required to conform to strict rules of conduct, including sexual abstinence. Lived sometimes as a period of frugal asceticism, hunting in fact wove close links between the hunters and the world of animals. Not merely desired for their meat, their skin, their fur or the ivory of their horns, rhinoceros, elephant, buffalo and antelope also haunted the psychological and spiritual world of men, and tainted objects of prestige, such as masks and royal regalia, with their horns, claws, fur and other attributed. Simultaneously feared and venerated, hunters were thus ambivalent figures who fed and protected the community while at the same time spilling blood and dealing out death. Kamong some peoples, such as the Chokwe of Congo, hunters even acquired mythical status. Chibinda Ilunga, who was said to have introduced the art of hunting in the 15th century, was honored by the Chokwe as the epitome of the "civilizing hero," and his easily recognizable figure (with nose and ears evoking the animal world, spreading hair, staff and medicine horn) appeared on all the insignia of royalty, from snuffbox to scepter, and from fly whisk to whistle. Like warfare, hunting had its own rituals, codes, hierarchy and dangers, and it was perceived as the most compelling metaphor for power. For was it not hunting, straddling as it did the crossroads of life and death, and of the human and animal worlds, that regulated the world order?

HARPS, DRUMS AND XYLOPHONES

Music in Africa—sacred or secular, group or solo—is everywhere. A language in its own right, it is the source not only of pleasure but also of communication and cultural exchanges. It comes as no surprise, therefore, that African craftsmen should have devoted their fertile imaginations to creating musical instruments—drums, xylophones, flutes, bells, harps and more—out of wood and metal. The richness and eclecticism of these pieces is astonishing. For above and beyond the material and acoustic qualities required, the craftsman-sculptor, who may also be the musician, is able to transform these highly personal objects into works of art of great symbolic power.

The African harp, a distant cousin of the harps of Egypt and Mesopotamia, is thus found in no fewer than 50 different cultures, all of which have devoted particular ingenuity to the art of carving this elegant instrument. In a spirit of anthropomorphism, the neck may be embellished with graceful human figures, while the resonance chamber becomes a trunk terminating in a pair of legs, generally bent. In a tribute to the creative skills of these craftsmen, meanwhile, the resonator may take on any one of a number of forms: oval, triangular, trapezoidal or waisted. Far from being the genteel "drawing room" instrument we know in the West, the harp in Africa is played almost exclusively by men who are singers as well as instrumentalists. In the villages, these African "bards" sing the origins of the world, its myths and legends. It is a vocation that may take on a profoundly spiritual role, accompanying rites of exorcism and acting as mediator between the world of the living and that of the ancestors. The power of its music and its other-worldly overtones have even led to harps being worshipped as gods, honored at their appearances among some peoples by ceremonial dances and processions. Among the Bwiti, the harp is believed, furthermore, to embody the complementary nature of the male and female principles, and of the seen and the unseen worlds.

Traditional *tam-tam* and *balafon*
in the village of Mogroum. Photograph from the *Croisière noire*, 1924-5.
Musée des Arts d'Afrique et d'Océanie, Paris.
Pages 228-9: **Anthropomorphic lamellaphone.** Wood and bamboo; 61 x 15 cm.
Harp with a human head. Wood and fiber; 83 x 23 cm. Both pieces: Congo, Zande.
Musée royal de l'Afrique centrale, Tervuren.

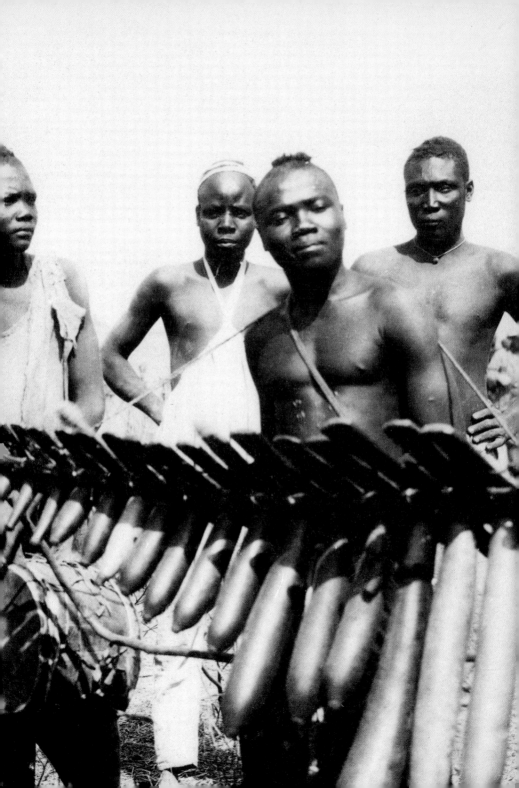

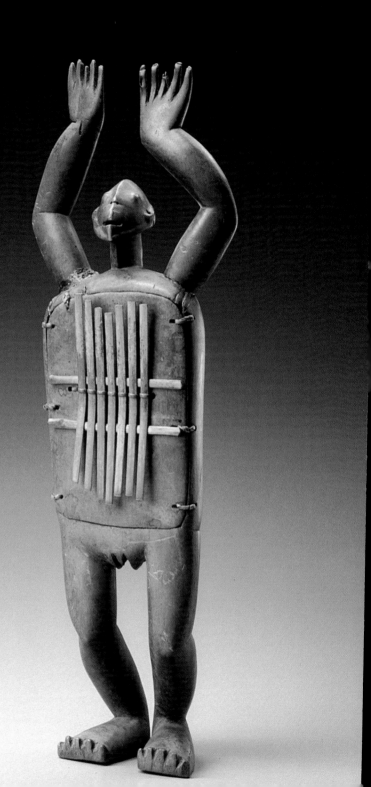

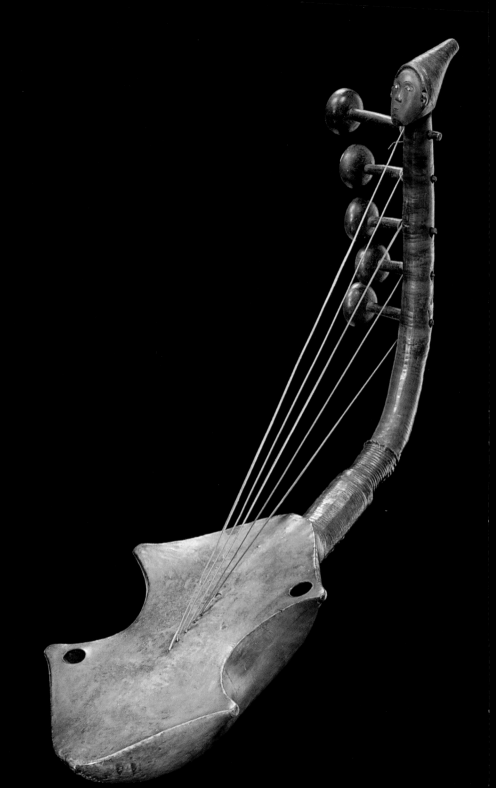

In the Grassfield region of Cameroon, it is drums that are particularly celebrated: monumental drums carved for each Bamum king; Bamileke drums in the form of buffalo decorated with carved chameleons and lizards, toads and frogs; and portable slit drums to accompany dancing and festivities. Yet, as a symbol of wealth and status closely associated with the exercise of power, the drum is above all the most feared and respected of instruments: it is the drums that beat the departure of warriors for battle, that hammer out the rhythms of incantations, and that act as spokesmen for chiefdoms and for mysterious secret societies alike. The "master-drums" of popular Akan bands play a more entertaining role. Much in demand for celebrating significant events such as entry into puberty, marriage, local festivities and funerals, they travel from village to village and frequently represent the sole secular diversion in the lives of the inhabitants. Sometimes embellished with overtly sexual motifs (such as a pair of breasts in high relief), in these cases they form "couples" with other drums, the males recognizable by their booming notes, the females by their shriller tones.

While *griots*, or wandering minstrels, accompany their mystical chants with the music of flutes, elongated and often decorated with attractive carvings, the *sanza*, or "thumb piano," makes music in numerous different "voices." When pinched between the player's thumb and forefinger, each note—attached to a flat sounding board—"speaks" or "sings" to "bring people together." Each of its voices—"mother," "father" or "child"—also represents a musical function, such as soloist or member of the chorus. Through the device of anthropomorphism, a Zande *sanza* now in the collections of the Tervuren Museum in Belgium plays this metaphorical role to the full: her arms raised in a gesture of joy or communion, the "woman-instrument" whose torso serves as the sounding board thus celebrates the sacred, ardent union of music and dance, and of the instrument and its player.

Opposite: Mangbetu drummers playing slit drums. Congo .
Old postcard. Archives Barbier-Mueller, Geneva.
Following pages:
Door. Ivory Coast, Senufo. Carved wood; h. 160 cm. Formerly Joseph Mueller collection.
Door. Ivory Coast, Baule. Carved wood; h. 146 cm. Formerly Joseph Mueller collection.
Both pieces Musée Barbier-Mueller, Geneva.

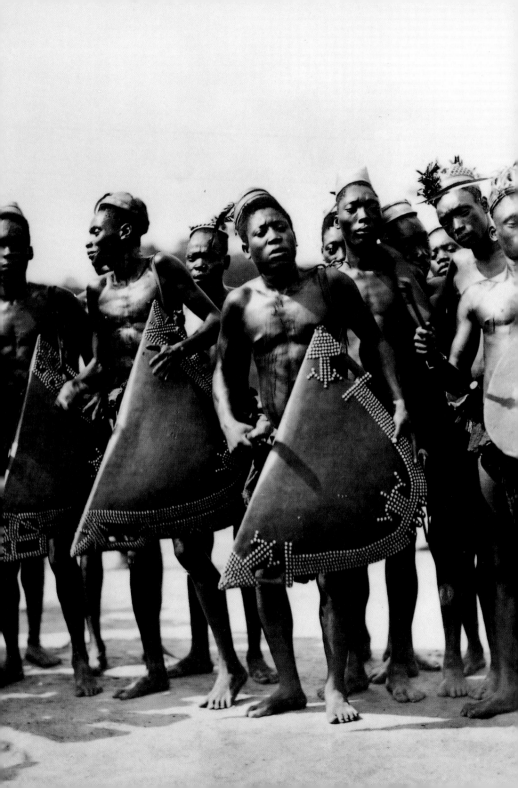

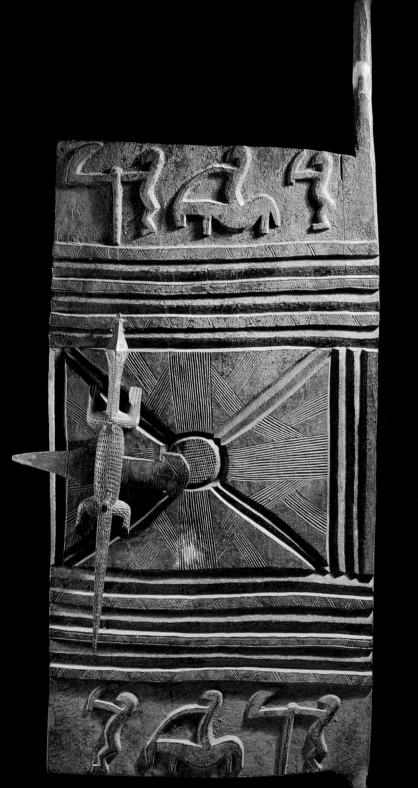

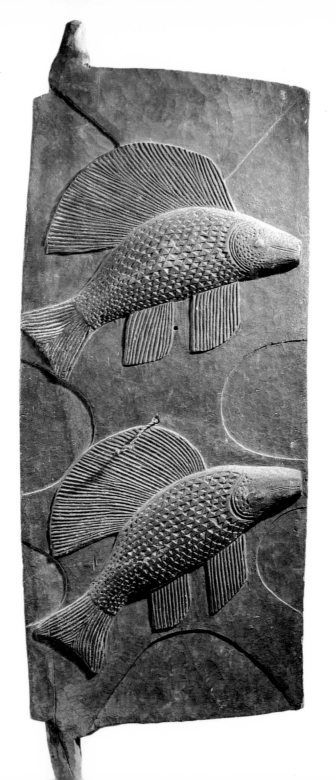

BAULE AND SENUFO DOORS:
BETWEEN THE ESOTERIC AND THE DECORATIVE

The Senufo and Baule peoples of the Ivory Coast have raised the art of combining beauty and usefulness to heights calculated to arouse the envy of any designer throughout the world. The entrances to their huts and enclosures used to be closed off with carved doors, decorated with traditional motifs conveying messages drawn from mythology or local wisdom. Sadly, the practice of making these large panels, so arresting in their vigorous beauty and freedom of expression, has now virtually died out. A strikingly beautiful example in the Barbier-Mueller collection shows two fish of rare elegance swimming gracefully against a watery background. On another, the crisscross pattern of a crocodile's skin recalls, in roundabout fashion, the scarifications sported by the Baule. Some motifs adorning Senufo doors are of an opacity bordering on the esoteric, with their meaning now hidden even to other carvers. But we should bear in mind that their original purpose was to guard the entrance to the secret worlds enshrined in places of worship or meeting places of the elders. Terrified by these symbols designed to ward off evil, the uninitiated would be encouraged to beat a hasty retreat.

LOINCLOTHS AND FABRICS TELLING THE STORY OF THE WORLD

"To be naked is to be silent," goes a Dogon saying. In cultures where writing is unknown, signs and symbols multiply. In Africa, they are everywhere, on sacred and secular objects, on the walls of huts and palaces, on the bodies of men and women, and of course on the fabrics that cover the body. The sheer inventiveness of African weaving and embroidery can never be over-emphasized. Like the most talented designers of contemporary Western fabrics, the craftspeople responsible for these designs were true artists, projecting onto the two-dimensional surface of the cloth or raffia-palm bark a decorative vocabulary of extremely subtle symbolic significance.

Fabric Dyed with indigo and embroidered with pink and yellow diamonds.
Mali, Dogon. Musée des Arts d'Afrique et d'Océanie, Paris.

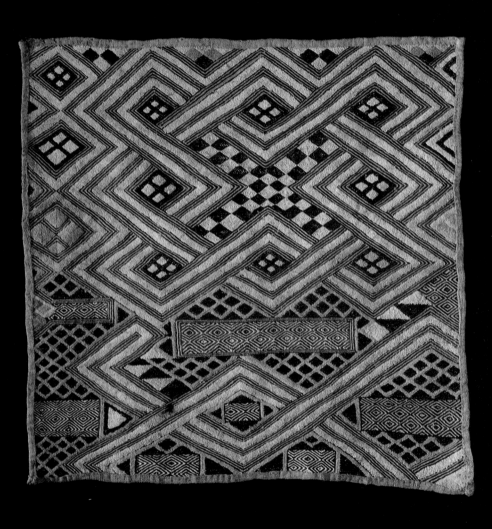

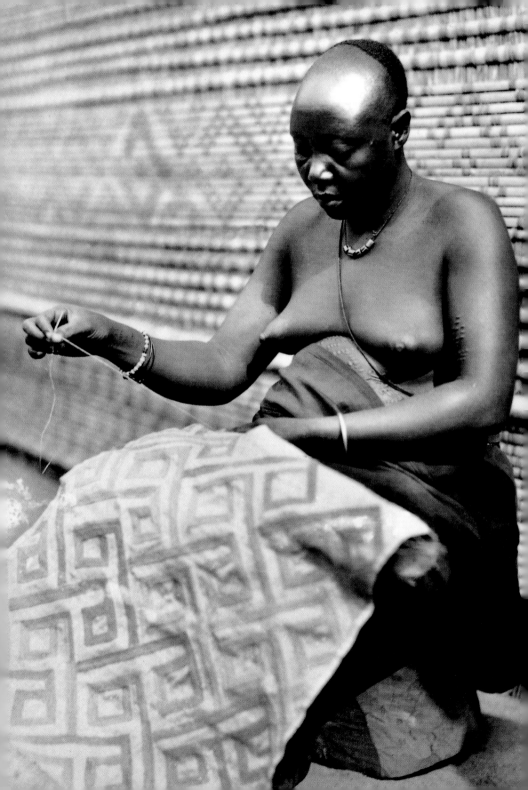

Very early, certainly, the people of Africa displayed a marked fondness for fabrics of foreign origin, fascinated by the shimmering luxury of the robes worn by Arab merchants and dignitaries. Casting aside the simplicity of their traditional loincloths, woven from plain cotton or plant fibers, African nobles now set their sights on brocade and silk tunics from the Yemen, and on silks from Egypt and Tunis, among other places. As a new religion, Islam, penetrated to the heart of the continent, so new fabrics and new aesthetic vocabularies crept into the lives of its inhabitants. As early as the 13th century, the kingdom of Mali (so astutely described a century later by the Arab explorer Ibn Battuta) converted to Islam, and its court began to attract wealthy merchants and marabouts from the distant lands of the Maghreb, whose products were so greatly admired. But Islam brought with it strict codes of conduct and prohibitions. Condemned as lewd and obscene, nakedness was outlawed. One town, however, was adroit enough to take advantage of the resulting new demand for textiles: Timbuktu, true capital of the Sahel from the 12th to the 16th century, and a great center of economic, intellectual and religious activity. By a nice irony, it was soon to be the flourishing ports of Gao and Djenne that were in turn to export their handsome indigo blue cottons to the Berber people of the Sahara. Far from being a lowly occupation, weaving became the preserve of cultivated men who were generally converts to Islam. With their high degree of mobility (their looms could be dismantled entirely), these "learned craftsmen" played an important part in the spread both of the technique of weaving and of the Muslim religion. Besides serving as an elegant adornment, fabrics were now also to become a valuable form of currency. Hoarded or bartered, woven or embroidered, they traveled the length and breadth of Africa and even beyond, offering a dazzling repertoire of forms and materials with which to seduce and inspire other peoples and cultures.

Among the most celebrated (and most collected) of all African fabrics, the raffia "velvet" of the Kuba people of Congo rapidly emerged as one of the most outstanding: remarkable compositions of diamonds and checks which in their abstract

Previous pages: Kasai **velvet.** Congo. 56 x 54 cm.
Musée des Arts d'Afrique et d'Océanie, Paris.
Kuba woman embroidering. Congo. Old postcard.
Archives Barbier-Mueller, Geneva.

geometry and graphic energy are powerfully reminiscent of canvases by Paul Klee. But this is to reduce to a mere formal exercise what in fact was more like a whole language in the service of the sacred. Woven by men on upright looms, embroidered collectively by the women, and finally shaved with a knife to obtain the softness of velvet, these fabrics exercises such a strong fascination over other African peoples that the Kuba were dubbed Bambala or "cloth people." Far from use for making everyday finery, however, these fabrics were destined to accompany the dead as a lavish and elegant accessory on their final journey to the other world.

The other fabrics woven with such virtuoso skill by Kuba craftspeople were known as *nchak*: ceremonial loincloths, several yards long and with no center or borders, which unfurl in fascinating sequences of plain and patterned areas, like a scroll of Chinese calligraphy. Here again, no gratuitous or secular elements are allowed to creep in. Made up of several rectangular strips, *nchak* are not merely coverings for the body, however prestigious or solemn the occasion; they are also the pillars of an entire graphic system, skillful and codified. As Christiane Falgayrettes-Leveau observes in her fine study, *Au fil de la parole*: "Thus there appear on these immense palimpsests grid networks, light or dense, but always emerging with the inevitability of after-images. These *nchak* are a simultaneous impression of matter, structure and color, as each element applied, whether ocher, yellow or shades of brown, merges with the background fabric. Further, it is charged with the tension of the stitching that fixes it and outlines its contours. At the center of this burgeoning activity there unfurl, in fabric against fabric, images that spill out beyond over the framework of the fabric in order to refer to signs similar to those found in ruperstrian [rock] paintings or in the works of artists such as Matisse, Klee or Chillida. ... The rhythm is created by innumerable symbols of the infinite. Time, as defined in the woven, concealed, constantly moving space of the *nchak*, finds its ultimate justification in the immemorial space of myths." Fluctuating between chaos and harmony, between the past and re-creation, these immense poems in plant fibers have exerted their fascination over writers and artists such as Braque, Matisse and Tzara, who collected them as avidly as the Portuguese had done in the 16th century for their cabinets of curiosities.

Among the Asante, fabrics—like so many other of their creations—formed part of a court art that was both sumptuous and elegant, reflecting a society that was

totally dominated by the figure of its king. Woven originally in white cotton, their *kente* fabrics rapidly gave way to shimmering imported silks, the vibrant motifs of which each had their own specific name. Nothing could be less spontaneous, however, than these checks and stripes designed to convey, in a similar manner to rings and staff pommels, proverbs or morally improving messages. Imposed by the king himself, the designs of these fabrics were subject to a sort of royal copyright process which was as authoritarian as it was exclusive.

We are at liberty to prefer the graphic freedom and extraordinary imaginative power of the bark paintings of the peoples of Upper Congo. Gashes and stripes; spirals, curves and arabesques; streaks and swerves; verging on the abstract, this is a language without limits. It is because they have no tradition of sculpture that the Bambuti and the Mangbetu emerge as such outstanding draftsmen? As the ethnologist Michèle Coquet notes in her masterly study, *Textiles africains*: "The curves that flourish on the surface of their fabrics are only an extension of those that they paint on their bodies."

Following pages: Nchak raffia fabric. Congo, Kuba.
Musée des Arts d'Afrique et d'Océanie, Paris.
Pages 244-5: **Drawings on an indigenous hut.** Bambari region.
Photograph from the *Croisière noire.*
Musée des Arts d'Afrique et d'Océanie, Paris.

Beaten bark. Congo, Pygmy. 77.5 x 67.5 cm.
Musée Barbier-Mueller, Geneva.

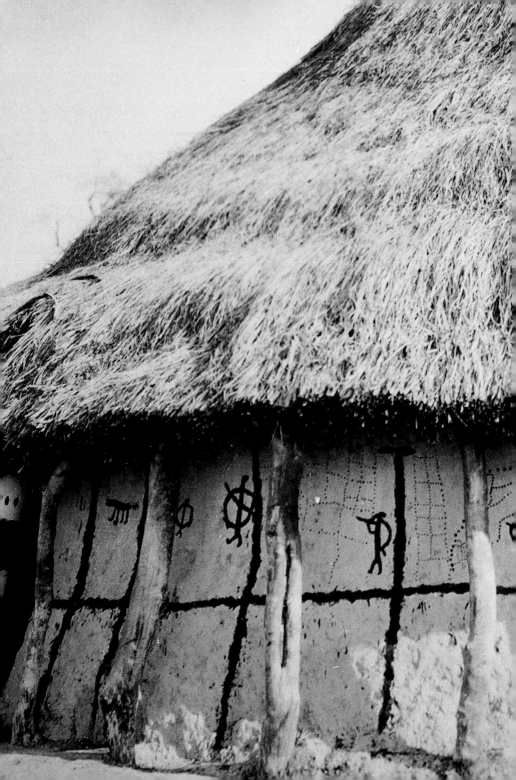

Gu **mask.** Ivory Coast, Guro. Wood; h. 31.6 cm.
Formerly Rasmussen collection.
Musée Barbier-Mueller, Geneva.

HEDDLE PULLEYS OF PURE BEAUTY

In Africa, men weave and women embroider. Yet it is the serene, harmonious features of an "African Eve" that generally adorn the tips of the elegant and practical little devices known as heddle pulleys. While the finest examples have been collected in the Ivory Coast since the 1920s, they have sadly now virtually disappeared in their place of origin. Whether purely decorative or of ritual significance (as their handsome black patina would suggest), these miniature sculptures speak the same aesthetic language as do masks and large-scale statues: the expression of a harmonious world order in which men and gods live side by side.

Opposite: **Mask with two faces.** Ivory Coast, Baule. Painted wood; h. 29 cm.
Formerly Roger Bediat collection. Musée Barbier-Mueller, Geneva.
Following pages: **Servant dressing the hair of a chief's daughter.**
Photograph by Marc Allégret for André Gide's *Voyage au Congo*
(Paris, Gallimard, 1929).

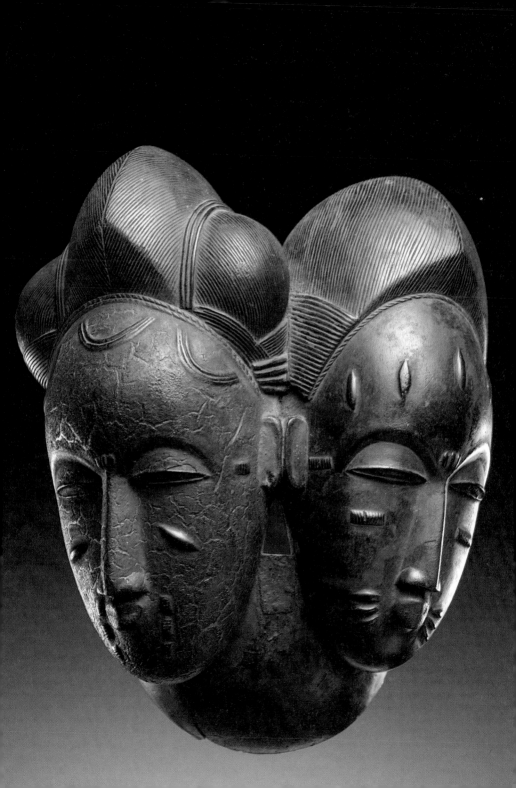

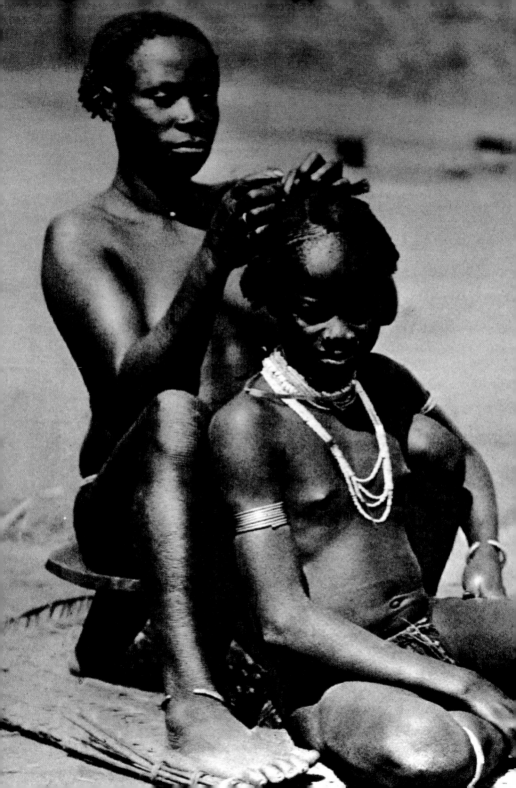

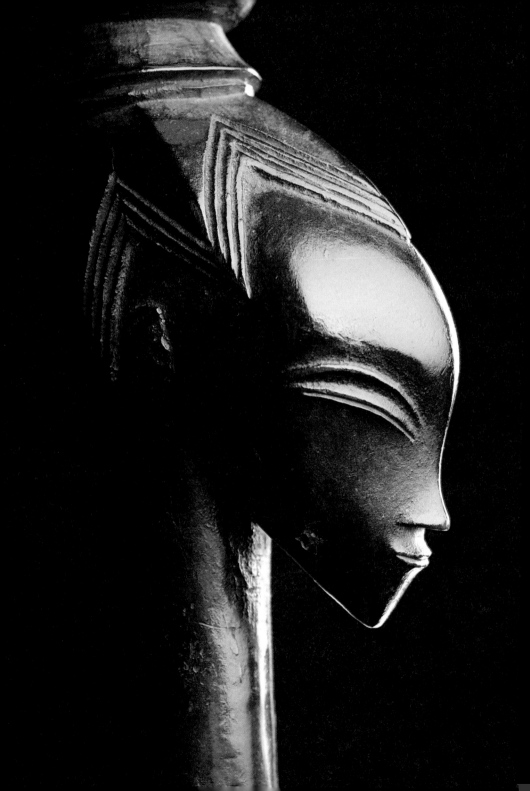

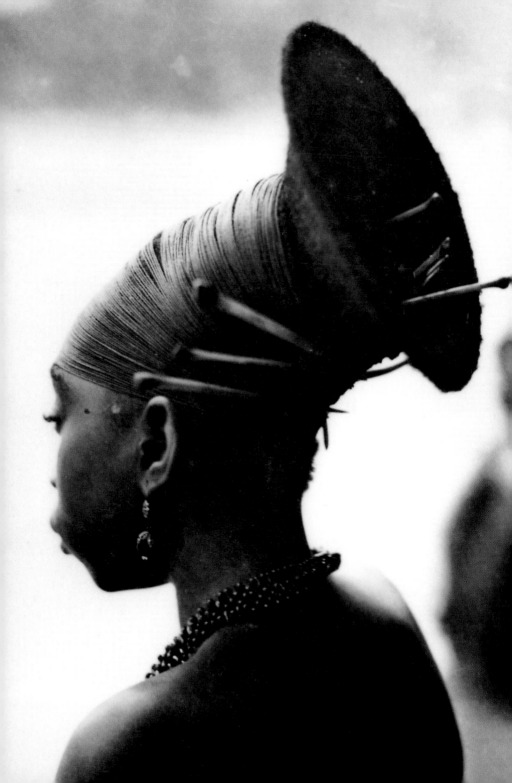

Pair of earrings. Mali, Mopti and Djenne region, Peul. Gold; h. c.13 cm.
Musée Barbier-Mueller, Geneva.

JEWELRY, FINERY AND ADORNMENTS

Settled or nomadic; rich or poor; men, women or children; young or old; peaceful or warlike: almost everyone in Africa, it seems, loves to celebrate the virtues of finery and the transformations it can effect. Ankle bracelets hammering the ground and hampering the wearer's gait with their weight; elaborate scarification symbolizing membership of a clan, a rank in society or a people; lengthening of the skull, filing of the teeth, tattooing, dyeing and mutilation: in Africa you have to suffer to be beautiful—or handsome.

And this passion takes as many forms as there are peoples in Africa: fascination for gold; love of beads or ivory, feathers or simply tree bark; lavishness or restraint; clothing or nakedness. Imprisoned in museum display cases, these ornaments created to gleam against the skin or dance with the body appear like orphaned children. These beaded capes from South Africa, Mangbetu loincloths made from banana leaves, Baule carved combs, generous ivory bracelets worn by the Masai: no exhibition, no book can restore their intended function, which is to adorn, to exalt, to seduce, to mesmerize. ...

Opposite: Masai woman wearing her finery.
Kenya. (?) Old postcard. Archives Barbier-Mueller, Geneva.
Previous pages:
Heddle pulley. Ivory Coast, Guro. Wood; h. 21 cm. Musée Barbier-Mueller, Geneva.
Mangbetu woman. Congo. Old postcard. Archives Barbier-Mueller, Geneva.

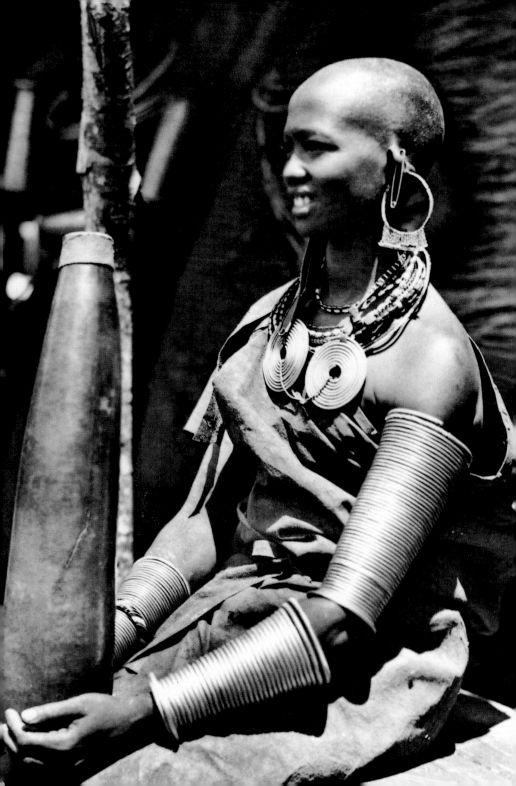

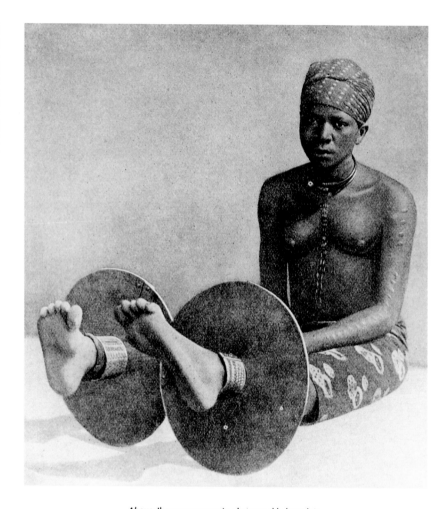

Above: Ibo woman wearing heavy ankle bracelets.
Nigeria. Old postcard. Archives Barbier-Mueller, Geneva.
Right: Pair of ankle bracelets.
Nigeria, Ibo region. Hammered and embossed brass; h. 10.3 cm.
Musée Barbier-Mueller, Geneva.
Following pages:
Mangbetu women wearing loincloths woven from plant fiber.
Congo, Mangbetu. Old postcard. Archives Barbier-Mueller, Geneva

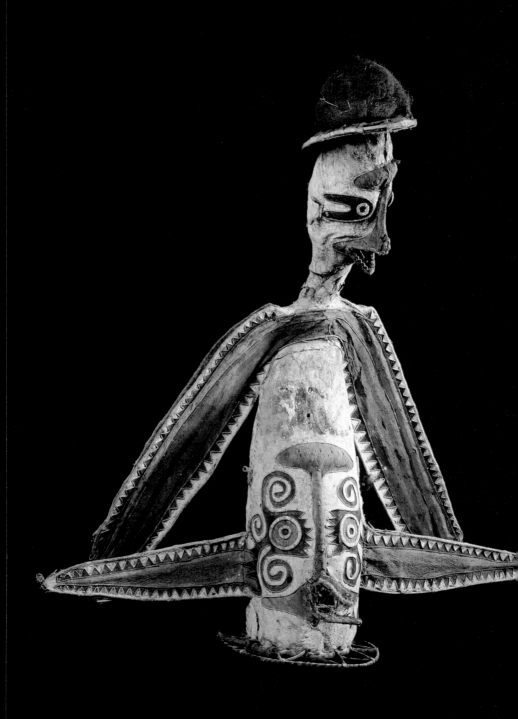

THE ARTS OF OCEANIA

Although Oceania covers over a third of the world's surface, its total land mass—excluding Australia—represents the equivalent of no more than an eighth of the area of Europe. Yet this string of tiny islands (some of them measuring only a few square miles, or even a few acres) lost in the vastness of the Pacific Ocean has produced an artistic tradition that is among the most imaginative, the most poetic and the most eclectic in the world. Defying all definition or classification, these works are now at last appreciated in their own right, freed from the shackles of an overtly Eurocentric approach. But the study of the art of this strange and colorful world, often dreamlike and sometimes macabre or disturbing, is nevertheless still in its infancy.

Opposite: Eharo **mask.** Papua New Guinea(?), Gulf of Papua, Elema. Bark cloth on cane framework, highlights in red, white and black pigments; h. 123 cm. Collected (?) by a British expedition before 1865. Musée Barbier-Mueller, Geneva.
Following pages: **Bowl in the form of a fish.** Papua New Guinea, Tami Islands. Wood, lime inlay; l. 63.5 cm. Formerly James Hooper collection. Musée Barbier-Mueller, Geneva.

When European sailors started to ply the waters of the Pacific in the 16th century, they were astonished by the huge diversity of peoples they encountered. But at the same time, cultural similarities emerged across great distances. In 1831, the French explorer Dumont d'Urville, a true man of the Enlightenment and as such obsessed with meticulous systems of classification, laid the foundations for the division of this vast area of the world into three zones: Melanesia (Black Islands), Polynesia (Many Islands), and Micronesia (Little Islands). Although this division remains in common use, largely for reasons of convenience, it is impossible now to ignore the somewhat artificial nature of the criteria upon which it rests. Naturally, the temptation to underline the characteristics specific to each region is almost irresistible. Polynesian art, for instance, is easily distinguished by its elegance and its finished quality; its Melanesian counterpart is more terrifying, playing on spectacular effects and the element of surprise; and the art of Micronesia favors surface decoration. Yet the boundaries between these apparently fixed entities remain fluid. Research over the last 20 years has redefined four great creative centers, thus laying emphasis on the circulation of motifs and objects, as well as of people, within this vast territory of islands and oceans. New Guinea and Australia make up the first group, representing the only zone speaking non-Austronesian languages and also the area of earliest habitation, by peoples of Asian origin. The populations of the second group, which comprises the islands of Melanesia, from the Admiralty Islands to New Caledonia, as well as the Tonga Islands, Fiji and Samoa, formerly known collectively as western Polynesia, is strictly Austronesian in origin. The third group brings together the markedly homogeneous populations of central and eastern Polynesia, including Easter Island, the Marquesas Islands, Hawaii and New Zealand. Micronesia, finally, forms the fourth distinct grouping, by virtue of its Asian origins.

More interesting still are a number of lines of reflection tending to emphasize similarities or differences. One example is the fondness of these island-dwellers for transforming the human body into the support for a work of art; another is the complex organization of spatial volumes manifested in the creation of the sumptuous and deeply religious buildings known as "big houses" or "meeting houses," whose immediately recognizable outlines are to be found throughout a region stretching from Indonesia to southern Polynesia. And finally, there remains the question to which scholars are still doggedly trying to find the answer: what is the

explanation for the presence of masks in Melanesia, when they are not found either in Polynesia or in most of the islands of Micronesia?

And this is only one of the many unanswered questions and mysteries that hover over these cultures, demonized by some and fantasized by others. This state of affairs is undoubtedly due to the poor conditions under which these objects have come down to us: collections amassed over a relatively short period (barely a century and a half); souvenirs brought back by sailors and missionaries, snatched from their context and thus now forever silent; curiosities that tell us more about the tastes of the travelers who collected them than about the genius of the peoples who made them. But we should be grateful, nevertheless, to the early explorers, navigators and ethnologists who first offered these singular and sophisticated works of art to Western eyes. We should also thank the artists of the early 20th century who rescued from the ranks of "crafts" works with "convulsive beauty" they found strangely compelling.

Among the latter was Alberto Giacometti. In a radio interview on April 6, 1959, he observed to Georges Charbonnier: "The sculpture of the New Hebrides is real, and more than real, because it seems to see. Here we are not dealing with the imitation of an eye, but with the imitation of a gaze. All other elements are there to support this gaze. ... But the strangest thing of all is that these Oceanian masks ... with two inlaid shells instead of eyes ... somehow give the impression of observing you with an extraordinarily lively, almost disturbing, gaze."

Following pages: **Large *vungvung* mask.** East New Britain, Baining. Bark cloth on cane framework; l. 298 cm. Musée Barbier-Mueller, Geneva.

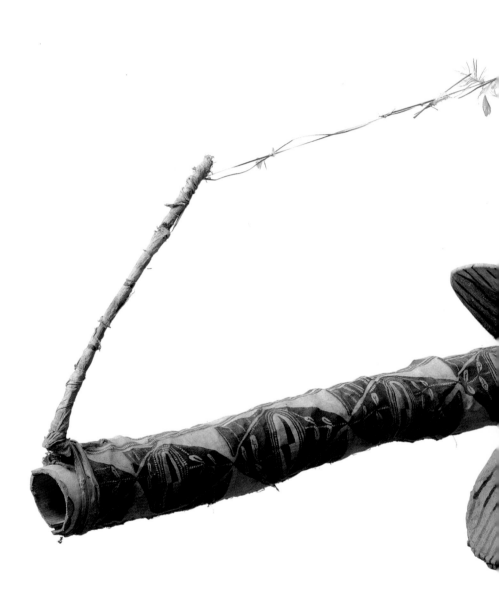

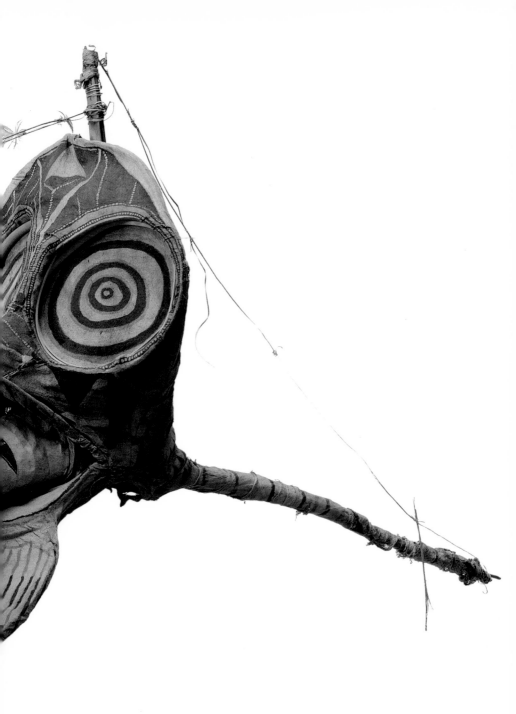

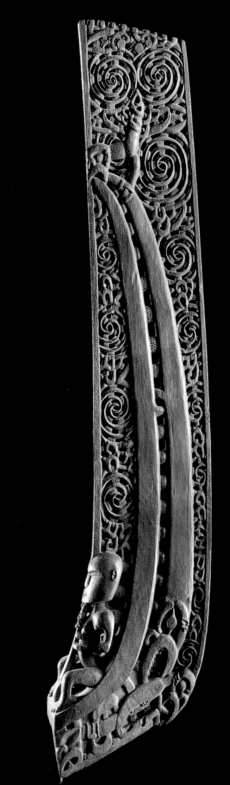

Polynesia: Realm of the Sea

As Polynesia's name suggests, many it undoubtedly is, with its string of basalt lava islands rising from the depths of the ocean. And many-faceted, too, in the arts that have flourished in the hands of its inhabitants: from the most monumental of sculpture to the lightest of bark cloth, from tattooing to basketwork, and from jewelry to dance and singing. Oriented exclusively toward the sea, which infuses their art and rituals in obsessive fashion, Polynesians are above all else seafarers haunted by a world of spirits and of ancestors who must be honored.

Few peoples, it seems, have so endeavored to understand the creation of the world and the origins of time. Thus, most of their foundation myths begin in the *po*, or original darkness, and tell the story of how Father Sky and Mother Earth together created all the other divinities and finally all their offspring, each of these divine beings personifying a particular aspect of the natural world. Among the Maori of New Zealand, the house as a whole is conceived as a symbol of the cosmos and as a metaphor for the community and its ancestors. The darkness of the interior recalls the *po*, while the pillars that support the main roof beam are the embodiment of the support offered by the ancestral gods, whose carved effigies they bear. Other regions have "portable" statues of the gods, but the most impressive effigies of divine figures generally form an integral part of ceremonial groups. We are famil-

Opposite: **Carving from the stern of a Maori great war canoe.** New Zealand. Wood; h. 192 cm. Formerly Atsbury and Charles Ratton collection. Musée Barbier-Mueller, Geneva.
Following pages: **Great war canoe.** 18th century (?) engraving. Archives Barbier-Mueller, Geneva.

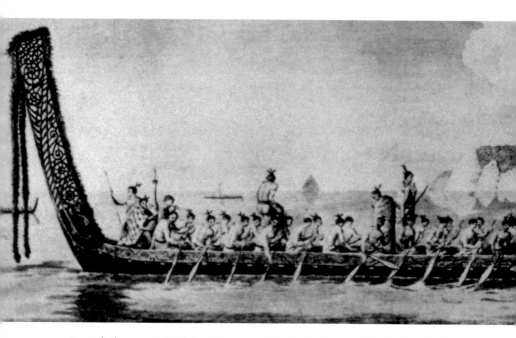

iar with the great *tiki* of the Marquesas Islands; their powerful cylindrical bodies—as though in anticipation of Cubism—so fascinated Picasso, he kept one such piece in his studio. And who could forget the monumental statues of Easter Island, as enigmatic as they are colossal, "mediating between sky and earth, between men and chiefs, and between chiefs and gods"?

In this profoundly hierarchical world, where power was concentrated in the hands of a hereditary oligarchy, two concepts specific to Polynesia underlay all artistic endeavor. *Mana* was a sort of "grace" granted to certain individuals, rendering them not only different and superior to other people but also *taboo*, that is (as in its adopted sense in Western languages) "forbidden" or even "dangerous." Chiefs were able to make use of these two ideas to restrict access both to principal food sources and to the sacred objects and materials used for religious rites, while the arts served to emphasize social distinctions and relationships between the sexes. Yet any study of the languages of Polynesia reveals one notable feature: the complete absence of any term or concept to designate artistic endeavor as an activity in its own right. Did the world of Oceania, like its African counterpart, repudiate the characteristically Western notion of "art for art's sake"? According to Adrienne Kaep-

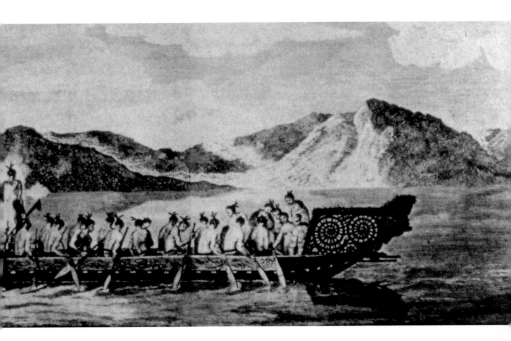

pler in her book *L'Art océanien*, it is more appropriate to consider this type of art in terms of "an ensemble of cultural expressions resulting from creative processes which manipulate or use words, sounds, movements, materials, scents and spaces in such a way as to arrive at a way of making manifest that which has no physical form." As a result, our perception of an art reduced to its sculptures in wood or stone, museum pieces torn once again from their original context and deprived of their intrinsic function, seems distorted and inadequate. Yet, as Adrienne Kaeppler observes again: "Polynesian creations were made to last. When it came to carving objects, preparing fine strands of coconut fiber, making lovely grass skirts or composing songs and dances—all forms of cultural expression that were handed down as a legacy from one generation to the next—time and energy were no object." Contacts between islands also proved very fruitful: patterns and objects circulated freely—as did ideas, gods and wives. Critics tend to disparage Polynesian art for its relatively monotonous quality, in comparison with the prodigious inventiveness of the peoples of Melanesia, where singularity and uniqueness are the rule. But this view is to underestimate a body of work in which stylization and restraint have attained heights seldom equaled elsewhere.

THE POLYNESIANS: BEYOND THE MYTH

"Polynesia": the very word triggers a string of images in Western minds, featuring a voluptuous earthly paradise peopled by velvet-skinned Tahitian maidens wearing grass skirts and serene smiles, as well as a host of other cliches poised limply between Rousseauesque visions of the "noble savage" and Gauguin's beautiful but ultimately disappointed dream. We now know, however, that the peoples of Polynesia were anything but "savages," and that furthermore they were neither as noble nor as friendly as the philosophers of the Enlightenment wished their contemporaries to believe.

When the first Europeans landed on the shores of Polynesia in the late 16th century, this multitude of islands was inhabited by some 500,000 souls, in a total area three times the size of the continent the travelers had sailed from. These peoples migrated from Southeast Asia nearly five thousand years earlier, bringing with them only the strict minimum of belongings: domestic animals and plants for cultivation. Some became farmers (as in Hawaii), while others became sailors (as in Tahiti) or fishermen (as in Tuamotu). But none were able to indulge in a life of idle tranquility befitting an earthly paradise. Regimented by a draconian system of etiquette, the people were expected to offer obedience to both their chiefs and their gods. The elaborate and sophisticated qualities of the works of art they produced, meanwhile, could hardly be further from the unadorned state of nature. Similarly, their supposed sexual freedom, source of many a lurid fantasy, is another generally accepted idea that requires qualification: if orgies did take place, they were always within a strictly religious context. And finally came the list of cruel practices—human sacrifices, torture and even cannibalism—found throughout Polynesia, which should have sufficed to destroy forever these complacent myths surrounding its inhabitants, who were no better or worse than their European counterparts.

Following pages: **Ritual dance in the Fiji Islands.** 18th century (?) engraving.
Archives Barbier-Mueller, Geneva.
Pages 274-5: **Necklaces.** Fiji Islands. Carved and whole sperm whale teeth.
Chief's daughter from the Samoan Islands (Taupu).
Late-19th century photograph. Both: Musée Barbier-Mueller, Geneva.

TONGA, SAMOA AND FIJI: THE ART OF APPEARANCES

Possibly because they feared to give anthropomorphic form to their divinities, the inhabitants of the islands of Tonga and Samoa have produced very little sculpture. The few effigies identified to date are restricted to small female figures carved in sperm-whale ivory, probably originally worn as pendants or hung from hooks in the house of the gods. With dangling legs, slightly bent knees and well-defined breasts, these figures are found in two-dimensional form on prestige objects such as clubs and fly whisks. But if the people of Tonga and Samoa accorded only secondary importance to carved figures, they excelled, by contrast, in the art of "appearances." A missionary named John Williams has left us this detailed description of an elegant Samoan girl, whom he came across on her wedding day in 1837: "Her dress was a beautiful grass skirt tied around her waist and reaching almost down to her ankles; a garland of leaves and flowers, woven in artistic and ingenious fashion, adorned her brow. The upper part of her body had been anointed with delicately perfumed coconut oil and partially painted with the aid of a red dye made from curcuma roots, and around her neck she wore a double row of large blue beads. Everything in her comportment was of a modesty that it was a pleasure to behold."

In these rigidly codified societies, artistic endeavors were not left to chance, and specialized activities were divided between the men and the women. Thus the manufacture of tapa (a cloth made from beaten bark) was a female responsibility, as was the making of grass skirts and baskets. Men were responsible for external tasks such as architecture, making dugout canoes and the arts of war. Every village would nominate a young woman of noble blood to carry out certain rituals, such as the preparation of kava, a holy drink for the exclusive consumption of priests. A 19th-century photograph shows one of these chiefs' daughters (*tapou*) wearing her finest ornaments: an extravagant headdress in bark cloth (*tuiga*), comprising human hair, feathers and shells, garlands of scented flowers and a sumptuous necklace carved from whale ivory. Declamation, music, dance and above all tattooing, a veritable sublimation of the human body, completed the range of arts practiced by the people of Samoa and Tonga, who also used their talents in the islands of the Fiji archipelago, some days' journey away by dugout canoe.

In the early 19th century, a few rare European ships braved the reefs that lay off the Fiji Islands in order to load their holds with precious cargoes of sandalwood. In

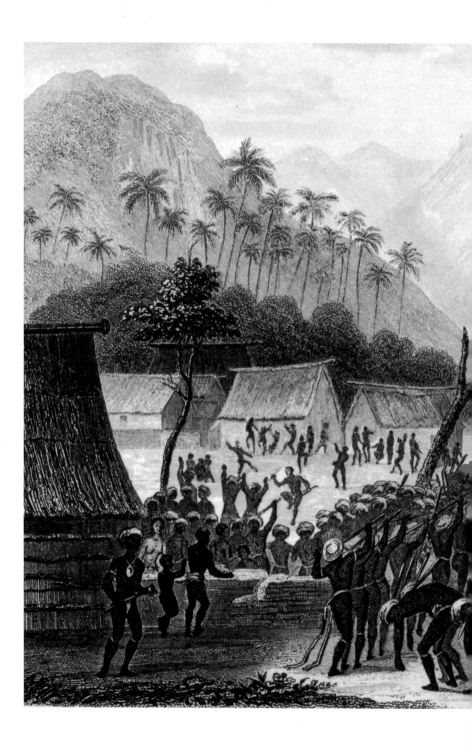

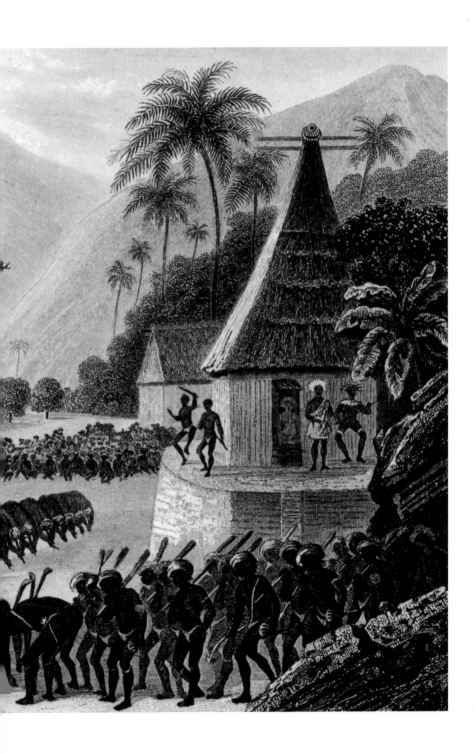

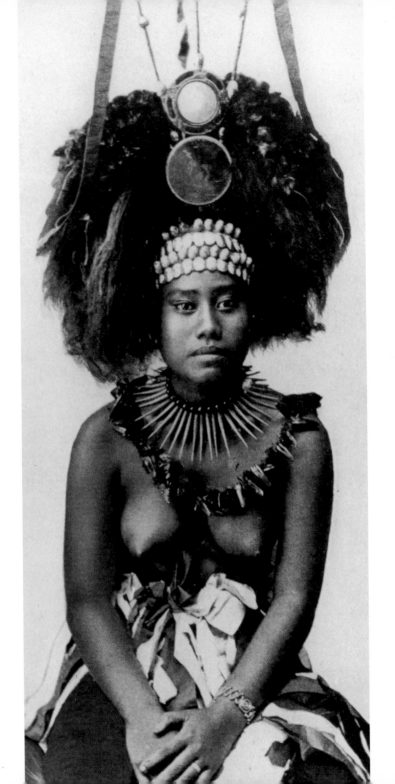

Headrest. **Fiji Islands.** Wood, ivory inlay; h. 16 cm.
Musée des Arts d'Afrique et d'Océanie, Paris.

return, they introduced the islanders to tools made from iron, to firearms and—most fatefully of all—to European diseases. The Fijians were grateful to European merchants, nevertheless, for the introduction of ivory, which they used unstintingly to decorate objects of status and power, such as long staffs, club-scepters and headrests. Few other peoples in Polynesia raised ornamentation and body decoration to such esoteric heights. Adept at making everything from wigs of human hair to shell armbands, and from pendants of pigs' teeth to the spectacular necklaces carved from sperm-whale teeth for the canoe-builders of Tonga and Samoa, the Fijians also decorated their bodies with elaborate tattoos and scarification on their arms and upper bodies, pierced ears, even amputating toes or fingers as a mark of mourning.

Besides devoting time to the traditional activities of weaving and basketry (making superb fans and baskets in cobweb-fine patterns), Fijian women also made a type of pottery, probably of Melanesian origin, unique in Polynesia. Sophisticated enough to support a wide range of decoration—printed, incised, painted, engraved or stamped—these pots were made only by fishermen's wives, and served as a form of currency for trade with other islands. A privilege accorded at birth, making the pots was an activity sufficiently sacred to require the observance of certain prohibitions, such as sexual abstinence. Women were also advised to stop work during pregnancy to avoid compromising the solidity of their pots.

The skills and artistic genius of the craftsmen of Fiji, meanwhile, may be seen in two types of object: splendid war clubs, their original purpose (smashing enemy

skulls) belied by marine ivory inlays and finely carved decoration; and ceremonial bowls in designs of breathtaking directness. The Barbier-Mueller collection contains an example, in the form of a stocky male figure, of a power equal to the ranks of the best sculpture.

THE MARQUESAS ISLANDS: REALM OF THE *TIKI*

"In Europe we do not appear to realize that among the Maori of New Zealand and the inhabitants of the Marquesas Islands the art of decoration was highly advanced. Especially in the Marquesas Islands. … Give an islander an object made up of geometric shapes of whatever kind, and he will contrive—harmoniously throughout—to leave no jarring or discordant gaps. The basis is the human body or face. Especially the face. You are amazed to find a face where you thought there was only a strange geometric figure. Always the same and yet never the same." Who could offer a better description than Paul Gauguin, in *Avant et après,* of the complex and sophisticated art of the Marquesas Islands, then generally considered one of the last bastions of cannibalism and anticolonial resistance? Certainly Gauguin's interest in this other world, even wilder and more distant than Panama or Martinique, should be set in the context of his radical and indignant rejection of a Europe that was outmoded, timorous and narrow-minded—and of which the administrative officers of Tahiti were sadly soon to offer him a debased caricature. But Gauguin, who had almost certainly not had the opportunity to admire the few pieces assembled in the Musée du Trocadéro, opened in 1878, nor the objects displayed at the Exposition Universelle of 1889, quite by chance one day came across a photograph of some Marquesas Islanders sporting traditional tattoos. Thenceforth the photographs went with him everywhere, and he consulted them in wonder before setting off on his great odyssey in September 1901. Having reached an agreement with the dealer Ambroise Vollard, the painter embarked on the Croix du Sud for Atuona, the administrative center of the archipelago. There, too, he was to be profoundly disappointed. As the 20th century dawned, the traditional culture was already under threat from the pernicious combined influence of the colonial administration and the Church. European ethnologists, for their part, had traveled the length and breadth of the archipelago in their quest for the finest pieces with which to enrich the collections of their museums.

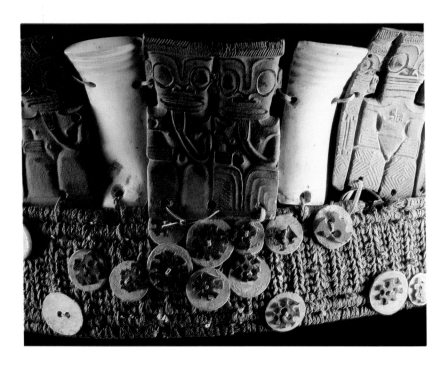

Crown (detail). Marquesas Islands. Tortoiseshell and shells; diam. 22 cm.
Formerly Joseph Mueller collection. Musée Barbier-Mueller, Geneva.

And who exactly were these islanders whose complex and sophisticated art seduced Gauguin with its "barbaric luxury?" One word alone might suffice to sum up the mental and artistic world of the Marquesan islanders: *tiki*. Found with slight variations throughout eastern Polynesia, the term is used to designate simultaneously a sort of half-god, more divine than human, and the great anthropomorphic figures used to decorate shrines or the facades of local dwelling houses, built on stone platforms. By extension, the word *tiki* could be applied to any motif, whether carved or not, derived from a legendary character with immediately recognizable features: dilated cheeks, large round eyes, a flat nose and a mouth reduced to two

Opposite: **Club with upper part in the form of a face.** Marquesas Islands. Wood. Formerly Joseph
Mueller collection. Musée Barbier-Mueller, Geneva.
Following pages: **Forehead decoration. Marquesas Islands.** Pearl oyster shell, tortoiseshell, woven fibers,
dolphin teeth; diam. (disk) 15.8 cm. Musée Barbier-Mueller, Geneva.

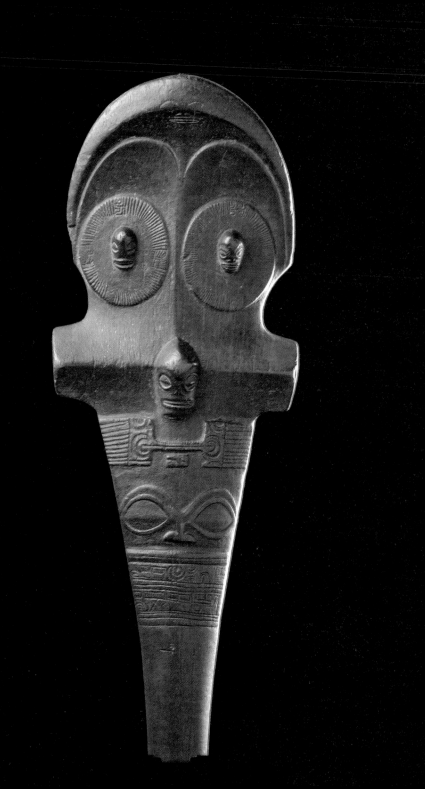

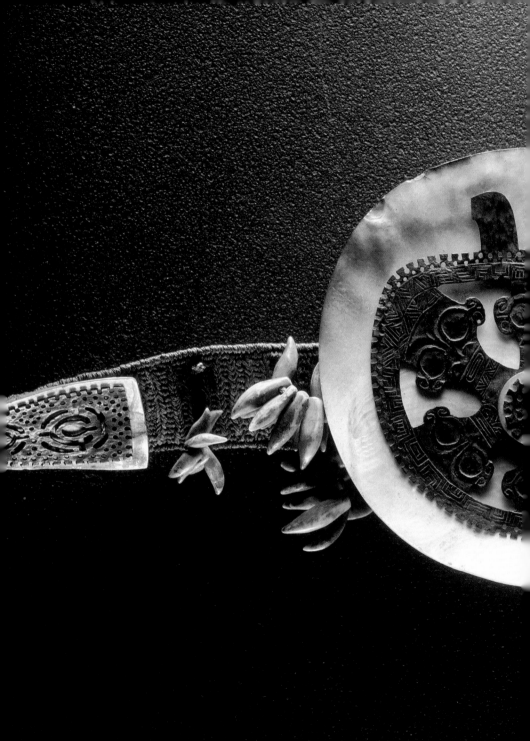

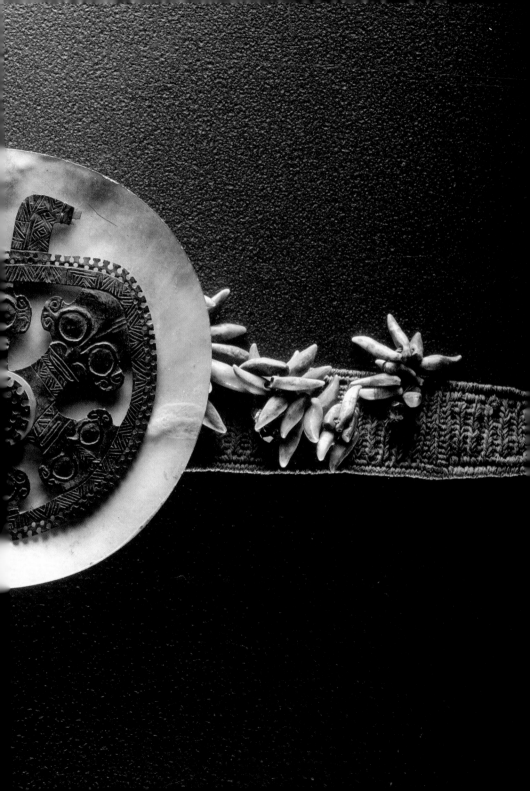

parallel bulges. Its body may be seen as a powerful cylinder in which a lightly modeled torso and arms can be discerned, while the well-defined hands invariably rest on the stomach, seat of the emotions. Is this the figure of a divinity, or, as contemporary ethnologists tend to believe, the personification of an ancestor?

The *tiki* appears in many variations and almost obsessive fashion on virtually every object, sacred or secular, that featured in the lives of the islanders: from carvings in wood and stone to jewelry in tortoiseshell or sperm-whale teeth, and from bark fabrics to tattoos. According to some accounts, it is the embodiment of the first man of the Creation, husband to Hina, the first woman. As a myth from the Austral Islands relates, he "had a body and the power to create other bodies." Weary of solitude, Tiki went to the beach, carved a child in the sand, buried it carefully and went away. On his return, he was astonished to find a beautiful woman and coupled with her. From their union were born children who were the origins of the world: Te-papa-una, or "Higher Platform," and Te-papa'a'o, or "Lower Platform," who in turn gave birth to Oatea and Oatuna, Light of Day and Space. Finally, Tiki decided to create a land for his offspring to live in. "Here I am, here I am, me, Tiki, let Nuku Hiva become an island!" he cried, before going on to found other islands of the archipelago. Another, darker version relates the dual nature of Tiki. Though he had given men the paper mulberry from which they made tapa, as well as the banyan tree and the bird with red feathers, he was also the god of all "deviants" (*kaikaia*), meaning those who had committed incest and those who had tasted human flesh. Finally, Tiki also appears as the ultimate virility symbol, so that small portions of his body (dismembered but magically reassembled by the god himself in another myth) are found incessantly on works produced in the Marquesas, from the tiniest earring to the most daunting war club.

While the human body (or, in its reduced version, the face) thus appears as the principal medium of religious and artistic expression, the islanders also expressed their taste for finery with considerable verve and panache. Here again, materials compete—wood, stone, human bones and hair—to express the "Beautiful," or even the "Terrifying." Cut and curled under heat, human hair coils through war horns, hangs from the tips of ritual staffs and winds round ankles, wrists, arms, waists and shoulders. Old men's beard hairs, considered the most precious, were reserved for particularly prized ornaments for the head and fingers.

War trumpet. Marquesas Islands. Sea conch, human hair.
Musée Barbier-Mueller, Geneva.

If there is one other motif inherent in the art of the Marquesas Islands, it is the eyes, dilated and hypnotic, that gaze so quizzically from fan shafts, bamboo flutes, bark cloth designs and various vessels. The word mata signifies not only the face and eye, but also a knot and the tie of a fishing net: so many faces and pairs of eyes, knots and ancestors, skulls and sacrifices.

HAWAII: EMPIRE OF THE GOD KU

When, in 1779, the supreme chief of Hawaii met Captain Cook, he took off his cape and wrapped it round the European's shoulders, thus offering him a gift of great value as a token of welcome and respect. The sumptuous nature of this ceremonial garment—composed of feathers in brilliantly contrasting yellow and red (the two sacred colors of Polynesia)—indicated the exalted rank of its owner.

The feathered cape of the Hawaiian chiefs was generally accompanied by a helmet in basketry surmounted by an equally flamboyant crest, designed to protect the top of the skull from all attacks of a supernatural or warlike nature, while also striking terror into the enemy with its spectacular appearance. Indeed, warfare and

Headdress. Generally worn by nobles. Hawaiian Archipelago basketry; h. 22 cm.
Musée des Arts d'Afrique et d'Océanie, Paris.

its aesthetic founded on power, aggression and ferocity colored all the arts in
Hawaii—as may be convincingly seen in the carved wooden faces, the features con-
torted into terrifying, grimacelike grins. The god depicted most frequently, more-
over, is none other than Ku, god of war and a sort of malevolent Mars figure of the
Polynesian world. But where the sculptors of other Polynesian islands have often
created rather cool forms, impersonal and stylized, the Hawaiians have opted for
realism, producing figures that stand stolid and square on their bowed legs, their
heads disproportionately large, chests thrust out, arms hanging free and limbs
angular. The figure of the god Kuka'ilimoku in the British Museum, for example,
which stood originally within the precincts of a temple, seems alternately terrify-
ing and sacred. The same Expressionist tendency is found in the sumptuous feath-
er effigies that the Hawaiians would display impaled on posts during ritual
processions; the bared teeth of these effigies made a fearsome impression on ear-
ly European observers. In the eyes of their creators, however, they were neither
monstrous nor malevolent, but quite simply divine; cries of birds rending the silence

Hawaiian chief's helmet. Hawaii. Feathers, fibers. Collected during James Cook's third voyage, 1778-9. British Museum, London.

were taken to be messages from the gods. Thus, to wear a cape of feathers was also, in a way, to assume a divine raiment.

RAPA NUI, ISLAND OF BIRD-MEN

"In the middle of the Great Ocean, in a region that is never visited, lies an island that is mysterious and isolated; there is no other land in the vicinity, and it is surrounded for more than 800 leagues in all directions by empty spaces, vast and shifting. On it stand tall and monstrous statues, the works of an unknown and now-vanished race, and its past remains an enigma."

On January 3, 1872, the frigate *La Flore* dropped anchor off the coast of Easter Island with Julien Viaud, alias Pierre Loti, on board. In his little midshipman's notebook, the awe-struck young man noted his impressions day by day, accompanying them with lively sketches. No detail escaped his attention on this strange island studded with reddish-colored craters and mournful-looking rock formations. In this hostile landscape, so far removed from the earthly paradises inhabited by friendly,

Hawaiian chief's cape. Hawaiian Archipelago. Feathers, fibers; h. 175 cm., w. 289 cm.
British Museum, London.

Following pages: **Effigies of gods.** Hawaii. Basketry, feathers, hair, shells, mother-of-pearl, teeth; h. 104, 63 and 102 cm. Collected during James Cook's third voyage. British Museum, London.

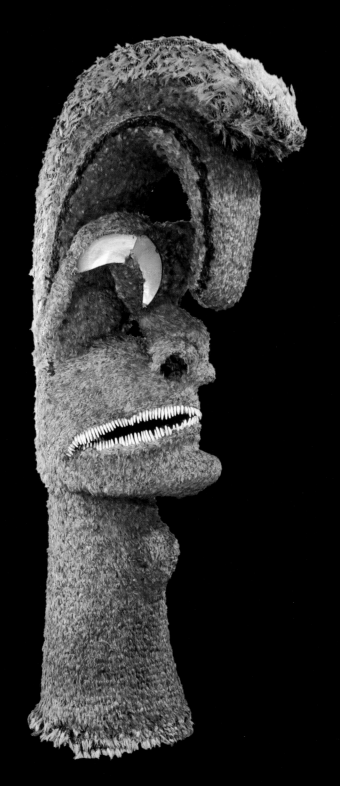

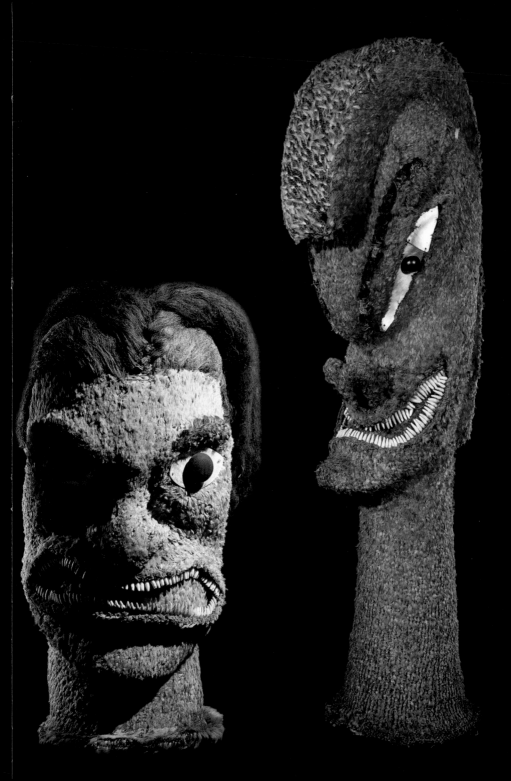

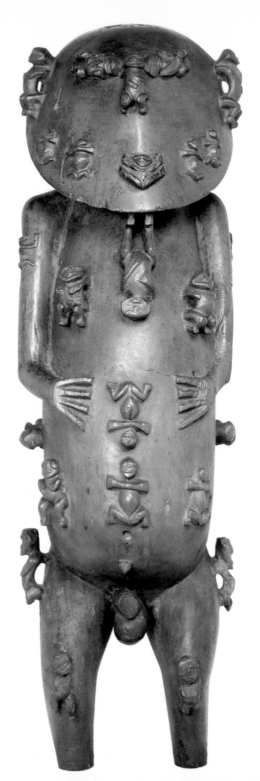

OTHER ISLANDS, OTHER GODS

Delighted to have discovered the beginnings of a true religion among the Poly-nesians, the missionaries nevertheless burned numerous "idols" that they deemed too "pagan" in an immense *auto da fé*. Among the figures that escaped was a strange wooden sculpture, smooth and abrupt as a Brancusi, representing Rao, "god of the shameful divinity" and "cadaver of the Devil." Sent to France as a token of the conversion of idolatrous peoples, and preserved today in the Musée des Arts d'Afrique et d'Océanie in Paris, this work from the Gambier Islands is now one of the most celebrated examples of the arts of Oceania. Paradoxically, it is also one of the least well documented. At times the sole surviving response to ques-tions posed by scholars is the contempt of the missionaries and early explorers.

West scholars tend too often to lump together under the convenient heading tiki gods of the Polynesian world that in fact have nothing to do with one anoth-er. What, for instance, do a colossal basalt effigy from the Marquesas Islands and a rare ivory figure from the Fiji Islands have in common? Every aspect of these works—their size, their ritual function and their aesthetic vocabulary—seems rather to point up their differences. While the first embodies the tutelary figure of an ancestor or god, the second was in all likelihood shrouded in bark cloth, like corpses, and displayed during funerary rites of a propitiatory nature.

In Tahiti, anthropomorphic figures, or ti'i were accompanied by other figures made simply from sticks covered with fiber netting, or to'o. On the Cook Islands, the presence of the divine was expressed through poles carved with a face at one end and a penis at the other. In New Zealand, "god staffs" were ensnared in a mesh of cords from which only a carved face was allowed to emerge. The further east one travels, in short, the more anthropomorphic figures seem to give way to quasi-abstract forms. The germ of common features with Melanesian cultures is unmistakably present. Do not the staffs of the Society Islands and the "god staffs" of the Cook Islands evoke, on a smaller scale, the great poles planted in front of ceremonial buildings in New Caledonia? And this is only one of a multitude of questions that point the way to a fundamental re-evaluation of the history of the Oceanian world.

Figure of the god A'a. Austral Islands Rurutu. Wood; h. 112 cm. British Museum, London.

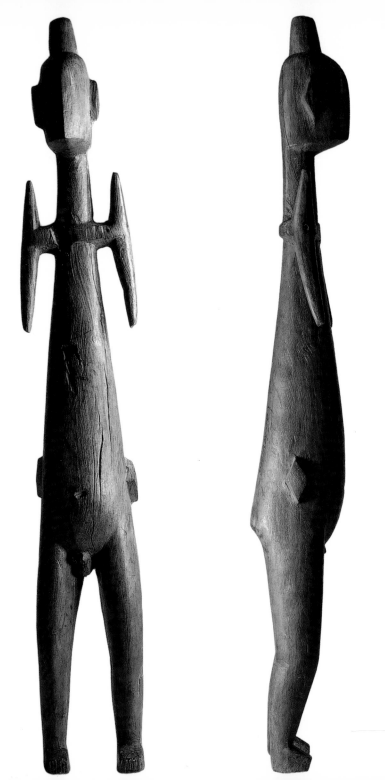

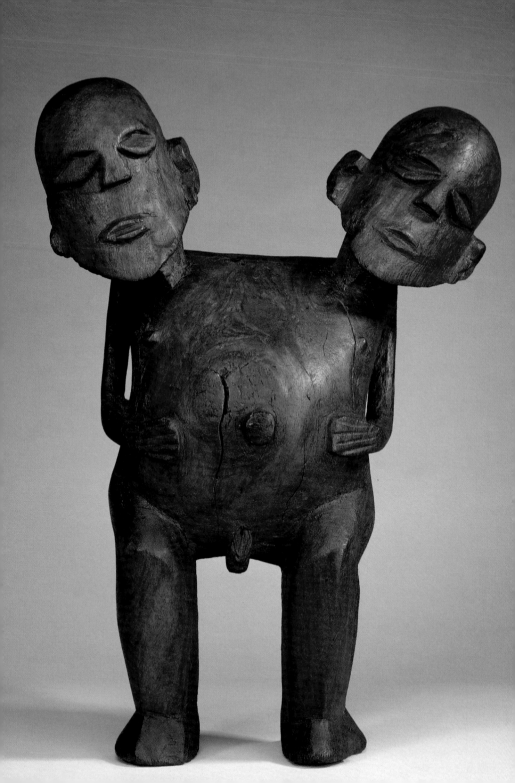

smiling natives that had been described by 18th-century voyagers, all was apparently desolation. The few dozen famished and fearful inhabitants encountered by Loti survived on a diet of roots. When they realized that the newcomers were about to uproot one of their ancient stone statues, its gaze swinging impotently up toward the murky heights of the skies, they let out piercing cries. Crowbars and levers soon sent the great effigies toppling to the ground, where they broke as they landed on their backs with a dull thud. Saws then bit into the soft volcanic stone, rending the air with a terrible grating noise. Removed from its trunk, the great brown hollow-eyed head of one of the *moai* was soon afterward loaded onto a boat and shipped to France: a strange, funereal odyssey for this statue of an ancestor, which now stands as a mocking trophy in the entrance hall of the Musée de l'Homme in Paris.

The future for the inhabitants of this wretched island, "discovered" by a Dutch ship on Easter Sunday 1722 and thus named Easter Island was more dire. When James Cook's expedition dropped anchor in Hanga Roa Bay, on March 14, 1774, the people were light-fingered but friendly. Yet less than a century later, a tragedy without precedent was to strike them, when more than a thousand Easter Islanders, including the king, his son and the island's chief dignitaries (priests and wise men known as *maori*), were carried off as slaves to the guano quarries of Peru. Most of them would perish from disease and ill-treatment, and the hundred or so who survived to return then infected the rest of the population; the entire island became a mass grave. On the arrival in 1864 of the first European missionary, Brother Eugène Eyraud, only some 600 native people remained to hear the word of God.

And yet the first explorers to venture into the treacherous waters of the South Pacific had been quite literally fascinated by the seafaring skills of the Polynesian peoples, whose ancestors had set off on the incredible voyage from the coasts of Indonesia to the distant shores of the Levant. Made with the aid of simple stone

Previous pages:
Figure of the god Rao.
Gambier Archipelago, Mangareva island. Wood; h. 106 cm.
Musée des Arts d'Afrique et d'Océanie, Paris.
Male figure with two heads.
Society Islands, Matavi Bay (?), Tahiti. Wood; h. 58.5 cm.
Collected in January 1882.
British Museum, London.

tools, their immense catamarans with magnificently carved prows cleaved the waves with pride, sometimes carrying up to 300 sailors on board. For the navigation of such great distances, a perfect understanding of the winds, currents and stars was required, aided by sophisticated measuring instruments. Masters of the "Great Ocean," the Easter Islanders were nonetheless solidly attached to their land, to which they introduced Polynesias chickens and rats, and whose sparse raw materials—consisting of palm trees and fish—gave the lie to Western fantasies of islands of earthly delights.

The universally respected and all-powerful master of this island was Make Make, the supreme god and creator of humans, who himself had emerged from the original egg laid by Tangoroa. When he broke the shell, Tangoroa shed the feathers that covered her body, and where these fell to earth, vegetation sprang up. Through masturbating with earth, Make Make then created the host of other gods in Easter Island mythology: Te Emu (the Landslip), Mata vara vara (Heavy Rainfall) and the female demons who would teach the art of tattooing to humans, Lizard Woman and Swallow Woman. …Strange wooden figures, displaying with a rare dramatic intensity their fleshless ribcages and jutting spines, are fascinating embodiments of these akuaku (spirits). Were they divinities of secondary rank, spirits of the dead, or the corpses of chiefs? Whatever the answer, the Easter Islanders were passionately devoted to these effigies, which they rocked like babies while chanting incantations, or hung from their bodies, where they would whirl and dance wildly during ritual celebrations.

The most important religious ceremony on the island was undoubtedly that of the Bird Man. Every year, at the beginning of spring in the southern hemisphere, the men, their faces painted red and black, wearing feather headdresses and brandishing long wooden clubs inlaid with images of eyes, would set off toward the ceremonial village of Orongo. A ritually coded competition would then take place among these candidates for the highly coveted rank of Bird Man. The prize went to

Following pages:
Imaginary scene at Easter Island (?) showing the crew
of the frigate *La Flore* toppling statues of *moai*.
Engraving after a drawing by Pierre Loti.
Musée de la Marine, Paris.

MYSTERIOUS STATUES

"It was about an hour and a half after we had set off again after pausing at Vaïhou that we began to make out, standing upright on the side of the mountain, great figures that cast immense shadows over the wretched vegetation. Arranged in no particular pattern, they looked toward us as though to see who was coming, although we also noticed a few long profiles with pointed noses looking in other directions. ... They had no bodies, but were only colossal heads, emerging from the ground on long necks and held erect as though scanning those distant horizons, eternally still and empty. What race of humans do they represent, with their pointed noses turned up at the end and their thin lips held in a pout of mockery or scorn? No eyes, only deep cavities beneath the forehead, beneath the vast and noble arch of the brows—and yet they appear to be gazing in thought." (Pierre Loti, *L'Ile de Paques, journal d'un aspirant de La Flore*).

Loti was only one of many travelers, from James Cook to Alfred Métraux, who would succumb to the disturbing fascination of these strange and herculean statues carved from the soft stone of the Rano Raraku volcano: the now celebrated *moai* of Easter Island. Gazing toward the houses of the lineage with their backs to the sea, standing proudly on the plinth of their open-air sanctuary (or *ahu*), these immense statues with their coral eyes and curious "hats" of red tufa have spawned an industry of theories and counter-theories. Some lie flat on the ground, sometimes shattered, invaded by lichens and abandoned; others still scrutinize the sky, upright and in single file; others again seem like unfinished sketches, still imprisoned in the rock. Alfred Métraux bluntly described these gigantic inert effigies as "monstrous cripples." What culture could have been wealthy and sophisticated enough to conceive monuments of such haughty arrogance? What sculptors could have been sufficiently inventive and skilled to accomplish such a gargantuan task? And what was the meaning of these stone giants with their unfathomable gaze? Distancing themselves from sensationalist theories of doubtful integrity, ethnologists prefer to stress the coherence of this body of work produced over nearly a millennium, peaking in all likelihood in the 14th and 15th centuries. According to the most generally accepted theory, the statues are representations of gods or ancestors, chiefs or other distinguished figures raised to

the ranks of protective gods of the lineage. All appear to obey the same aesthetic canons, with torsos reduced to massive trunks surmounted by disproportionately large heads with staring eyes (a preoccupation found obsessively in all Easter Island sculpture and throughout Polynesia). In addition, some of them bore on their necks incisions in the form of undulating lines or chevrons, probably alluding to ritual tattoos. With their technical virtuosity (if only by reason of their weight, reaching up to 80 ton), these sculptures could only be commissioned works produced by highly specialized artists. Known as *tahonga*, these "sculptor-priests" passed down their skills and expertise from generation to generation and were well versed in all the rituals that attended such creations, from the first blow of the pick on the rock to the final polishing of the piece. Paid in fish or crayfish, these men were held in high regard by the community for which they carved these colossal figures.

The *tahonga* were probably also responsible for the creation of wooden figurines that are no less astonishing, with fleshless ribcages, emaciated cheekbones and a fixed, wild-eyed stare verging on the hypnotic. Sometimes two-headed, sometimes hermaphrodite, with arched and elongated bodies, these *moai kavakava* or "beings from the other world," push this stylized idiom to the limits and exert a compelling power. Moai papa, for their part, have surprisingly flat upper bodies, punctuated only by breasts that emphasize, once again, the sexual ambiguity of the figure. Composite creatures mingling anthropomorphic characteristics with those of lizards or birds, and representations of seals, turtles, fish and mollusks complete the repertoire of the Easter Island sculptors. Paddles or dance staffs (*rapa*), meanwhile, surmounted by Januslike faces that seem to look both forward and backward, scrutinizing the visible and invisible worlds, are strikingly elegant and modern.

Previous pages:
Staff or stick topped with human head (?).
Easter Island. Wood, h. 156.3 cm. Formerly Joseph Mueller collection.
Musée Barbier-Mueller, Geneva.
Figurine representing a *moai kavakava*.
Easter Island. Wood, obsidian, bone; h. 30 cm. Collet collection.
Musée des Arts d'Afrique et d'Océanie, Paris.

the man whose servant found the first egg laid by a sooty tern on the small island of Motu Nui, which lay more than a mile off a shark-infested coastline! The winner, his head, brows and lashes shaved, would then become the embodiment for the coming year of this divine figure whose elegant, hybrid silhouette embellished the island's petroglyphs, and was later to captivate the painter Max Ernst with its haunting lyricism.

THE MAORI, OR HORROR OF THE UNADORNED

Just as the word *tiki* is sufficient to evoke the artistic world of the Marquesas Islands, so the word *tatu*, meaning "tattoo," informs the artistic activities of the Maori people. Widespread throughout Polynesia (from Samoa to Tahiti and from Hawaii to Easter Island), the art of tattooing was perfected by this seafaring, warlike people who landed on the coasts of New Zealand about AD 1000. No potential medium seems to have escaped their passion for decoration and their delight in lines and spirals: the same repertoire was to mark the scarified cheeks of their chiefs, the flourishing architecture of their granaries and communal houses and the prows of their immense war canoes, as well as musical instruments, quill boxes and other objects of daily life. A strange decorative vocabulary is to be found in these curvilinear compositions, in which the discerning eye may gradually make out an anthropomorphic figure evoking the memory of a dead ancestor, the profile of a head with a disproportionately large, pointed tongue like a bird's beak, or the outline of a lizard, crocodile or fish.

While tattoos on women were confined to the lips and chin, on men they extended from the waist to the knees, as may be seen in numerous engravings based on sketches executed by members of Cook's expeditions. Facial tattoos, sacred in essence, were apparently the preserve of high-ranking dignitaries, who remained tabu throughout the time necessary for this delicate and painful operation, during which they were fed through a carved funnel.

From the deep and tortuous lines etched on the faces of chiefs it is only a small step to the grooves and slashes cut into statues and the wooden beams of meeting

Dance staff (*rapa*). Easter Island. Wood. 18th century; h. 78.8 cm. Formerly Butler Museum, Harrow School (England). Musée Barbier-Mueller, Geneva.

houses: here again is the same horror of the unadorned, the same proliferation of curve and countercurve found throughout Maori architecture. Spirals and chevrons, hybrid creatures combining human and reptile features, evocations of birds, monsters in contorted or aggressive postures, primordial divinities with arms raised, ancestral figures with tattooed buttocks: in short, a teeming, swarming, disturbing cosmogony, like the bestiary of a medieval cathedral or illuminated manuscript.

Meeting houses, conceived in their entirety as the images of the bodies of distant ancestors, were not the only symbolic representations of the cosmos. The great war canoes seemingly fulfilled a similar metaphorical role: the splendid carvings decorating the prow thus represented Father Sky in the upper part, with Mother Earth shown horizontally below. Images of spines and ribs in the stern were references to the world of the ancestors.

In contrast to this profusion, Maori jewelry carved in nephrite—a type of jade, hard and difficult to work, with a handsome emerald color—seems a model of restraint. Generally following the sinuous outlines of a *tiki* decorated with eye motifs in mother-of-pearl, pendants were endowed with a highly valued prophylactic power. Precious talismans, they were handed down from generation to generation.

Old Maori chief, with face tattoos.
Period photograph. Archives Barbier-Mueller, Geneva.

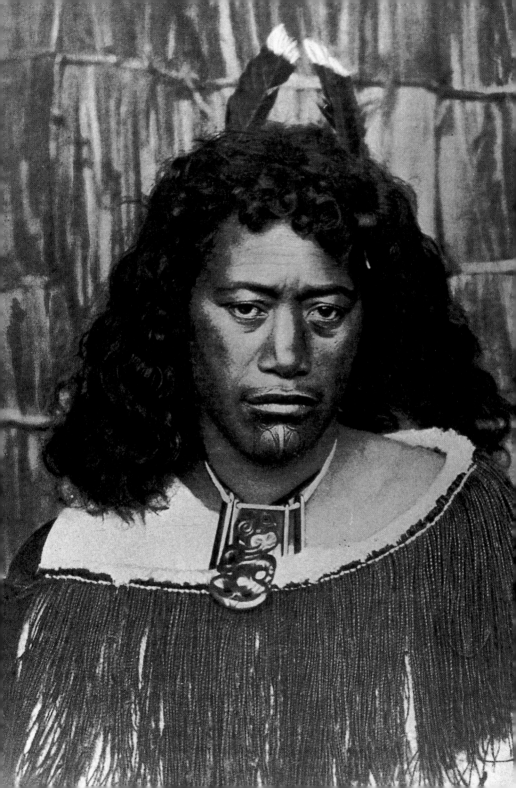

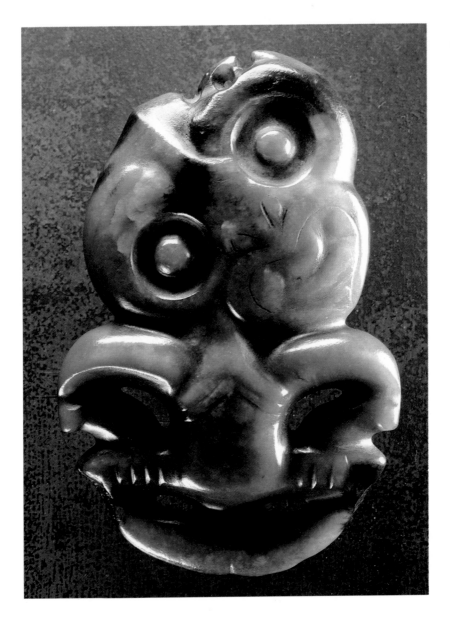

Opposite: **Young Maori dignitary wearing a sacred pendant.** Period photograph.
Archives Barbier-Mueller, Geneva.
Above: **Pendant (*hei tiki*).** New Zealand. Jadeite (nephrite); h. 6.5 cm.
Musée Barbier-Mueller, Geneva.

PRESENTATION AND REPRESENTATION

Among the peoples of Polynesia, the arts of the dance, theater, poetry and oratory were held in the same high esteem as weaving and jewelry-making, architecture and sculpture. On many islands, the art of oratory took precedence. In Samoa, to cite only one example, orators delivering a speech would be wrapped in a length of bark cloth and equipped with the insignia of their function: a fly whisk and staff. Although the Tahitians did not display any particular aptitude for the plastic arts, they excelled in the performing arts, as may be deduced from the magnificent workmanship of their musical instruments, including exuberantly carved drums and finely decorated bamboo nose flutes. Composing, acting and dancing were viewed as noble activities worthy of the highest respect: chiefs and their wives and children would take part in theatrical performances, arrayed in their most sumptuous costumes and finery for the occasion. Sometimes satire and mockery formed part of these performances, which freely lampooned priests and rulers. Tahiti was also celebrated for its *arioi*, or professional clowns, who traveled from island to island performing their caustic monologues.

In other circumstances, such as death rituals or presentation ceremonies, music and dance, performed by specialized artists in the middle of ceremonial enclosures, assumed a supremely sacred significance.

Opposite: Fly whisk handle topped with a pair of janiform figures.
Austral Islands. Hardwood; h. 32.4 cm. Formerly A. Baessler collection.
Musée Barbier-Mueller, Geneva.
Following pages:
Fly whisk handle topped with animal-headed human figure (?).
Austral Islands. Hardwood; h. 27 cm. Formerly Beasley collection.
Musée Barbier-Mueller, Geneva.
Human-form bowl. Used for the sacred *yaqona* beverage
offered by priests to ancestral spirits.
Fiji Islands. Hardwood; h. 35.9 cm. Musée Barbier-Mueller, Geneva.

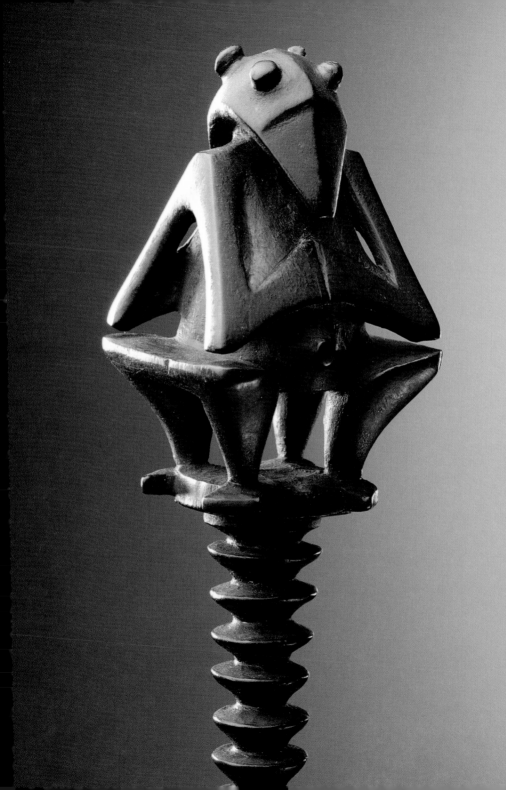

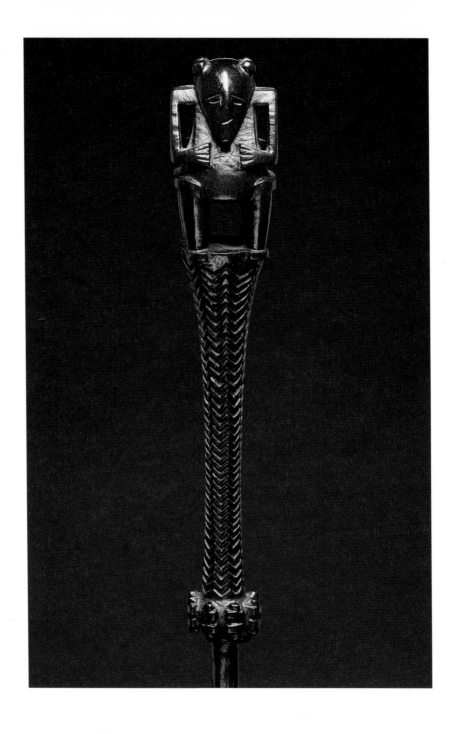

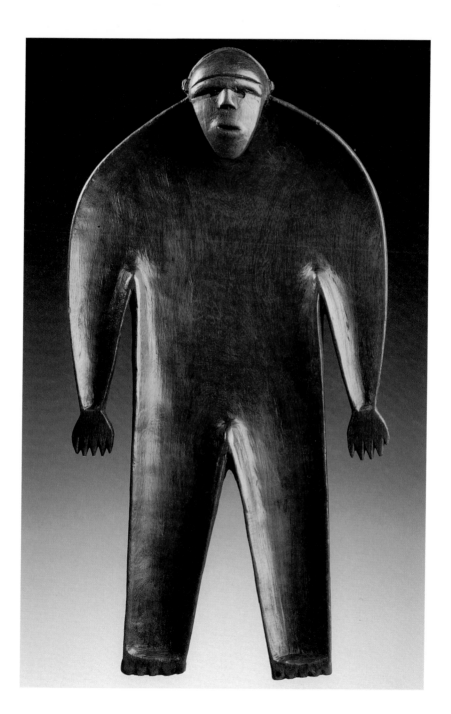

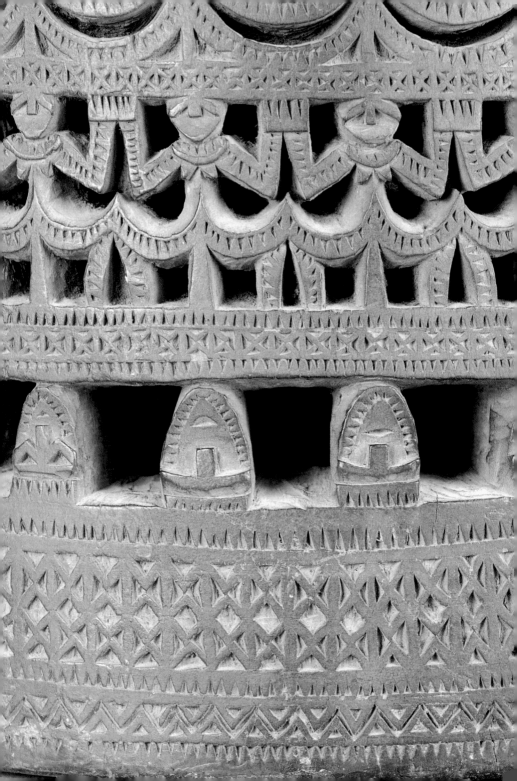

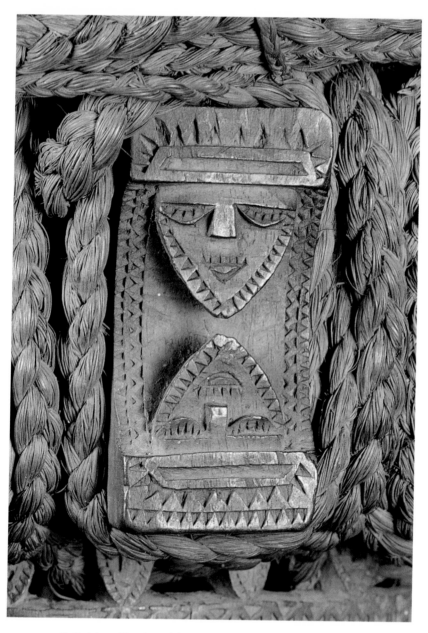

Vertical drum. (Two views of details). Austral Islands. Wood fiber; h. 125 cm.
Formerly Vivant-Denon collection. Musée des Arts d'Afrique et d'Océanie, Paris.

TAPAS: PRECIOUS AND SACRED CLOTH

In Tahiti, no ceremony surrounding the presentation of a gift was complete without the presence of a large piece of bark cloth, or tapa: an indication of the importance accorded to these prestigious objects that entranced European voyagers with the sophistication of their workmanship.

With a few rare exceptions, making tapas was a female affair. Handed down by a goddess (Polynesian cosmology attributed the origin of this fabric to the goddess Hina, who could be seen beating bark under a banyan tree at the full moon), it was an art practiced only by women, though planting the threes was men's work.

Far from being merely a garment, the tapa was also a mark of rank, merit and wealth. It also fulfilled a deeply religious function, enveloping the statues embodying gods set on ritual platforms, or serving as a shroud at death rituals. A badge of identity, the tapa also announced ethnicity, featuring the decorative repertoire specific to each region and to each clan.

In the Fiji Islands, stenciling was the preferred decorative technique; in Tonga, the tapa played a mnemonic role, serving as the sketchy outlines of a form of writing and narrating historic deeds; in the Marquesas, the tapa was white, unless used to cover the heads of ancestor figures, in which case it was covered with tattoolike patterns that gave it the appearance of human skin. The exceptionally refined tapa of Tahiti bore printed patterns of leaves and flowers, while their Hawaiian counterparts were distinguished by the wide range of colors. But the most arresting were undoubtedly those of Easter Island, covered with anthropomorphic figures representing gods.

The peoples of Melanesia were to push the techniques used in making tapas to even greater heights. The Baining of New Britain in Papua New Guinea, for instance, would stretch them over a fine wicker or bamboo framework in order to create their unmistakable masks: gigantic insects with long noses and a dreamlike quality that was to captivate the Surrealists, and most notably the Swiss sculptor Alberto Giacometti.

Fragment of tapa (bark cloth). Cook Islands (?). Beaten bark; l. 150 cm.
Musée des Arts d'Afrique et d'Océanie, Paris.

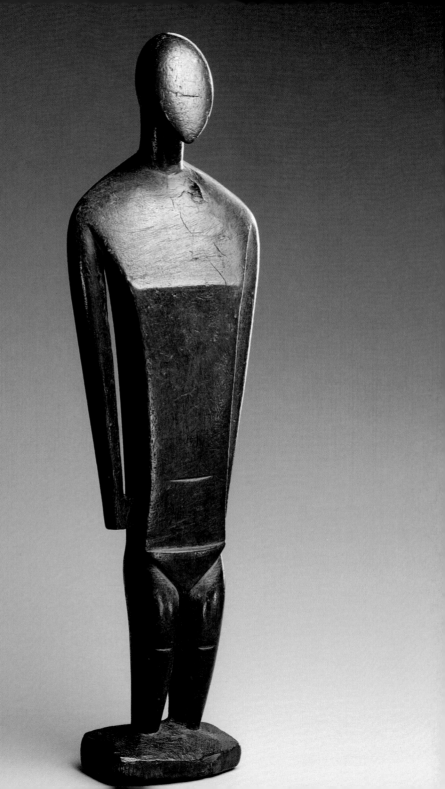

Micronesia: Between Sea and Sky

"What is important above all else for the people of Micronesia is to understand how the sea, sky and earth fit together," Adrienne Kaeppler observes with succinct accuracy in *L'Art océanien*. Marooned on their tiny volcanic islands strung like drops of coral and fire across the waters of the Pacific, this seafaring people has always been oriented toward the sea and has forged its mental and spiritual universe and taken its inspiration from the immense waters that surround it. Trading links, diplomatic relations and exchanges of gifts and materials have all encouraged the people of Micronesia to set to sea, leaving their tiny atolls behind. While carving was not (with a few magnificent exceptions) among their chief artistic preoccupations, these intrepid sailors nevertheless created canoes as proud as cathedrals and communal houses as lofty as ships.

Figurine representing a divinity. Caroline Archipelago, Nukuoro Atoll. Hardwood; h. 40.2 cm.
Formerly Paul Guillaume and Georges Ortiz collection.
Musée Barbier-Mueller, Geneva.

Magellan was the first European to land on the shores of Micronesia: in 1521, the Portuguese navigator dropped anchor at Guam, to be followed seven years later by a certain Alvaro de Saavedra Cérion. Disembarking at Pohnpei, the latter named the island "Barbudos," after the beards worn by the local people. Contact with Europeans did not intensify until the early 19th century, with the arrival, in the coveted waters of the Pacific, of whalers and merchant ships on their way back from Asia. These were followed, in classic fashion, by missionaries, colonists and soldiers.

Few of the world's regions seem to have been regarded with such indifference, or even contempt, as Micronesia. A melting pot of cultures, languages and artistic practices, all of which reflect these complex origins, this archipelago of "little islands" (as its name suggests) has a disconcerting, almost disturbing side. While some of its inhabitants undoubtedly came from Southeast Asia nearly 4,000 years ago, others display unmistakable similarities with the peoples of Melanesia, and even of Polynesia. Many and complex as they are, these lines of descent are an indication of the long history of migrations behind peoples who quite simply defy all classification or generalization.

One common denominator nevertheless links these populations: their overriding love of the sea and its inexhaustible resources, fulfilling needs ranging from the economic to the spiritual and artistic. Besides dividing people, the ocean also sometimes unites them.

Canoes were honored above all other objects and frequently invested with religious symbolism, and among some Micronesian populations their construction was the prerogative of high-ranking members of society. With their deep hulls, large triangular sails and sides painted sometimes in the solemnly religious colors of red and black, all united by a rare purity of line, these vessels were created not merely as a means of transport over the ocean but also as a source of communal pride. At Truk, the great war canoes known as *wa faten* were equipped with detachable carvings in the form of birds with tails spread and beaks facing each other. Far from being purely decorative, these embellishments to the prow and stern served to broadcast the intentions of the canoe's occupants: peaceful if the figures were in the low position, warlike if held high. Miniature models of these boats, faithfully reproducing every detail of the originals, were kept in meeting houses, where they were displayed on shelves or suspended from the roof beams. Dedicated to particular spir-

Dish. Western Islands, Wuvulu (Maty Island).
Hardwood, glossy red-brown patina; l. 43.7 cm.
Musée Barbier-Mueller, Geneva.

its or gods, these models were believed to house the souls of dead people. Remarkable fetishes ("good weather charms") in the form of human heads spiked on sticks, intended to keep malevolent spirits at bay and offer protection from storms and typhoons, completed the arsenal of Micronesian sailors, eternally subject to the whims of the "Great Ocean."

Motifs drawn from the sea and its flora and fauna also can be found less obviously in other, equally original works from Micronesia, in the form of splendid shell-encrusted covered containers, tortoiseshell dishes, and stools for grating coconut, whose stylized outlines are reminiscent of birds. Although extremely rare, anthropomorphic images also formed part of the Micronesian repertoire, as may be seen from the impressive wooden statue from the Caroline Archipelago now in the Auckland Museum. Couched in an aesthetic vocabulary of singular restraint, this monumental figure (more than six feet high) is believed to represent Ko Kawe, protective god of the Sekawe clan and wife of Ariki Tu Te Nato Aki, god of the kingdom of death. The same plastic power and stripped-down purity of form can be found in another masterpiece in the Barbier-Mueller collection: a female figure verging on the abstract, a distant and fortuitous cousin of the idols of the Cyclades,

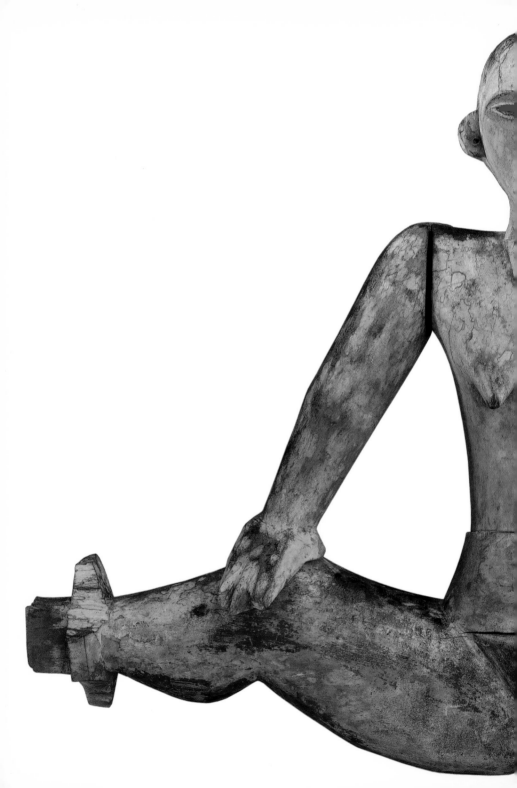

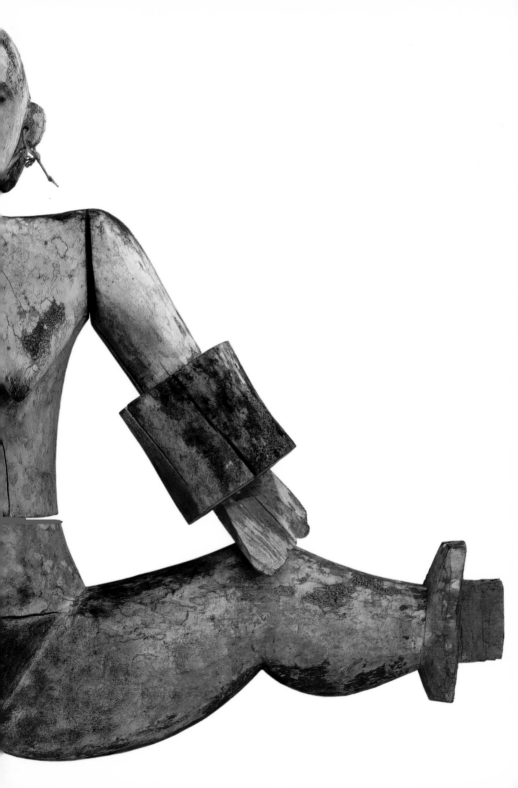

which were also fashioned by unknown seafaring sculptors. Whether she is a tutelary goddess or the spirit of an ancestor, one thing is certain: the hieratic, full-frontal pose and the powerful torso and burly shoulders are marks of an authoritarian divinity, feared and respected. Some ethnologists even conjecture that such a goddess would probably have been honored with human sacrifices.

But above and beyond these curious white masks fringed with goatee beards, these precious mats and belts decorated with tattoolike motifs, and these fabrics so tantalizingly similar to their Indonesian counterparts, the genius of Micronesia is illustrated in supreme fashion by its dazzling architecture, at once monumental and decorative, symbolic and practical.

Solidly planted in the ground in order to resist the ravages of storms and cyclones, the meeting houses, or *bai*, of the Caroline Archipelago, Yap and Belau (formerly Palau) offer a striking sight, with their imposing stone platforms, high sloping roofs like ships' sails and deep overhanging gables. Virtuoso examples of the architect's art, built without the aid of a single nail or screw but only with removable pegs, these ceremonial buildings also bear striking similarities to the lofty buildings of the Southeast Asian islands and Melanesia. The same hierarchical organization of space, the same symbolism of the cosmos and the same penchant for narrative decoration are common to all. Thus, the gables of the houses on Belau sport numerous images linked to the notions of fertility and prosperity (including plants, fishes, food animals, roosters and phalluses), while rows of severed heads recall the practice of head-hunting, linked to the cult of ancestor worship throughout Southeast Asia and Melanesia. The narrative scenes that unfold, in black, white and ocher pigments, on the beams and facades of these houses are full of freshness and spontaneity. These entertaining bas-reliefs, in which the tutored eye may make out particular episodes from the mythology of specific islands, the outlines of European sailing ships or shoals of fish in some way represent the collective memory of the island, and its visual and poetic chronicle. Sometimes straddling the roof was the brazen, haughty figure of Dilukai, a young woman whose provocative posture,

Previous pages:
Figurine from a men's longhouse (*bai*)
The figurine represents the young woman named Dilukai. Belau.
Wood, pigments, fibers; h. 60 cm. Linden Museum, Stuttgart.

her legs spread wide, was a paradoxical reminder of the virtues of chastity. Micronesian legends recount how Dilukai's brother Bagei carved this lascivious portrait of his sister in order to chastise her for her shameless ways. Above and beyond its original symbolism, the vigor and intensity of this image proved irresistible to the German Expressionists of Die Brücke group, from Ernst Ludwig Kirchner to Karl Schmidt-Rottluff, and from Max Pechstein to Emil Nolde. Unlike their French counterparts, some of these young artists were only too eager to accompany ethnological expeditions, accumulating sketches and drawings "on the ground" that would later provide inexhaustible inspiration and exert an influence over their entire subsequent output.

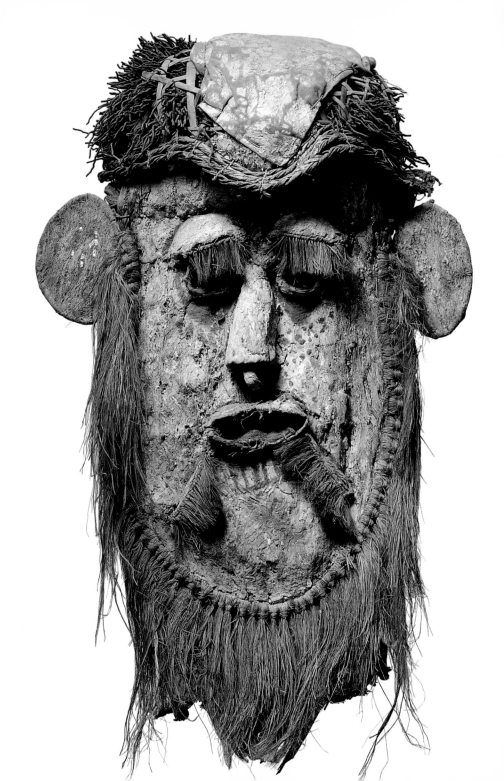

Melanesia: Realm of the Singular

While in Western eyes the names of Polynesia and Micronesia stood for purely geographical concepts, that of Melanesia was rapidly colored by a distinctly disapproving moral stance. Dubbed "black savages," the people of Melanesia—survivors of a Stone Age culture long vanished in the West—were dismissively lumped together under the pejorative name of Kanak indians. Yet these island-dwellers distributed over a string of islands forming an arc between New Guinea (which is included) and New Zealand (which is not) now stand revealed as exceptional artists, whose creations defy any attempts at generalization or classification. For here, unlike in Africa, all that is singular, individual or different—in short, anything that smacks of flair and imagination—reigns supreme.

Mask (*lali*).
New Ireland, Muliama area. Bark cloth, fiber, plant matter, cloth; h. 65 cm.
Collected by R. Parkinson before 1909.
Musée Barbier-Mueller, Geneva.

In the cultures of these mountainous islands pitted with volcanoes, there was nothing monotonous, nothing static, nothing shackled to the services of conformism. The overriding aim here was to dazzle, to amaze, to intrigue—and sometimes even to terrorize. To this end, no element was left to chance: artistic activity became a "laboratory" in which forms and techniques were experimented with in a truly astonishing spirit of freedom. The materials used, whether lasting or ephemeral, were both striking and compelling in their eclecticism: from simple palm leaves to human hair, passing on the way every possible variety of wood, grain, fruit and colored clay, and not overlooking the skins of certain mammals, the shimmering feathers of numerous birds, shells, tusks, skulls and teeth, as well as delicately ethereal spiderwebs.

The great specialist in these regions, Christian Kaufmann, nevertheless holds up a warning to Western art lovers from the outset: "To Western eyes, Melanesian forms of expression seem more heterogeneous, more complex, "savage" and archaic, more strange even than their counterparts in Polynesia." And he throws down a further challenge: "What do we see? Are these individual works, in the sense understood by European art from the Renaissance to the present day, that is to say unique creations—ex nihilo for preference nowadays—by individuals becoming increasingly different from one another? Or are these rather images that have become art, but which belong fundamentally to ancient cultures, subject to the conditions of life in the tropics, and which have grown in complexity as they have evolved historically?" Furthermore, have "artists" in the European sense of the term ever really existed in Melanesia? According to Kaufmann, "image maker" would be a more appropriate term, reflecting the primordial importance in these societies without writing of the role and place of these "bearers of tradition," who were also the exclusive and specialized keepers of a visual tradition.

But as is sadly so often the case with what used to be termed "primitive" art, our conception of the creations of Melanesian culture is nonetheless only partial. Though dominated to all appearances by static pieces (such as the tree-fern funeral effigies of Vanuatu, the doorposts of New Caledonia, the ceremonial dwelling

Necklace used for ritual sorcery. New Guinea. Fiber ring, shells, bones, pig's tusks, sections of a mother-of-pearl pectoral ornament; maximum height 38.5 cm. Musée Barbier-Mueller, Geneva.

posts of the Solomon Islands and the men's longhouses of New Guinea), the output of these islands only attained its full, captivating power through its extraordinary talent for movement and metamorphosis. In this, Melanesia is similar to Africa: only those who have experienced at first hand the haunting quality of a masked dance can begin to understand from within the mental and artistic world of these peoples. Whether relating scenes from the creation of the world or, more prosaically, chastising, soliciting or even attacking the spectators, all the masks with their ruffs of feathers and leaves play on the element of surprise. Equally unpredictable are the stick figures of Malekula, dancing about like marionettes above a leaf screen. Nor should we forget either the portable mannequins of the New Guinea Highlands, carved heads raised high in the air on stakes, or finally the *yena* masks, driven into the ground but with enormous heads that the slightest shake would set nodding.

One essential principle inherent in Melanesian art should not be forgotten, however: none of these works was conceived in order to be contemplated in isolation or seclusion (let alone in a museum display case). Each was intended to take its place in a well-defined environment, as part of a structured group. Thus masks and decorations, the complex iconography of dwellings, ceremonial places and ritual dances formed a single whole, with a duty to proclaim together the symbiotic relationship between the present-day clan and their distant origins. For if there is one essential difference between the art of Polynesia and that of Melanesia, it is precisely in the close and omnipresent relationship between the latter and the fundamental organization of society. "Figures of ancestors," not of gods, is the attribution generally given to these effigies by Western scholarship. All too often, sadly, we do not know how to read these disconcerting forms and images, prisoners as we are of our naturalistic, rationalistic European conception of the world. Perhaps we should take comfort in the fact that the triangular facades of the Abelam spirit dwellings in New Guinea do not have the same meaning for the fully initiated, who have completed the seven stages of initiation, as for the partially initiated. Hence it behooves ethnologists to remain particularly modest in their assertions, and to bear in mind Christian Kaufmann's advice: "To begin with, perhaps we should try to dream like the Melanesians. ... But for this we lack visual memories of a Melanesian childhood."

THE LAPITA CULTURE: COMMON ORIGINS

Fine stone sculptures—stylized pestles and mortars—unearthed by chance by gardeners or road improvement works, represent in the eyes of archaeologists the most ancient examples of artistic works by the inhabitants of the Highlands of Papua New Guinea. Displaying a highly developed aesthetic vocabulary, these sculptures are generally dated to about 8000 BC.

In about 2000 BC, however, a radically different culture arose in these regions, dubbed Lapita after the archaeological site in New Caledonia which had yielded some vestiges of it. Although numerous questions still surround the origins of these populations (some believe they came from Indonesia or the Philippines, while others maintain that the culture originated in New Britain or New Ireland), one thing is sure: these were people who spoke Austronesian languages, rather than the Papuan languages of their predecessors. But it was their art, and most notably their ceramic work, that was about to invade the whole of the Pacific region, revealing the scale of contacts and exchanges between the islands as well as the emergence of a veritable cultural melting pot. From deepest Melanesia to the islands of Samoa and Tonga in the extreme west of Polynesia, indeed, we find the same vocabulary of complex geometrical motifs and stylized human figures. Even more significantly, the same repertoire is also found on objects belonging to the Dongson civilization of Southeast Asia, thus demonstrating the complex nature of the relationships between all these South Pacific cultures. While archaeologists have drawn attention to the development of certain iconographic themes, numerous mysteries still shroud the true part played by the Lapita heritage in the domains of cults and beliefs—a matter on which ethnological research may succeed in shedding some light in years to come.

PAPUA NEW GUINEA: IMAGINATION IN THE SERVICE OF ART

New Guinea is that strangely shaped island, like a proud bird raising its head, that lies like a bridge between the world of Indonesia and the continent of Australia. This patchwork of cultures and peoples (speaking more than 700 languages according to some ethnologists) was for many years little known and little understood. Worse: as a focus of dread and alarm, New Guinea was single-handedly to crystallize all the fears and fantasies aroused in Westerners by these wild, virgin territories, so far distant from any vestige of "civilization." Here diversity, eclecticism and the ephemeral are the rule, and any attempt to encapsulate the art of this region alone in just a few pages is a daunting challenge, verging on the impossible. Here, more than anywhere else, the meaning and symbolism of these disconcerting objects constantly escape our Western judgments, constrained to gape in mute wonder before such technical prowess, ingenuity and playful creativity. Here, in the shadow of mountainous peaks capped with snow or ice, on the margins of swamps and the banks of muddy rivers, and on the fringes of dense and humid tropical forests, the union of the macabre and the poetic, the dreamlike and the sophisticated, and of animal, plant and human life is celebrated with power and passion. Declamations, music, dancing, masks, body painting, tattoos and the organization of villages and gardens: all forms of artistic expression are designed to communicate with the world of the ancestors, to mark rites of passage and to rehearse over and over again the intimate spiritual links that unite humans with their environment.

The complex nature of the play of influences between these remote regions and the primitive civilizations of Southeast Asia cannot be over-emphasized. To be convinced of this, it is sufficient to admire the graceful curves and countercurves that decorate the prows of war canoes, interpreted by some as evocations of water spirits, or as stylized depictions of coral, of octopus tentacles or of other fearsome sea monsters. But far from showing slavish imitation, the art of New Guinea borrows such motifs in order to recreate them, mingling tradition, innovation and individual initiative with rare power. Naturalism, expressionism, abstraction: no aesthetic

Hook for hanging skull trophies.
Papua New Guinea, (?) Gulf of Papua. Hardwood; h. 70 cm.
Formerly Webster collection, then Pitt-Rivers Museum, Farnham (England).
Musée Barbier-Mueller, Geneva.

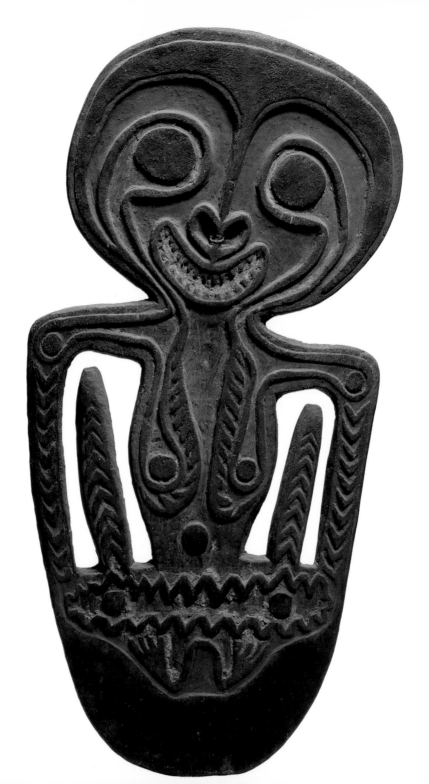

Board carved with "portrait" of a guardian spirit.
Papua New Guinea, (?) Gulf of Papua. Wood; h. 192 cm. Musée Barbier-Mueller, Geneva.

vocabulary appears to have been overlooked in this remarkable laboratory of shapes that the Western world has not ceased either to explore or to praise in recent decades.

Among the most fertile and inventive of all regions of New Guinea is the small patch of swampy land in the very north of the island, following the sinuous meanders of the river that has inspired its name: the Sepik province. Here every object—from the simplest coconut bowl to the most colossal men's longhouse; from a precious flute mouthpiece encrusted with shells and mother-of-pearl to the decorated skull of an ancestor; from a roof finial to a complex arrangement of flowers and foliage that could be blown away in an instant by the merest breath of wind—

Skull trophies and carved boards From the Gulf of Papua. Period photograph.
Archives Barbier-Mueller, Geneva.

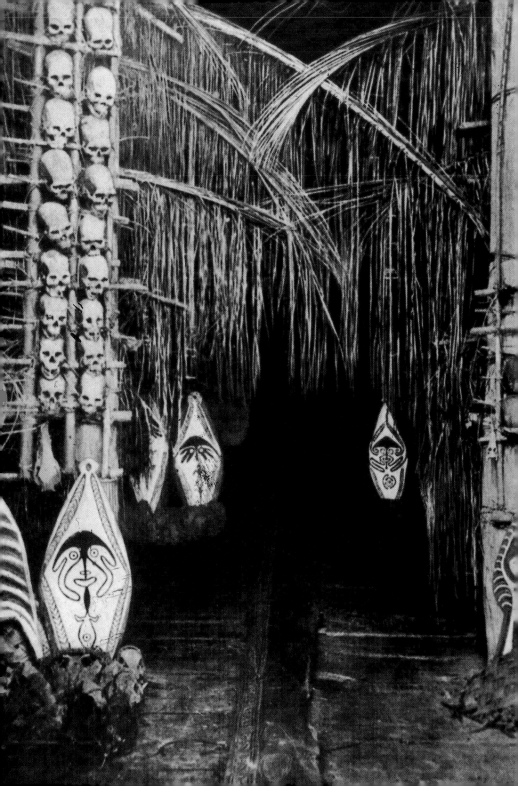

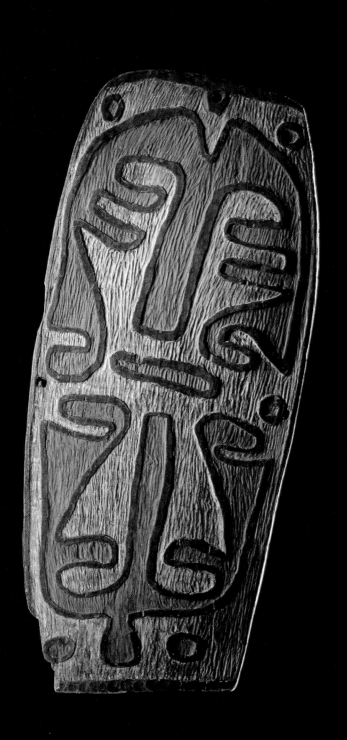
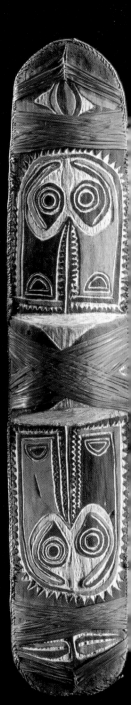

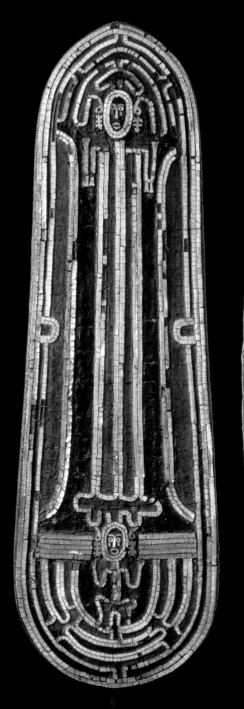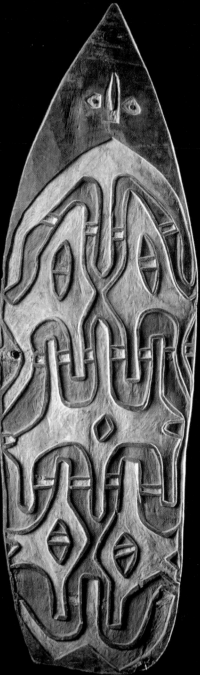

possesses a poetic power and creative intensity rarely found. And if there is one basic premise that we would do well to forget in the context of these regions, it is the myth of the anonymous "primitive" artist. We have already seen the extent to which we must qualify or modify this prejudice, still clung to so doggedly, with regard to Africa. Here, even more, there are no tired stereotypes, no hard and fast rules, no comforting hidebound prototypes. Each Sepik artist has his own strong identity, respected and recognized by the community, and is given a mandate to produce his own distinctive works under the protection of something akin to our copyright laws. It is up to him to enhance his reputation by impressing a discerning and demanding public with his originality and his skill at transcending existing models and his aptitude for the tricks of the artist's trade, handed down from generation to generation. It comes as no surprise to discover that the Surrealists were greatly taken with this intrinsic and exhilarating freedom, in which lies the genius of the Sepik people. Here a bird's beak becomes a crocodile's jaw, there the spinal column of an ancestor is transformed into an insect. Sinuous arabesques, pointed breasts and jutting shoulder blades are all so many means of scrambling all categories of representing the human body, which instead is taken apart ad infinitum, offering itself as a conundrum to all those eager to decipher these streams of enigmatic signs which some Western scholars have described as "automatic writing."

It is a language that appears more serene, more harmonious and more balanced than the art that flourished on the shores of Lake Sentani, in the island's west: is the influence of the ancient civilizations of Southeast Asia discernible here once again? Sadly a joint policy of destruction by the colonial government and missionaries caused most of the sculptures that once embellished ritual houses to be hurled into the waters of the lake. As luck would have it, however, they were fished out again a few years later, their outlines dulled and their surfaces and handsome decorations scarred by their unfortunate experience. Almost simultaneously, Western artists

Previous pages: Shields. From left to right:
Papua New Guinea. Hardwood; 165 x 75 cm.
Papua New Guinea. Wood; 142 x 30 cm.
Solomon Islands. Wood, shell inlays; 81 x 26 cm
Irian Jaya. Hardwood; 166 x 51 cm.
All four: Musée Barbier-Mueller, Geneva.

discovered another example of the creative genius of this people: painted cloth made from beaten bark, soon to be supplanted by ordinary cotton prints.

But if there is one art above all that has enjoyed an unprecedented vogue in recent years, it is that of the Asmat people. Who has not admired their oblong shields, with motifs outlined in relief and silhouetted powerfully against a polychrome red, white and black background? Yet the primary function of this type of decoration, elegant and sophisticated though it may be, was to terrorize any enemy with its implicit allusions to the practice of head-hunting (a function that aesthetes and collectors preferred to overlook, concentrating instead on extraordinary graphic freedom, worthy of a Paul Klee). The principal purpose of Asmat art, nevertheless, was to appease the ancestors and avenge the souls of the dead, in order to prevent them from disturbing the world of the living with their demands and wanderings. Numerous carved wooden figurines reminded every member of the tribe of this duty. The static quality of these effigies (invariably shown squatting, elbows on knees) was probably a reference to the fetal position in which all human life starts, but also and more importantly to the Asmat custom of burying their dead in that position. The same symbolism of death was to be found in large numbers of other sculptures in Melanesia, including the Korwar figures of the Bay of Geelvink: believed to be able to communicate with the dead, and even to appease the souls of those who had died by unnatural means, these angular, disjointed figures in fact served as supports for the skulls of the dead, and were thus reliquaries of the most solemn religious significance.

THE GULF OF PAPUA: VARIATIONS ON THE HUMAN BODY

The Gulf of Papua, in the heart of New Guinea, appears to have developed an original aesthetic language inspired essentially by representations of the human body, the face in particular. Oscillating between naturalism and stylization, and between disjointed, angular lines and curves and countercurves, it is a style immediately recognizable above all others, despite the infinite number of variations adopted by the

Following pages: **Post figure.** Solomon Islands, Ulawa (?). Wood; h. 84.5 cm.
Formerly André Breton collection. Musée Barbier-Mueller, Geneva.
Hector Raraana 1913 photograph, a native of Ulawa, by W.J. Beattie. Archives
Barbier-Mueller, Geneva.

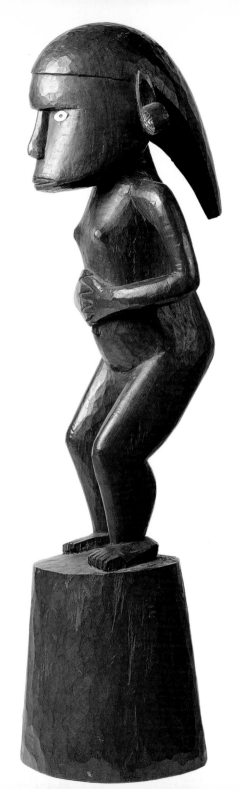

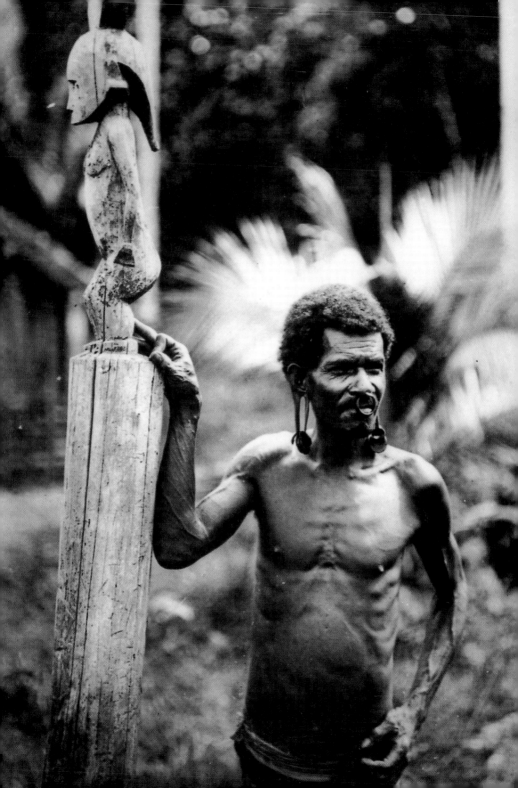

assortment of different peoples living in the region. The ritual houses of the Ele-ma, with their immense pointed facades as impressive as a cathedral, offer a truly astounding repertoire of forms covering their walls: depicted standing or squatting, anthropomorphic figures in bas-relief picked out in color—not unlike the faces used to decorate shields—are believed to represent spirits of ancestors. The Purari peo-ple, concentrated around the estuary of the great river that gave them its name, dis-played the same obsession with the human face, which appears in numerous guises and truncated forms on masks and sacred boards, occasionally abridged to a jaw armed with teeth—an extreme and macabre example of this type of reduction. Subtler still, the motif of two "Cs," back to back and linked in the middle by a cir-cle or diamond, would appear to give rise to an example of the metamorphoses so liberally used and abused by the people of Melanesia: for cannot the trained eye detect—in what at first sight seems merely a confusion of sinuous lines—a some-what disturbing proliferation of human faces, or a true "cryptoportrait" of a guardian spirit? It is true that, following the example of numerous island tribes, few peoples have celebrated the cult of trophy heads with such enthusiasm: it was a point of honor for every clan and village to possess its own collection, with the finest specimens neatly arranged on shelves like so many tangible signs of the commu-nity's prosperity and power. This practice, so reprehensible to Western eyes, never-theless gave rise to a singularly original and prolific art form—as may be seen in the magnificent hooks from which the skulls were hung, with two-dimensional curves and volutes which have seduced many a Western collector.

THE SOLOMON ISLANDS: SKULLS AND CANOES

In the western Solomon Islands, as in other regions of Melanesia such as the Van-uatu Islands and the Sepik area, modeling over the skull of a dead chief represent-ed the supreme act of homage. The special quality of the materials required for this delicate task (including a paste made from parinarium nuts and a multitude of tiny shells to reproduce the jewelry worn by the deceased when alive) are an indication of the exceptional nature of this practice, reserved for the very greatest figures.

Figurehead. From a canoe used for head-hunting expeditions. Solomon Islands. Wood, nautilus shell inlay; h. 29.5 cm. Collected by Count R. Festetics de Tolna, 1895. Musée Barbier-Mueller, Geneva.

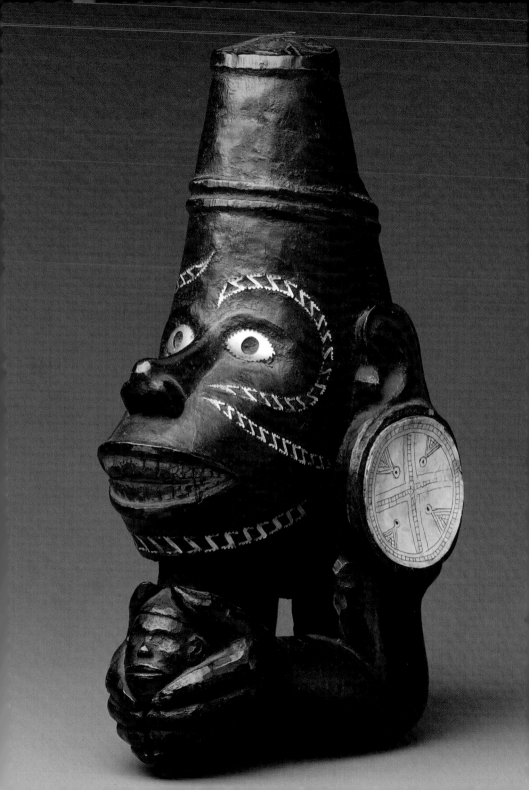

Once they had undergone this remarkable treatment, the skulls themselves were considered as artifacts alongside canoes and wood carvings.

The other artistic creations of the Solomon Islanders, though less bizarre and unexpected, nevertheless share the same austere stylization and the same language of ascetic minimalism, far removed from the exuberance displayed by some of their neighbors. Among the indisputable masterpieces produced by them are the lively figureheads they carved in hardwood, highlighted with a handsome and gleaming black patina. One example, now in the Barbier-Mueller collection, still brandishes a macabre trophy in the form of a human head, intended to ward off evil as well as making unmistakable reference to local customs. The same black sheen (the result of a subtly blended mixture of smoke black, sap and plant ingredients) and the same shell and mother-of-pearl decorations are to be found on other objects made by these inspired fishing people, including ritual axes, dance paddles (koka) and above all sacrificial bowls in the form of human heads and recipients for offerings sporting handles in innumerable different variations. The jewelry worn in the archipelago (including forehead ornaments carved from large shells and highlighted with open-work patterns in tortoiseshell, and large disk-shaped pendants decorated with stylized cut-out silhouettes of frigate birds), rivals the most distinguished creations of contemporary jewelers in its elegant restraint.

Kapkap ornament. Western Solomon Islands (?). Shell, openwork tortoiseshell; diam. 12 cm. Formerly James Hooper and H. Gibson collection. Musée Barbier-Mueller, Geneva.

343

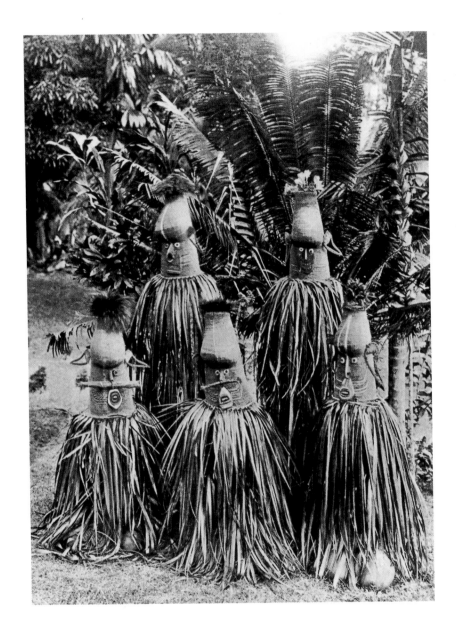

Sulka **masks.** Period photograph. Archives Barbier-Mueller, Geneva.
Opposite: Sulka **mask** The conical shape is suggestive of a yam. East New Britain.
Fiber, cane, pith, cassowary feathers, soft wood ears (restored); h. 73 cm.
Formerly Umlauff Museum, Hamburg. Musée Barbier-Mueller, Geneva.

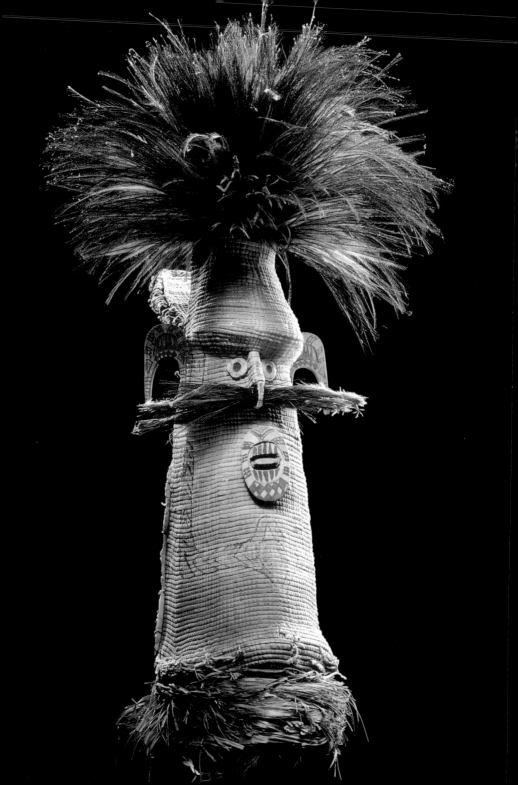

MASKS OF MELANESIA: UNBEARABLE LIGHTNESS

If we were to adhere dutifully to the strict definition of masks as "second faces" intended to disguise the features of the wearer, we would risk overlooking a large number of artistic phenomena that are inextricably linked with this notion of metamorphosis and splitting in two, so highly prized by the peoples of Oceania. One fact emerges clearly, however: while Melanesia appears as the spiritual home of masks (from Sepik to New Caledonia, via New Ireland and New Britain), Polynesia, by contrast, seems to have spurned mask-making in favor of the facial ornaments and tattoos that its peoples have raised to high levels of perfection. This curious division apart, however, few populations seem to have celebrated the virtues of disguise and masquerades, the sublimation of "self" to the "other," with such enthusiasm. Masks come in bewildering variety: headdress masks, helmet masks, costume masks and sculpture masks; masks made from plants, wood or painted bark; giant masks and gossamer-fine masks; black or polychrome, terrifying or soothing masks; funeral masks, dance masks, ceremonial masks, war masks and masks for sheer fun. As diverse in function as they are in form, they display a dizzying range of aesthetic languages and materials, from tortoiseshell to human hair, from tree fern to cassowary feathers, and from sheet metal to rattan and resin and coatings.

If there is one people above all others who have displayed unprecedented genius in the making of what we hardly dare call masks, it is the Baining of New Britain. Virtually independent of their wearers, these gigantic faces appear to shed tears of blood from their hypnotic eyes as they seem to defy the laws of gravity. These "phantom" faces, as light as kites and as unreal as mirages, find their opposite in the brutal power of Malagan masks from New Ireland, "barbaric" collages of forms and meanings that are simultaneously exotic, disturbing and savage.

Opposite: **Dance mask.** Nissan Island. Wicker framework covered with bark fiber; h. 59 cm.
Collected by R. Parkinson c.1903. Musée Barbier-Mueller, Geneva.
Following pages: **Large mask.** West New Britain, Vitu Island.
Bark cloth, dried leaves, wood, pigment (?); h. 66 cm.
Large mask (*kavat*). East New Britain, Baining. Bark cloth, cane framework; h. 100 cm.
Both: Musée Barbier-Mueller, Geneva.

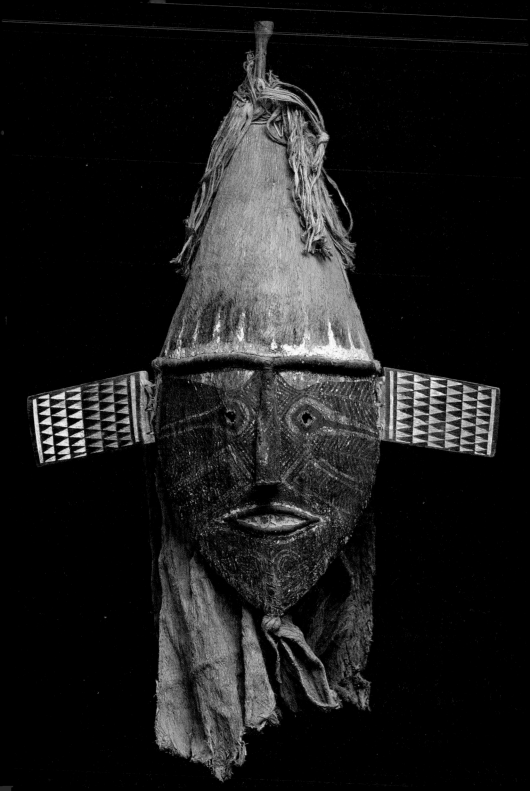

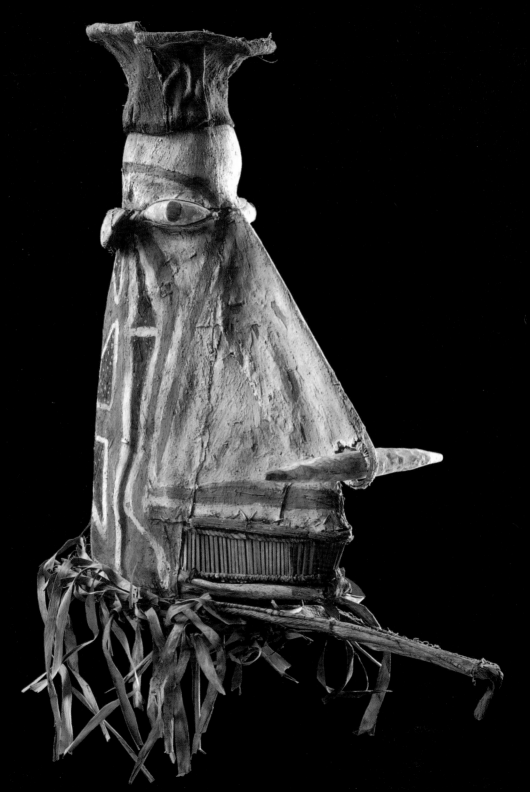

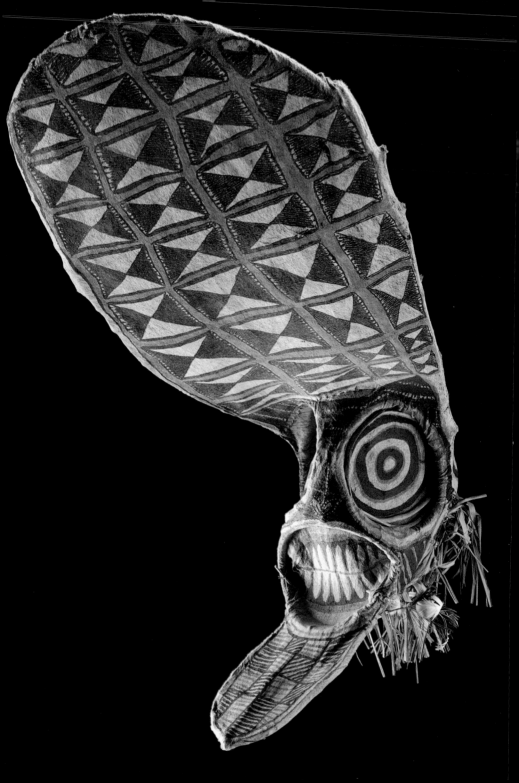

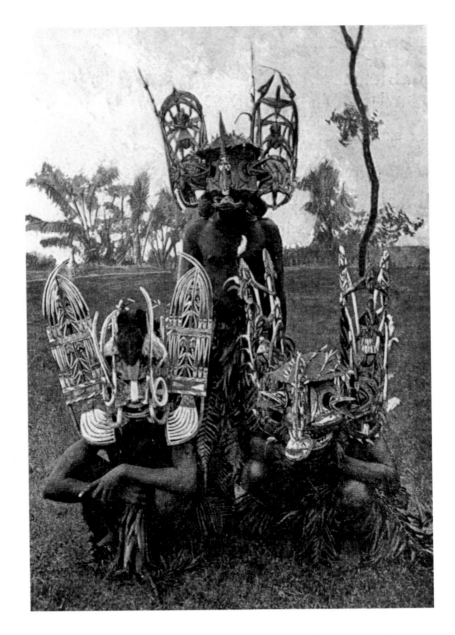

Above: **Three men wearing *matua* masks** Northern New Ireland. Period photograph.
Archives Barbier-Mueller, Geneva.
Opposite: **Heavy *malagan* mask.** Northern New Ireland. Wood, polychrome decorations; h. 82 cm.
Formerly Museum of Ethnography, Dresden. Musée Barbier-Mueller, Geneva.

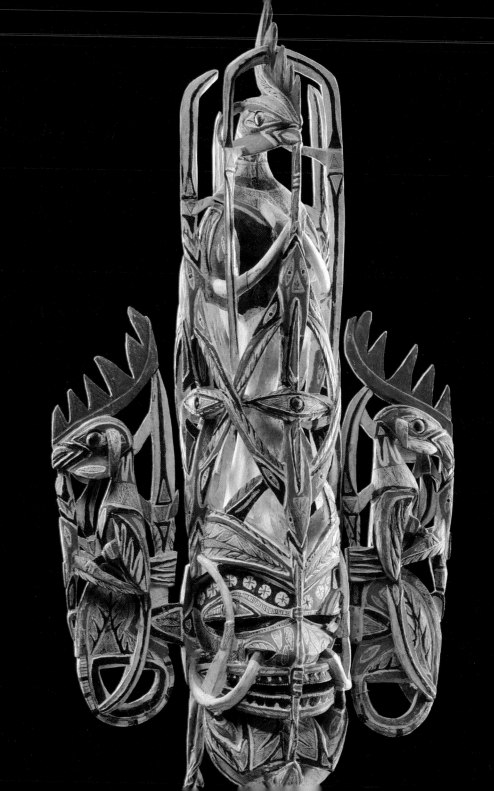

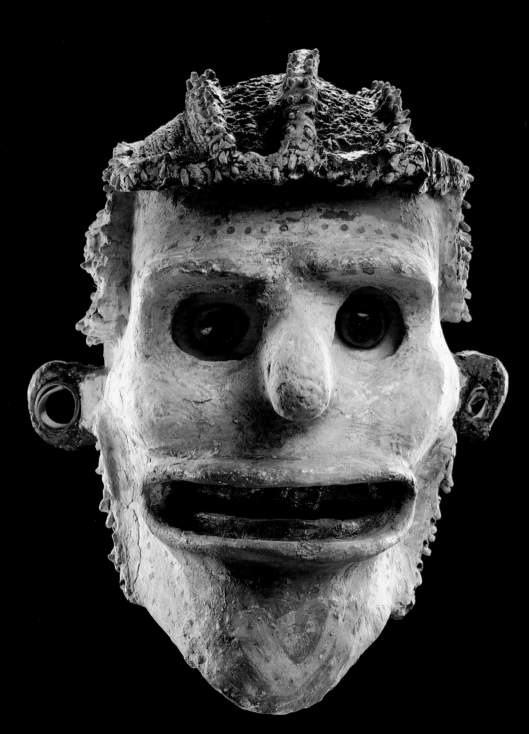

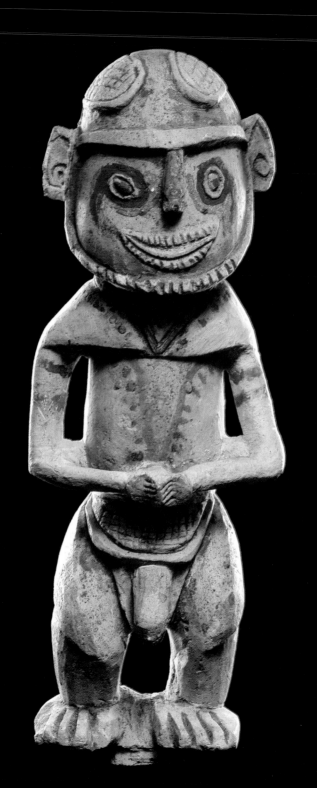

NEW IRELAND: THE BEAUTY OF THE EPHEMERAL

The sculptures made by the deft and expert carvers of New Ireland are both strange and fascinating. Far removed from any notion of restraint or sobriety, these remarkable combinations of eclectic forms, colors and materials conspire to create structures of great subtlety while simultaneously offering the most hermetic of puzzles to our Western judgment. Any artistic achievement lies precisely in the ephemeral nature of these flimsy constructions of fiber, wood, bark and feathers. No sooner were they completed than they were consecrated and burned, after the custom reserved for objects of all kinds used during the death rituals of New Ireland, known as *malagan*. Corresponding to the richness of the message transmitted (including references to the spirit world, ancestors and the history of the clan) was a profusion of images, mingling elements from the human, animal and plant kingdoms with a rare degree of extravagance. Here you can make out the outlines of a flying fish, there a pig's tusks, the crimson crest of a cock or the silhouette of a bird with a snake in its beak: in short, a teeming inventory of the natural world that would prove irresistible to the Surrealist poets, themselves adept at collage techniques and associations of ideas as burlesque as they were incongruous. Indeed, the friends of André Breton would place the Bismarck Archipelago (as New Ireland was then known) plumb in the middle of their ideal map of the world.

This overwhelming horror of the plain and unadorned was in marked contrast to the extreme stylization of the chalk effigies called *kulap* which were placed in small ritual shelters, away from the unclean gaze of women and children. Of an unblemished whiteness, like a Japanese Noh mask, or sporting a rictuslike grin and highly expressionistic face painting, these figurines served as the earthly residence of the souls of the dead—when they were not carried off by night to be sold in secret to a European collector.

Opposite: **Ancestral effigy or** *kulap.* Southern New Ireland. Wood, chalk decoration with polychrome highlights [See illustration.] and fiber; h. 75 cm. Collected c.1890. Musée Barbier-Mueller, Geneva.
Previous pages: **Sculpture modeled over human skull.** Central New Ireland; h. 25.5 cm. Collected by the consul Max Thiel before 1907. Musée Barbier-Mueller, Geneva.
Ancestral effigy or *kulap.* Southern New Ireland. Wood, chalk decoration with polychrome highlights; h. 29.3 cm. Formerly Joseph Mueller collection. Musée Barbier-Mueller, Geneva.

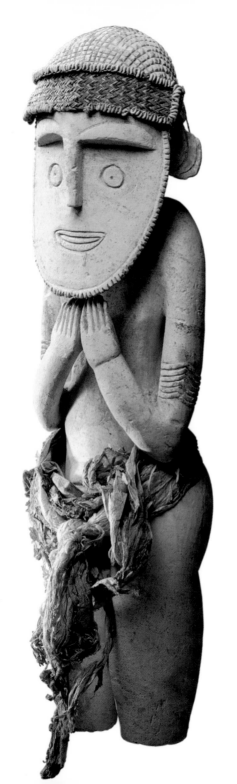

THE VANUATU ISLANDS: A FASCINATION WITH DEATH

She fixes us with her bulging eyes, her head daubed with strange and violent red and blue streaks. Who is she? The ogress Nevimbumbao, comfortably installed on her rush-seated chair from which she surveys, like a *dea mater*, the surrounding chaos of Picasso's studio. By what bizarre quirk of history did this curious figure made from plant fibers and tree fern contrive to cross the oceans in order to end up in the workshop of the most inspired painter of the 20th century? Picasso himself was undoubtedly almost totally ignorant of the culture that had produced this "idol" with features hesitating somewhere between the horrific and the humorous, between the grotesque and the terrifying. Nevimbumbao's native land was Malekula, one of the "coral and fire islands" that make up the Vanuatu archipelago. "The land that stands upright" is the rough translation of the name chosen by the island's native inhabitants when it gained independence in 1980. Struck by their sepulchral beauty, composed of mists and ashes, Cook had christened these islands the New Hebrides; while the Frenchman Bougainville, seduced by their gentle landscapes and soft light, preferred the name Great Cyclades, with its Homeric overtones.

Ever since those voyages, archaeologists and ethnologists have pored enthusiastically over the art and culture of this handful of rocks spread out over more than 500 miles within the arc of Melanesia, repositories of a prodigious wealth of rituals and costumes that have miraculously survived not only devastating earthquakes and other natural disasters but also the iconoclastic fury of men. Here again, it would be insulting even to attempt to classify such a great diversity of aesthetic languages and functions. But one thing is unmistakable: the extraordinary creative skill

Opposite:
The ogress Nevimbumbao (ceremonial headdress).
Vanuatu, southern Malekula. Tree fern, plant fiber; 114 x 60 x 92 cm.
Musée des Arts d'Afrique et d'Océanie, Paris.
Following pages:
**The ogress Nevimbumbao and head of (?) her son Sasndaliep
(ceremonial headdress).** Vanuatu, southern Malekula.
Tree fern, pigments, plant-based paste; 74 x 43 cm.
Funerary figure, or *rambaramp*, with head (?)
Modeled over the skull of the deceased. Vanuatu, southern Malekula. Skull,
plant matter pigment; 172 x 54 x 10 cm.
Both: Musée des Arts d'Afrique et d'Océanie, Paris.

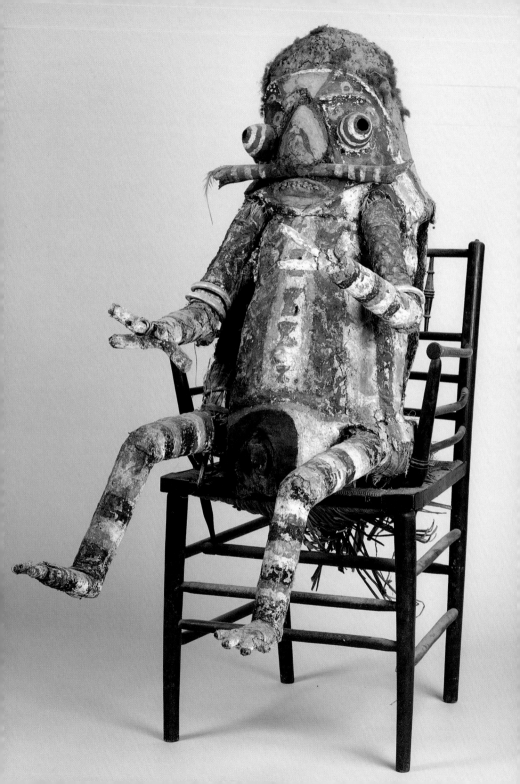

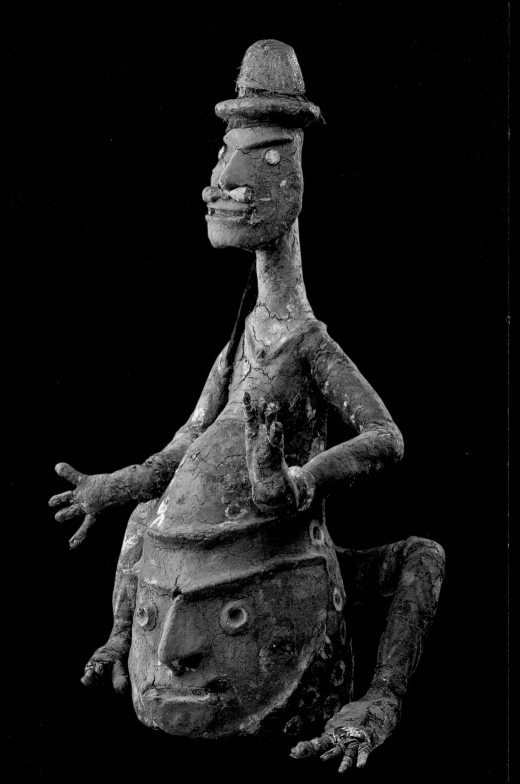

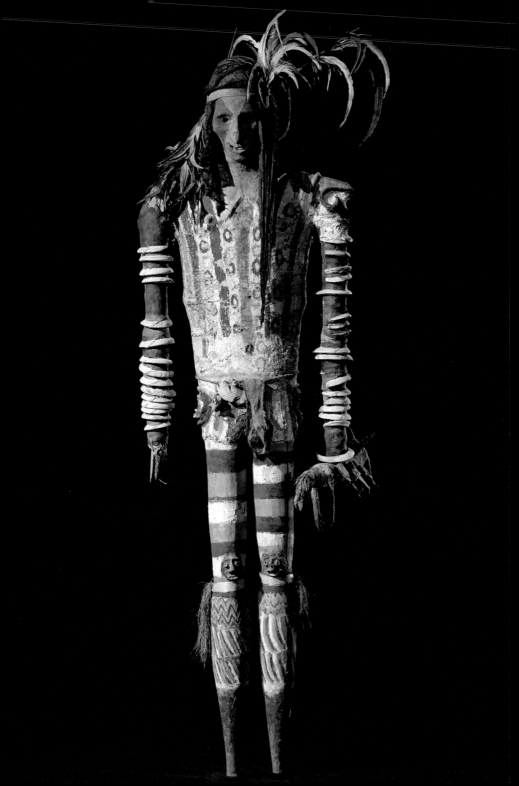

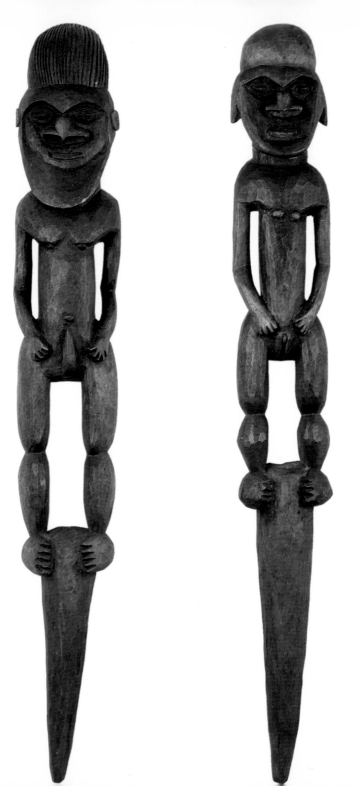

of this people, who have used virtually every available organic material (including pigs' tusks, spiderwebs, pastes made from plants and human hair and skulls) to express their fascination with death and their veneration of the souls of the departed. The inhabitants of Vanuatu describe their extravagant and fragile headdresses made from ferns and fibers, their wooden masks fringed with beards, and their marionettes bristling with feathers as being flowerlike. Admired by the living, these ritual objects, so beautiful and full of color, were conceived in order to appease and seduce the ancestral spirits. Sadly, the objects that we admire in museum display cases are all too often, like their African counterparts, missing vital parts: masks without their feather ruffs and cloaks, statues minus their brilliantly colored markings, and drums abruptly condemned to silence, never more to utter the muffled, violent music of the ancestors, haunting and sacred.

Far from deploring the joint actions of museum curators and collectors, the Ni-Vanuatu have expressed their gratitude to the "white men" who have preserved thousands of objects that would otherwise have been destroyed once their ritual function had been fulfilled. One solitary question still haunts their spirits, however. These funerary figures topped with the corpse's own skull; these sculptures fashioned from wood, tree fern or stone, the materials of which indicated different social ranks by their degree of fragility; these magnificent mats woven from pandanus leaves and sometimes dyed by women; these great ritual dishes with their breathtaking design: are all these objects definitively and categorically dead? Certainly they are deactivated, decontextualized, deconsecrated, we might be tempted to reply. But equally certainly they are not despised, ignored or ridiculed.

NEW CALEDONIA: THE POWER OF CHIEFDOMS

According to the ethnologist Maurice Leenhardt in *Gens de la Grande Terre*, the inhabitants of New Caledonia "raised the ground level to create a slightly elevated roadway in the form of a hog's back. About 35 to 200 feet long and 17 to 35

Roof finials: male and female figurines.
New Caledonia. Wood; 126 x 19cm and 118.5 x 16 cm.
Formerly Pablo Picasso collection.
Musée des Arts d'Afrique et d'Océanie, Paris.

feet wide, this roadway is bordered at regular intervals by dark araucarias (monkey-puzzle trees) or coconut palms, planted with care so that the curve they form exaggerates the sense of perspective. Together they form a handsome avenue, at the far end of which stands a large Caledonian hut, surmounted by an arrow of white shells. Flanking the avenue on either side is another avenue, narrower and level, bordered by araucarias and erythrinas (coral trees). ... All these surfaces are covered with fine and carefully tended lawns. This green covering of the ground is supposed to resemble a carpet so closely that the Kanak people, and especially the women, now instinctively and mechanically weed out every blade of grass around them that might interfere imperceptibly with the harmony of the lawn. Straight, level, carpeted with soft grass, bordered with coconut palms, curved, arranged—where the terrain permits—in regular terraces, and all leading to the mound of the Great Hut, dominating the whole, these avenues display rare qualities of design, of restraint and of aesthetic awareness. They reveal the great taste and profound sense of overall design possessed by the people." Should we then view the Kanak as sophisticated and ingenious planners or—better still—veritable landscape architects? This is what Leenhardt appears to be saying in this piece, in stark contrast to the black and diabolical image peddled by generations of overtly racist Europeans.

Considered for many years as specimens that had barely emerged from the Stone Age, the people who colonized the islands in the far south of Melanesia more than 3000 years ago were nevertheless capable of creating an aesthetic language of their own, frequently austere and sometimes unvarying, but always imbued with an unusual artistic power. Massive, virile and severe, and dominated exclusively by the people's devotion to the worship of their chiefs and traditions, this is an art devoid of any anecdotal element or superfluous decoration. All artistic endeavor here—from the erection of great huts and the sculptures that embellished their doorposts and roof ridges to the making of masks, ritual axes and clubs—had but one *raison d'être*: to exalt the power of the chiefs and their ancestors. And all Kanak work seems to be haunted by the same disturbing and instantly recognizable face, with deep eye sockets, broad, jutting cheekbones and a prominent and sometimes hooked nose. Among the most spectacular and successful of all their creations is their procession of powerfully carved wooden masks, with lips curled in a manner that is both menacing and intriguing.

On December 20, 1843, Lieutenant Commander Julien Lafférière reported: "We saw appearing in the midst of the scene two great black masks with features that were hideous in both shape and size, surmounted by great feathered caps of the colback type. The people who wore them had their upper bodies covered with a type of short cloak, also in black feathers, which accorded well with the rest of the disguise." The French naval officer went on: "These two figures came and leaped about before those present, to the chanting of the Paliki-Pouma troupe, rushing from one end to the other of the open space between the singers and the spectators, and presenting us with a highly original type of savagery; all these black men, completely naked, feebly lit by the flickering red light of a straw fire which was rekindled from time to time, stamping their feet and contorting their bodies while waving their long arms about, hissing like snakes or uttering piercing shrieks or muffled groans; the two monstrous masks meanwhile rushing and leaping about like wild beasts unchained; and all this noise, all this agitation, conducted and regulated by the voice and animated gestures of Chief Paliki-Pouma, himself fairly hideous: it was a tableau that had something infernal about it, and that would have been worthy of the most talented painter."

"Monstrous," "hideous," "infernal": these words would recur with monotonous regularity in the accounts of explorers and missionaries as they described the sacred rites and "terrifying" masks of the Kanak people. Only in the 1930s, with the more enlightened approach of avant-garde artists, would these objects acquire the status of true works of art. With their glistening black surface, their eyes and teeth often picked out in white and their lips highlighted in red, these powerful sculptures in the round certainly had the necessary attributes to seduce even the boldest of the Cubist painters. But as in Africa, Kanak masks and Melanesian masks as a whole were not intended merely as screens to hide the wearer's face. These masks, indeed, are complete costumes, made of wood, plant fibers and human hair, which the wearer would put on as a disguise to conceal not only his body but also his identity. They were also in some way an attribute of the chiefdom, a profoundly sacred accessory put at the disposal of the chief by the founding clans. Complex and ambiguous, they were the incarnation—according to the ethnologist Jean Guiart—of the avatars of a single demiurge: Gomawe, lord of the kingdom of the dead, god of money as well as the individual whose features he is supposed to

Kanak **masks.** Made with real hair and decorated with
"cloaks" of pigeon feathers. Period postcard.
Archives Barbier-Mueller, Geneva.

reproduce. Kanak masks—whether intended for death rites (sometimes including
in their composition the hair of men in mourning) or war, or simply for dancing—
above all reflect the cultural identity of a people who have managed to survive the
vicissitudes of history. Nowadays their role is chiefly playful: the spectators are first
frightened, then they laugh at their fright. And nowadays, too, they are told that
the masks are only objects.

Opposite:
Face of a *kanak* mask. New Caledonia. Hardwood.
Restored on upper and lower protuberances; h. 52 cm.
Musée Barbier-Mueller, Geneva.
Following pages:
Group of *atingting* drums
Northern Ambrym, Vanuatu. Early 20th-century. Old photograph.
Archives Barbier-Mueller, Geneva.

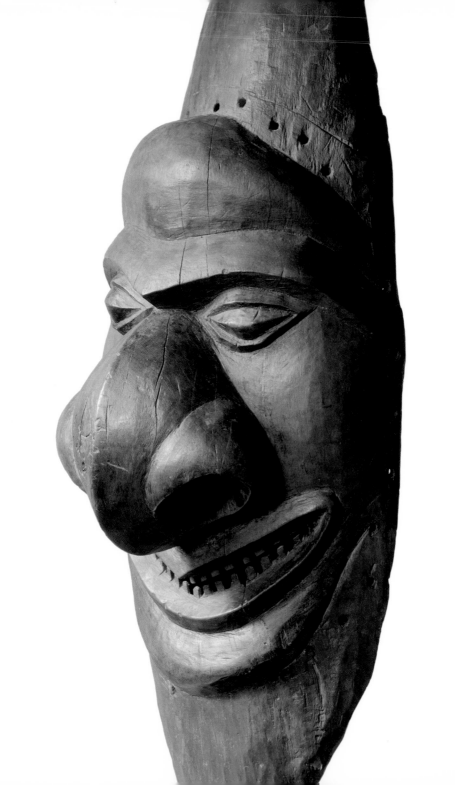

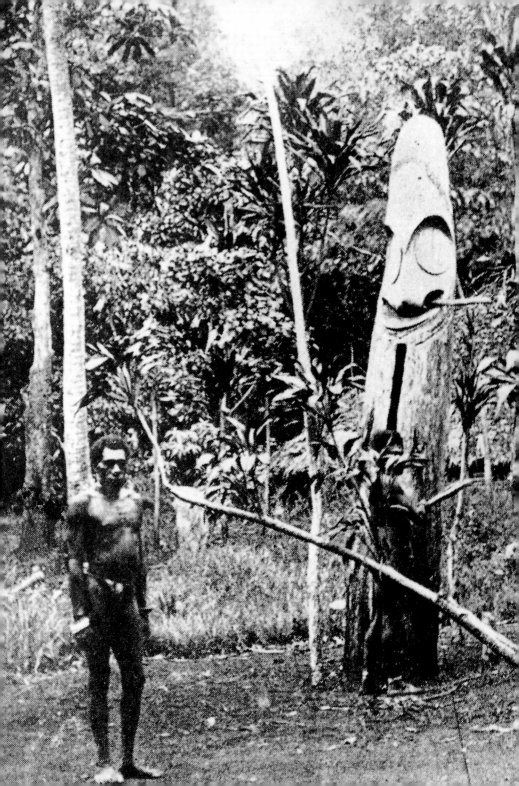

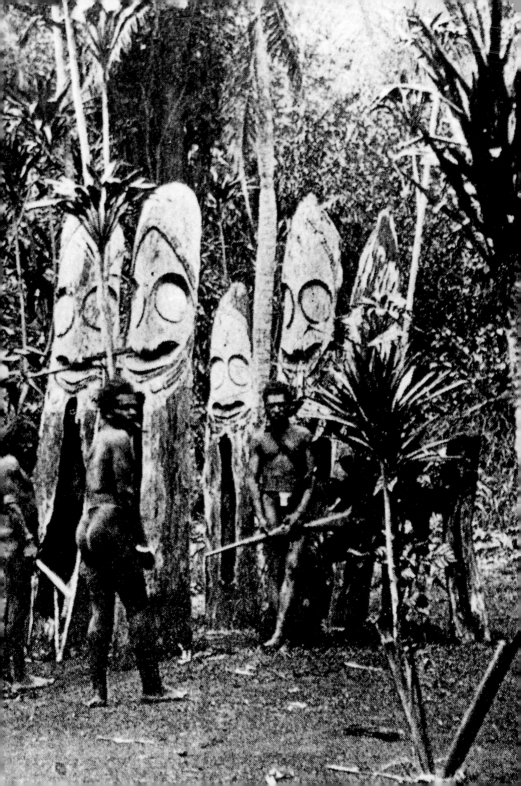

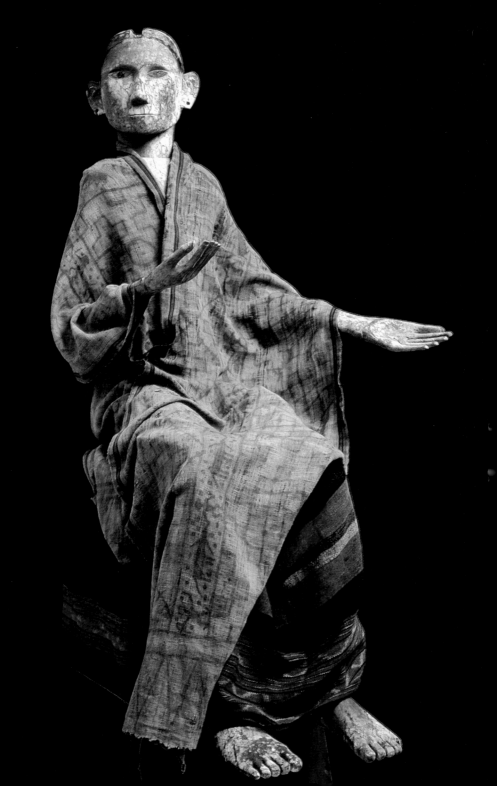

THE ARTS OF THE SOUTHEAST ASIAN ISLANDS
The Cult of Ancestor Worship

With the exception of the kingdoms of Java and Bali, heavily influenced by Indian civilization, the traditional cultures of the islands of Southeast Asia have succeeded in perpetuating their artistic and religious customs through two forms of decoration: ritual jewelry and ceremonial fabrics. Far beyond the level of mere craftwork, these objects have recently attracted the interest of of collectors. The cult of ancestor worship, meanwhile has initiated a tradition of funerary art among the most inventive and original in the world.

As Jean-Paul Barbier rightly observed in *L'Or des îles*: "The primitive arts in Indonesia and the Philippines and the arts of Melanesia and Polynesia form a triptych, of which it is impossible to separate the panels without compromising any true understanding of the Malayo-Polynesian world, including also Madagascar." Yet how dilatory we have been in studying this immense region, with no fewer than 13,000

Opposite:
***Tau-tau* sculpture.** Representing a deceased person of high rank.
Sulawesi, Sa'adan Toraja. Semihard wood, shells, *mawa* cloth; h. 105 cm.
Musée Barbier-Mueller, Geneva.
Following pages:
Domestic altar. Southern Moluccas, Tanimbar Archipelago, Selaru Island. Wood;
h. 130 cm. Collected c.1900.
Statue of an ancestor (*Ai tos*). Central Timor, Tetum. Hardwood, shell; h. 91 cm.
Both: Musée Barbier-Mueller, Geneva.

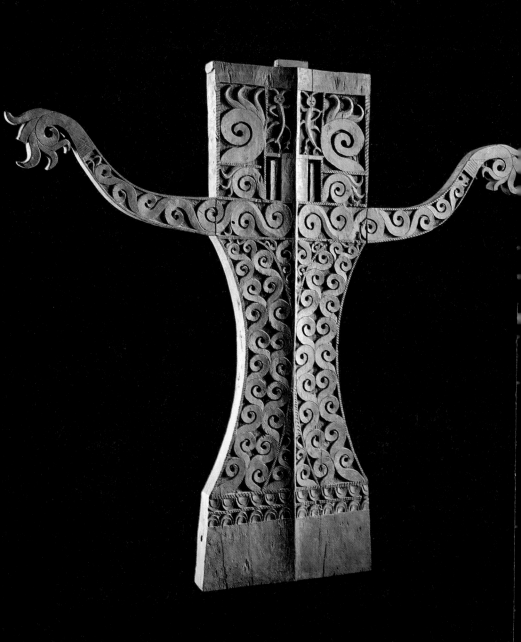

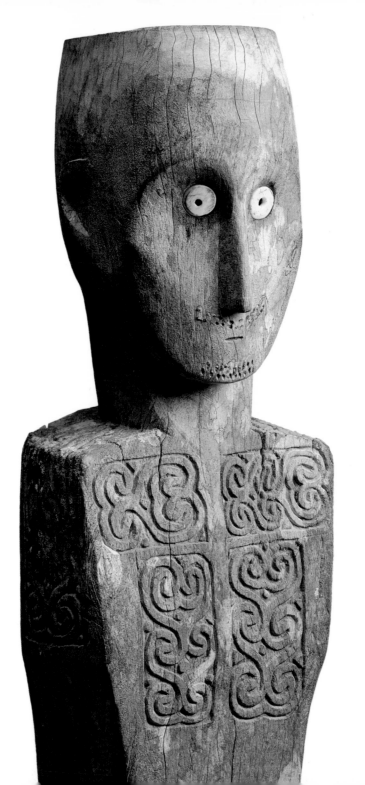

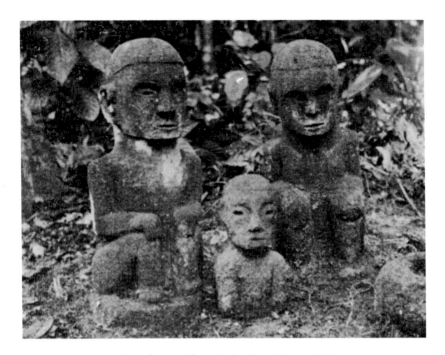

Group of ancestral figures in the village of Marjanji Asi.
Photographed before World War II. Archives Barbier-Mueller, Geneva.

islands scattered over nearly 2,000 square miles—some huge, such as Borneo, others tiny, such as Lombok. Far from forming separate, rigidly defined entities, these "microsocieties" of ancient seafaring peoples have frequently shared the same customs and rituals, including head-hunting, the use of communal houses or chief's houses, and above all ancestor worship.

Yet the history of these "primitive" Asian populations is peppered with more doubts than certainties, and it would be futile (if not presumptuous) to make any claims to an exhaustive study of their artistic output. What exactly do we know, for instance, about the tribes conveniently lumped together under the name Dayak, whose works are found in numerous museums and private collections? Collected in

Previous pages:
Tomb door bearing the stylized head of a buffalo.
The buffalo was the animal sacrificed to accompany the dead on their journey to the other world.
Sulawesi, Sa'adan Toraja. Wood; h. 103 cm. Musée Barbier-Mueller, Geneva.
Dayak tomb
in the form of a house. Photograph, Archives Barbier-Mueller, Geneva.

Borneo, these pieces are seductive in their "savage beauty," but according to ethnologists, the great majority of them will remain forever silent with regard to their original context. But, their aura of mystery apart, it is impossible not to be lost in admiration in front of the virtuoso workmanship of these shields with their curvilinear decoration, of these tombs in the form of houses, or of these powerful wooden posts and panels over which swarms a bestiary intended to ward off evil. At a time when the penetration of Islam into even the remotest villages on the island means inevitably that these cultures will be destroyed within the next few decades, we should be grateful to the collectors who over the years have saved from destruction and oblivion the tens of thousands of objects now preserved in the West. The systematic study of these pieces will perhaps enable ethnologists to provide the answers to many as yet unanswered questions. Other peoples, meanwhile—such as the Toraja of Sulawesi, the Batak of northern Sumatra and the inhabitants of the islands of Nias, Flores and Sumba—appear to be much better known.

What traveler in search of the exotic would not be set dreaming by the image of the majestic houses with curved roofs on the island of Sulawesi (formerly Celebes)? Perched on their tall stilts, they look like proud ships, or strange shipwrecks washed up among these grandiose mountain landscapes. A Toraja house is not merely the material and tangible sign of the prosperity of the family that dwells there: it is also a symbol of the cosmos. The roof represents the sky, the inhabited parts the earth, the lower floor the underworld, and the central pillar the axis of the universe. The counterpart to the "house of the living" is the "house from which no smoke escapes," or the tomb, which may assume the lofty shape of a boat (the ship of the dead?), or alternatively may take on the shape of a buffalo (the sacred beast par excellence) or a dwelling house, or a rough-hewn grotto or cave. A carved wooden figure, richly arrayed, watches over the corpse and is believed to shelter its soul, scrutinizing the world of the living with its eyes made from shells.

Tarnished with the unenviable reputation of being bloodthirsty cannibals, the Batak inhabit the land to the south of Lake Toba and on the Samosir peninsula, in

Following pages:
Statue representing a female ancestor (?). Possibly the wife of one of the founders of the clan.
Northern Lombok Island, Sasak. Stone; h. 105 cm.
Musée Barbier-Mueller, Geneva.
Female effigy. Sumba Island. Soft stone; h. 60 cm. Musée Barbier-Mueller, Geneva.

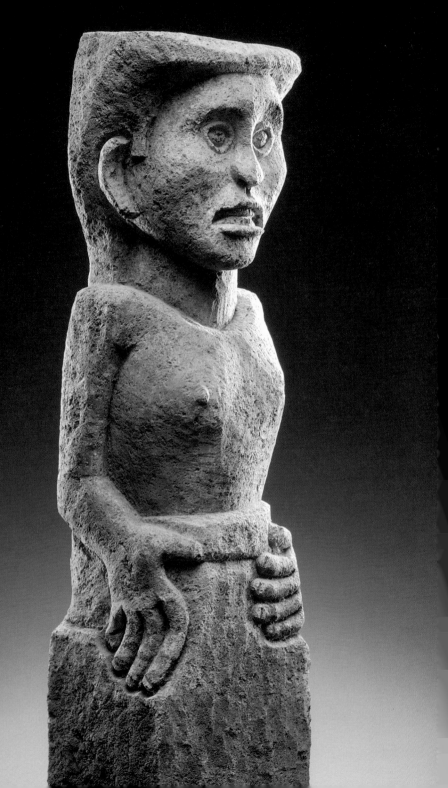

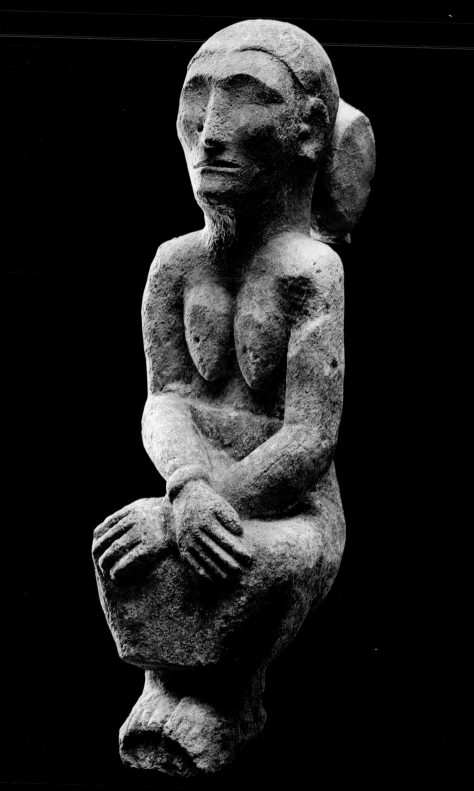

tall and extremely handsome houses with twin-pointed roofs reaching proudly up to the sky. Sorcerers' knives encrusted with human teeth, magic staffs topped with feathers, buffalo horns intended as containers for various concoctions and fetish sticks (*pagar*), frequently "powered" by human sacrifices, reflect the omnipresent nature of magic in these regions, where the powers of the healer-soothsayer are apparently infinite. The science of *datu* (comprising magic spells, recipes and performances) is even consigned to sheets of bark in a form of writing derived from ancient Javanese and created—most exceptionally among a people described as "primitive"—by the Toba themselves. But the inhabitants of northern Sumatra have left the clearest traces of their genius in their splendid stone sculptures of their ancestors: proud horsemen astride mounts hovering improbably between buffalo, horse and snake (a protective monster known to the Batak as *singa*), severe effigies whose austere features verge on portraiture.

The profoundly hierarchical warlike culture that flourished on the little island of Nias (until the early 20th century, when it succumbed to the two-pronged attack of Dutch colonialism and Christianity) also honored its ancestors in reverent fashion. To judge by their quality, magnificent hardwood statues fashioned in memory of the dead, and depicting dignitaries or chiefs wearing turbans or arrayed with jewels, were the work of true artists. In stark contrast to these portraits are crude effigies of mythical ancestors, eyes bulging, brandishing their genitals.

While the Nage on the island of Flores placed their ritual statues in pairs on the threshold of small buildings on the outskirts of villages, close to the sea (the masculine figure always on the right and the female figure on the left), the inhabitants of Sumba preferred to place their spirit couples, male and female, around fences, steps and stone foundations. These divinities were never addressed directly, but were rather approached through the intervention of intermediaries, who had to be invoked and cajoled. Another contrast emerges between the astonishing realism of these stone figures and the extreme stylization of the statues found on the island of Atauro, not far from Timor, the rough angularity of which is almost reminiscent of the work of Lipchitz.

Figure of a male ancestor.
Atauro Island. Hardwood; h. 52 cm. Musée Barbier-Mueller, Geneva.

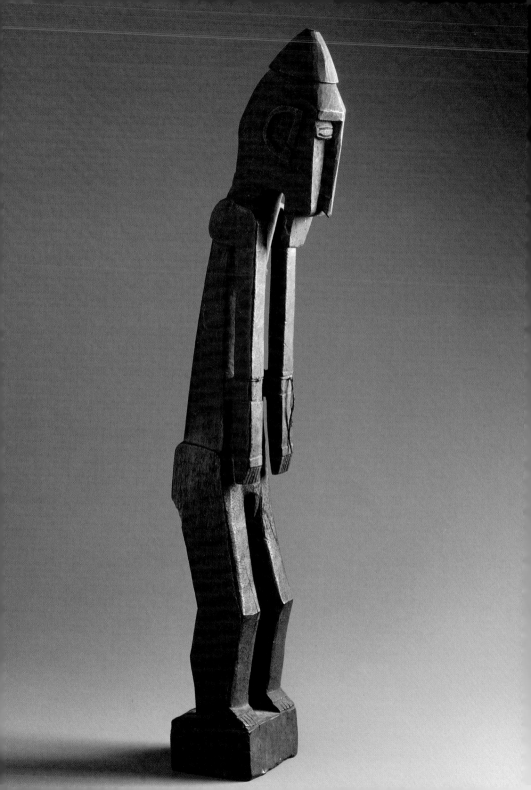

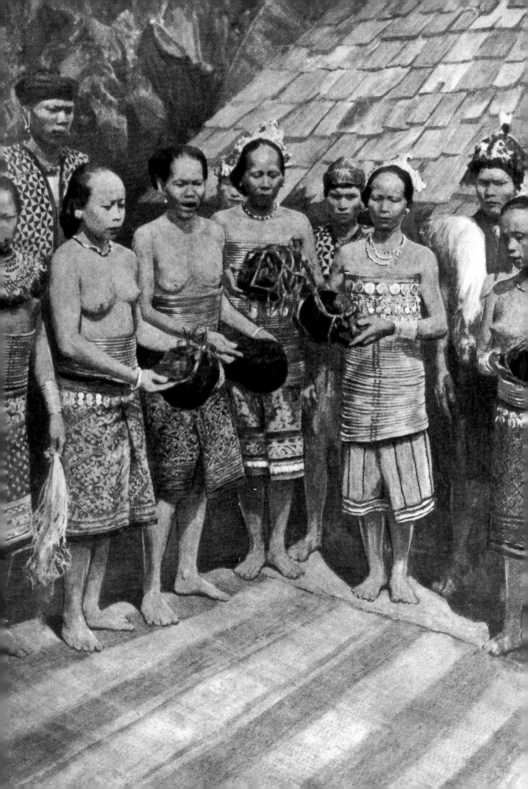

Jewelry and Ornamentation: The Memory of Peoples Without Writing

Far from serving merely for flirtation and coquetry, the jewelry of the 'primitive' peoples of Indonesia, Malaysia and the Philippines is the traditional expression of a veritable 'language' that anthropologists have only recently started to attempt to decipher. Constituting the domestic treasure handed down by inheritance, these parures are accurate reflections of the social position of their owners. In their forms, colors and designs, moreover, they are a symbolic expression not only of family and blood ties but also of myths and rituals. Exchanged at marriage ceremonies, finally, metal and fabric jewelry also plays an important part in systems of economic exchange between tribes and ethnic groups, and on a broader level between the coastal and inland populations of the islands. Any signs that these parures are starting to disappear are cause for concern, for—in the words of the collector Jean-Paul Barbier—'it is the entire history of a people without written records that vanishes with them.'

Ceremony during which fabrics and jewelry are exchanged to reaffirm bonds between tribes. Period photograph.
Archives Barbier-Mueller, Geneva.

Nage men (Flores Island) wearing *lado* diadems.
1920-1930. Photograph.
Archives of the Tropen Museum, Amsterdam.

In those circumstances, how would we begin to study of the ritual goldwork produced in the Southeast Asian archipelago? The ethnologist Susan Rodgers provides an initial note of caution: each ornament "should be decoded in the same way as a complex text with several layers of meaning. … The particular form of a piece of goldwork, the process by which it was made and its place of origin may also reveal large slices of the social history of an ethnic group or village." (*L'Or des îles*). Nor

Lado **diadem.** Reserved exclusively for men of high rank.
Flores Island, Nage. Gold; h. 47 cm.
Musée Barbier-Mueller, Geneva.
Following pages:
Figure representing an ancestor Wearing a turban and necklace,
Nias Island. Hardwood; h. 40 cm.
Stéphane Barbier-Mueller collection, Geneva.
Complete set of women's jewelry. Southern Nias Island.
Gold, hammered in places; h. (crown) 16.5 cm; l. (earrings) 12 cm; l. (necklace) 22 cm.
Musée Barbier-Mueller, Geneva.

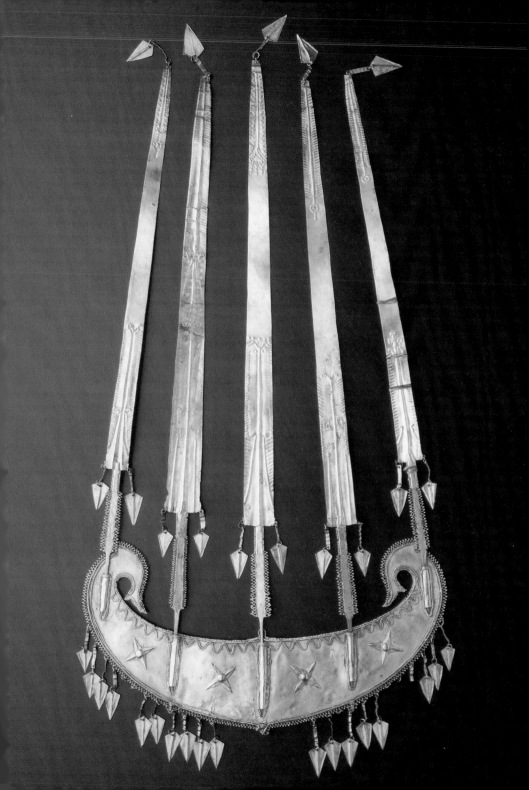

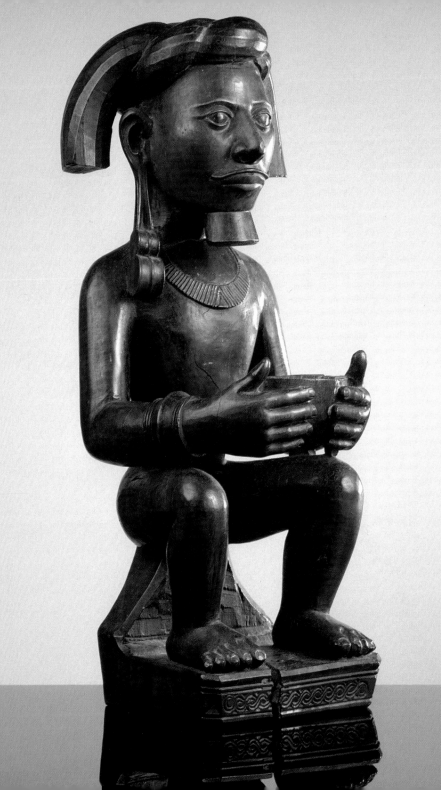

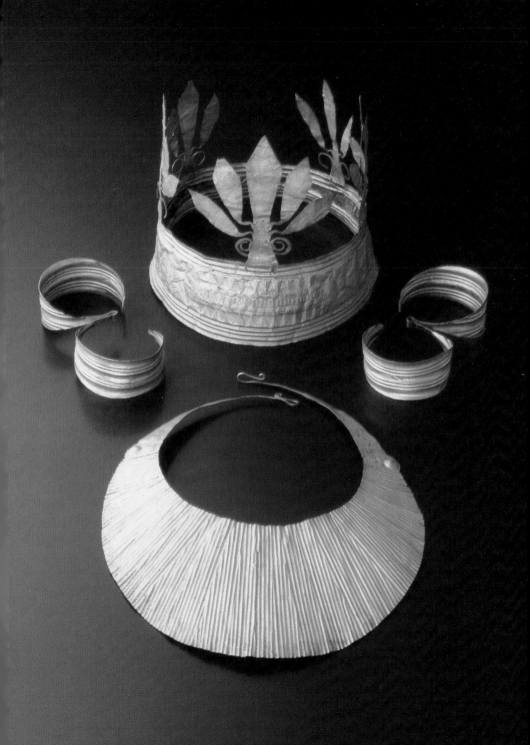

should we forget the extent to which jewelry formed a part of body decoration as a whole, alongside tattooing, the wearing of particular garments, weapons or masks, the decoration and even filing of teeth, and of course face and body painting. Sophisticated systems of communication, all these forms of ornamentation indicated in their own way, and for both sexes, the transition from one social category or phase of life to another: from adolescence to adulthood, for instance, or from life to preparation for the great voyage to the "other world."

But first and foremost, jewelry remains unrivaled as the most obvious means of broadcasting to all the extent of the family fortunes and the elevation of social rank. Thus, noble families in the Batak regions of Sulawesi and eastern Indonesia appropriated to themselves the right to own and wear jewelry in precious metals, relegating more ephemeral decorations made from shells, feathers and bone to the less well-off. It was a practice fostered by Portuguese merchants, swiftly followed by their Dutch and British counterparts, who produced showers of gold and silver coins which could be melted down to feed this hunger for showy decoration. The raja, or local chiefs of Sumba elected not to wear these jewels personally, however, but rather to heap them on their personal slaves, who represented them like mannequins at important ceremonies. Arrayed in all the paraphernalia of royalty, these slaves thus served as intermediaries with the community as a whole. Hereditary jewels, meanwhile, were carefully preserved in the family house, or adat, and revered as solemnly as holy relics. Should anyone be reckless enough to sell them to foreigners or exchange them at a marriage ceremony curses would rain down upon his head. In some Indonesian societies, these hoards of antique blades, old fabrics, jars and bowls imported from China, as well as ornaments in gold, silver, copper and even brass, were invested with powerful magical properties.

But more than all these things, the jewelry of the Southeast Asian islands acted as an essential form of mediation, not only between the sexes and different social ranks, but also between different parts of the cosmos. Thus, within the highly regulated framework of marriage gifts, the "givers of the wife" presented "feminine" fabrics to the "takers of the wife," who in return offered "masculine" metal in the form of valuable ornaments. Nowadays, this form of exchange has largely transcended the context of ritual marriage transactions in order to "espouse" the dimensions of the international art market.

What therefore remains of the religious symbolism once attached to this secular finery? In the eyes of the Sa'adan Toraja, there still exists a mythical relationship between the ritual activity of the smith, the origins of metalworking and the creation of humanity. Hence, anyone who treats the precious ornaments kept in carved wooden houses in a casual or offhand way does so at their peril. The majority of "traditional" jewelry appears to have lost its ritual status, however: Now highly coveted works of art, these pieces inevitably finish their long journeys in the display cases of museums or private collectors. As Susan Rodgers observes with some regret: "What a contrast between a piece exhibited in a well laid-out museum of primitive art, and the jumble of magic sticks, rings for casting spells and ancestral relics that would have surrounded a Toba Batak sorcerer in the 19th century: the museum contains a collection of silent 'things' in wood, metal or stone, stripped of their power, while the treasure of the Toba datu would have brimmed with sacred energy born of its contact with the supernatural." (L'Or des îles).

It is a reflection that could be applied with equal justice to numerous "primitive" objects—masks, idols or fetishes—which have been transformed by the vagaries of fashion or the dictates of good taste into objects of pleasure, pure and simple. Unless of course they could be said to embody in some way the final "grigris" of a West in constant quest of spirituality.

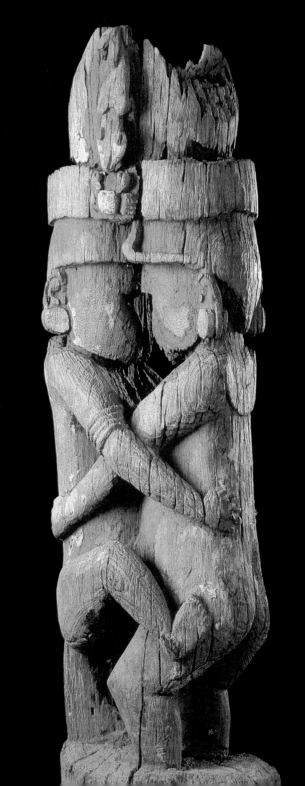

EPILOGUE

"Western man is no longer master of the world: standing before him now are no longer "natives," but interlocutors. We should know how to open the discussion; it is indispensable to recognize that there no longer exists a solution of continuity between the 'primitive' or 'backward' world and the West of today. It is no longer enough, as it was half a century ago, to discover and admire Negro or Oceanian art; we must rediscover the spiritual sources of these arts in ourselves." Such is the earnest hope expressed by Mircea Eliade in her moving treaty, *Mythes, rêves et mystères* (1989).

At a time when Apollinaire's dream of seeing masterpieces of "primitive" art taking their place alongside the classical sculptures and old masters in the Louvre is in the process of becoming a reality, how anachronistic it seems to have to justify such an enterprise! Displaying masks and "fetishes" a few hundred yards from the *Venus de Milo* should be acclaimed universally as a gesture that is as symbolic as it is moving. Yet the small world of ethnologists, art historians, collectors and dealers continues to be shaken to its foundations by impassioned debate and violent argument—not to mention the numerous political ambitions and sterile rivalries that have also come into play. At the dawn of the third millennium, when such questions should no longer prompt the slightest murmur of reproach, the continuing crusade for the complete rehabilitation of the primal arts has something incongruous, even shocking, about it.

As ever, practicing artists appear once again to have refuted in most dazzling fashion such nervous, fearful or corporate reactions: Western painters who have dipped their brushes in the humid heat of Africa, such as the young Spanish painter Miquel Barceló; and African artists who, with a kind of poetic justice, now seek inspiration in the Western classical tradition, such as the Senegalese sculptor Ousmane Sow with his Masai and Peul warriors displaying echoes of Michelangelo.

Post for a ritual house or sacred canoe-house. Melanesia, Solomon Islands. Wood; h. 211 cm.
Musée du Quai Branly, Paris. Gift of M. and Mme Jean-Paul Barbier, 1999.

Leaving aside all art historical jargon, we have no choice but to recognize the exceptional vitality of artists from the regions of the world covered in this book, in fields ranging from painting to photography and even cinema. Where once all took place under the watchful gaze of the Other, now artists are contemplating and taking inspiration from their own imaginary worlds and their creations, and from their past, their religions and their traditions.

Battered and bruised by frequent wars, epidemics and other terrible scourges, Africa is nevertheless turning its attention to the vestiges of its past and attempting to contain both looting and extortion. The notion of heritage is taking shape, as is that of museums, while African universities are now reclaiming the role usurped for so many years by Western archaeologists, ethnologists and scientists. In the countries of Oceania, the distinguished reputation of certain contemporary artists stands as sweet revenge for the prolonged humiliation and iconoclastic destruction suffered under colonial rule. Hackneyed and lost for inspiration, old Europe, meanwhile, still casts covetous glances in the direction of these masks, "fetishes" and "idols," and the frenzied collecting continues unabated. This "acceptable" exoticism is now quite respectable, invading galleries, smart interiors in the world's great capital cities and even tourist brochures. What could be more thrilling than a Dogon masked dance or a Toraja death ritual, with their frisson of Otherness and just the right amount of well-spiced (and carefully controlled) savagery? While ethnologists attempt to collect every scrap of first-hand information about vanishing and bastardized traditions, rituals and costumes, art historians now at last have the courage to look freely at objects whose intrinsic beauty sometimes transcends the cultural context and environment in which they were produced. Too often at odds with each other, these two worlds have everything to gain by sharing their discussions and sensibilities.

In conclusion, may we offer a modest piece of advice to the lay person for whom this book is intended: open your eyes, without prejudice or reserve, but with delight and even passion; explore, sample and discover "Beauty" in all its many and unexpected forms—whether in a Batcham mask with bulging cheeks from Cameroon, in the multicolored checks of an Asante fabric from Ghana, in a hammered gold ornament from the islands of Southeast Asia or in plant-based textures of a funerary effigy from Vanuatu. And may this book serve to open doors and offer guidance in this stirring and ineluctably subjective quest.

SELECT BIBLIOGRAPHY

Charbonnier, Georges. "Entretien avec Alberto Giacometti," *Les Lettres Nouvelles* (April 1959).

_____. *Le monologue du peintre*. Paris: Julliard, 1959.

Daix, Pierre. *De Cézanne à l'art nègre, parcours d'un collectionneur*. Geneva: Musée Barbier-Mueller, 1997.

_____. *Picasso l'Africain*. Geneva: Musée Barbier-Mueller, 1998.

Malraux, André. *Picasso's Mask*, translated and annotated by June Guicharnaud, with Jacques Guicharnaud. New York: Holt, Rinehart, and Winston, 1976.

"Primitivism" in Twentieth-Century Art: Affinity of the Tribal and the Modern, edited by William Rubin. New York: Museum of Modern Art; Boston: New York Graphic Society Books, 1984.

Seckel-Klein, Hélène, and Emmanuelle Chevrière. *Picasso collectionneur*. Paris: Réunion des musées nationaux, 1998.

AFRICA

Travel Narratives

Barbot, Jean. *Barbot on Guinea: The Writings of Jean Barbot on West Africa, 1678-1712*, edited by P. E. H. Hair, Adam Jones, and Robin Law. London: Hakluyt Society, 1992.

_____. *A Description of the Coasts of North and South Guinea*. London, 1732.

_____. *Journal d'un voyage de traite en Guinée, à Cayenne et aux Antilles, fait par Jean Barbot en 1678-1679*. Dakar, 1979.

Caillié, René. *Travels through Central Africa to Timbuctoo, and across the Great Desert to Morocco, Performed in the Years 1824-1828*. London: Cass, 1986, facsimile reprint of the first English edition, London: Colburn and Bentley, 1830.

Calame-Griaule, Geneviève. *Words and the Dogon World*, translated by Deirdre LaPin. Philadelphia: Institute for the Study of Human Issues, 1986.

Dapper, Olfert. *Beschreibung von Africa durch O. Dapper*. New York: Johnson Reprint, 1967. Includes facsimile of 1670 edition, Amsterdam: von Meurs. (Long excerpts have been translated into French in the catalog *Objets interdits* [Paris: Musée Dapper, 1989]).

Griaule, Marcel. *Conversations with Ogotemmêli: An Introduction to Dogon Religious Ideas*, with an introduction by Germaine Dieterlen. London: Oxford University Press, 1965.

Griaule, Marcel, and Germaine Dieterlen. *Le renard pâle*. Paris: Institut d'ethnologie, 1965.

Leiris, Michel. *L'Afrique fantôme*. Paris: Gallimard, 1934.

Park, Mungo. *Travels in the Interior of Africa*. London: Cassel, 1887.

General Works:

Balandier, Georges, and Jacques Maquet, eds. *Dictionary of Black African Civilization*. New York: L. Amiel, 1974.

Féau, Etienne, and Hélène Joubert. *L'art africain*. Paris: Scala, 1996.

Fry, Jacqueline. *The Art and Peoples of Black Africa*, with a preface by Michel Leiris. Translated by Carol F. Jopling. New York: Dutton, 1974.

Kerchache, Jacques, Jean-Louis Paudrat, and Lucien Stéphan. *Art of Africa*, translated by Marjolijn de Jager. New York: Harry N. Abrams, 1993.

Laude, Jean. *The Arts of Black Africa*, translated by Jean Decock. Berkeley: University of California Press, 1971.

Leiris, Michel, and Jacqueline Delange [Jacqueline Fry]. *African Art*, translated by Michael Ross. London: Thames and Hudson, 1968.

Paulme, Denise. *Les civilisations africaines*. Paris: "Que sais-je?", 1980.

Willett, Frank. *African Art: An Introduction*. Revised edition. New York: Thames and Hudson, 1993.

Art Books and Specialized Studies:

Arts de la Côte-d'Ivoire dans les collections du musée Barbier-Mueller, edited by Jean-Paul Barbier, 2 vols. Geneva: Musée Barbier-Mueller, 1993.

Blier, Suzanne Preston, *The Royal Arts of Africa: The Majesty of Form*. New York: Harry N. Abrams, 1998.

Butor, Michel. *Ethnic Jewelry: Africa, Asia, and the Pacific*, translated by Daniel Wheeler, Mary Laing, and Emily Lane. Photographs by Pierre-Alain Ferrazzini. New York: Vendôme, 1994.

Coquet, Michèle. *African Royal Court Art*, translated by Jane Marie Todd. Chicago and London: University of Chicago Press, 1998.

_____. *Textiles africains*. Paris: Société Nouvelle Adam Biro, 1993.

Garrard, Timothy F. *Gold of Africa: Jewellery and Ornaments from Ghana, Côte d'Ivoire, Mali,*

and Senegal in the Collection of the Barbier-Mueller Museum. Photographs by Pierre-Alain Ferrazzini. Munich: Prestel; New York: te Neues, 1989.

Grunne, Bernard de. Naissance de l'art en Afrique noire, la statuaire nok au Nigeria. Luxembourg: Banque Générale du Luxembourg; Paris: Nouvelle Adam Biro, 1998.

Leloup, Hélène. Statuaire dogon. Strasbourg: Editions Amez, 1994.

Meyer, Laure. Les arts des métaux en Afrique noire. Saint-Maur: Editions Sépia, 1997.

Ndiaye, Francine. L'art du pays dogon dans les collections du musée de l'Homme. Zurich: Museum Rietberg, 1995.

Perrois, Louis. Ancestral Art of Gabon: From the Collection of the Barbier-Mueller Museum, translated by Francine Farr. Photographs by Pierre-Alain Ferrazzini. Geneva: Musée Barbier-Mueller, 1985.

_____. Arts royaux du Cameroun. Geneva: Musée Barbier-Mueller, 1994.

_____. L'art du Gabon. Paris, 1972.

_____. La statuaire fang du Gabon. Paris, 1972.

Sculpture, chefs-d'oeuvres du musée Barbier-Mueller, edited by Douglas Newton. Paris: Imprimerie Nationale, 1995.

Leenhardt, Maurice. Folk Art of Oceania, translated by Michael Heron. Photographs by Emmanuel Sougez. New York: Tudor, 1950.

Thomas, Nicholas. Oceanic Art. London: Thames and Hudson, 1995.

Art Books and Specialized Studies:

Barbier, Jean-Paul. Indonésie et Mélanésie: Art tribal et culture archaïque. Geneva: Musée Barbier Mueller, 1977.

Butor, Michel. Ethnic Jewelry: Africa, Asia, and the Pacific, translated by Daniel Wheeler, Mary Laing, and Emily Lane. Photographs by Pierre-Alain Ferrazzini. New York: Vendôme Press, 1994.

Kasarherou, Emmanuel. Le masque kanak. Marseilles: Editions Parenthèses, 1993.

Leenhardt, Maurice. Gens de la Grande Terre. Paris: Gallimard, 1937.

Orliac, Catherine, and Michel Orliac. Easter Island: Mystery of the Stone Giants, translated by Paul G. Bahn. New York: Harry N. Abrams, 1995.

Sculpture, chefs-d'oeuvres du musée Barbier-Mueller, edited by Douglas Newton. Paris: Imprimerie Nationale, 1995.

OCEANIA

Travel Narratives:

Bougainville, Louis-Antoine de. A Voyage Round the World, translated by John Reinhold Forster. Amsterdam: N. Israel; New York: Da Capo, 1967. Reprint of the London edition, 1772.

Gauguin, Paul. "Avant et Après," in The Writings of a Savage, edited by Daniel Guérin. Introduction by Wayne Andersen. Translated by Eleanor Levieux. New York: Viking, 1978.

Loti, Pierre. Journal d'un aspirant de La Flore. 1872; repr. Ville-d'Avray: Editions Pierre-Olivier Combelles, 1988.

General Works:

D'Alleva, Anne. Arts of the Pacific Islands. New York: Harry N. Abrams, 1998.

Guiart, Jean. The Arts of the South Pacific, translated by Anthony Christie. New York: Golden Press, 1963.

Kaeppler, Adrienne, and Christian Kaufmann. Oceanic Art. New York: Harry N. Abrams, 1997.

SOUTHEAST ASIA

General Works:

Barbier, Jean-Paul. Indonésie et Mélanésie: Art tribal et culture archaïque. Geneva: Musée Barbier-Mueller, 1977.

_____. Indonesian Primitive Art from the Collection of the Barbier-Mueller Museum. Geneva: Musée Barbier-Mueller and Dallas: Dallas Museum of Art, 1984.

Art Books and Specialized Studies:

Butor, Michel. Ethnic Jewelry: Africa, Asia, and the Pacific, translated by Daniel Wheeler, Mary Laing, and Emily Lane. Photographs by Pierre-Alain Ferrazzini. New York: Vendôme, 1994.

Rodgers, Susan. Power and Gold: Jewelry from Indonesia, Malaysia, and the Philippines from the Collection of the Barbier-Mueller Museum. New York: te Neues, 1988.

Sculpture, chefs-d'oeuvres du musée Barbier-Mueller, edited by Douglas Newton. Paris: Imprimerie Nationale, 1995.

AFRICA

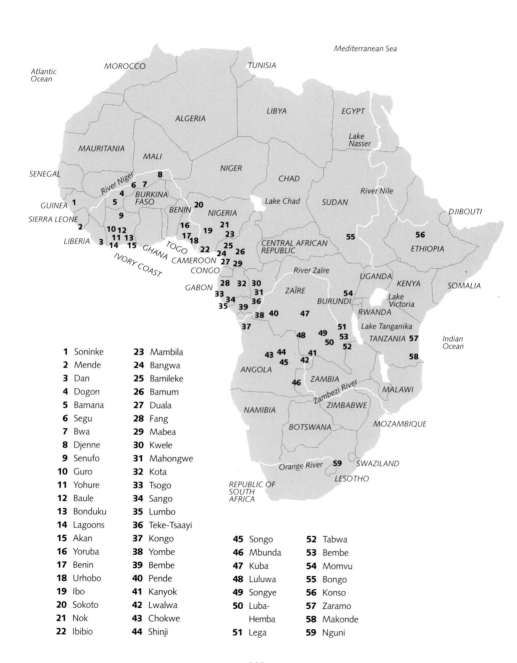

1 Soninke
2 Mende
3 Dan
4 Dogon
5 Bamana
6 Segu
7 Bwa
8 Djenne
9 Senufo
10 Guro
11 Yohure
12 Baule
13 Bonduku
14 Lagoons
15 Akan
16 Yoruba
17 Benin
18 Urhobo
19 Ibo
20 Sokoto
21 Nok
22 Ibibio

23 Mambila
24 Bangwa
25 Bamileke
26 Bamum
27 Duala
28 Fang
29 Mabea
30 Kwele
31 Mahongwe
32 Kota
33 Tsogo
34 Sango
35 Lumbo
36 Teke-Tsaayi
37 Kongo
38 Yombe
39 Bembe
40 Pende
41 Kanyok
42 Lwalwa
43 Chokwe
44 Shinji

45 Songo
46 Mbunda
47 Kuba
48 Luluwa
49 Songye
50 Luba-
 Hemba
51 Lega

52 Tabwa
53 Bembe
54 Momvu
55 Bongo
56 Konso
57 Zaramo
58 Makonde
59 Nguni

393

OCEANIA

MARIANA
ISLANDS

HAWAII

MICRONESIA

CAROLINE
ARCHIPELAGO

MARSHALL
ISLANDS

NUKUORO

Cenderawasih MATY ADMIRALTY
Bay ISLANDS

IRIAN JAYA Lake **1** **14** NEW IRELAND
 Sentani **2 6** Astrolabe GAZELLE PENINSULA
10 **3 4 5** Bay WITU **13**
NEW GUINEA **11** NISSAN
 7 8 NEW BRITAIN **12**
 Gulf of Papua Huon BOUGAINVILLE
MABUIAG **9** SAIBAI Gulf NEW GEORGIA
 PAPUA NEW SOLOMON
 GUINEA ISLANDS SAN CRISTOBAL
 MARQUESAS
 Torres Strait ENTRECASTEAUX VANUATU ISLANDS
 ISLANDS ISLANDS SAMOA
 ISLANDS
 AMBRYM SOCIETY
 ISLANDS TUAMOTU
 FIJI COOK
1 Abelam (Maprik) NEW CALEDONIA **15** ISLANDS ISLANDS TAHITI
2 Murik RAROTONGA AUSTRAL
3 Kopar TONGA ISLANDS
4 Iatmul **MELANESIA** ISLANDS
5 Biwat (Mundugumor) **POLYNESIA**
6 Kayan (East Sepik province) NORFOLK
7 Elema Tasman EASTER
8 Kerebo (Kerawa) Sea ISLAND →
9 Kala Lagawya Pacific
10 Asmat Ocean
11 Bali-Vitu
12 Mamusi
13 Kairak and Uramot **16**
 Baining
14 Kara NEW
15 Kanak ZEALAND
16 Maori

SOUTHEAST ASIAN ISLANDS

1 Batak	**7** Sasak
2 Iban	**8** Ngada
3 Kenyah	**9** Nage
4 Kayan	**10** Ende
5 Bahau	**11** Atoni
6 Sa'adan	**12** Tetum
Toraja	**13** Bajau

395

ACKNOWLEDGMENTS

This book would never have been written but for one chance meeting: with the great Swiss collector Jean-Paul Barbier, some ten years ago. His small "sanctuary-museum," tucked among the narrow streets of the old town of Geneva, was a dazzling discovery. There, beautifully displayed against a discreet, ascetic setting, were masterpieces of African art rubbing shoulders with jewelry from throughout the world and ethnic fabrics and finery, together revealing the expert eye and consummate discrimination of the individual who had collected them over the years. Every collector and every aesthete—whether poet, writer, scientist, curator or simply lover of beautiful objects—is after all primarily *un regard*, or way of seeing. And Jean-Paul Barbier's *regard* appears infallible, if we are to judge from this peerless collection that he and his wife have so lovingly created over the years, taking over the family tradition started by his father-in-law Joseph Mueller. But Jean-Paul Barbier's infectious passion has always been combined with the extraordinary generosity of an enthusiast who thinks nothing of spending hours in long discussions of the virtues of some piece or other that he believes to be exceptional. Assiduous and frequent visits to his museum, his splendid exhibitions and his inexhaustible archives are thus the inspiration behind numerous observations throughout the text of this book. My warmest gratitude thus goes to Jean-Paul Barbier and to those who work with him, especially Madame Laurence Mattet.

I owe another deep debt of gratitude to all the lovers of "primitive" art that I have been fortunate enough to encounter during my work on this book: collectors, ethnologists and curators who have always offered me a warm and profoundly generous welcome, from Christiane Falgayrettes-Leveau, director of the Musée Dapper, to Etienne Féau, curator of African art at the Musée des Arts d'Afrique et d'Océanie, and from Jacques Kerchache, my guide to the memorable Tainos exhibition, to Douglas Newton, whom I met on a fascinating journey to the ethnology museum in Basel. May they not be disappointed by the results of my researches.

My wholehearted thanks go also to the editorial team who have helped to bring this project to fruition: first of all to my editor, Martine Assouline, for her renewed trust in me, to Julie David for her careful and rigorous editing of the text, and to Eléonore Therond for the inventiveness of her design. I offer them all my sincere gratitude.

Finally, of course, come Laurent and Cassandre Schneiter, who have been intimately involved with this "long adventure" from start to finish.

The publishers would like to thank Monique and Jean-Paul Barbier-Mueller and all who work at the Musée Barbier-Mueller, and most particularly Laurence Mattet. Without their support this book would not have been possible. They extend their gratitude also to Douglas Newton for the particular attention that he has been kind enough to give this project, and to all those who have contributed to its creation: the photographers Gérard Bonnet (Marseille), Hugues Dubois (Brussels), Pierre-Alain Ferrazzini (Geneva) and Béatrice Hatala (Paris); Delphine Allannic, Musée de la Marine, Paris; Vivianne Baeke and Boris Wastiau, Musée royal de l'Afrique centrale, Tervuren; Alison Deeprose, the British Museum, London; Muguette Dumont, Musée de l'Homme, Paris; Anita Jenkins, Smithsonian Institution, National Museum of African Art, Washington; Dominique Lacroze, Musée Dapper, Paris; the Linden Museum, Stuttgart; Caroline de Lambertye, Réunion des musées nationaux, Paris; Madame Seckel, Musée Picasso, Paris; Frederico Sodré Borges, Museu de Historia Natural da Faculdade de Ciências da Universidade, Porto; Suzanne Wessendorf, Museum der Kulturen, Basel; Julie Zeftel, The Metropolitan Museum of Art, New York.

PHOTO CREDITS

INDEX